GLOBAL
CLAY

GLOBAL
THEMES IN WORLD CERAMIC TRADITIONS
CLAY

JOHN A. BURRISON

INDIANA UNIVERSITY PRESS

This book is a publication of

Indiana University Press
Office of Scholarly Publishing
Herman B Wells Library 350
1320 East 10th Street
Bloomington, Indiana 47405 USA

iupress.indiana.edu

This book is printed on acid-free paper.

Manufactured in China

Cataloging information is available from the Library of Congress.

ISBN 978-0-253-03188-4 (cloth)
ISBN 978-0-253-03189-1 (ebook)

Second Printing 2020

Back jacket photos, top row from left to right:
Blue-glazed "faience" hippopotamus figure from the tomb of steward Senbi II at Meir, Upper Egypt, ca. 1900 BCE. Collection of the Metropolitan Museum of Art, New York, www.metmuseum.org.

Soft-paste porcelain "pilgrim" flask, Medici Porcelain Factory, Florence, Tuscany, Italy, 1575–1587. Collection of J. Paul Getty Museum, Los Angeles, California, www.getty.edu.

Faience plate in the Ottoman style of Iznik, Turkey, by Joseph-Théodore Deck, Paris, France, ca. 1870. Collection of the Metropolitan Museum of Art, New York, www.metmuseum.org.

Bottom row from left to right:
Terracotta pair thought to be Greek fertility goddesses Demeter and her daughter Persephone, Myrina, Asia Minor, ca. 100 BCE. Collection of British Museum. London, www.britishmuseum.org. Photograph: Marie-Lan Nguyen, CC BY 2.5, via Wikimedia Commons.

Five-claw dragon chasing "flaming pearl" (now broken), glazed tiles on Nine Dragon screen wall facing Gate of Imperial Supremacy, Forbidden City, Beijing, China, erected in the early 1770s during reign of the Qianlong Emperor. Photograph: Richard Fisher, CC BY 2.0, via Wikimedia Commons.

Porcelain rabbit *okimono*, Mikawachi, Hirado, Nagasaki Prefecture, Japan, 2nd half of 19th century. Collection of Los Angeles County Museum of Art, www.lacma.org.

Front jacket flap photo:
Fritware plate, Iznik, Turkey, 1535–1545. Collection of Musée du Louvre, Paris, France. Photograph: Sailko, CC BY 3.0, Wikimedia Commons.

To the memory of
Samuel P. Bayard
and MacEdward Leach,
my mentors,
who introduced me
to academic folklore study
and gave me
an international perspective
on the subject.

CONTENTS

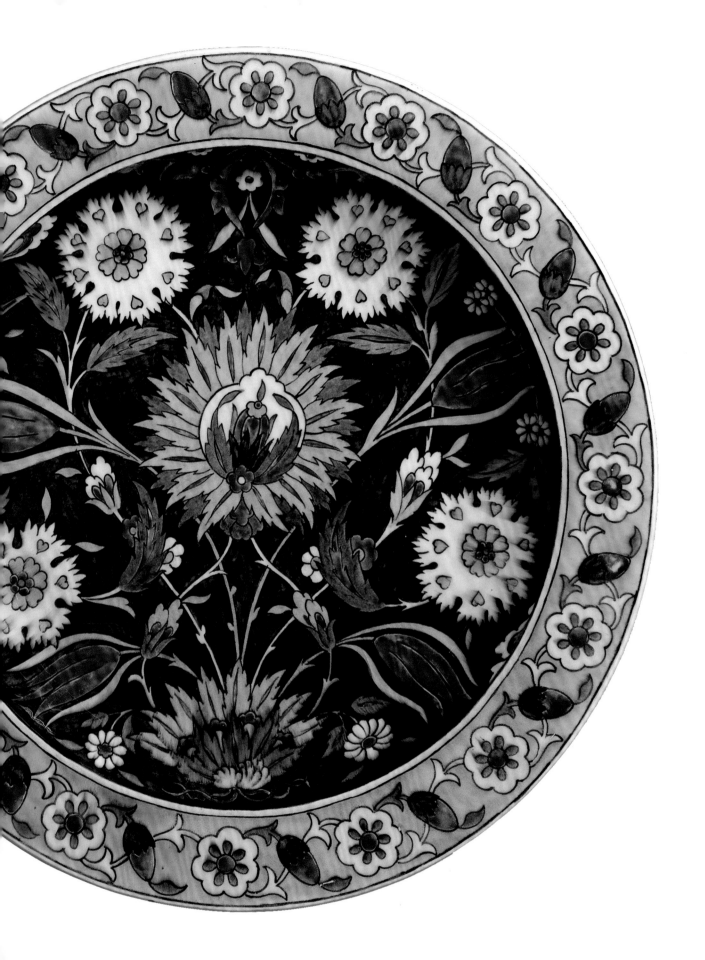

ACKNOWLEDGMENTS

THIS BOOK WOULD NOT HAVE BEEN POSSIBLE WITHOUT THE GENEROSITY of institutions and individuals making their images available for use as illustrations here. I gratefully acknowledge and thank the following:

Museums

The Metropolitan Museum of Art, New York; the Los Angeles County Museum of Art (via Wikimedia Commons); the Walters Art Museum, Baltimore (via Wikimedia Commons); York Art Gallery, York, England (via Wikimedia Commons); Rijksmuseum, Amsterdam; the J. Paul Getty Museum, Los Angeles; the Jewish Museum, New York City; the Victoria and Albert Museum, London; the David Collection, Copenhagen; Museum Boijmans Van Beuningen, Rotterdam; The Potteries Museum and Art Gallery, Stoke-on-Trent; UBC Museum of Anthropology, Vancouver; Michael C. Carlos Museum, Emory University, Atlanta; Winterthur Museum, Winterthur, Delaware; Freer Gallery of Art, Washington, DC; the Museum of Early Southern Decorative Arts/Old Salem Museums and Gardens, Winston-Salem, North Carolina; McKissick Museum, University of South Carolina, Columbia; and the Birmingham Museum of Art, Birmingham, Alabama. The first seven of these museums now make high-resolution images from their collections available gratis as participation in OASC (Open Access for Scholarly Content), Creative Commons, and the like, while the Victoria and Albert Museum permits free use of its images for academic publications; the others kindly granted permissions and supplied images at my request.

Other Institutions

Wikimedia Commons (a tremendously useful online visual database affiliated with Wikipedia); Flickr.com (for Creative Commons images); the Chipstone Foundation, Milwaukee; the Center for Southwest Research, University Libraries,

University of New Mexico, Albuquerque; and Wellcome Trust, London (via Wikimedia Commons).

Dealers

Andrea Fisher Fine Pottery; Jeremy Wooten, Wooten & Wooten; Rock Island Auction Company; Maurice Sauvin, Sauvin European Folk Arts; Allan Katz Americana; Brandt Zipp, Crocker Farm Auction; and Skinner, Inc.

Individual Photographers/Owners of Photographs

Giovanni Andreani, Robert Bégouën, Dennis Darling, Jillian DiMedio, Catherine S. Elliott, Wallace F. de Faria, Karen Green, Janet Koplos, Jenny Lewis, Noela Mills, Nick Pangere, Vijaya Perumalla, Julie Rana, Carolyn Robinson, Phil Rogers, Pan Shan, Tony and Marie Shank, J. Garrison and Diana Stradling, and Erik Wada.

———— ➤●◄ ————

Nothing pleases me more than to acknowledge the support and camaraderie of fellow researchers over the years, some of whom are no longer with us. Among these are scholar-potters and museum curators and directors. In Europe: Peter Brears, John Hudson, Richard Coleman-Smith, Julia Poole, Rosemary Weinstein, and Arnold Mountford (England); Megan McManus (Northern Ireland); Clodagh Doyle (Republic of Ireland); Graeme Cruickshank, John Laurenson, and Christine Rew (Scotland); J. Geraint Jenkins and James Bentley (Wales); Marcel Poulet and Jean Cuisenier (France); Harald Rosmanitz and Walter Manns (Germany); and Paul Petrescu and Magdalena Andreescu (Romania). In the United States: Georgeanna Greer, Linda Carnes-McNaughton, Charles G. (Terry) Zug III, Joey Brackner, Henry Glassie, Ralph Rinzler, Cinda Baldwin, Jill Beute Koverman, Susan Myers, Laura Addison, Gary and Diana Stradling, Karen Duffey, Chris Brooks, Samuel D. Smith, Robert Hunter, Suzanne Findlen Hood, Carl Steen, Nancy Sweezy, Mark Hewitt, Stephen Ferrell, Johanna Brown, Gail Andrews, Jane Przybysz, Philip Wingard, and Carole Wahler.

I also owe a debt of thanks to Georgia State University colleagues Randy Malamud, Alex Fedorov, Baotong Gu, Reiner Smolinski, and Malinda Snow of the Department of English for various kinds of help; and to Carol Winkler, then Associate Dean for the Humanities in the College of Arts and Sciences, for granting me released time to work on this project.

Finally, I wish to express my appreciation to the director of Indiana University Press, Gary Dunham, for his support of this project, to my designer, Jennifer Witzke, and to my editor, Janice Frisch, and her assistant, Kate Schramm, both Ph.D. graduates of Indiana University's Department of Folklore and Ethnomusicology, for their diligence and patience in working with this author who still has one foot planted in the mid-twentieth century.

GLOBAL
CLAY

INTRODUCTION

Turn, turn, my wheel! The human race,

Of every tongue, of every place,

Caucasian, Coptic, or Malay,

All that inhabit this great earth,

Whatever be their rank or worth,

Are kindred and allied by birth,

And made of the same clay.

Henry Wadsworth Longfellow, "Kéramos" (1877)[1]

Global Clay IS A BOOK ABOUT POTTERY FROM AROUND THE WORLD, from the earliest wares to those of today. But this is not a survey in the usual sense, as it does not approach the subject in a linear, chronological way as a historian would, or in a spatial or ethnographic way as a geographer or anthropologist would. Although it certainly benefits from those methodologies, this book first of all is driven by ideas: themes shared by clay-working societies wherever they are found.[2]

The approach used here is informed by my training as a folklorist, with its focus on the continuity of traditions over time and space and how they respond to change. Folk traditions connect the individual to society, providing an anchor to previous generations and, at the same time, a resource for creative behavior in the present. Like those traditions, the study of folklore is evolving, but one methodology that has remained constant is the comparative approach, a goal of which is to address the Big Question: How did certain cultural products come to be so widespread (especially in the days before print and electronic media)?[3] The universality of certain pottery ideas is what *Global Clay* will specifically address.

Walk into traditional pottery workshops anywhere in the world and you are immediately struck by their similar layouts. The similarities are due not to the

adoption of a common design plan, but to the demands of working with clay in a traditional way. For example, there's a good reason why potter's wheels are usually placed near a window: for light and air. Folklorists explain such similarities as the result of *polygenesis*, or the independent inventions of an idea found in unconnected places, as opposed to *diffusion*, or the spread of a tradition from a single source.[4] You'll be reminded of those two options, as well as their possible combination, as we explore some widespread, and intriguing, ceramic themes.

So, as a folklorist whose interests began with traditional music and oral literature, how did folk pottery become my research specialty? Two brief answers: my friendship with fellow University of Pennsylvania graduate student Henry Glassie—who would become a world-class material culture scholar and influence my trajectory—and my subsequent friendship with north Georgia folk potter Lanier Meaders.[5]

Before meeting Lanier in 1968 I had no interest or background in ceramics; but thinking back, a much earlier experience with traditional pottery may have prepared me for expanding my later research focus beyond the American South to the rest of the world. At the age of thirteen I spent part of a summer with friends in Jalisco, Mexico (my first time outside the United States), and we visited the pottery town of Tlaquepaque. I was not attuned to carefully observing then, of course, so have only the vaguest memory of the workshop, but in that memory is the picture of an open-air courtyard with artisans at work shaping and painting earthenware.

My two previous pottery books focus on the state of Georgia, but while working on the first I'd begun taking research trips to the British Isles, initially looking for (and finding) connections to American folk pottery, then falling in love with the diverse ceramic traditions of England, Wales, Scotland, and Ireland for their own sake. One of those adventures included a pottery-focused side trip to Rhineland Germany, and returning there several years later I was able to revisit one of a select number of German potters who still make traditional blue-and-gray salt-glazed stoneware. More recent trips to China, Turkey, and Romania—all countries with rich ceramic traditions, both historical and contemporary—broadened my horizons beyond the West.

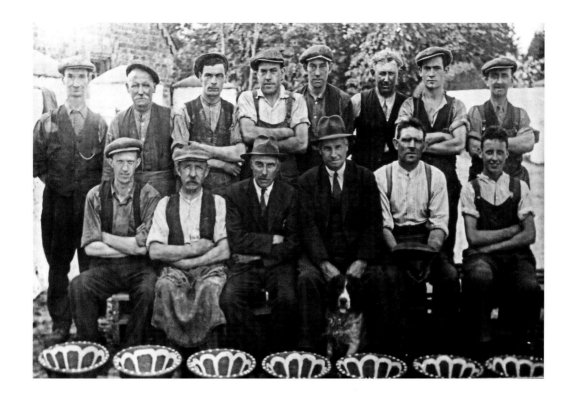

A brief account of one firsthand experience will serve to illustrate the nature of field-based research. I teach a course on Irish folk culture at Georgia State University, and on my first two trips to the country found no pottery that was identifiably Irish (except for the semi-industrial Belleek wares of County Fermanagh and studio tablewares of County Kilkenny's Nicholas Mosse), leading me to wonder if Ireland ever had a significant postmedieval ceramic tradition. Then I came across an article by Megan McManus of the Ulster Folk & Transport Museum at Holywood, Northern Ireland, summarizing her research on the pottery center of Coalisland in County Tyrone.[6] At the time, she was one of the very few people who knew anything about traditional pottery in Ireland. We corresponded, and I was invited to give a public lecture at the museum and do field research to support Megan's work.

The summer of 1986 was a tense time in Northern Ireland. A few days before arriving with my archaeologist friend and research associate, Linda Carnes-McNaughton, three Royal Ulster Constabulary officers were shot dead by the Irish

Republican Army in County Down, and the same thing happened to a civilian contractor for the RUC in County Tyrone where we would conduct our fieldwork. Only certain roads were approved for border crossing, with British Army checkpoints on the northern side, and parking in town centers was prohibited due to the threat of car bombs. Despite this war-zone atmosphere, the people treated us with their typical Irish warmth and hospitality (relieved, I think, that we were there for reasons other than to report on the sectarian Troubles). The residents of Coalisland were prepared for our coming by a notice Megan had placed in the local newspaper, so there was little need to explain our presence.

Coalisland is named, not surprisingly, for its coal deposits, with a canal built to transport the fuel down to Dublin. The canal became a convenient way to bring raw materials to, and ship finished wares from, the potteries. The first mention of pottery making in the area is in the *Belfast News Letter* of 1759, announcing a partnership to "carry on earthenware manufacture at Port Tallyhoa on the canal in County Tyrone, where all kinds of black [manganese-colored] and brown ware and country [drain] tiles may be had at reasonable terms." An 1834 Ordnance Survey map shows nine pottery sites, while an 1843 geological survey records thirteen kilns.[7] The most prominent name in later years was the Burns family, which maintained workshops for a century beginning in the 1850s. The Burnses were not potters themselves but landowners who ran shops with hired workers as a commercial venture. Their two operations, Burnbrae Pottery (fig. 0.1) and Samuel Burns Pottery, closed in the 1950s.

Megan was particularly anxious for us to interview Bobbie Cranston, one of the last surviving workers at Burnbrae and son of David Cranston, a skilled thrower there. The following excerpt from our recorded conversation offers a glimpse of what life was like for the workers:

> B.C.: The kiln [pronounced "kill"] at that time, at nighttime, was a good place for people to call in, to spend an hour. They had nowhere else to go, but they come to the kiln. There's a bit of heat and all on a cold winter's night. Just like me and you talking would tell a yarn, put a bit to it or take a bit off it.
> J.B.: What kind of yarns, then?
> B.C.: Nearly all ghost stories.
> J.B.: Sammy was telling us about a banshee that was supposed to be associated with the Burns family. Do you remember about that at all?
> B.C.: I heard my father talking about that, a banshee. It was supposed to be at a wake (that's somebody dead in the house). This wee woman was sitting up saying a wail, crying, called a banshee. And ever after that she disappeared. That's what I heard it said to be.
> J.B.: When they were burning the kiln, did anybody ever bring an instrument and play music?

B.C.: Yes, a fellow used to bring an accordion down, at nighttime. You'd stay all night. It was a big bore to sit there, so they'd play a bit of music on the accordion, or the banjo—four-string [tenor] banjo. The fellow done that's dead now, William James Cardwell.

J.B.: Did he work at the pottery?

B.C.: He did.

J.B.: What was the status of the potter in this community? Were potters regarded pretty highly in the Coalisland area?

B.C.: Yes, pretty highly; it was a skilled job. If you were a potter, you were a somebody. He had the skill in his hands. If you were a potter, you had a good job, you were well paid. A kiln burner was well paid. You were paid a weekly wage. But then, the other ones was only classed as laborers.

J.B.: Who were the potters who worked at the Burns potteries?

B.C.: In my time, it was my fa' [father], David Cranston. He was a crock maker. And there was Frank McKay, he was a flowerpot [pronounced "fluerpo'"] maker. And there was John Mullin, he was a flowerpot maker. And there was Terry Donnelly, he was a flowerpot maker too. That's all I can remember.[8]

I was able to locally purchase for the museum a lead-glazed earthenware "pea strainer" (colander) made about 1930 by Bobbie's father, David Cranston (fig. 0.2). Sgraffito-decorated (see Chapter 1) and inscribed "Home Sweet Home A Present. From. Ireland" instead of the usual Orange Order (Protestant) iconography, it was a piece the museum could display without the risk of alienating its Catholic patrons. It belongs to a tradition of Ulster sgraffito-decorated bowls that began in the mid-nineteenth century and is probably related to similar bowls made in Scotland.[9]

Another focus of our Coalisland fieldwork was to explore local cemeteries for ceramic grave markers, a tradition we'd found elsewhere in the British Isles and one I first became aware of in the American South (see Chapter 7). We found a half dozen, some of brown salt-glazed stoneware, our first indication of stoneware production in Ireland. The most elaborate example, in a local church cemetery, is cross-shaped and rusticated like tree bark, the type-impressed inscription indicating that the deceased "died young" in 1887 (fig. 0.3). According to Mary McNally, whom we also interviewed, it was made as a one-off item by her grandfather, John Hughes, who worked as a molder at the semi-industrial Corr & McNally's (also known as Kelly's Yard and later Ulster Fireclay Works) in Coalisland.

Fieldwork is one kind of research that went into this book, but firsthand experience with all the traditions included here would have been unrealistic. Even if such extensive travel had been possible, it wouldn't have been the best way to pursue the themes I set out to explore, as many of the examples I needed to develop these themes are historical pieces in museum and private collections. So I had to adopt a strategy different from that of my two previous pottery books, involving

Figure 0.2. "Pea strainer" (colander) by David Cranston, lead-glazed earthenware with sgraffito inscription, leaf-resist decoration, and fluted rim, made for a fellow Burnbrae Pottery worker ca. 1930. Purchased by the author for Ulster Folk & Transport Museum collection. Photograph: author.

Figure 0.3. Brown salt-glazed stoneware cruciform grave marker, rusticated and with type-impressed inscription on base, by John Hughes of Corr & McNally's, ca. 1887, in St. Mary and St. Joseph Roman Catholic Church cemetery, Coalisland, County Tyrone. Photograph: author.

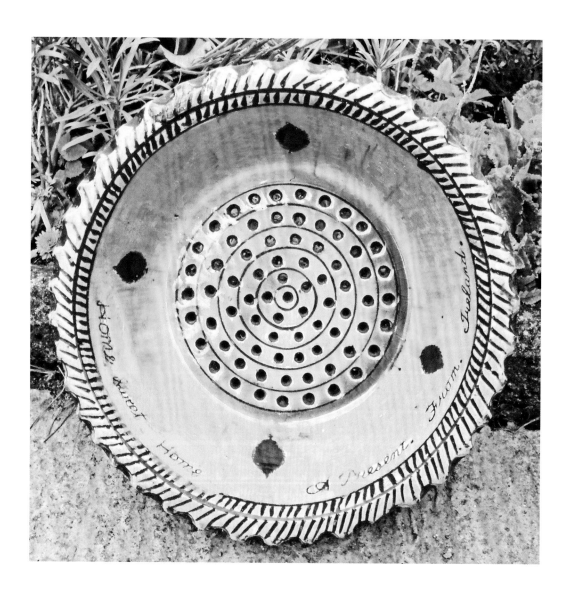

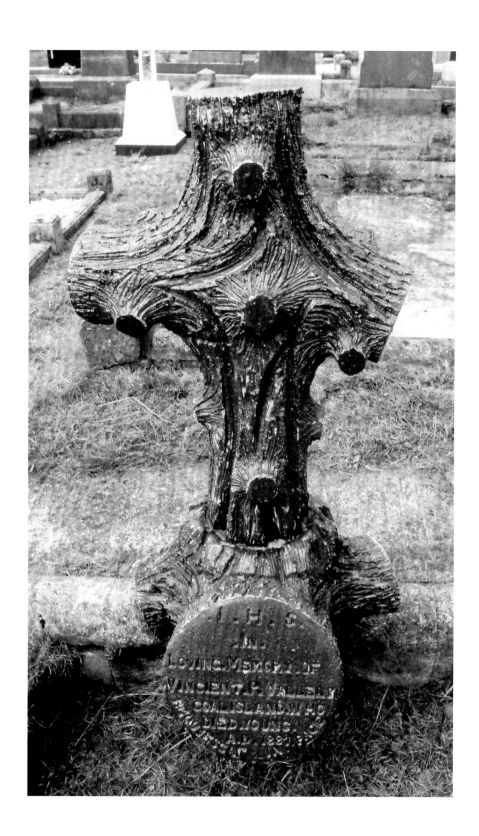

a great deal of reading, Internet searching, and contact with researchers abroad as well as in the United States.

The study of material culture is inherently a visual field, one that requires illustration in its publications. To support my comparative approach, I realized that the right images could serve as evidence of the universality of the chosen themes; locating and getting permission to publish them was as time-consuming as the actual writing. Fortunately, a number of museums are now generously making high-resolution photographs from their collections available for free, as are Internet sites like Wikimedia Commons. In fact, the impetus to begin this project was the study collection of more than 30,000 images I'd amassed on my computer over the years, used for public presentations such as the lecture series I gave in Atlanta in 2013 called "Around the World in Eighty Clays." While putting that together several universal themes emerged more clearly in my mind, leading to the following chapters.

To restate: this is not a comprehensive survey; it wasn't my intention to represent every ceramic tradition on the planet, but to explore and support the themes I've chosen, wherever they have led me, with illustrations and bibliographic citations. "Global" is not just a faddish catchword, and global thinking is not just a current trend but an imperative, if we are to make sense of and adapt to the new world order that impacts us all with its many opportunities and challenges. *Global Clay* is my effort to break down the perceptual barriers that prejudice our view of other cultures so that the humanity we all share is revealed. In this case, that humanity is expressed in useful and beautiful things made of clay.

Notes

1. Lewis Leary, ed., *The Essential Longfellow* (New York: Collier, 1963), 94. "Kéramos" was written in 1877 and published the following year in *Kéramos and Other Poems*.

2. Not all of the world's cultures have had a ceramic tradition. Two exceptions to the nearly universal distribution of traditional pottery making are Australia and Hawaii. My Australian contact, the artist Noela Mills, offered this explanation: "There was no tradition of pottery amongst the indigenous Australian aborigines. They painted on cave walls and bark, carved wood for utilitarian objects, but being nomadic and walking from one place to another, they didn't accumulate possessions" (Noela Mills, email correspondence to author, June 30, 2015). However, Australia has seen a few European potter settlers like George Duncan Guthrie, a Scotsman who came in the 1850s for the gold rush and after finding stoneware clay established Bendigo Pottery, a semi-industrial operation still in business at Epsom, Victoria. My contact in Hawaii, anthropologist Mara Mulrooney of the Bishop Museum in Honolulu, had this to say: "Ancient Hawaiians did not make pottery (despite the fact that

there are clay sources in the Hawaiian Islands). Archaeological evidence suggests that, with the exception of Fiji, Polynesians stopped making pottery around 2000 years ago" (Mara Mulrooney, email correspondence to author, September 2, 2015).

3. For the comparative approach in folklore study, see Robert A. Georges and Michael Owen Jones, *Folkloristics: An Introduction* (Bloomington: Indiana University Press, 1995), 40–42 and chap. 5; Jan Harold Brunvand, *The Study of American Folklore: An Introduction*, 4th ed. (New York: Norton, 1998), 35–36; Richard M. Dorson, ed., *Folklore and Folklife: An Introduction* (Chicago: University of Chicago Press, 1972), 7–12; Christine Goldberg, "Comparative Approach," in *American Folklore: An Encyclopedia*, ed. Jan Harold Brunvand (New York: Garland, 1996), 151–154; and Ulrika Wolf-Knuts, "On the History of Comparison in Folklore Studies," www.hanko.uio.no/planses/Ulrika.html (accessed September 12, 2016).

4. For polygenesis and diffusion, see Georges and Jones, *Folkloristics*, 134–153, and John Greenway, *Literature among the Primitives* (Hatboro, PA: Folklore Associates, 1964), 191–202. Two archaeology-based publications that specifically address early ceramic diffusion are H. H. E. Loofs-Wissowa, ed., *The Diffusion of Material Culture*, Asian and Pacific Archaeology Series 9 (Honolulu: Social Science Research Institute, University of Hawaii, 1980), Part 1, and Peter Jordan, Kevin Gibbs, Peter Hommel, and Henry Piezonka, "Modelling the Diffusion of Pottery Technologies across Afro-Eurasia: Emerging Insights and Future Research," *Antiquity* 90 (June 2016): 590–603.

5. John A. Burrison, *Roots of a Region: Southern Folk Culture* (Jackson: University Press of Mississippi, 2007), 9; Burrison, *Brothers in Clay: The Story of Georgia Folk Pottery*, rev. ed. (Athens: University of Georgia Press, 2008), xxvii–xxx.

6. Megan McManus, "The Potteries of Coalisland, County Tyrone: Some Preliminary Notes," *Ulster Folklife* 30 (1984): 67–77. See also McManus, "Coarse Ware," in *Traditional Crafts of Ireland*, ed. David Shaw-Smith (New York: Thames & Hudson, 2003), 196–207; Mairead Donlevy, *Ceramics in Ireland* (Dublin: Ard-Mhúsaem na hÉireann [National Museum of Ireland], 1988); and Charles E. Orser, Jr., "Vessels of Honor and Dishonor: The Symbolic Character of Irish Earthenware," *New Hibernia Review* 5:1 (2001): 83–100.

7. McManus, "The Potteries of Coalisland," 67–68, 70.

8. Bobbie Cranston, interview at his Coalisland home on August 12, 1986, conducted, recorded and transcribed by the author.

9. Sgraffito-decorated bowls similar to those of Ulster were made in late-1800s Scotland at Cumnock Pottery, Cumnock; Seaton Pottery, Aberdeen; and Dryleys Pottery, Montrose. See Gerald Quail, *The Cumnock Pottery* (Ayr, UK: Ayrshire Archaeological and Natural History Society, 1993), and Alison Cameron, *A Feat of Clay: 100 Years of Seaton Pottery* (Aberdeen, UK: Aberdeen Art Gallery and Museums, 2005).

1 | INTERNATIONAL FOLK POTTERY

A Brief Primer

White Ware of Siegburg.

Red Brown Ware of Raeren.

Brown or Mottled Ware of Frechen.

Rusty, Dark Brown and Enameled Wares of Kreussen.

Gray Ware of Grenzhausen, with Blue, Brown, and Purple Enamels.

Brown and Gray Wares of Bouffioux.

Ferruginous Ware of Bunzlau.

Dark Red Ware of Dreyhausen.

Color comparison of typical stonewares from different German, Belgian, and Polish
production centers, E. A. Barber (1907)[1]

IN THIS BOOK I USE THE TERMS "FOLK" AND "TRADITIONAL" INTER-
changeably to describe the potters and their products featured here. By folk
potters I mean those who've learned their designs and handcrafting skills by
observation and practice in a family or apprenticeship setting, and are thus hu-
man links in a chain of artistic transmission that can span many generations and
centuries. Participating in a group-shared tradition doesn't mean, however, that
folk potters can't interpret what they've learned to suit their individual needs and
creative impulses, with each contributing to the tradition as it's handed on.

This understanding distinguishes folk pottery from the ceramics more famil-
iar to many readers: machine-molded table and kitchen wares mass produced in
factories and the work of school-trained studio potters guided by an aesthetic
consciousness rooted in the mid-nineteenth century. Until the Industrial Revolu-
tion and subsequent Arts and Crafts movement, virtually all pottery making was
folk; in many parts of the world it still is. I should point out, however, that the

term "folk pottery," adopted by American researchers and collectors in the 1970s, is not universally recognized; in Great Britain, for example, the equivalent term is "country pottery."[2] Although my focus here is on such wares, I'll occasionally use industrial and studio examples for comparison. I'll also be using "pottery" and "ceramics" interchangeably to mean any fired-clay object, while recognizing that in some circles the latter is a broader term that can encompass more than pots. A "pottery" can also refer to a production site or workshop.

Despite the amazing diversity of the world's ceramic traditions over time, space, and cultures, it is possible to break them down in a simplified way into types based largely on fabric (clay body) and surface treatment (glaze and decoration) as a touchstone for the variety of wares I'll be discussing. And an understanding of the nature of clay is a good place to begin. Clay is a pliable earth composed largely of silica and alumina—the two most abundant minerals in the earth's crust—broken down from stone over millions of years. When mixed with water, the platelike particles slide against each other, and this plasticity allows clay to be shaped into virtually any form imaginable. Most clays include other elements, such as iron, as well as organic material (but not nearly so much as soil or dirt). To be usable as pottery, the clay must be hardened by firing, after which it will retain its shape even when wet.[3]

Much of the typology laid out below will be familiar to pottery enthusiasts, but the nonspecialist reader should find it helpful for explaining terminology used in the following chapters.

Earthenware

Earthenware is pottery composed of coarse-grained clay that fires at a relatively low temperature (up to 2,000°F/1,093°C, but often lower). The resulting product is at best only partly vitrified, with the spaces between the grains not filled with glass melted from the silica, and is therefore porous and relatively soft. There is much variation in the fired color, but the most characteristic is reddish brown, with a significant amount of iron in the clay.

Unglazed earthenware, sometimes called terracotta, is the world's oldest pottery (fig. 1.1), dating to even before the Neolithic period (the New Stone Age) when pottery making became widespread, and is still being made today. Early potters developed several ways of strengthening their pots. To decrease shrinkage and cracking while drying and firing, a temper such as sand or crushed stone, grog (crushed potsherds), shell, or organic material (e.g., straw) would be added to the clay. To smooth the surface of pots and make them less likely to leak, the exterior

could be burnished with a stone and/or coated with refined slip (liquid clay) before firing. Decorative techniques include incising, stamping, modeling the damp clay, and painting before or after firing.

Glaze is the glassy coating that seals a pot and enhances its appearance. Two types of glaze have been used on folk earthenware, as well as on the fritware that follows: lead glaze and low-fired alkaline glaze. In the former, lead serves as a flux to help melt the glassy ingredient (quartz or flint); in the latter, confined to the Middle East, an alkaline substance such as plant ash serves the same purpose. These glazes do not always bond well to the clay body, so a small amount of body clay could be added to a lead-glaze solution for a better fit, giving the normally clear finish a yellowish cast when fired. Historic Euro-American earthenware is often referred to as redware, with the lead glaze intensifying the reddish color of the clay beneath it.

The ways in which glazed earthenware can be decorated provide stylistic clues about when and where it was made and the society that created it. The most basic approach is to color the glaze with a metallic oxide, the commonest being copper for green (fig. 1.2), iron for brown, and manganese for dark brown or purple-black (fig. 1.3). Adding tin oxide turns a clear glaze white and opaque, an ideal "canvas" on which to paint (fig. 1.4).

Slip (clay—white or colored—liquefied to the consistency of cream) can be applied to contrast with the body clay. Three widespread approaches to slip decoration are trailing, sgraffito, and inlay. For trailing, the slip, controlled by the decorator's hand movements, flows from a container through a narrow tube to lay a design onto the pot's surface (figs. 1.3 and 1.5). For sgraffito, a pot's surface is first coated with white slip, then a design is scratched or scraped through this engobe to expose the dark clay beneath (fig. 1.6). Slip inlay, practiced in the earthenware tradition of Sussex, England (fig. 1.7), as well as the stoneware traditions of Korea (*sanggam*) and Japan (*mishima*), involves cutting or impressing designs or letters into the damp clay that are then filled with slip. Further decorative techniques are underglaze painting, overglaze enameling, and lusterware with copper, silver, or gold salts painted on tin glaze for a metallic sheen (fig. 1.8).

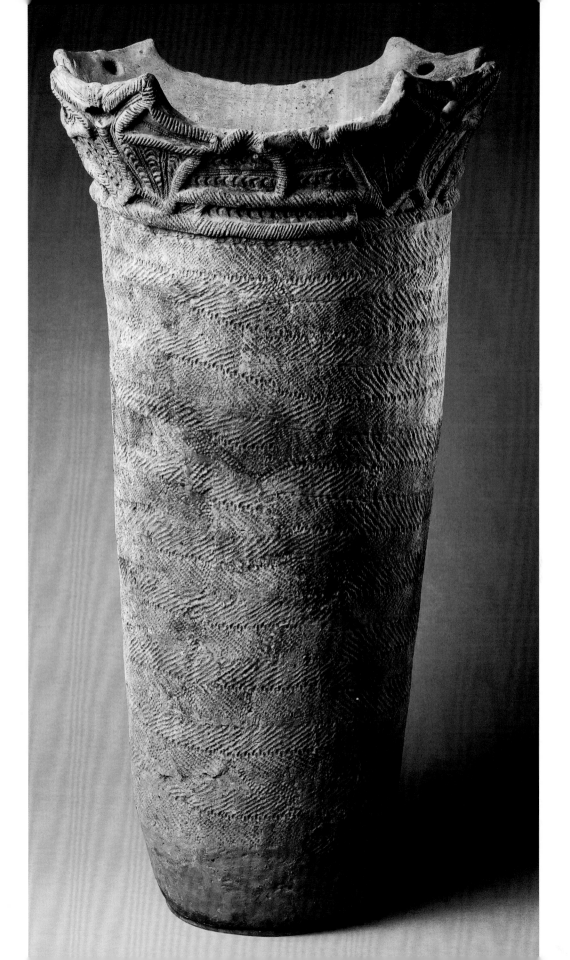

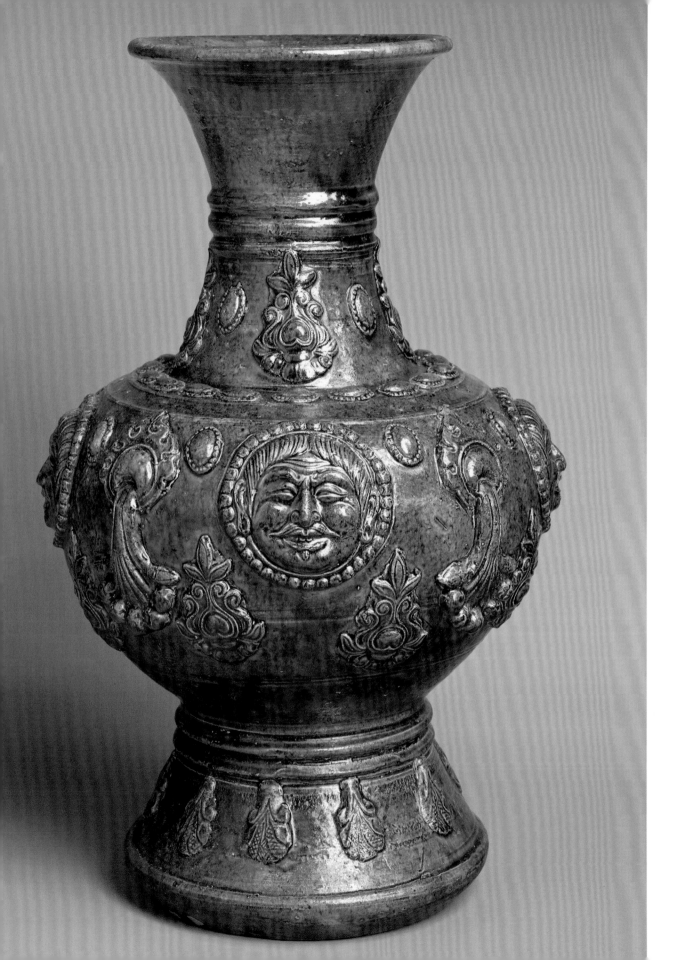

Fritware

Fritware, or stonepaste, was created by medieval Islamic potters in response to imported Chinese white wares that were greatly admired for their blankness. Its composite body (related to that of earlier Egyptian "faience" and later European soft-paste porcelain), which combined quartz, clay, and an alkaline flux fused into a glassy frit, is light in color and thus suited to painted decoration (fig. 1.9).[4] The fritware of Ottoman Turkey, called *çini*, continues today in an improved version.

Stoneware

Composed of a fine-grained clay that vitrifies at high temperature (typically 2300°F/ 1260°C), stoneware fires to a light gray, tan, or buff color and, as the name indicates, is hard as stone and thus able to withstand rough usage. The successful development of stoneware depended on the discovery of high-firing refractory clays and advances in kiln design.

There are two very different approaches to glazing traditional stoneware. The earliest, developed in China before the time of Christ and later spread to Korea, Japan, and Southeast Asia, is high-firing *alkaline glaze*, with plant ash and/or lime acting as a flux to help melt a silica source such as quartz or feldspar (fig. 1.10). When body clay is added as a binder, iron in the clay colors the glaze green in a reduction (smoky) kiln atmosphere and brown in an oxidizing (carbon free) one. A natural ash glaze occurs when wood-fuel ashes blown by the kiln draft from the firing chamber melt on the ware; one origin theory is that Asian potters observing this began to add ashes as an intentional glaze, prepared as a solution for coating the wares prior to firing. How Far Eastern alkaline glazes came to be used on folk stoneware of the American South will be considered in Chapter 3.

Chinese potters of the Song dynasty (960–1279 CE) created a range of colors in their glazes by carefully controlling the firing conditions and amount of added iron (sometimes with other ingredients) to yield jade-like celadon ware (fig. 1.11), related sky-blue Jun/Chün ware (often highlighted by spectacular copper-purple splashes; fig. 1.12), and black or dark-brown Jian/Chien (Japanese: *tenmoku/temmoku*) ware with its papercut- and leaf-resist, tortoiseshell, oil-spot, or hare's-fur

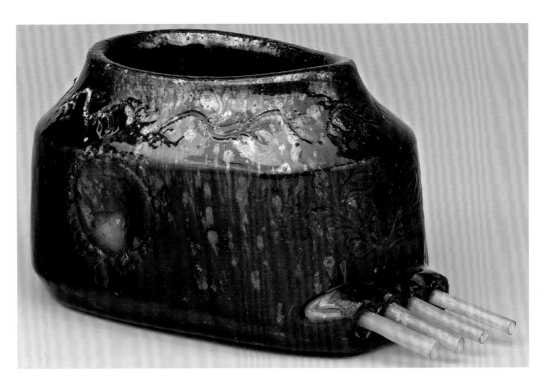

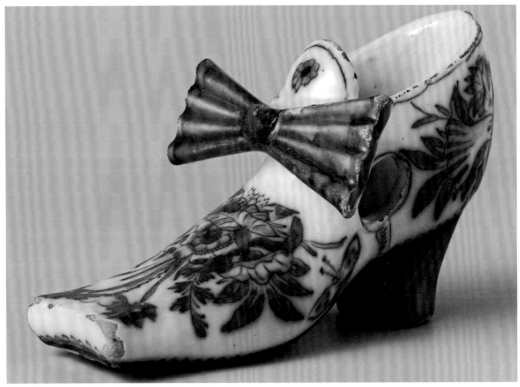

Figure 1.3, facing top. Earthenware slip cup with manganese-colored lead glaze. This tool, made to decorate a plate's surface by trailing 4 parallel lines of slip (liquid clay), is signed by potter Judah R. Teaney of Nockamixon Township, Bucks County, Pennsylvania, and dated 1827. *Collection of The Metropolitan Museum of Art, New York, www.metmuseum.org.*

Figure 1.4, facing bottom. Earthenware "shoe" with cobalt-blue decoration on tin-colored lead glaze, perhaps meant as a love token, Delft, Holland, 1660–1675. Similar tin-glazed shoe-shaped items were made in 17–18th-century Persia (some as exfoliating foot rasps) and England. Note the dark clay body where the white glaze chipped off. *Collection of Rijksmuseum, Amsterdam, Netherlands, https://www.rijksmuseum.nl.*

Figure 1.5, below. Lead-glazed earthenware "salt kit" with slip-trailed decoration by Jonathan Snell, Wetheriggs Pottery, Clifton Dykes, Cumbria, England, 1974. This distinctly British form was meant to keep salt dry and handy in the kitchen; a cook would reach through the separately thrown hood for the salt inside. *Private collection; photograph: author.*

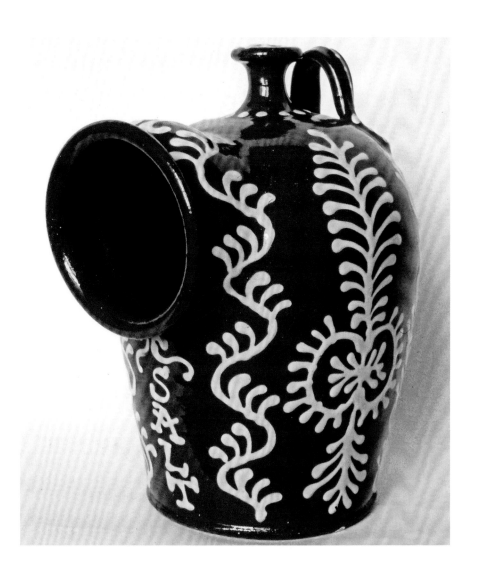

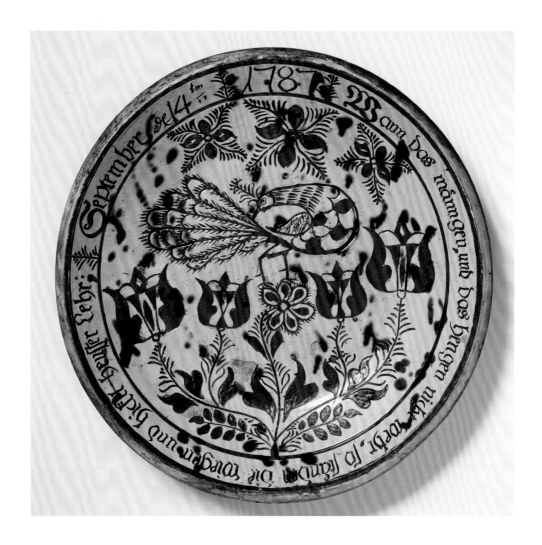

Figure 1.6, above. Sgraffito-decorated earthenware plate (further enhanced with dark-green copper-oxide splashes) by George Hubener, Limerick Township, Montgomery County, Pennsylvania, 1787. The red clay body shows through under a yellowish lead glaze where the white slip was cut away. Tulips and peacocks are frequent motifs in Pennsylvania German folk art; the poetic German inscription translates, "Were there no men or roosters / Cradles and also chicken pens would be left empty." *Courtesy of Winterthur Museum, Winterthur, Delaware; Bequest of Henry Francis du Pont, 1965.2300.*

Figure 1.7, facing top. Lead-glazed earthenware "pill" flask with inscription and floral design slip-inlaid in printer's type and die impressions, Chailey, Sussex, England, 1797. The technique of slip-inlaying continued in Sussex through the 19th century. *Photograph © Victoria and Albert Museum, London, https://www.vam.ac.uk.*

Figure 1.8, facing bottom. Earthenware plate with eagle molded in relief and metallic luster painted on tin glaze, Manises, Valencia, Spain, ca. 1500. The Eagle of St. John was the heraldic emblem of Queen Isabella of Castile. *Collection of the Metropolitan Museum of Art, New York, www.metmuseum.org.*

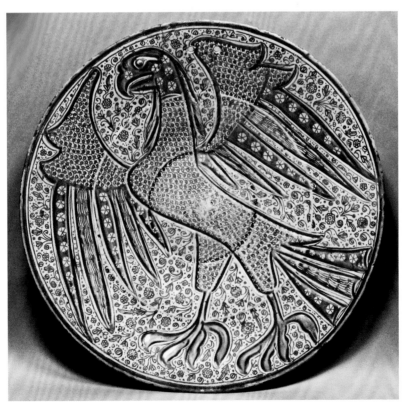

Figure 1.9. Molded fritware mug with cobalt-blue highlights, Kashan, Iran, late 12th century. The pricks in the wall are filled with the low-fired alkaline glaze, adding some translucence like that of porcelain to the light-colored body. The Arabic inscription in relief translates, "The taste of wisdom is first bitter, then sweeter than honey." *Courtesy of the David Collection, Copenhagen, Denmark, inv. #40–1966. Photograph: Pernille Klemp.*

effects (fig. 1.13).[5] The most prevalent of these types is celadon, a smooth, semi-transparent, lime-alkaline glaze used on both stoneware and porcelain to produce various shades of green when reduction fired; it spread from China to Korea and Southeast Asia.

Salt-glazed stoneware, on the other hand, is a European tradition, developed in fifteenth-century Germany. Common salt vaporizes when thrown into the kiln at the height of firing, the sodium fusing with the molten clay on the pots' surface to create a coating of clear glass with a slightly pitted ("orange-skin") texture. An origin theory for this glaze is that potters fueling their kilns with wooden staves from salted-fish barrels observed the resulting glaze and began to purposefully introduce salt. Sprigging (applying a clay relief from an intaglio mold to a pot's surface), incising, and painting with cobalt-blue and manganese-purple/brown prior to firing became the prevalent decorative techniques (fig. 1.14).

In Britain, salt-glazed stoneware was initially made by German potters working in the London area, but the first successful long-term operation was begun by Englishman John Dwight at Fulham (now part of London) in the 1670s. Stoneware production then spread to other British centers, and was introduced to America's east coast in the early 1700s by both German and English immigrant potters, with cobalt blue becoming the predominant approach to decoration from Canada south to Virginia (fig. 1.15). In Germany by the early 1500s, and later in England, potters achieved the look of aged bronze by salt-glazing over an iron wash ("brown salt-glazed stoneware"; fig. 1.16).

Other glazes on folk stoneware are Albany slip (United States) and Bristol glaze (Britain and United States). The former, a natural clay glaze with a high iron content mined in the Hudson Valley near Albany, New York, was first used about 1810 to line the inside of northern salt-glazed wares and was also applied as an overall glaze, reaching the South once trade with the North resumed after the Civil War. Some southern potters salt-glazed over the smooth brown coating, creating interesting variations in color and texture (fig. 1.17). Bristol glaze, developed in Bristol, England in the 1830s and adopted in America a half-century later by

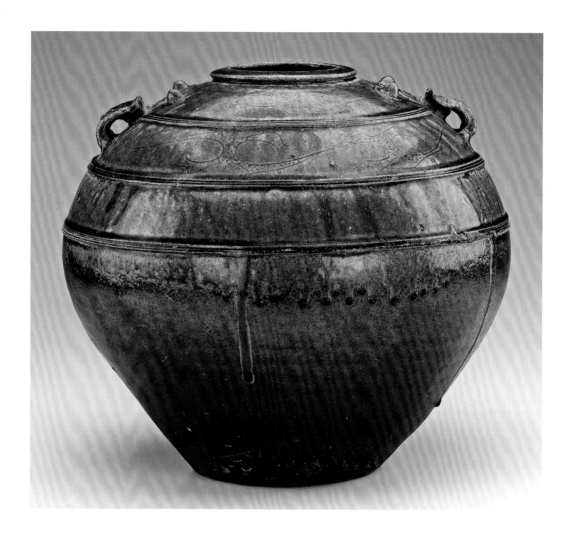

Figure 1.10, above. Stoneware jar, ash-glazed on upper half, Zhejiang province, China, Han dynasty, 1st–2nd century CE. Alkaline-glazed stoneware was made in China as early as 800 BCE (Western Zhou dynasty). *Courtesy of Freer Gallery of Art, Smithsonian Institution, Washington, DC, Purchase, F1952.10.*

Figure 1.11, facing top. Celadon dish with molded fish (an auspicious prosperity symbol), Longquan, Zhejiang province, 13th century. Longquan and Yaozhou, Shaanxi province, were the two main celadon centers of Song dynasty China. *Collection of Ethnological Museum Berlin, www.smb.museum/en/museums -institutions/ethnologisches-museum/home.html. Photograph: Daderot, public domain, via Wikimedia Commons.*

Figure 1.12, facing bottom. Stoneware plate of the type known as Jun ware, probably Henan province, China, late Song or early Yuan dynasty, 13th century. The opalescent, straw-ash glaze appears blue in reflected light; the bold purple splash is from reduction-fired copper oxide. *Collection of the Metropolitan Museum of Art, New York, www.metmuseum.org.*

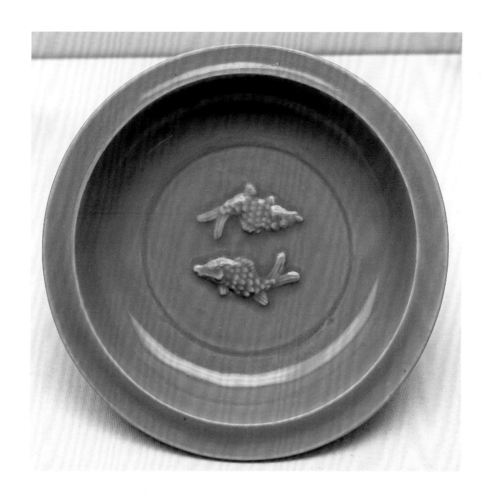

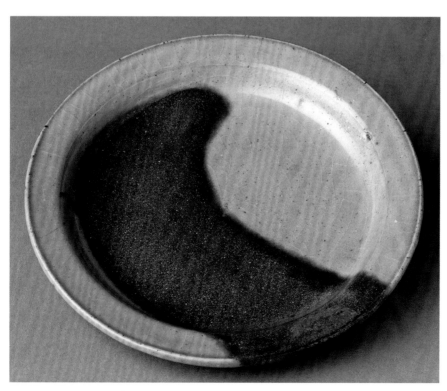

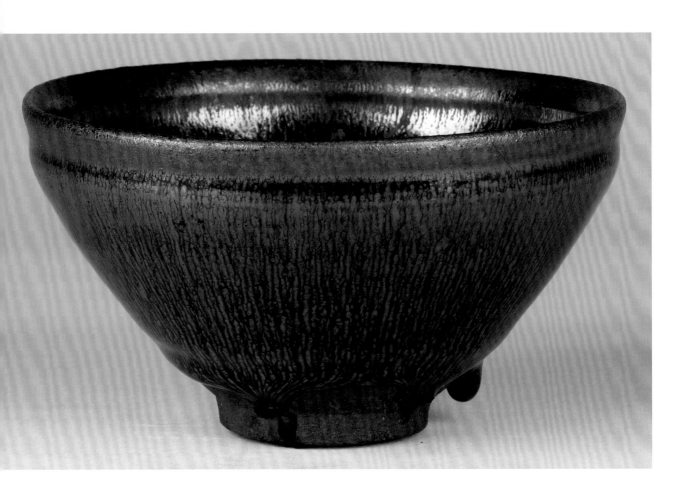

Figure 1.13, above. Stoneware tea bowl with "hare's-fur" glaze, probably Fujian province, China, 12th century. The dark, iron-rich glaze of such Jian-ware bowls offered a pleasing contrast to the froth of whisked powdered tea. In his *Treatise on Tea*, the Song dynasty Emperor Huizong wrote, "black teacups are highly valued, and those with streaks like hare's fur most of all." *Collection of the Metropolitan Museum of Art, New York, www.metmuseum.org.*

Figure 1.14, facing. "Baluster" jug attributed to Johann Mennicken, Grenzhausen, Germany, early 1600s. He migrated to the Westerwald from Raeren (now in Belgium), where his kinsman, Jan Emens Mennicken, is said to have developed both the baluster form and the blue-gray style of salt-glazed stoneware (perhaps inspired by imported Chinese blue-and-white porcelain) that would become the Westerwald standard. *Collection of Rijksmuseum, Amsterdam, Netherlands, https://www.rijksmuseum.nl.*

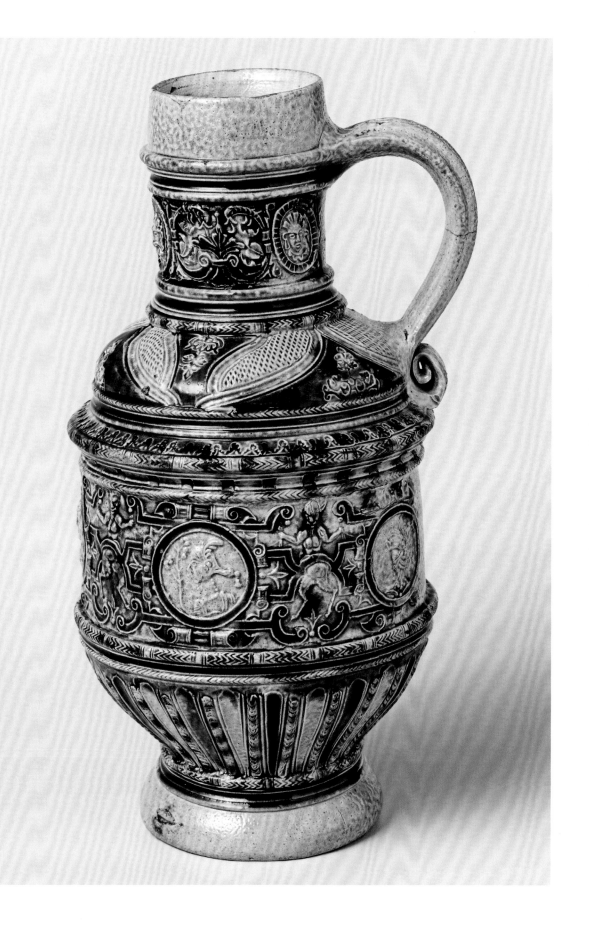

Figure 1.15, above. Heart-shaped presentation inkstand with removable inkwell and sander, salt-glazed stoneware with cobalt-blue decoration, by William (Johan Willem) Crolius or his son, William Jr., New York, 1773, the earliest-known dated example of American stoneware. Crolius Sr., an immigrant potter from the Westerwald, was practicing his craft by 1730 in Manhattan where he and descendants maintained a German-based stoneware tradition. *Collection of the Metropolitan Museum of Art, New York, www.metmuseum.org.*

Figure 1.16, facing. Brown salt-glazed stoneware jug of 4-gallon capacity, Liverpool area, Merseyside, England, ca. 1840s. Vessels from this local tradition, as yet little studied, were exported to America's Atlantic seaboard and may have influenced stoneware forms such as syrup jugs of the antebellum South. *Private collection; photograph: author.*

Figure 1.17. Stoneware preserve jar, salt-glazed over Albany slip, by William R. Addington, Gillsville (marked "Maysville," the nearest post office), Hall County, Georgia, 1880s. Addington was trained at nearby Jug Factory in present-day Barrow County where the double glaze (called "frogskin" at North Carolina's Jugtown Pottery) was first used in Georgia. The dark kiln-ceiling drip is an unintentional "decorative" touch. *Private collection; photograph: author.*

semi-industrial operations, employs zinc oxide in the feldspar-based glaze solution as a whitener and opacifier, resembling the appearance of porcelain when fired.[6]

Porcelain

The composition of this translucent white ceramic that rings when struck remained a secret kept by Far Eastern potters for centuries, frustrating those elsewhere who desired to reproduce it. The recipe, perfected in China by the Yuan dynasty (1271–1368 CE), combines "china clay" (kaolin) with feldspar-rich "china stone" (*petuntse*) in a proportion that fully vitrifies at an even higher temperature than stoneware.[7] Cobalt-oxide blue, which can withstand such heat, initially was the favored color for painting under a clear, highly refined alkaline glaze (fig. 1.18), but other colors requiring a series of firings were soon added to the porcelain palette. When production was hand-based and learned by apprenticeship, porcelain was a folk ceramic, but when the process became largely mold-based and mechanized its status shifted to that of an industrial product.

Gender and the Potter's Wheel

The development of the potter's wheel in Mesopotamia during the fourth millennium BCE changed the course of world ceramics by making it possible to shape pottery rapidly and thus increase production exponentially.[8] With this new tool, pottery making then had the potential of becoming a full-time commercial enterprise—a professional craft, as opposed to the part-time domestic craft it had been when the slow process of hand building was the only option. So how does this technological innovation relate to the issue of gender?

It's theorized that in early clay-working societies the first potters were women, who hand built their pots using the coiling, paddle-and-anvil, or pinching techniques.[9] For a vessel of any size, the base and lower wall had to dry enough to

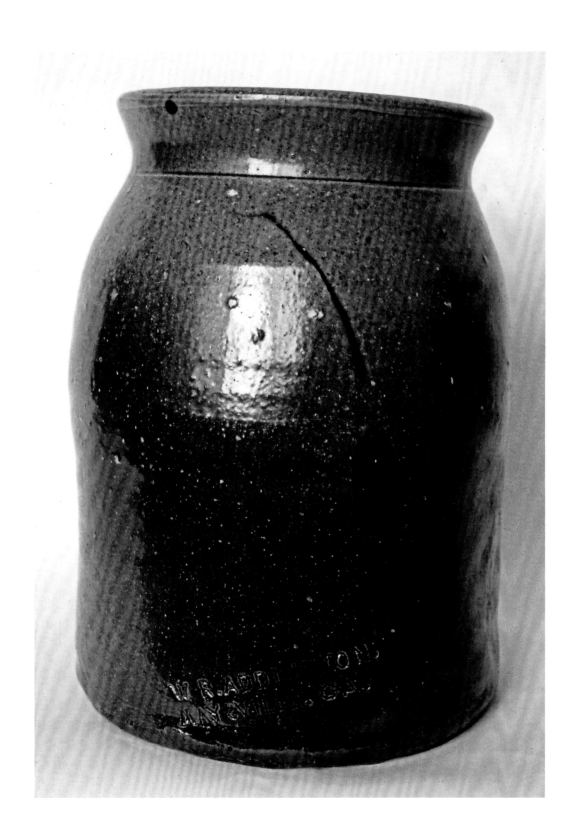

support the upper part. Coming back to the pot (or group of pots) periodically to finish the job was suited to the domestic tasks customarily assumed by women, especially child rearing and food preparation. The hand building of pottery could proceed in this leisurely way in a domestic space convenient to those tasks so long as the output was limited to use by the maker's family and neighbors, with any surplus bartered or sold. It's also thought that some of the oldest fired-clay objects, hand-modeled images of what may have been Earth Mother or fertility goddesses (see Chapter 6), were made by women.[10]

With professionalization of the craft made possible by the wheel (and a dedicated workspace to accommodate this and related equipment), men assumed the large-scale production of useful wares and entered the marketplace. There are, of course, no documents recording who made pottery in prehistoric times, so this is largely speculation, based to some extent on later illustrations from ancient Egypt and Greece of male potters at the wheel and observation of women continuing a premodern tradition of hand building into recent times (fig. 1.19).[11]

That, at least, is the theory. It does tend to support the fact that in historic times up to the present throughout much of the world, traditional wheel-thrown pottery usually is a male pursuit, while hand building often is a female one.[12] Of course there are exceptions, especially with the recent women's liberation movement softening gender roles. And this doesn't mean that women haven't been involved in pottery making where men are at the wheel; they've often worked at supporting tasks and may also be decorators, if rarely given credit when pieces are signed. In my study of Georgia, to be specific, of the 450 or so known folk potters in the state's ceramics history I found only three women—that is, until the later twentieth century, when women such as Arie Meaders, Grace Nell Hewell, Marie Rogers, and Lin Craven broke into the craft.[13]

Fueling my inspiration while working on this book was *Jung Yi, Goddess of Fire*, a thirty-two-episode period drama produced in 2013 (thankfully subtitled in English) that I stumbled upon on an Atlanta Korean television station. Set in the Joseon dynasty and based loosely on the real-life Baek Pa-sun, Korea's first

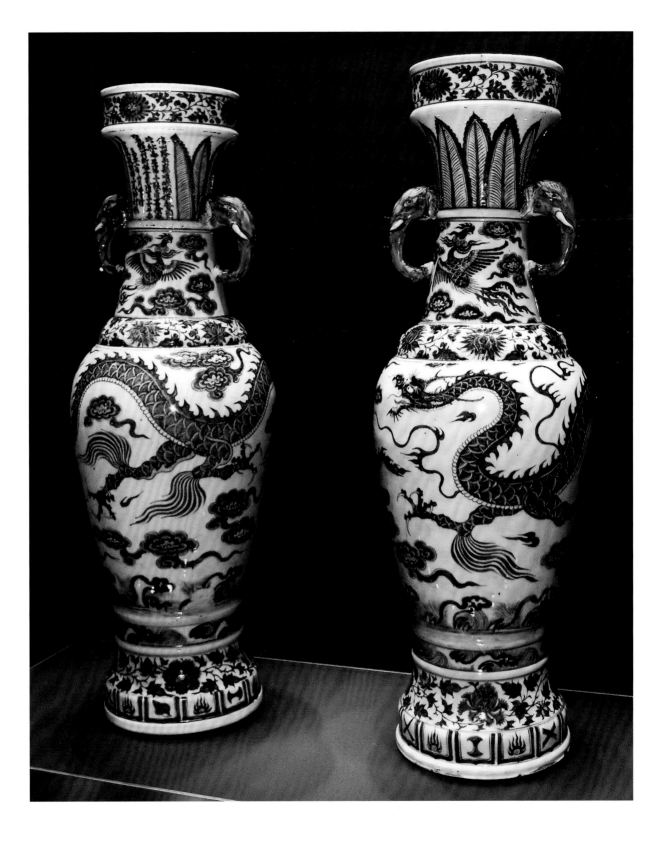

known female potter, the drama details her rise from apprentice to artisan at the royal kiln, overcoming the master's resistance and superstitious prejudice against women there. There are scenes of her testing clay, developing her skill at the wheel, decorating the porcelain that was the kiln's chief product, and firing the tunnel kiln. Her creativity and mastery were such that the royal family became patrons, but her fame also attracted the attention of Japanese invaders in the 1590s when, along with other Korean artisans, she was abducted to continue her craft in Japan.

This fictionalized treatment of a historical personage dramatically illustrates the struggles of women to enter the sometimes male-dominated world of traditional pottery. Baek Pa-sun was the Korean predecessor of Arie, Grace, Marie, Lin, and other pioneering women in the American South who set the stage for greater gender balance in the regional pottery tradition.

Notes

1. Edwin AtLee Barber, *Salt Glazed Stoneware* (London: Hodder & Stoughton, 1907), 6.
2. One of the first appearances in print of the term "folk pottery" is Harold F. Guilland, *Early American Folk Pottery* (Philadelphia: Chilton, 1971). For the British counterpart, "country pottery" (not an exact equivalent, as it's applied mainly to earthenware; stoneware in Britain was a more urban, semi-industrial product), see Peter C. D. Brears, *The English Country Pottery: Its History and Techniques* (Rutland, VT: Tuttle, 1971), and Andrew McGarva, *Country Pottery: The Traditional Earthenware of Britain* (London: A & C Black, 2000). Defining folk pottery as traditionally handcrafted raises the issue of molds used in the forming process. On occasion, traditional potters, including those of some early societies (e.g., Dynastic Egypt, Tang dynasty China, the Roman Empire, and pre-Columbian Peru) have used molds to shape certain products, which were then finished by hand. However, the industrial technology that combines molds with such devices as jigger and jolly machines removes potters' hands from the equation. As a further complication, the distinction between a workshop and a factory is not always clear-cut; there are ateliers with an owner/manager (who may or may not be a potter) and a staff of hired potters who still work by hand, and there are semi-industrial factories in which machines and skilled potters coexist.

3. Suzanne Staubach, *Clay: The History and Evolution of Humankind's Relationship with Earth's Most Primal Element* (New York: Berkley Books, 2005), xii–xiv, 44–46.

4. Egyptian "faience" (a misnomer, as it is not the tin-glazed earthenware to which the French term normally applies) is actually a clayless quartz and alkali composite, a sort of artificial stone that could be molded with great detail for small objects. It's classified as ceramic but not pottery. See A. J. Spencer and Louise Schofield, "Faience in the Ancient Mediterranean World," in *Pottery in the Making: World Ceramic Traditions*, ed. Ian Freestone and David Gaimster (London: British Museum Press, 1997), 104–109.

5. Nigel Wood, *Chinese Glazes: Their Origins, Chemistry, and Recreation* (Philadelphia: University of Pennsylvania Press, 2011); Yutaka Mino and Katherine R. Tsiang, *Ice and Green Clouds: Traditions of Chinese Celadon* (Indianapolis, IN: Indianapolis Museum of Art, 1986).

6. Bristol glaze was developed by Anthony Amatt at William Powell's Temple Gate Pottery, Bristol, England, and first used there in 1835 (Adrian Oswald, R. J. C. Hildyard, and R. G. Hughes, *English Brown Stoneware 1670–1900* [London: Faber & Faber, 1983], 95). For its use on semi-industrial stoneware of the United States, see, for example, Lyndon C. Viel, *The Clay Giants: The Stoneware of Red Wing, Goodhue County, Minnesota*, 3 vols. (Des Moines, IA: Wallace-Homestead, 1977–1987). As carried over from salt-glazed stoneware, a two-tone effect was achieved by applying an iron wash (England and Scotland) or Albany slip (United States) to a pot's upper third.

7. In China, both stoneware and porcelain are referred to as *ciqi* ("porcelain"), as distinguished from earthenware by being high-fired and ringing when struck; see Li Zhiyan, Virginia L. Bower, and He Li, eds., *Chinese Ceramics From the Paleolithic Period through the Qing Dynasty* (New Haven, CT: Yale University Press; Beijing: Foreign Languages Press, 2010). This does not mean that the whiteness and translucence by which porcelain is defined in the West aren't appreciated in China, where those features were achieved only after centuries of experimentation and refinement.

8. St. John Simpson, "Early Urban Ceramic Industries in Mesopotamia," in Freestone and Gaimster, *Pottery in the Making*, 50–51.

9. With coiling, a pot's wall is built up with rolled ropes or fillets of clay that are stacked, joined, and smoothed over as the shape is manipulated. With the paddle and anvil technique, one hand of the potter holds a convex stone or wooden "anvil" against the inside of a pot's wall as the other hand beats the corresponding place on the outside with a wooden paddle, thinning, raising, and shaping the wall. The most basic approach to hand building is pinching, with a clay lump opened up and shaped by the hands alone.

10. Staubach, *Clay*, 62, 204–207.

11. Sarah K. Doherty, *The Origins and Use of the Potter's Wheel in Ancient Egypt* (Oxford: Archaeopress Archaeology, 2015).

12. See, for example, Moira Vincentelli, *Women and Ceramics: Gendered Vessels* (Manchester, UK: Manchester University Press, 2000); Vincentelli, *Women Potters: Transforming Traditions* (New Brunswick, NJ: Rutgers University Press, 2004); Ronald J. Duncan, *The Ceramics of Ráquira, Colombia: Gender, Work, and Economic Change* (Gainesville: University Press of Florida, 1998); Duncan, *Crafts, Capitalism, and Women: The Potters of La Chamba, Colombia* (Gainesville: University Press of Florida, 2000). In the nonfolk realm,

the Arts and Crafts movement of the West introduced women to the potter's wheel in the late nineteenth century, with women studio potters now commonplace.

13. John A. Burrison, *Brothers in Clay: The Story of Georgia Folk Pottery*, rev. ed. (Athens: University of Georgia Press, 2008), 185–186, 262–263, 265, 279; Burrison, *From Mud to Jug: The Folk Potters and Pottery of Northeast Georgia* (Athens: University of Georgia Press, 2010), 97, 109–113, 147–151; Billy Ray Hussey, ed., *Women Folk Potters: The Southern Pottery Heritage* (Robbins, NC: Southern Folk Pottery Collectors Society, 1998).

2 | MONUMENTS TO CLAY

Public Markers of Craft Identity

"All this of Pot and Potter—Tell me then,

Who is the Potter, pray, and who the Pot?"

The Rubáiyát of Omar Khayyám (early twelfth century)[1]

TRADITIONAL POTTERS OF THE PAST, AS WELL AS THE PRESENT, HAVE tended to cluster in pottery-making communities rather than to work in isolation. In parts of the Far East such nucleated workshops, as well as individual ones, are referred to as "kilns," in reference to one of the most critical and prominent features of the production process. For example, devotees of Japanese ceramics refer to the "Six Ancient Kilns": Shigaraki, Tamba, Bizen, Tokoname, Seto, and Echizen, each comprising a number of related villages or towns working in a shared regional style.

In Rhineland Germany's Westerwald region stoneware production today is concentrated in *Kannenbäckerland* ("Jug-Baking Land"), which includes the combined towns of Höhr-Grenshausen and Ransbach-Baumbach as well as Grenzau, Hilgert, Hillscheid, and Montabaur. In Staffordshire, what was a hand-based folk craft in the 1600s became, under the leadership of such entrepreneurs as Josiah Wedgwood, Josiah Spode, and Ralph, Aaron, and Enoch Wood a century later, the center of England's pottery industry, collectively known as "The Potteries" or "Six Towns": Stoke-on-Trent, Hanley, Burslem, Tunstall, Longton, and Fenton.

In the American South, no fewer than seven pottery centers were named Jugtown after one of their chief products: in North Carolina, Catawba and Lincoln counties, Buncombe County, and Randolph and Moore counties where the famous Jugtown Pottery was founded in 1921 (fig. 2.1); in South Carolina, Greenville County; in Tennessee, White County; in Georgia, Upson and Pike counties; and in Alabama, Shelby County. A few of these Jugtowns were officially recognized with post offices.

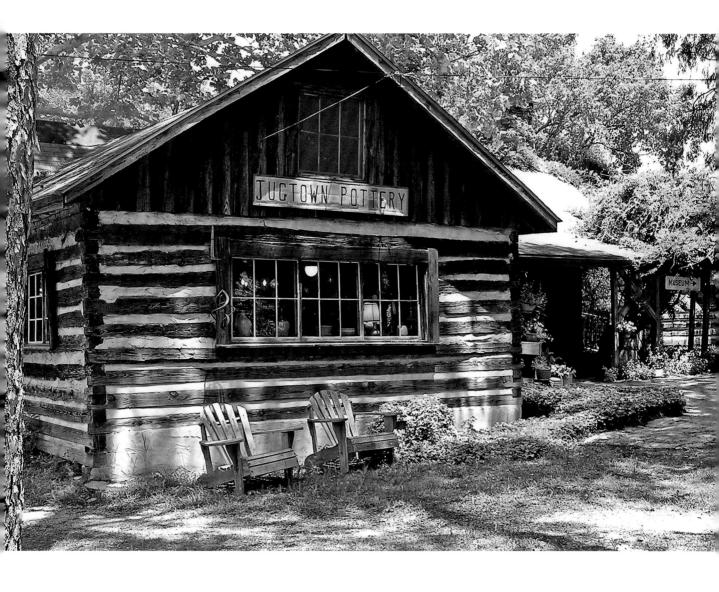

Figure 2.1. Jugtown Pottery, Seagrove, Moore County, North Carolina, founded 1921 by Jacques and Juliana Busbee and now owned and operated by Vernon and Pam Owens and their children, Travis and Bayle. The revival and transformation of this pottery community that today includes about 100 workshops began here. *Photograph: Janet Koplos, courtesy of photographer and American Craft Council.*

Today, in certain communities throughout the world, concentrations of traditional potters are still at work. Access to a good clay source begins to account for this ceramic gregariousness, as these small-scale operations, in the past at least, could not afford to import their clay from any distance or use preprocessed commercial clay as do today's studio potters. Another factor would be the mutual help a potter could turn to when needed, a security blanket arising from the shared sense of occupational kinship that Georgia potter D. X. Gordy called a "brotherhood of clay."[2] An obvious disadvantage, on the other hand, is the potential competition with potter neighbors. In the Old World, such relationships were formalized with trade guilds that established quality-control standards, regulated prices, and settled disputes among members, functions sometimes assumed today by potters' cooperative organizations.

What I've learned for Georgia, with its eight pottery centers, probably applies in outline to at least some centers elsewhere. Historically, the Georgia centers began when a pioneer potter, migrating from another center, settled near a good clay source. After successfully producing and selling wares (mainly to farmers who needed them to store food and drink), he attracted others into his orbit looking to supplement their farming incomes. Some of these had previous pottery backgrounds, while others learned the craft by apprenticing with an established potter there. Marriage between members of different pottery families contributed literally to that occupational kinship, leading in extreme cases to large "clay clans" or pottery dynasties, such as the Ferguson-Hewell group of Jug Factory in Barrow County and Gillsville in Hall County, that resulted in a total of more than sixty folk potters over several generations, all related by blood or marriage.[3]

These examples, which belong to what we can think of as *ceramic geography*, made me wonder how the inhabitants of such communities express pride in their occupation and present themselves to outsiders as a means of attracting customers. For while some folk potters work at the craft only part time or seasonally by combining potting with other activities such as farming, most create their wares to sell or barter, not just for their own use and certainly not as a hobby.

However modest their business models may be in comparison to factories like those arising in eighteenth-century Staffordshire, folk potters, to put food on their tables, develop strategies responsive to their customers' demands and changing market conditions, especially when forced to compete with mass-produced wares of industrial manufacture. One strategy is to locally display their individual or collective craft identity in a visible way that calls public attention to what they're about. Alternatively, the very components of the production process, while not intentionally promotional, can also serve as a kind of advertisement. Visitors to

such a community are informed by these various signs that they have arrived at a very special place.

Signs on the Landscape: Production Markers

One of the ways to recognize one's presence in a pottery community is to observe the physical evidence of production visible on the landscape. In Horezu, Romania, Ceramica Pietraru boasts its craft identity with a giant mug built of wood as part of the workshop and showrooms (fig. 2.2). But unless there is signage, a workshop may not signal what goes on inside or be distinguished externally from local domestic architecture. And for those traditional potters who work in their homes or outdoors, there is no dedicated workshop. It's also unlikely that an outsider could recognize sources of the potter's most basic raw material, for clay diggings are often hidden from public view. In Germany's Westerwald region, however, it would be hard to miss the industrial-scale clay mines, or *Tongruben*, that dot the landscape and supply the local stoneware potters (fig. 2.3).

What remains, then, to identify folk-pottery operations or centers by the production process alone is the kilns. In some parts of the world they can be so large as to dominate the landscape. Such is the case with the multichamber, wood-fired climbing kilns of Japan (fig. 2.4). The "dragon" kiln at Tianbao, a suburb of Jingdezhen, China, built in the 1970s by a potter named Jin Yue An and fired at least twice a year, is 160 feet long (fig. 2.5). Staffordshire's massive nineteenth-century bottle kilns were on a similar scale. A photo taken at Longton in 1901 includes a group of those kilns, the coal-smoke-polluted air, and the Daisy Bank marl (clay) pit where broken wares also were dumped—an enormous clay digging conveniently located adjacent to the factories that was certainly not hidden from view (fig. 2.6). Most of those kilns have since fallen victim to urban redevelopment, but today one can experience their impressive size at Longton's Gladstone Pottery Museum (fig. 2.7).

The Medium Is the Message: Signs of Clay

In Europe and early America it was a common practice for businesses to advertise with wooden shop signs incorporating the establishment's name and illustrating the goods or service available there. Some folk-pottery centers and workshops have taken a more appropriate approach with signs of the same material as their products, like actual pots or monuments such as fountains that incorporate ceramic work for which the community is known. Although this is largely a recent phenomenon, there are historical precedents.

Figure 2.2, above. Giant mug annex of Ceramica Pietraru workshop and showrooms, Horezu, Vâlcea County, Romania. Laurentiu Pietraru sells wares of other local potters as well as those of his family. *Photograph: Trazvan, https://www.dreamstime.com.*

Figure 2.3, facing. *Tongrube* (clay mine), Mengerskirchen, Hesse, 2008, one of several large-scale Westerwald operations that supply stoneware potters of Germany's *Kannenbäckerland*. *Photograph: Volker Thies, CC-BY-SA 3.0, via Wikimedia Commons.*

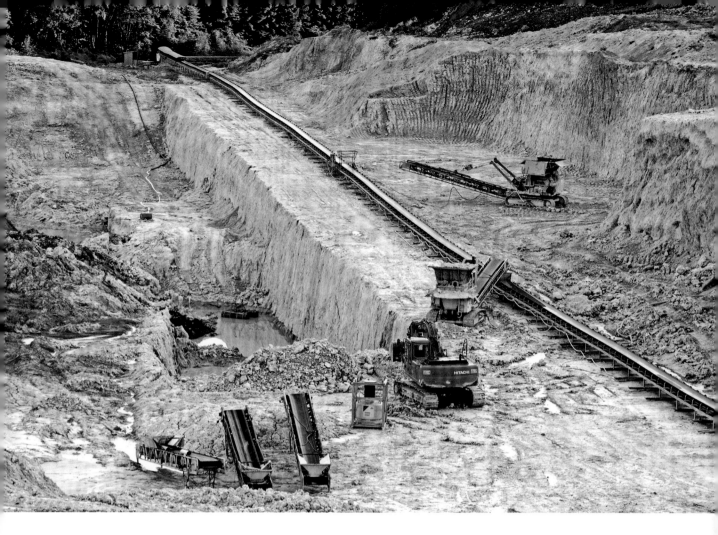

In colonial Salem, North Carolina, Moravian master potter Gottfried Aust created a large slip-decorated earthenware plate in 1773 as a trade sign in response to a proposal that year "to place proper signs at the houses of the tradesmen . . . in order that strangers could find them more easily. Such signs should have the name of the master and the trade."[4] Aust's plate, the only local sign to survive today from that period, measures nearly twenty-two inches in diameter, with two pierced clay lugs on the back to receive a cord from which it hung; showing no evidence of weathering, it probably was displayed in a window from inside the pottery shop (fig. 2.8).

Much more recent uses of actual pots as emblems of local identity include "*Los Cuatros Elementos*," an assemblage of unglazed earthenware *cántaros* (jugs) created in 2001 by traditional potter Paco Tito (Francisco Martínez Villacañas) of

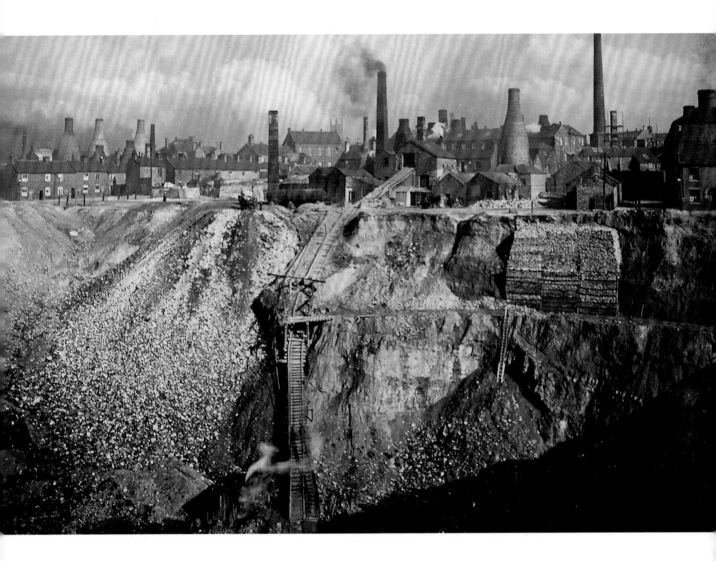

Figure 2.4, facing top. Nine-chamber kiln called *Yuntanza Gama*, built in the late 1970s by potter Shinman Yamada, the largest of 3 *noborigama* (step-climbing) kilns at Yachimun no Sato pottery village, Yomitan, Okinawa Prefecture, Japan. *Photograph: Eric Wada, courtesy of photographer and Ukwanshin Kabudan, Honolulu, Hawaii.*

Figure 2.5, facing bottom. Dragon kiln, Tianbao village (near Jingdezhen), Jiangxi province, China. The 160'-long climbing kiln was built in the 1970s by potter Jin Yue An and is being fired here by his melon-eating assistants in 2011. *Photograph © Catherine S. Elliott, courtesy of photographer.*

Figure 2.6, above. Pottery factories with bottle kilns above Daisy Bank marl pit and spoil dump, Longton, Stoke-on-Trent, Staffordshire, England, 1901. At one time more than 2,000 such kilns are said to have been in use, but the 1956 Clean Air Act sounded their death knell. *Photograph: William Blake, courtesy of The Potteries Museum and Art Gallery, Stoke-on-Trent.*

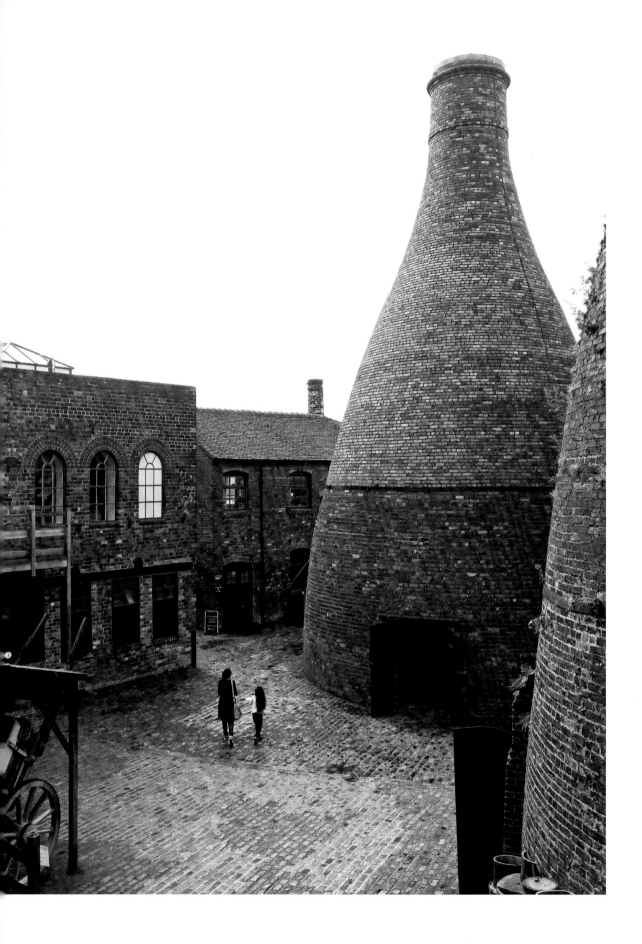

Úbeda, Andalusia, Spain, as part of the Plaza de la Constitución fountain complex in nearby Jaén (fig. 2.9), and a similar fountain assemblage in the French stoneware center of Saint-Amand-en-Puisaye, Burgundy, created by local studio potter François Eve in 1994 (fig. 2.10).

In the Spanish town of El Puente del Arzobispo, a large billboard composed of painted tiles proudly advertises and illustrates the community's ceramic heritage (fig. 2.11). Fountains made of local tiles can be seen in Kütahya, Turkey (fig. 2.12) and Talavera de la Reina, Spain, towns famous for their ceramics, and park benches composed of Spanish tiles offer seating for residents and visitors alike (fig. 2.13). Perhaps the cleverest use of local ceramics as a way of declaring a pottery center's heritage is the blue-and-white porcelain traffic-light columns in China's "porcelain capital," Jingdezhen (fig. 2.14).

In the central plaza of Ráquira, Colombia ("Town of Potters") there's a nearly life-size terracotta sculpture by Javier Sierra depicting his grandmother, Doña Lucía Rodríquez, hand building a cooking pot (fig. 2.15), along with other sculptures of pottery in use. Javier and his brother Fabio work together in the local tradition of clay figurines.[5]

Throughout Germany's Kannenbäckerland one can see stoneware monuments by local potters; most consist of large salt-glazed pots with cobalt-blue decoration. In Höhr-Grenshausen, for example, there's a salt-glazed sculpture of the town arms, which features a trio of jugs in its design (fig. 2.16). Elsewhere in the Rhineland, the town of Frechen honors its stoneware history with its specialty of the mid-1500s to mid-1700s, the *Bartmannskrug*, or bearded-man jug (exported to Britain and America by the thousands). "The world's largest Bartmannskrug" was erected on Sternengasse there in 2001 to mark the fiftieth anniversary of gaining official "city rights" (although Frechen has existed since the Middle Ages). The monument, a collaboration by potter Manfred Zimmermann and sculptor Manfred Holz, both of Frechen, stands nearly eight feet high, weighs a ton, and could hold a thousand liters (fig. 2.17).

Frechen further honors its historic specialty with a bronze fountain in the city's pedestrian zone depicting a column of those bearded-man jugs, designed

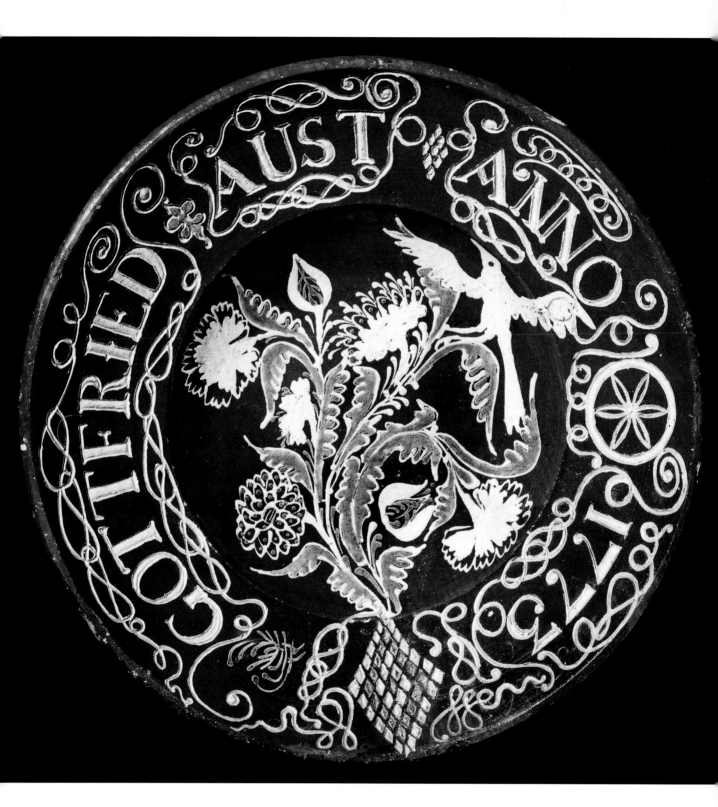

Figure 2.8, facing. Lead-glazed earthenware shop sign, 21.85" diameter, decorated with inlaid and trailed polychrome slip, by Gottfried Aust, first Moravian master potter, Salem (now part of Winston-Salem, Forsyth County), North Carolina, 1773. *Collection of Wachovia Historical Society, Winston-Salem, North Carolina, courtesy of Old Salem Museums & Gardens.*

Figure 2.9, below. "*Los Cuatros Elementos*" assemblage of terracotta *cántaros* (jugs) associated with the *Plaza de la Constitución* fountain in Jaén, Andalusia, Spain, created by folk potter Paco Tito of nearby Úbeda in 2001. *Photograph: Johnnywalker61, https://www.dreamstime.com.*

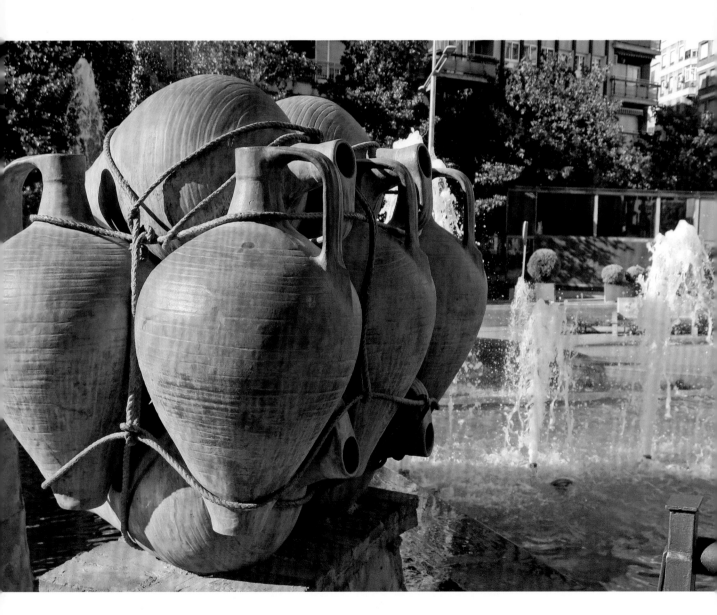

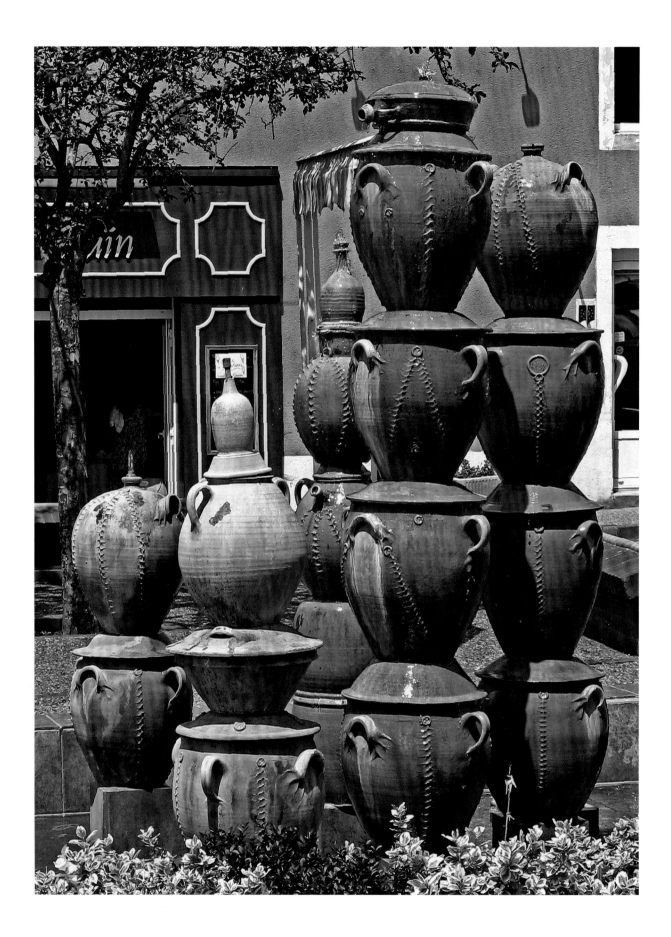

Figure 2.10, facing. *Fontaine des Potiers* in the French stoneware center of Saint-Amand-en-Puisaye, Burgundy, created by local studio potter François Eve in 1994. *Photograph: Hubert Denies, CC-BY-SA 3.0, via Wikimedia Commons.*

Figure 2.11, below. Welcome sign of local painted tin-glazed tiles for the pottery town of El Puente del Arzobispo, Toledo, Castile-La Mancha, Spain, adding visibility in the centuries-old competition from nearby and better-known Talavera de la Reina. *Photograph: Benjamin Nuñez González, CC-BY-SA 4.0, via Wikimedia Commons.*

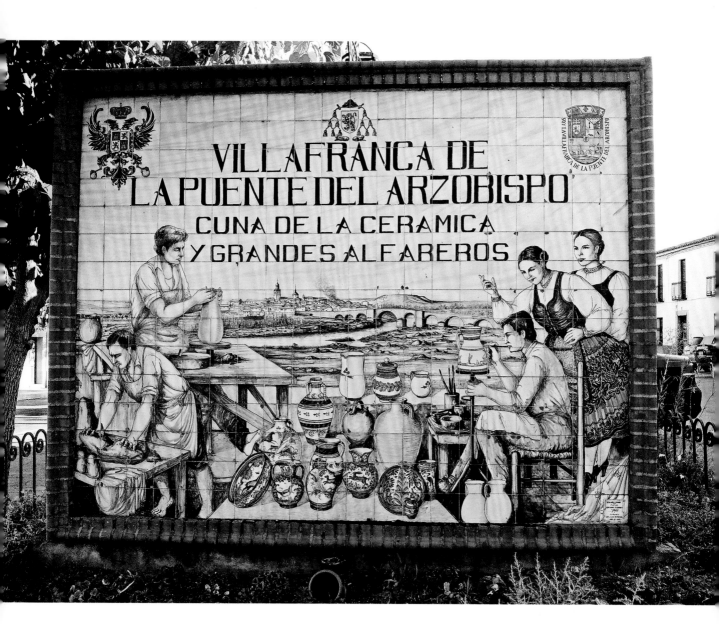

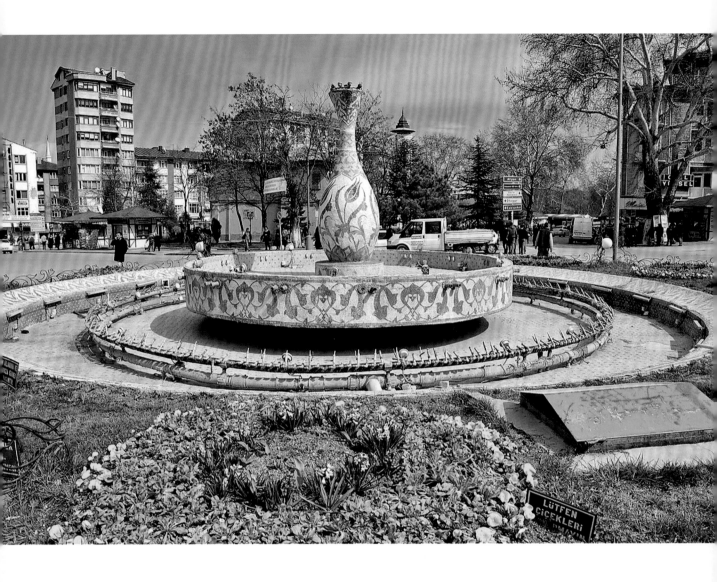

Figure 2.12, above. Çinili Vazo ("Tiled Urn") fountain created in 1970s for Victory Square traffic roundabout in the Turkish pottery town of Kütahya. *Photograph: Nick Pangere, www.nomadicniko.com, courtesy of photographer.*

Figure 2.13, facing. Bench of painted tin-glazed tiles featuring Don Quixote and his squire, Sancho Panza, protagonists of Miguel de Cervantes Saavedra's 1605 novel, in Parque Gasset, Ciudad Real, Toledo province, Castile-La Mancha, Spain, made in the pottery center of Talavera de la Reina in the same province. *Photograph: Javier Martin, public domain, via Wikimedia Commons.*

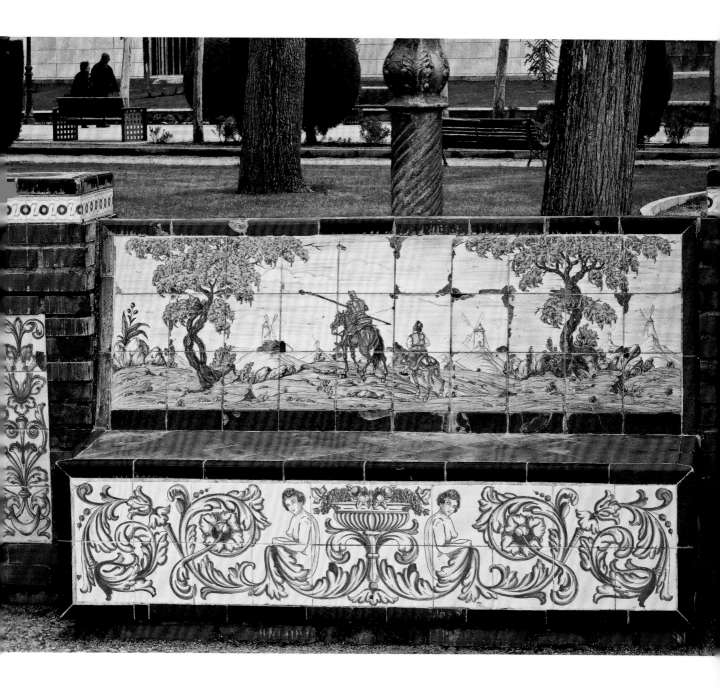

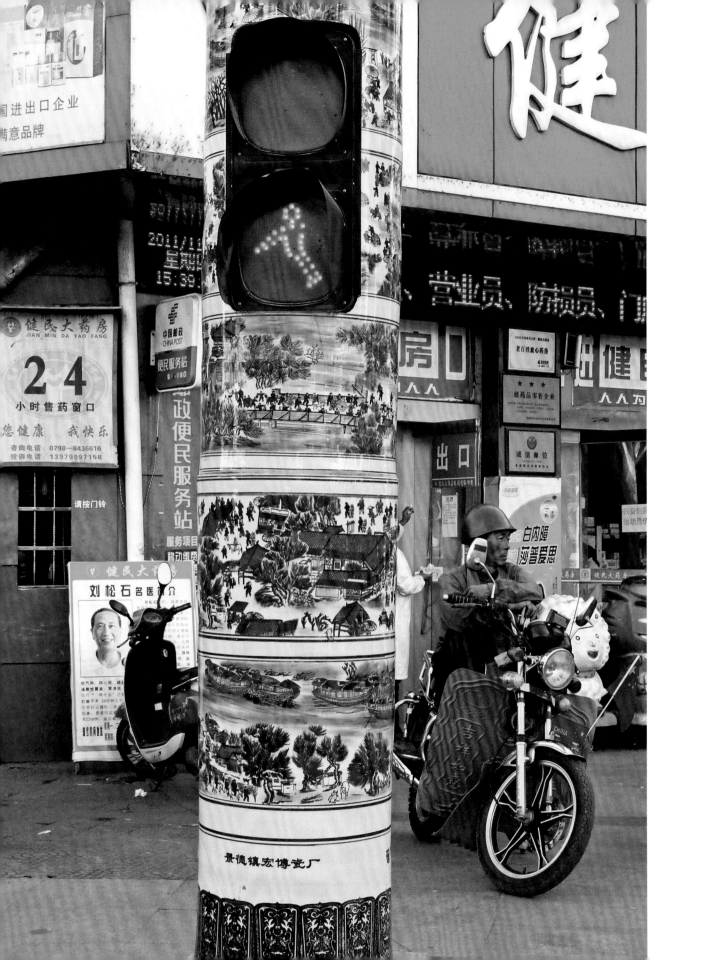

Figure 2.14, facing. Porcelain traffic-light column with cobalt-blue decoration, Jingdezhen, Jiangxi province. Porcelain street lights and trash cans also grace China's "porcelain capital" today. *Photograph: Noela Mills, courtesy of photographer.*

Figure 2.15, below. Terracotta sculptures created ca. 1995 by folk potter Javier Sierra in central plaza of Ráquira, Boyacá, Colombia, with nearly life-size homage to the artist's potter grandmother, Doña Lucía Rodríquez, in foreground. *Photograph: Jillian DiMedio, http://anywherethatswild.com/, courtesy of photographer.*

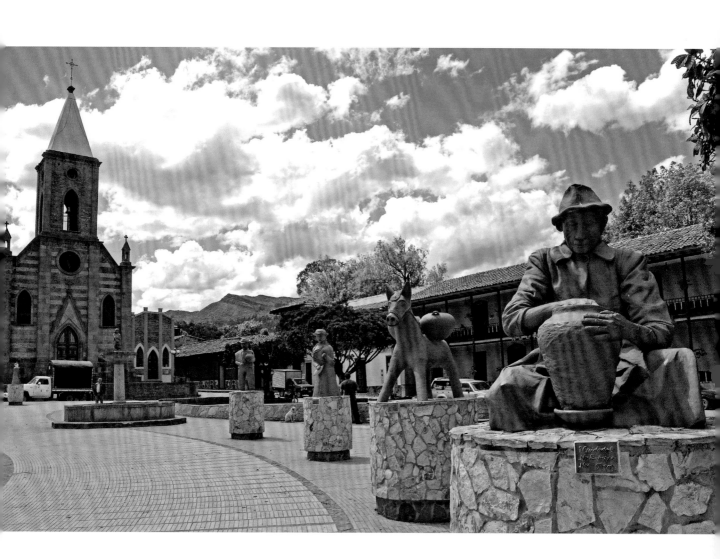

Figure 2.16. Salt-glazed stoneware monument in Höhr-Grenzhausen, Rhineland-Palatinate, Westerwald, Germany, reproducing the town coat of arms with its trio of jugs. *Photograph: author.*

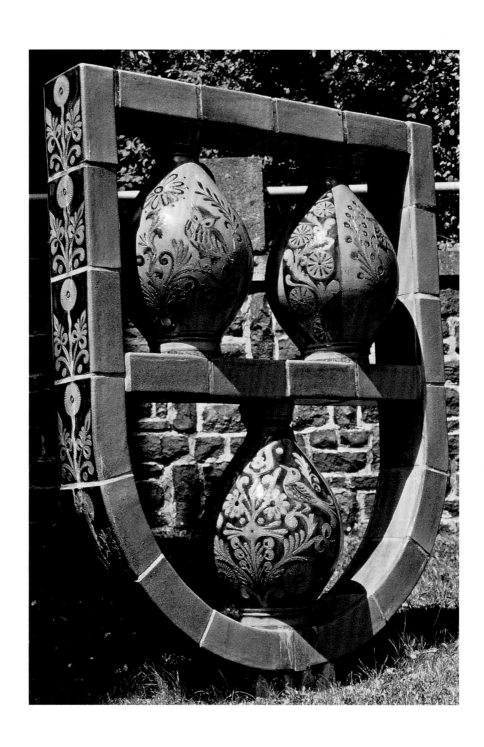

by local sculptor Olaf Höhnen (fig. 2.18). In France, sixteenth-century ceramic master Bernard Palissy, best known for his colorful "rustic-ware" platters incorporating molded reliefs of snakes, fish, and frogs, is commemorated with two late nineteenth-century bronze portrait statues by sculptor Louis-Ernest Barrias; one at the entrance to the Musée National de Céramique in Sevres, the porcelain center west of Paris (fig. 2.19), the other in Square Félix-Desruelles, Paris. A third statue, this one carved in stone by Jean Pierre Victor Huguenin in 1857, graces the exterior of Paris's Louvre Museum. Palissy is one of the few potters to be so publically honored; such was his reputation even beyond France centuries later that another ceramic innovator, Dr. Abner Landrum of Pottersville in antebellum Edgefield District, South Carolina, named one of his sons after him.[6]

Social Clay Landscapes

In addition to those inanimate markers of pottery history or current practice, there are public places and events where one can see traditional pottery being made, sold, and celebrated. Such a place is Talako Pottery Square in Bhaktapur, Nepal, where members of the potter caste known as *Kumhar/Prajapati* work at their wheels in the open or under shed roofs surrounding the square, sun-dry hundreds of freshly thrown pots (turnip-shaped banks a specialty), fire their clamp kilns, and sell their wares (fig. 2.20). In Nepal's 2015 earthquakes the town's main plaza, Durbar Square, was heavily damaged, but from what I can gather Pottery Square remains intact.

In societies that still depend on utilitarian and ceremonial folk pottery there are lively markets dedicated exclusively to such wares, as well as pottery sections of more diverse markets (fig. 2.21). Elsewhere, the emphasis tends to be on decorative ceramics. These markets are not always located where the pottery is made, but have a reputation for selling the wares of certain production centers. For example, the colorful earthenwares of Rishtan, Uzbekistan, are sold in Bukhara, nearly five hundred miles away—an eleven-hour truck drive (fig. 2.22). Pottery festivals, such as Târgul Olarilor (Pottery Fair) in Sibiu, Romania, which features the traditional slip-decorated wares of Corund, seventy miles distant, serve to celebrate as well as sell. In the United States, there is no better venue for collectors and dealers of Native American art than the Santa Fe Indian Market, held every August in New Mexico's capital since 1922, where a thousand artists in all media, including traditional potters, display and sell their work.

My state, Georgia, has several annual events devoted exclusively to traditional pottery, both contemporary and historic. In northeast Georgia, where the living tradition is concentrated, there's Gillsville's festival (begun as "Turning and

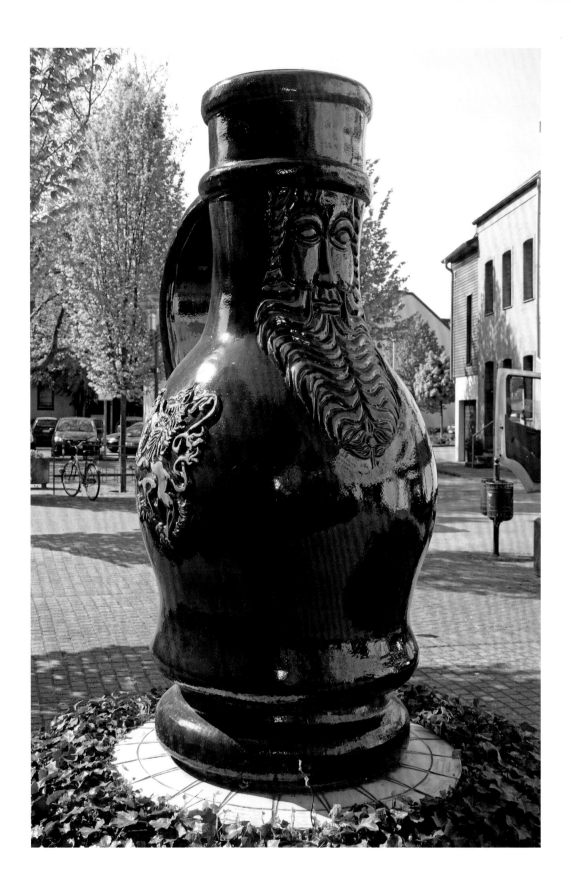

Figure 2.17, facing. *Bartmannskrug* monument in Frechen, North Rhine-Westphalia, Germany, created in 2001 by local artists Manfred Zimmermann and Manfred Holz. *Photograph: tohma, CC BY-SA 4.0, via Wikimedia Commons.*

Figure 2.18, below. Bronze *Bartmannskrug* fountain in Frechen designed by local sculptor Olaf Höhnen, with 28 variations on the bearded-man jug theme. *Photograph: tohma, CC BY-SA 4.0, via Wikimedia Commons.*

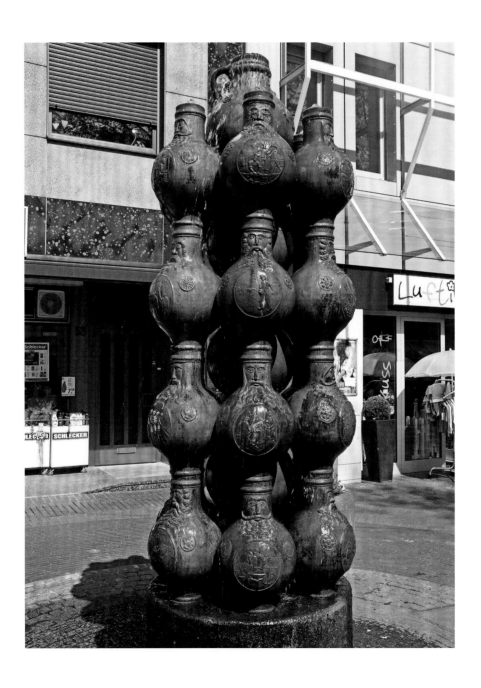

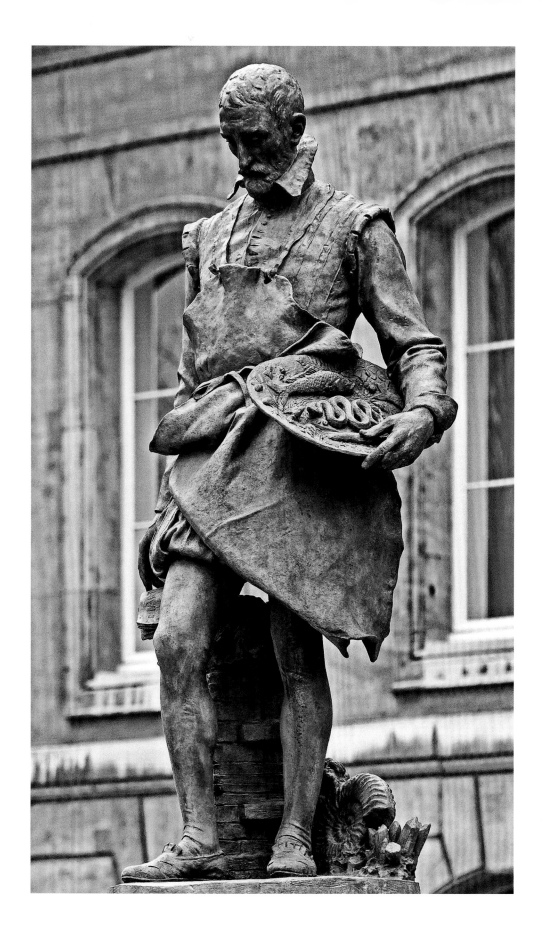

Figure 2.19. Life-size bronze statue of Renaissance ceramist Bernard Palissy at Musée National de Céramique, Sèvres, France, designed by Parisian sculptor Louis-Ernest Barrias in 1883. The subject, wearing a potter's apron, holds one of his "rustic-ware" platters; at his feet is a kiln, with crystals and fossilized seashells representing his naturalist interests. *Photograph: Coyau, CC BY-SA 3.0, via Wikimedia Commons.*

Burning" in 1993 by Hewell's Pottery, which no longer participates), the North Georgia Folk Potters Festival at Banks County Middle School in Homer, begun in 2000, and the Folk Pottery Show and Sale at Sautee Nacoochee Center, begun in 2009. Such events offer buyers an opportunity to meet the makers and create a personal meaning for the wares they take home. Georgia JugFest at Knoxville, in the middle of the state, began to celebrate Crawford County's historical stoneware tradition in 2005. In North Carolina, where a collector market has existed for nearly a century, the "kiln opening" is a customary event for some sought-after traditional potters, who try to control the mayhem that can result when frenzied collectors, after waiting hours for the sale to begin, scramble to compete for the best pieces (a situation captured in J. B. Stanley's 2006 murder mystery, *A Killer Collection*).

Heritage Museums

Finally, there are permanent institutions that collect, preserve, display, and promote folk pottery, either exclusively (rare in the United States) or as a substantial part of their mission. Most art and history museums have such ceramics in their collections, but they're not always showcased and may even be "buried" in storage. In Japan, where folk pottery has almost a cult following, there are too many museums devoted to the subject to list here.[7] Cultural tourism also is alive and well elsewhere in Asia, with several "working" pottery museums where hand skills are demonstrated, such as the Ancient Kiln Folk Customs Museum in Jingdezhen and Bat Trang Pottery Village in Hanoi, Vietnam.

For Europe, I'll single out two large museums that emphasize pottery: Hetjens-Museum (Deutsches Keramikmuseum) in Düsseldorf, Germany, and The Potteries Museum and Art Gallery at Stoke-on-Trent, England. In their exhibits both museums understandably feature the products of their own countries, but also include a smattering from other parts of the world as a nod to broader inclusiveness. I couldn't help noticing, though, when visiting some years ago, that they displayed pre-Columbian pieces from Latin America but nothing from the United States, as if to say that this country isn't old enough to have produced ceramics worthy of

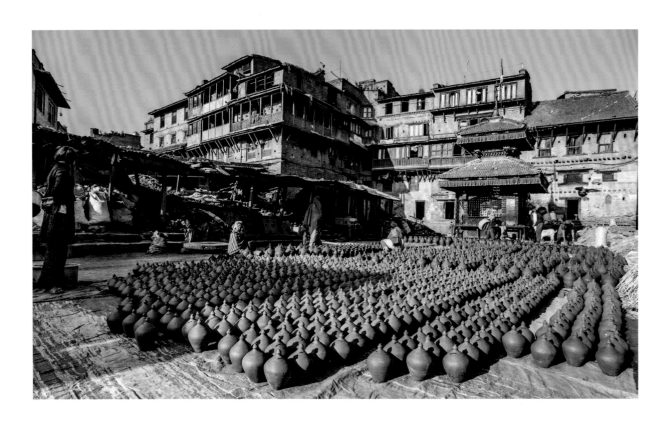

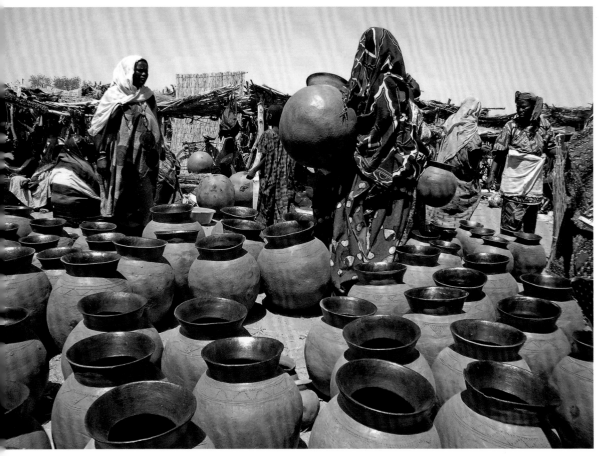

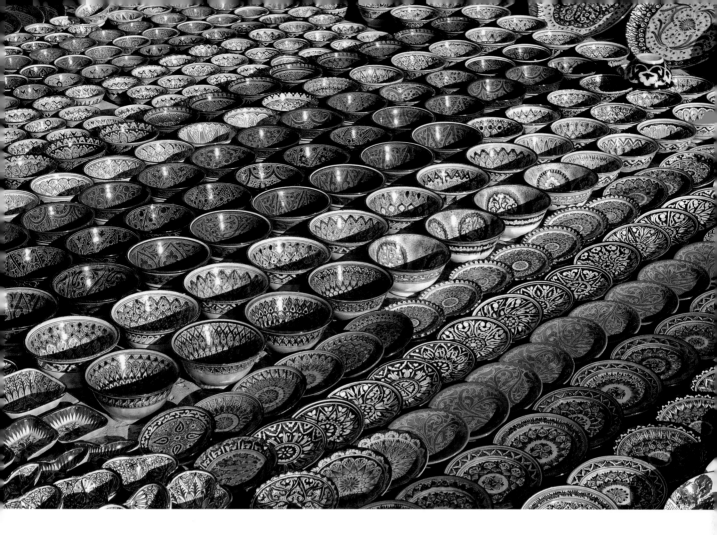

Figure 2.20, facing top. Talako Pottery Square, Bhaktapur, Kathmandu Valley, Nepal, a UNESCO World Heritage Site. In foreground are scores of recently thrown banks, partly coated with slip and drying in the sun. Behind them a potter rests at his "slow" wheel, rotated by hand with a stick thrust into a socket in the wheel's face. *Photograph: Jerryway, https://www.dreamstime.com.*

Figure 2.21, facing bottom. Shopping for millet-cooking pots at weekly market, Gorom-Gorom, Burkina Faso, West Africa, 2008. *Photograph: C. Hughes, CC BY-SA 2.0, via Wikimedia Commons.*

Figure 2.22, above. Decorative earthenwares from Rishtan (blue-green-white spectrum) and Bukhara (red-brown-yellow spectrum), Uzbekistan, for sale in Bukhara, 2011. Such wares are often used to serve the favorite Uzbek dish, *plov*, a pilaf of rice, lamb, and vegetables. Rishtan, in the Fergana Valley, is said to be home to some 150 pottery workshops. *Photograph courtesy of Wallace F. de Faria.*

their collections. American researchers, museum curators, and collectors would strenuously disagree. Wouldn't a carefully selected sampling of American pottery offer an excellent opportunity for those two museums to illustrate ceramic influences of the Old World on the New? Of all the countries of Europe, England and Germany, after all, had the greatest impact on the development of historic American pottery.

Some illustrations in this book draw from the wonderful ceramic collections of American institutions such as The Metropolitan Museum of Art in Manhattan, the Museum of Fine Arts in Boston, the Los Angeles County Museum of Art, and the Walters Art Museum in Baltimore, but to call these pottery museums would be mistaken, given the other media well represented in their collections. A few art museums have permanent galleries featuring traditional pottery, such as the Pennsylvania-German room in the Philadelphia Museum of Art with its wonderful group of historic slip-decorated earthenware, the Buchsbaum Gallery of Southwestern Pottery in Santa Fe's Museum of Indian Arts and Culture with a selection of nearly three hundred examples representing all the pottery pueblos, and the recently opened William C. and Susan S. Mariner Southern Ceramics Gallery at the Museum of Early Southern Decorative Arts in Winston-Salem, North Carolina, with historical earthenware and stoneware from seven southern states.[8] Fine museums located in the communities they represent are the North Carolina Pottery Center in Seagrove (home to about one hundred workshops), which promotes the historic and contemporary work of both folk and studio potters throughout the state, and Sky City Cultural Center and Haak'u Museum at Acoma, New Mexico, which interprets the culture of Acoma Pueblo, especially its rich and still-vital Native American pottery heritage.

So is there a museum in the United States devoted exclusively to folk pottery? Here I can answer with some authority, as I have served as the curator of such an institution. The Folk Pottery Museum of Northeast Georgia is part of the Sautee Nacoochee Center near the town of Helen in the hills of White County.[9] The museum, which opened in 2006, celebrates one of the region's most notable artistic achievements, with 180 historic and contemporary pots to tell the story of north Georgia's ceramic heritage. Featured are the two centers that carry on a continuous tradition of handcrafted stoneware since the nineteenth century: Mossy Creek in White County and Gillsville in Hall County, both within an easy drive of the museum.

This museum and others of a similar nature are yet another way in which traditional pottery contributes in a publically visible way to a sense of local identity.

Notes

1. Edward FitzGerald, trans., *The Rubáiyat of Omar Khayyám*, 5th ed. (1889), verse 87; Wikisource, https://en.wikisource.org/wiki/The_Rubaiyat_of_Omar_Khayyam_(tr._Fitzgerald,_5th_edition).

2. John A. Burrison, *Brothers in Clay: The Story of Georgia Folk Pottery*, rev. ed. (Athens: University of Georgia Press, 2008), vi.

3. Burrison, *From Mud to Jug: The Folk Potters and Pottery of Northeast Georgia* (Athens: University of Georgia Press, 2010), 38–39.

4. John Bivins, Jr., *The Moravian Potters in North Carolina* (Chapel Hill: University of North Carolina Press, 1972), 223–25, and Luke Beckerdite and Johanna Brown, "Eighteenth-Century Earthenware from North Carolina: The Moravian Tradition Reconsidered," in *Ceramics in America 2009*, ed. Robert Hunter and Luke Beckerdite (Hanover, NH: University Press of New England, 2009), 17–19.

5. Ronald J. Duncan, *The Ceramics of Ráquira, Colombia: Gender, Work, and Economic Change* (Gainesville: University Press of Florida, 1998), 103–107.

6. Cinda K. Baldwin, *Great & Noble Jar: Traditional Stoneware of South Carolina* (Athens: University of Georgia Press, 1993), 19. The names Abner Landrum gave to one son, Palissy, and two others, Wedgwood (after Josiah Wedgwood, "father" of Staffordshire's pottery industry) and Manises (the lusterware center in Valencia, Spain), indicate his wide-ranging ceramics interest and reading, and help to explain how he may have come across a description of Chinese high-firing alkaline glazes that led to a regional stoneware tradition in the South (see Chapter 3). Palissy also figures prominently in American poet Henry Wadsworth Longfellow's 1877 tour de force, "Kéramos."

7. For Japanese pottery museums, see Penny Simpson, Lucy Kitto, and Kanji Sodeoka, *The Japanese Pottery Handbook*, rev. ed. (New York: Kodansha USA, 2014), 118–124, and Anneliese Crueger, Wulf Crueger, and Saeko Itô, *Modern Japanese Ceramics: Pathways of Innovation and Tradition* (New York: Lark, 2007), 304–317. Included are museums featuring both traditional and studio pottery, folk craft museums with good ceramic collections, and historic and active kilns. As recent as these publications are, the listings may not be up to date.

8. For pottery in the Philadelphia Museum of Art's Pennsylvania-German room, see Beatrice B. Garvan, *The Pennsylvania German Collection* (Philadelphia: Philadelphia Museum of Art, 1982), 162–235. Included in the gallery are works in media other than clay (furniture, etc.), but the lion's share of the space is devoted to Pennsylvania slip-decorated earthenware, much of it collected by Edwin AtLee Barber, a curator and then director of what was first known as the Pennsylvania Museum and School of Industrial Art and a pioneer scholar of American ceramics (his 1903 *Tulip Ware of the Pennsylvania-German Potters* may be the first book-length study of a Euro-American folk craft).

9. Burrison, *From Mud to Jug*, chap. 9.

3 | THE SINCEREST FORM OF FLATTERY

Cross-Cultural Imitations

Two birds flying high,

A Chinese vessel, sailing by.

A bridge with three men, sometimes four,

A willow tree, hanging o'er.

A Chinese temple, there it stands,

Built upon the river sands.

An apple tree, with apples on,

A crooked fence to end my song.

Variant of the "Blue Willow" poem[1]

THIS IS AN "EAST MEETS WEST" STORY, SPECIFICALLY ABOUT THE IMpact of the Far and Middle East on the rest of the world's ceramics. To put it another way, it's a story about cultural diffusion: the spread of ceramic ideas from a single place of origin—China—to virtually the rest of the globe. The diffusion I'll be discussing occurred mainly through trade, migration of potters, and later access to information through print and museum collections.

White Ware: The Porcelain Story

The story begins with one of China's great ceramic innovations, the development of that pure white, translucent product we call porcelain. Chinese potters were making wares from white clay as early as the twelfth century BCE, and by the Tang dynasty (618–907 CE) an early version of porcelain (fig. 3.1) was being exported to the Islamic world by sea and land routes such as the Silk Road through Central Asia.[2] Bear in mind that while much of today's porcelain is cheaply mass produced and regarded as having little value, centuries ago a porcelain vase or dish was a rarity, treasured like a precious jewel. Outside China at the time of Tang, most

Figure 3.1. Tang dynasty dish recovered from the Belitung shipwreck off Indonesia, made in Gongxian, Henan province, ca. 825 CE. An early example of Chinese blue-and-white ceramics, it's closer to stoneware than porcelain, which was perfected in later dynasties; Gongxian high-fired white wares were made as early as 575. *Collection of ArtScience Museum, Singapore; Photograph: Jacklee, CC BY-SA 3.0, via Wikimedia Commons.*

Figure 3.2, facing. Tin-glazed earthenware bowl likely inspired by Chinese white wares, Basra, Iraq, 9th century. The influence went in both directions; cobalt-blue decoration on Middle Eastern wares may have inspired the same on some Gongxian white wares such as figure 3.1. The repeated Arabic inscription in the center is "*ghibta*," translated as "felicity." *Collection of the Metropolitan Museum of Art, New York, www.metmuseum.org.*

Figure 3.3, below. Pair of maiolica (tin-glazed earthenware) *albarellos* (pharmacy jars), Florence, Tuscany, Italy, early 1400s. The dark clay body is exposed where the white glaze is absent. *Collection of The Metropolitan Museum of Art, New York, www .metmuseum.org. Photograph: Sailko, CC BY-SA 3.0, via Wikimedia Commons.*

Figure 3.4, above. *Lebrillo*, Puebla, Mexico, ca. 1650, continuing the tin-glazed earthenware tradition brought in the previous century by potters from Talavera de la Reina, Spain. The rim inscription indicates the basin's function: to wash purificators, altar linens used to wipe the Eucharist chalice after Communion. *Collection of The Metropolitan Museum of Art, New York, www.metmuseum.org.*

Figure 3.5, facing. Tin-glazed earthenware plate painted in imitation of Japanese Imari porcelain, Delft, Holland, early 1700s (Dutch wares imitating porcelain of Ming dynasty China were more common). *Collection of Rijksmuseum, Amsterdam, Netherlands, https://www.rijksmuseum.nl.*

Figure 3.6, above. Tin-glazed earthenware plate with transfer-printed Blue Willow pattern, Spode factory, Stoke-on-Trent, Staffordshire, England, 1818. In this special-order variation of the pseudo-Chinese design, the recipient's name and year replace the usual pair of birds in flight. *Photo © Victoria and Albert Museum, London, https://www.vam.ac.uk, England.*

Figure 3.7, facing. Fritware dish luster painted on tin glaze with interlocking Islamic design, Kashan, Iran, dated 1268 (Western equivalent). *Courtesy of the David Collection, Copenhagen, Denmark, inv. # Is195. Photograph: Pernille Klemp.*

pottery was darkish earthenware, with limited options for decoration; in Europe, lighter-colored stoneware would not appear for several more centuries. Imagine the wonder of Middle Eastern potters and consumers when the first examples of this magical product arrived by ship and pack camel.

The problem for Muslim potters desirous of producing their own porcelain is that they lacked knowledge of the ingredients and technology that remained a Far Eastern secret until the eighteenth century. But that didn't stop them from trying; the medieval Islamic world was quite advanced scientifically for the time. The real challenge for Middle Eastern potters, then, was to create the *appearance* of porcelain in lieu of duplicating the process. They did this in two ways, one of which was to be Islam's own gift to global ceramics: tin glazing.

The idea of adding tin oxide to whiten and opacify clear glaze as a "canvas" for painted decoration on earthenware is attributed to Muslim potters of eighth-century Iraq (fig. 3.2). The idea was not new; it had been used for Mesopotamian tiles and building bricks in 1000–600 BCE, then forgotten.[3] The Chinese white-ware imports are thought to have prompted rediscovery of the technique, which then spread to other Islamic countries.

Moorish potters introduced tin-glazed earthenware to Spain as Hispano-Moresque ware; it then was embraced by potters in Italy, to be known as maiolica (fig. 3.3); from Italy it spread to France, where it's known as faience, and to the Netherlands, where it's called delftware (from Delft, Holland, the main production center).[4] As delftware it reached London potters by 1600, then continued on to potters in Bristol, Staffordshire, Liverpool, and Ireland. Tin-glazed earthenware was seldom traditionally handcrafted in the United States but it was in Mexico, introduced about 1550 by potters from Talavera de la Reina, Spain, to Puebla (fig. 3.4), where it's known as Talavera Poblana pottery and is still being made. Portuguese potters were making *faiança* by the mid-1500s, with painted designs inspired by imported Ming-dynasty porcelain; in the next century their wares were traded to colonial America.[5]

Dutch potters of the seventeenth and eighteenth centuries also interpreted Ming-dynasty Chinese porcelain as well as Imari-style Japanese porcelain (fig. 3.5) in tin-glazed earthenware, while English pottery factories, responding to the public's *chinoiserie* ("Chinese taste") craze, created Chinese-style designs to be transfer printed on molded, tin-glazed earthenware. The most famous of these, still being manufactured, is the Blue Willow pattern, attributed to engraver Thomas Minton in the late 1780s, when Staffordshire potters such as Josiah Spode adopted the design (fig. 3.6). Blue Willow inspired poems (e.g., this chapter's opening epi-graph), a romantic pseudolegend based on the pattern's imagery, a 1901 comic

Figure 3.8. Hispano-Moresque lusterware *brasero* (brazier), *Mudéjar* (Moorish-influenced) style with birds flanking a palm tree and Kufic-like inscription, Manises, Valencia, Spain, ca. 1430. *Collection of the Walters Art Museum, Baltimore, Maryland, CC BY-SA 3.0, via Wikimedia Commons.*

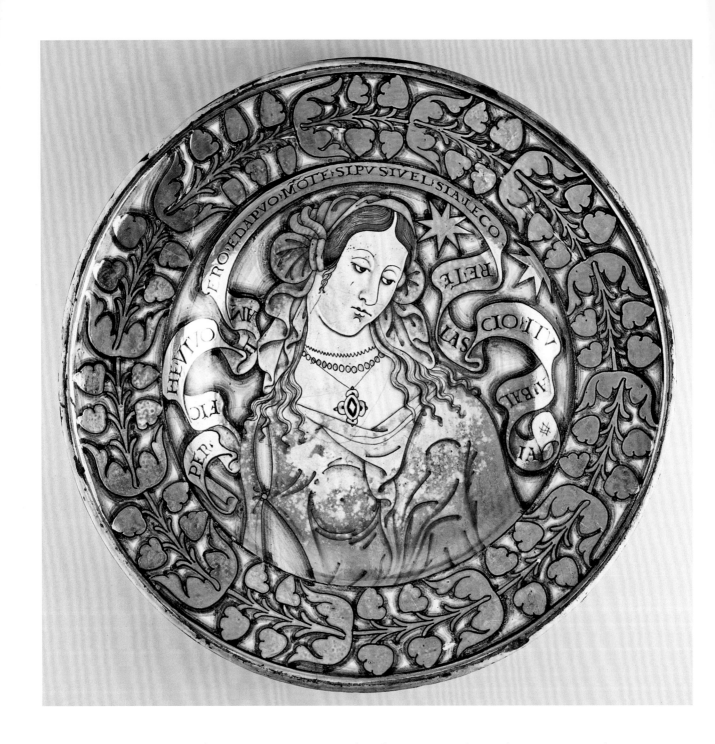

Figure 3.9. Lusterware maiolica plate, Deruta, Umbria, Italy, 1510–1520. Display plates of the *bella donna* type, with an idealized image of a beautiful young woman, were a Deruta specialty. Made as love gifts, most include a scroll with the intended recipient's name or an inscription that on this example translates, "As long as I live I will love you, and after your death my one humble desire is to be united with you. I am left at your mercy." *Collection of the Walters Art Museum, CC BY-SA 3.0, via Wikimedia Commons.*

Figure 3.10. Fritware plate, Iznik, Turkey, 1535–1545. With its central motif of grape clusters and a floral cavetto painted in cobalt blue on white slip, it's a fairly faithful copy of Chinese porcelain plates from Ming dynasty Jingdezhen; the border is an Ottoman interpretation of the Chinese "rock and wave" design. *Collection of Musée du Louvre, Paris, France. Photograph: Sailko, CC BY 3.0, Wikimedia Commons.*

opera, a 1914 silent film, and a 1940 children's book by American author Doris Gates.[6] So popular was the English pseudo-Chinese pattern that it came to be reproduced by factories in China and Japan!

Along with tin glazing, a further Islamic ceramic idea that spread more narrowly to traditional potters of Spain and Italy was lusterware, in which a sulfate of copper, silver, or gold was painted on a pot's fired, tin-glazed surface, then reduction-fired at a lower temperature to yield a metallic sheen when burnished. The technique was borrowed from glass decoration in Egypt and Iraq, with lusterware proving popular among well-to-do Muslims as a substitute for wares of precious metal frowned upon by Islamic law.[7] Fine examples of the type were made at Kashan, Iran (fig. 3.7), Manises, Spain (fig. 3.8), and Deruta, Italy (fig. 3.9).

The other Middle Eastern invention to approximate the look of porcelain was the development, beginning in the ninth century, of a light-colored ceramic body known as fritware or stonepaste, which, unlike tin glazing, remained confined to the Islamic world. A treatise of 1301 on Seljuk pottery by Abu'l Qasim of Iran includes a recipe: ten parts ground quartz, one part ground alkaline frit (glass with borax and potash), and one part white clay.[8] If the body was not quite light enough to effectively show off painted decoration, a white slip coating improved the contrast (fig. 3.10).

Some European potters and their clientele were not satisfied with tin-glazed wares (which chipped easily to reveal the darker fabric beneath) as porcelain look-alikes; they wanted the real thing as a domestic product. However, like their Islamic predecessors, Western potters initially could not solve the porcelain-technology riddle. The first successful European attempt to create something like the Chinese product occurred in Florence, Italy, under the patronage of Francesco I de' Medici, Grand Duke of Tuscany. The experimental factory operated from 1575 to 1587, producing elegant white composite wares now classified as soft-paste porcelain (fig. 3.11).[9] Other Continental factories followed suit, with the manufacture of soft-paste porcelain reaching England and then America (fig. 3.12) in the eighteenth century.

Figure 3.12, facing. Soft-paste porcelain "pickle stand," American China Manufactory, Philadelphia, Pennsylvania, 1770–1772. Gousse Bonnin and George Anthony Morris established America's first successful—if short-lived—porcelain factory. This rococo-style compote for sugared fruits and nuts is one of 6 known examples and is related to soft-paste sweetmeat dishes of the 1750s by Bow China Works, London. *Collection of the Metropolitan Museum of Art, New York, www.metmuseum.org.*

Figure 3.13, below. Hard-paste porcelain "tureen stand" from the baroque Swan Service modeled by J. J. Kändler and J. F. Eberlein, Meissen Porcelain Manufactory, Meissen, Germany, 1737–1741. Made for the factory's director, Count Heinrich von Brühl, many of the service's 2200 pieces bear his painted coat of arms. *Collection of Gardiner Museum, Toronto, Canada. Photograph: Daderot, CC0 1.0, via Wikimedia Commons.*

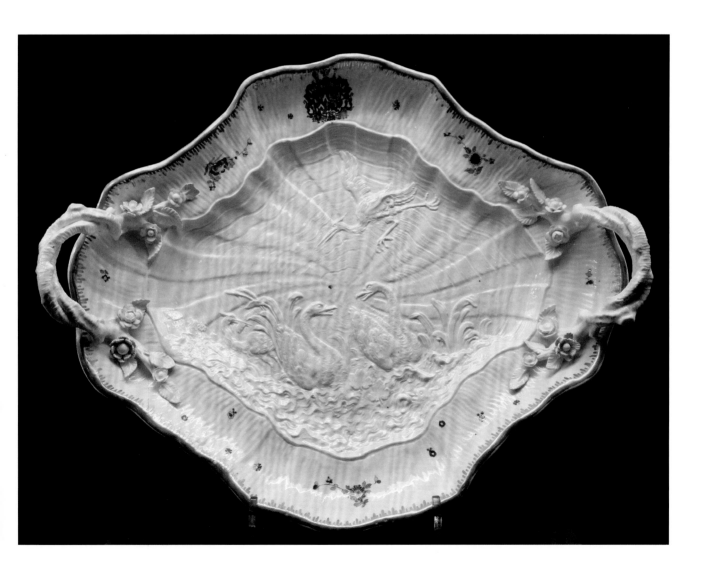

It's generally thought that the West's first "true," or hard paste, porcelain was created at Meissen, Germany, in 1710 by the alchemist Johann Friedrich Böttger (based on experiments by the scientist Ehrenfried Walther von Tschirnhaus) under the patronage of Augustus the Strong, Elector of Saxony and King of Poland, a passionate collector of Far Eastern porcelain (fig. 3.13). However, an English challenge to the claim of "first" is the recent recognition of a small group of hard-paste vessels possibly made at Vauxhall (now in the London borough of Lambeth) under the patronage of the second Duke of Buckingham, a good quarter century before Meissen.[10]

The English venture would have been short lived, but the Meissen factory continues today as Staatliche Meissener Porzellan-Manufaktur GmbH. And, of course, porcelain also is still actively made in China, where this remarkable saga of imitation and reinterpretation of a ceramic idea began, to then make its way around the world in a ten-thousand-mile-long conceptual bucket brigade.

Other Borrowings from China

At the same time the Islamic world was seeing its first shipments of Chinese white wares, it was also receiving another ceramic influence from China: a type of Tang dynasty lead-glazed earthenware known as *sancai* ("three colors" or polychrome) ware. The usual colors are brown, green, and white, often with a "splashed" effect from the oxide-tinted glazes running in the firing (fig. 3.14). The look was picked up and combined with the sgraffito technique by potters of Iran and Central Asia (fig. 3.15) as well as those of the Christian Byzantine Empire (fig. 3.16), which then influenced the pottery tradition of northern Italy (fig. 3.17).[11]

At Yixing county in China's Jiangsu province a distinctive type of unglazed stoneware teapot (fig. 3.18) has been made of local *zisha* ("purple sand") clay since at least the early 1500s (Ming dynasty). When Yixing tea wares reached Europe they were emulated in red stoneware by Ary/Arij de Milde of Delft, Holland (fig. 3.19) and other Netherlands potters beginning in the 1670s (prompted by the importation of Yixing wares and tea by the Dutch East India Company); by the Dutch brothers John and David Elers working in Staffordshire, England, in the 1690s; and by Johann Friedrich Böttger at Meissen, Germany, alongside his new porcelain. The Dutch and English imitations continued into the 1700s; what came to be known as "Böttger stoneware" enjoyed a revival at Meissen in the 1920s and 1930s. Yixing remains an active pottery center today, responsible for some of China's most creative traditional ceramics.[12]

Now the East-West story comes much closer to home. In the 1960s, pioneer American pottery researcher Georgeanna Greer of San Antonio, Texas, made

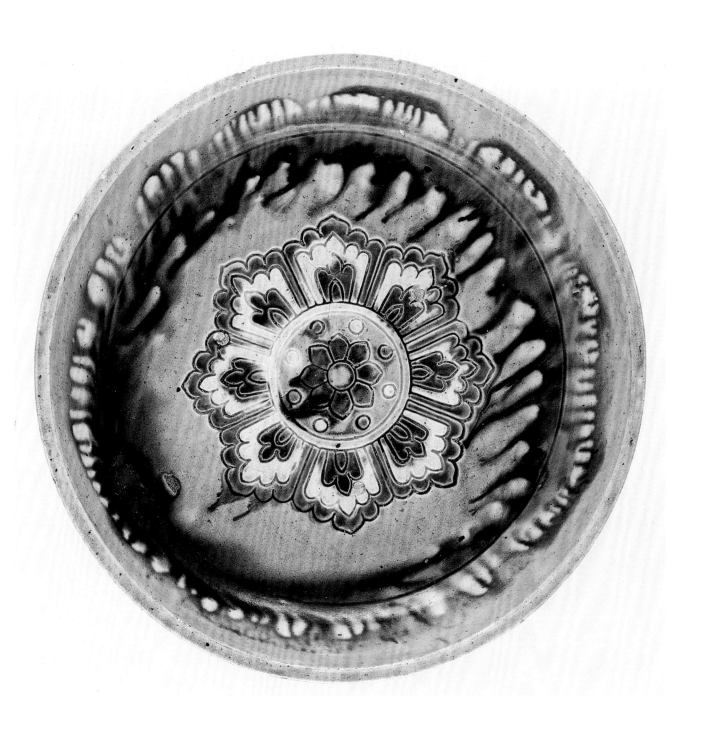

Figure 3.14. Lead-glazed earthenware basin with "splashed" and painted *sancai* colors over impressed floral roundel, China, Tang dynasty, 8th century. *Collection of Los Angeles County Museum of Art, www.lacma.org, public domain.*

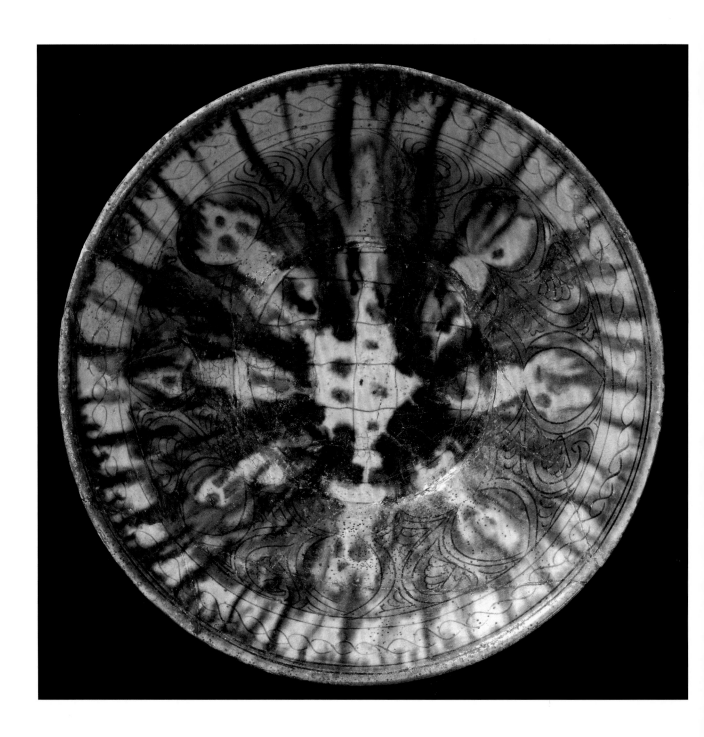

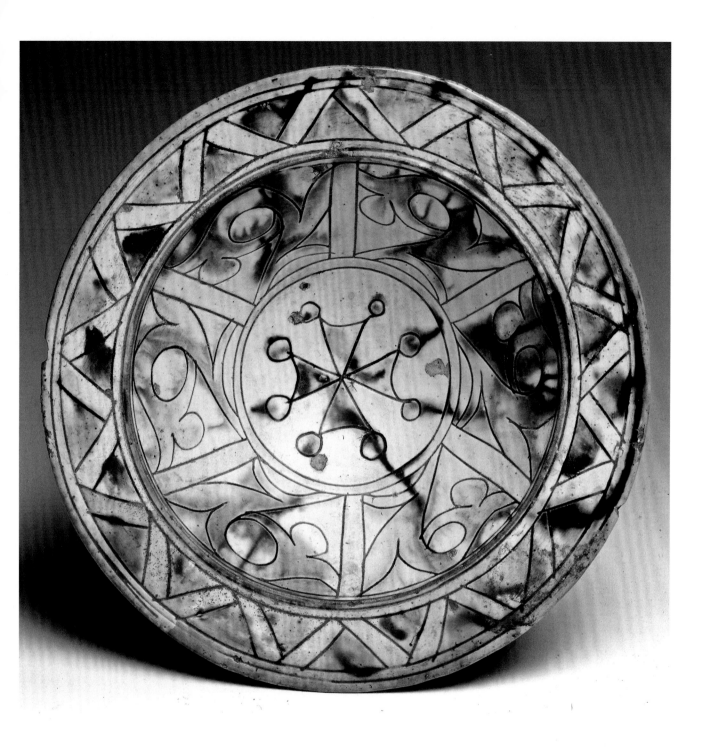

Figure 3.16. Earthenware bowl with loosely painted and sgraffito decoration, Syria or Palestine, 13th century. Some Eastern Mediterranean Byzantine art combines Christian and Islamic design elements—here, a Maltese cross and Kufic-like palmettes interpreted as the Arabic *laka* ("for you"). *Courtesy of the David Collection, Copenhagen, inv. # 1/1996. Photograph: Pernille Klemp.*

Figure 3.17. Earthenware plate with loosely painted and sgraffito birds and leaves, Bologna or Ferrara, northern Italy, 15th century. *Collection of the Metropolitan Museum of Art, New York, www.metmuseum.org.*

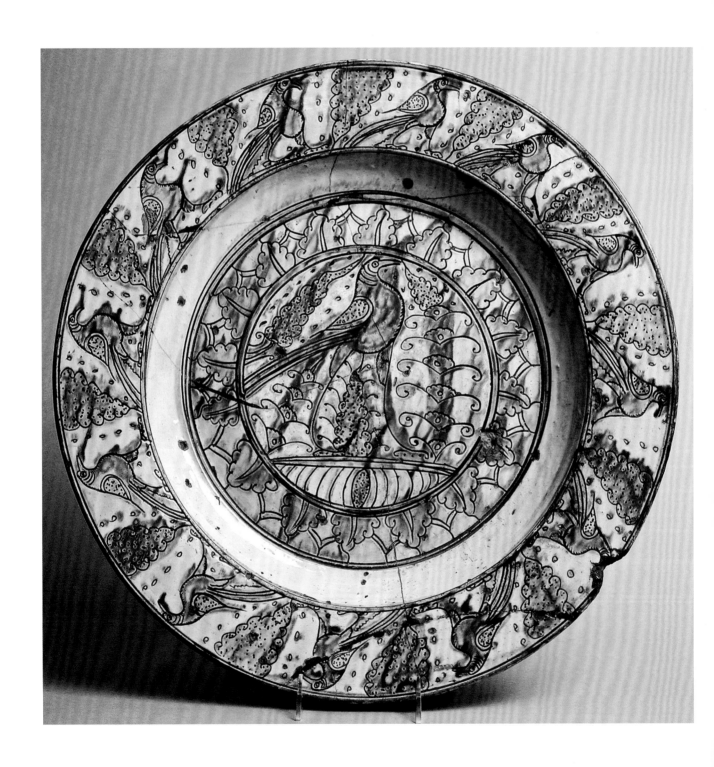

Figure 3.18. Stoneware *zisha* ("purple sand" clay) teapot, Yixing, Jiangsu province, China, 1680–1700. Such unglazed, slightly absorbent wares are said to take on the flavor of tea with frequent use. *Collection of Rijksmuseum, Amsterdam, Netherlands, https://www.rijksmuseum.nl.*

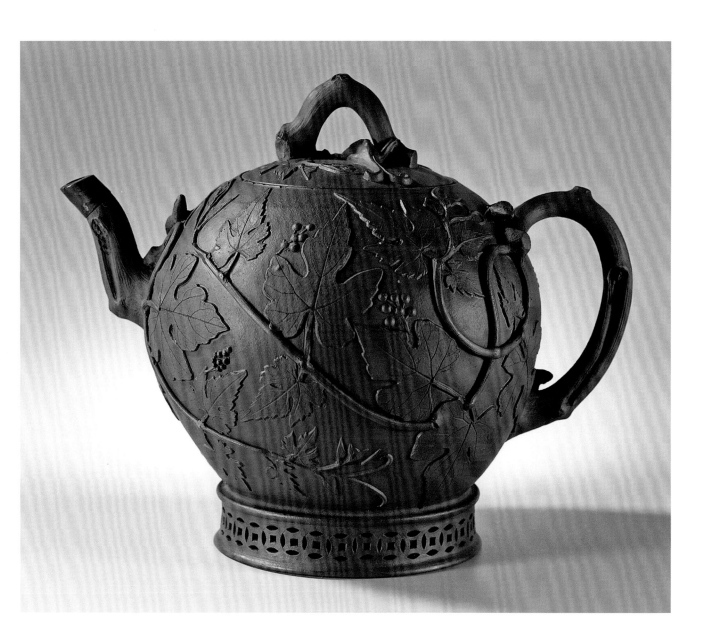

Figure 3.19. Red stoneware teapot in Yixing style by Ary/Arij de Milde, Delft, Holland, ca. 1700. *Collection of Rijksmuseum, Amsterdam, Netherlands, www.rijksmuseum.nl.*

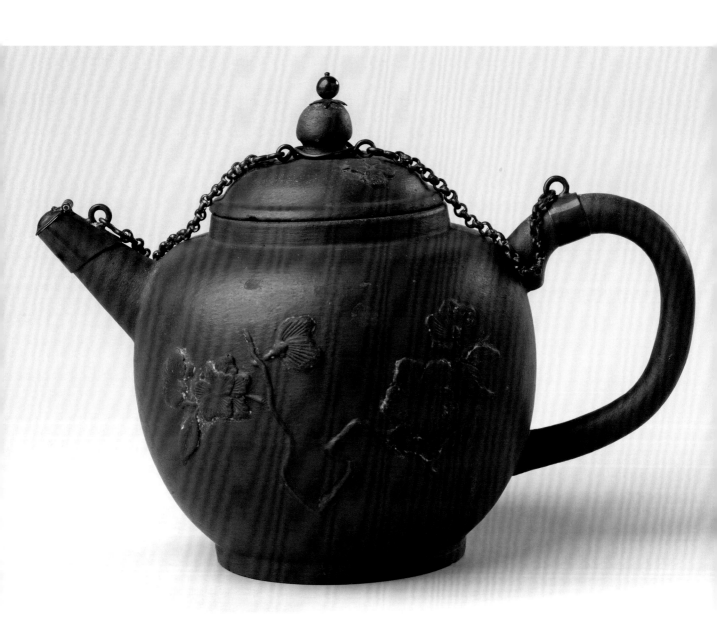

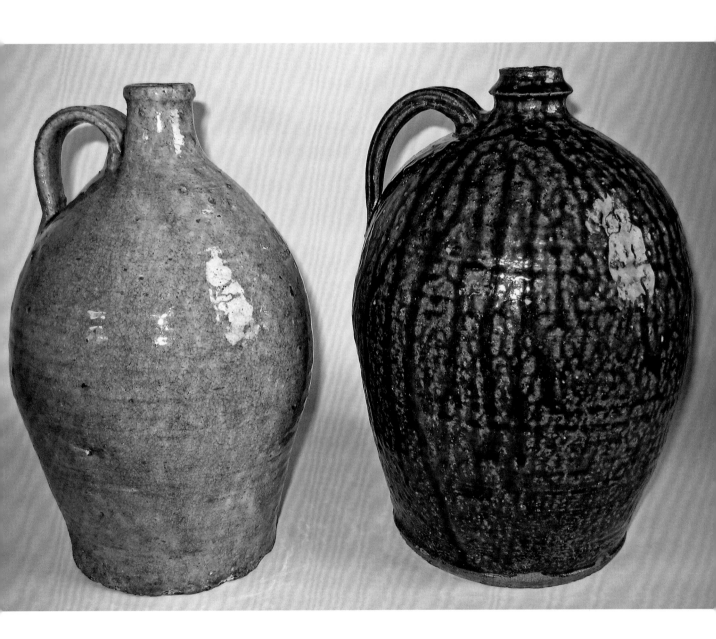

Figure 3.20. Stoneware whiskey jugs attributed to antebellum north Georgia, with lime-based (l.) and ash-based (r.) subtypes of alkaline glaze. *Private collection; photograph: author.*

a startling discovery: the green or brown, often runny-textured glazes on the southern stoneware she was collecting were remarkably similar to the high-firing, woodash- and lime-based alkaline glazes of the Far East, introduced to her by San Antonio studio potter and glaze authority Harding Black.[13] Her research led her and others to South Carolina's old Edgefield District (present-day Edgefield, Aiken, and Greenwood counties) as the likely source of those Asian-looking glazes on some folk pottery of the lower South.

It's now believed that the glazes were developed by Dr. Abner Landrum in his efforts to produce "up-country porcelain" when he began his Pottersville Stoneware Manufactory there about 1810. The first dated example of southern alkaline-glazed stoneware, signed by Landrum in 1820, is a simple bottle with a glaze resembling Chinese celadon.[14] The most likely theory as to how he came up with the glazes is that in his reading he ran across recipes for Chinese high-firing ash- and lime-based glazes used at Jingdezhen, written by Jesuit missionary François Xavier d'Entrecolles in letters of 1712 and 1722 and published by Jean-Baptiste Du Halde in French in 1735, then a year later in English as *The General History of China*, a work said to have been on every serious bookshelf in the later eighteenth and early nineteenth centuries.[15]

The smoking gun for this theory—proof that Landrum read the d'Entrecolles letters or some adaptation thereof—is yet to come to light, but for me the clincher is that the letters mention both plant-ash and lime as alkaline fluxes, as well as the use of both (not just the ash) in antebellum Edgefield stoneware glazes and in glazes I've documented for Georgia (fig. 3.20).[16] Intriguingly, since at least the 1930s Georgia's Meaders pottery family has referred to their ash glaze as "Shang-hai glaze," suggesting a folk memory of some Chinese connection.[17]

Eastern Influences on Western Studio Potters

The Arts and Crafts movement arose in the second half of the nineteenth century, fueled by the writings of Englishmen John Ruskin and William Morris, critics of dehumanizing factory work and advocates for good design and craftsmanship. The potter's wheel made its way into the artist's studio, with some of the new

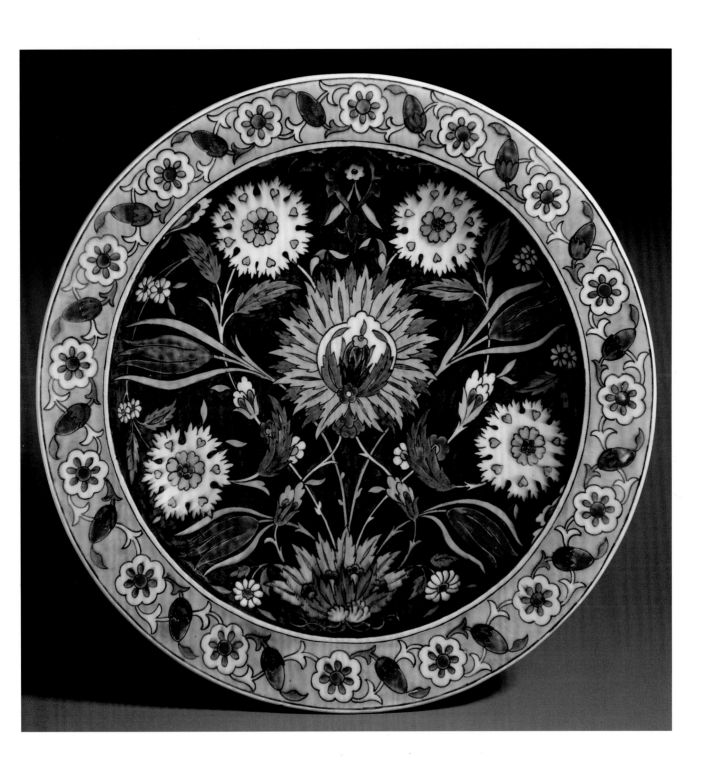

Figure 3.22. Ash-glazed stoneware bottle by Phil Rogers, Marston Pottery, Rhayader, Powys, Wales, ca. 2014, representing a Japanese aesthetic introduced to the West by Bernard Leach. *Courtesy of Phil Rogers.*

artist-potters, along with other Victorians, falling under the spell of exoticism stimulated by the 1856 publication of Owen Jones's *The Grammar of Ornament*.

One such potter was Joseph-Théodore Deck, a native of Alsace, France, who began his career as a ceramic stove maker. In 1856 Deck opened a studio in Paris to produce "artistic faience," some of it inspired by Japanese Kutani ware and Ottoman fritware of Iznik, Turkey (fig. 3.21).[18] An English counterpart was William De Morgan, an associate of William Morris, whose artistic interest began with stained glass and shifted to pottery and tiles. In 1872 he set up a studio in London's Chelsea district, borrowing and reinterpreting the design motifs and brilliant colors of Persian and Ottoman pottery as well as recreating the Hispano-Moresque lusterware technique.[19]

The next chapter in this "East Meets West" story begins in Japan with Bernard Leach, who first encountered Japanese pottery in 1911 and soon was learning from traditional potters there, later becoming associated with potter Shōji Hamada and philosopher Yanagi Sōetsu, founder of the *Mingei* (Folk Craft) movement. In 1920 Leach returned to England, where he'd first studied art, and set up a studio at St. Ives, Cornwall, introducing Western potters to Japanese ceramics through his teaching, publications, and speaking engagements.[20] It was largely through his and Hamada's influence that ash glaze came to be adopted by Western studio potters (those in the American South were ironically unaware until recently that ash glaze is an old tradition in the region).

One of Leach's many spiritual disciples is Phil Rogers, a studio potter of international renown and author of *Ash Glazes*, whose Marston Pottery is located at Rhayader, Wales (fig. 3.22).[21] Phil's Korean wife, Ha Jeong Lee, contributes further to the East-West connection by applying William Morris–influenced designs to her slip-inlaid, Korean Buncheong-style stoneware.

For the final chapter of this hands-across-the-sea story I return to the American South, specifically to North Carolina, where Jacques and Juliana Busbee opened Jugtown Pottery in 1921 at Seagrove, Moore County, after discovering the area's old, still-active pottery tradition. The cosmopolitan Busbees employed young Ben Owen and Charlie Teague, both trained in the local lead-glazed earthenware and

Figure 3.23, below. Stoneware "Han translation" jar with "Chinese blue" glaze by Travis Owens, Jugtown Pottery, Seagrove, Moore County, North Carolina, 2001, continuing an East-West fusion tradition begun at Jugtown Pottery in the 1920s. *Private collection; photograph: author.*

Figure 3.24, facing. Ash-glazed stoneware jar by Daniel Johnston, Seagrove, North Carolina, 2007. The form is Far Eastern but the melted-glass decoration is North Carolinian. *Private collection; photograph: author.*

salt-glazed stoneware tradition, and introduced them to Asian ceramics, creating an East-West fusion still seen today in the work of Ben Owen's grandson, Ben III, the related Owens family who now own Jugtown Pottery (fig. 3.23), and others influenced by that fusion.[22]

The North Carolina chapter took a different turn when Mark Hewitt settled at Pittsboro, less than fifty miles from Seagrove, in 1983. Mark's ceramic background is an industrial one; a native of Stoke-on-Trent, Staffordshire, he's the son and grandson of directors of the Spode china factory. Inspired by Bernard Leach's *A Potter's Book*, he undertook a three-year apprenticeship with Michael Cardew, himself an early apprentice of Leach.[23] Along with their Asian influences, both Leach and Cardew admired the traditional slip-trailed earthenware of England and used that decorative technique in some of their work. Thus, Mark brought to North Carolina that East-West studio sensibility as well as receptiveness to the vernacular pottery of his new home. After meeting Burlon Craig, North Carolina's last old-fashioned folk potter, and one of his disciples, Kim Ellington—both masters of Catawba Valley ash-glazed stoneware—Mark adopted elements of the North Carolina tradition such as the melted-glass decoration Burl had revived from his predecessors.[24]

Mark has taken on a succession of apprentices who go on to further his eclectic style. One is Daniel Johnston, who traces his genealogy in clay as having "been trained in the Leach, Cardew and Hewitt school of making pots."[25] His other influences are learning to make big jars with a traditional stoneware potter in Thailand, and studying slip decorating with English studio potter Clive Bowen. In England Daniel made a pilgrimage to Cardew's Wenford Bridge studio and saw the collection he'd amassed over the years. He recalls, "These were pots from many different potting cultures. There was a [Shōji] Hamada tea bowl just sitting in the corner and some old pots from Abuja [Nigeria, where Cardew had worked]. There were English slipware jugs and older Cardew pieces as well. . . . I had the profound sense I was also connected to all of those pots."[26] A native of Seagrove, Daniel returned to build a home and workshop, where he is establishing a reputation as one of North Carolina's finest potters of his generation (fig. 3.24).[27]

———— ≫•≪ ————

There are many more instances of cross-cultural ceramic borrowing than those I've highlighted, of course, but it's the connections defying the great distances between East and West that I find most impressive. What do these stories tell us? First, that folk potters of the past, despite lacking the transportation and communication

resources we enjoy today, were not so isolated and hidebound as we might think. While honoring their traditions, they were on the lookout for ways to improve them and also satisfy their customers as tastes and market conditions changed. One way or another, ceramic ideas from other cultures were in the air, ripe for the picking, to serve those ends. And second, that some of the studio potters discussed above belong to a tradition too, one different philosophically from those I focus on in this book, but still involving the handing on of ideas from master to apprentice, ideas ultimately inspired by the work of folk potters on the other side of the world.[28]

Notes

1. *Wikipedia*, s.v. "Willow Pattern," https://en.wikipedia.org/wiki/Willow_pattern (accessed August 18, 2016).

2. Emmanuel Cooper, *Ten Thousand Years of Pottery*, 4th ed. (Philadelphia: University of Pennsylvania Press, 2000), 83, and John Carswell, *Blue and White: Chinese Porcelain Around the World*, 2nd ed. (London: British Museum Press, 2007). For an overview of Chinese ceramics trade and its impact on ceramics elsewhere, see Li Zhiyan, Virginia L. Bower, and He Li, eds., *Chinese Ceramics: From the Paleolithic Period through the Qing Dynasty* (New Haven, CT: Yale University Press; Beijing: Foreign Languages Press, 2010), chap. 10. See also Peter Frankopan, *The Silk Roads: A New History of the World* (New York: Knopf, 2016), chap. 1.

3. Cooper, *Ten Thousand Years*, 84–86.

4. Alan Caiger-Smith, *Tin-Glaze Pottery in Europe and the Islamic World: The Tradition of 1000 Years in Maiolica, Faience and Delftware* (London: Faber and Faber, 1973). The first known English delftware is a colorful plate dated 1600 in the Museum of London collections, attributed to Jasper Andries and Jacob Jansen at Aldgate, London, immigrant potters from Antwerp.

5. Mário Varela Gomes, ed., *On the World's Routes: Portuguese Faience (16th–18th Centuries)* (Lisbon: Instituto de Arqueologia e Paleociências da Universidade Nova de Lisboa, 2013); Reynaldo dos Santos, *Faiança Portuguesa, Seculos XVI e XVII* (Porto, Portugal: Livraria Galaica, 1960); John G. Hurst, David S. Neal, and H. J. E. Van Beuningen, *Pottery Produced and Traded in North-West Europe 1350–1650*, Rotterdam Papers 6 (Rotterdam: Museum Boijmans Van Beuningen, 1986), 67–68; and Charlotte Wilcoxen, "Seventeenth-Century Portuguese Faianca and Its Presence in Colonial America," *Northeast Historical Archaeology* 28:1 (1999): article 2, 1–20.

6. Robert Copeland, *Spode's Willow Pattern: And Other Designs After the Chinese*, 3rd ed. (London: Cassell Illustrated, 2000), and Mary Frank Gaston, *Gaston's Blue Willow: Identification & Value Guide*, 3rd ed. (Paducah, KY: Collector Books, 2003). For variants of the pseudolegend featuring star-crossed lovers Chang and Koong-see, who upon death are

transformed into doves, see Joseph J. Portanova, "Porcelain, The Willow Pattern, and *Chinoiserie*," http://www.nyu.edu/projects/mediamosaic/madeinchina/pdf/Portanova.pdf, and "The Legend of Blue Willow," http://www.angelfire.com/biz/starfire27/Legend.html (both accessed August 18, 2016). For the novel, see Doris Gates, *Blue Willow* (New York: Viking, 1940).

7. Cooper, *Ten Thousand Years*, 86–88; Sheila R. Canby, "Islamic Lustreware," in *Pottery in the Making: World Ceramic Traditions*, ed. Ian Freestone and David Gaimster (London: British Museum Press, 1997), chap. 16; Robert B. J. Mason, *Shine Like the Sun: Lustre-Painted and Associated Pottery from the Medieval Middle East* (Costa Mesa, CA: Mazda, 2004); and Ernst J. Grube et al., *Cobalt and Lustre: The First Centuries of Islamic Pottery*, Nasser D. Khalili Collection of Islamic Art, vol. 9 (London: Nour Foundation, 1994).

8. Cooper, *Ten Thousand Years*, 90–92.

9. Arthur Lane, *Italian Porcelain* (London: Faber and Faber, 1954), and G. Cora and A. Fanfani, *La Porcellana dei Medici* (Milan: Fabbri, 1986).

10. For the Meissen story, see Robert E. Röntgen, *The Book of Meissen*, 2nd ed. (Atglen, PA: Schiffer, 1996), and John Sandon, *Meissen Porcelain* (London: Shire, 2010). For the English challenge to the German origin of European hard-paste porcelain, see the six articles exploring the "Lord Buckingham" porcelains in *English Ceramic Circle Transactions* 20:1 (2008). The German and English body compositions differ from each other, and both differ from the Chinese.

11. Cooper, *Ten Thousand Years*, 85–86.

12. For Chinese *zisha* wares, see K. S. Lo, *The Stonewares of Yixing: From the Ming Period to the Present Day* (London: Sotheby's Publications; Hong Kong: Hong Kong University Press, 1986); He Yun'ao and Zhu Bang, *Yixing Zisha* (North Weald, UK: Xanadu, 2014); and Chunfang Pan, *Yixing Pottery: The World of Chinese Tea Culture* (San Francisco: Long River, 2004). For European imitations, see Lo, chap. 10; Jan Daniel van Dam, "European Redwares: Dutch, English and German Connections, 1680–1780," in *British Ceramic Design 1600–2002*, ed. Tom Walford and Hilary Young (Beckenham, UK: English Ceramic Circle, 2003), 33–41; Dirk Syndram and Ulrike Weinhold, eds., *Böttger Stoneware: Johann Friedrich Böttger and Treasury Art* (Dresden: Deutscher Kunstverlag and Staatlicht Kunst-sammlungen, 2009); and Edwin A. Barber, "So-Called 'Red Porcelain,' or Boccaro Ware of the Chinese, and Its Imitations," *Bulletin of the Pennsylvania Museum* 34 (April 1911): 17–23.

13. Georgeanna H. Greer, "Preliminary Information on the Use of the Alkaline Glaze for Stoneware in the South, 1800–1970," in *Conference on Historic Site Archaeology Papers 1970*, vol. 5, ed. Stanley South (Columbia: Institute of Archaeology and Anthropology, University of South Carolina, 1971), 155–170, and Greer, *American Stonewares, The Art and Craft of Utilitarian Potters* (Exton, PA: Schiffer, 1981), 202–210. See also John A. Burrison, "Alkaline-Glazed Stoneware: A Deep-South Pottery Tradition," *Southern Folklore Quarterly* 39:4 (1975): 377–403.

14. Mark Hewitt and Nancy Sweezy, *The Potter's Eye: Art and Tradition in North Carolina Pottery* (Chapel Hill: University of North Carolina Press, 2005), 106–107.

15. John A. Burrison, *Brothers in Clay: The Story of Georgia Folk Pottery*, rev. ed. (Athens: University of Georgia Press, 2008), 58–62, and Daisy Wade Bridges, *Ash Glaze Traditions in Ancient China and the American South*, Journal of Studies 6 (Charlotte, NC: Ceramic Circle of Charlotte and Southern Folk Pottery Collectors Society, 1997). Ash glaze was used on French stoneware as early as the sixteenth century at Beauvais and Saint-Amanden-Puisaye, later at Martincamp and La Borne, perhaps developed independently of Chinese influence; see Marcel Poulet, *Poteries et Potiers de Puisaye et du Val de Loire, XVIème-XXème Siècle* (Merry-la-Vallée, France: n.p., 2000); Martine Houze, *Grès du Berry: Art Populaire Berrichon, Collection Guillaume* (La Ferté-sous-Jouarre, France: GEDA, 1996); and Gérard Vincent, *Les Grès Anciens du Berry* (Issoudun, France: Alice Lyner, 2009).

16. Cinda K. Baldwin, *Great & Noble Jar: Traditional Stoneware of South Carolina* (Athens: University of Georgia Press, 1993), 144–147, and Burrison, *Brothers in Clay*, chaps. 9, 10, and 16. For alternative hypotheses see Carl Steen, "Alkaline Glazed Stoneware Origins," *South Carolina Antiquities* 43 (2011): 21–31.

17. See Allen H. Eaton, *Handicrafts of the Southern Highlands* (New York: Russell Sage Foundation, 1937), 213, for the earliest reference I've found to "Shanghai" glaze, from Eaton's interview with L. Q. Meaders at Mossy Creek, Georgia, a potter brother of Cheever.

18. Théodore Deck, *La Faïence*, new ed. (Paris: Quantin, 1887); Bernard Bumpus, *Théodore Deck: Céramiste* (London: H. Blairman & Sons, 2000); and Frederica Todd Harlow, "Deck and the Islamic Style," *Saudi Aramco World* 43:4 (1992): 8–15.

19. Martin Greenwood, *The Designs of William De Morgan* (Ilminster, UK: Richard Dennis and William W. Wiltshire III, 1989), and Rob Higgins and Christopher Stolbert Robinson, *William De Morgan: Arts and Crafts Potter* (London: Shire, 2010).

20. Bernard Leach, *A Potter in Japan, 1952–1954* (London: Faber & Faber, 1960); Emmanuel Cooper, *Bernard Leach: Life and Work* (New Haven, CT: Yale University Press, 2003); Bernard Leach, *Hamada, Potter* (Tokyo: Kodansha International, 1975); and Susan Peterson, *Shoji Hamada: A Potter's Way & Work* (New York: Weatherhill, 1995).

21. Phil Rogers, *Ash Glazes*, 2nd ed. (Philadelphia: University of Pennsylvania Press, 2003).

22. For Jugtown Pottery, see Jean Crawford, *Jugtown Pottery: History and Design* (Winston-Salem, NC: John F. Blair, 1964); Douglas DeNatale, Jane Przybysz, and Jill R. Severn, eds., *New Ways for Old Jugs: Tradition and Innovation at the Jugtown Pottery* (Columbia: McKissick Museum, University of South Carolina, 1994); Charlotte Vestal Brown, *The Remarkable Potters of Seagrove: The Folk Pottery of a Legendary North Carolina Community* (New York: Lark, 2006), 41–50; and Hewitt and Sweezy, *The Potter's Eye*, 218–248 (Pam and Vernon Owens). For Ben Owen III, see Kathy L. Kay, *Built upon Honor: The Ceramic Art of Ben Owen and Ben Owen III* (Rabun Gap, GA: Hambidge Center; Charlotte, NC: Mint Museum of Art, 1995); Brown, *The Remarkable Potters of Seagrove*, 104–105; Hewitt and Sweezy, *The Potter's Eye*, 204–218; and Denny Hubbard Mecham, ed., *The Living Tradition: North Carolina Potters Speak* (Conover, NC: Goosepen Studio & Press, 2009), chap. 9.

23. Bernard Leach, *A Potter's Book*, 3rd ed. (London: Faber, 1976), and Garth Clark, *Michael Cardew: A Portrait* (Tokyo: Kodansha International, 1976).

24. For Mark Hewitt, see Hewitt and Sweezy, *The Potter's Eye*, 189–203; Mecham, *The Living Tradition*, chap. 6; Henry Glassie, *Mark Hewitt: Outside* (Wilmington, NC: Louise Wells Cameron Art Museum, 2002); and Christopher Benfey, *At the Crossroads: Pottery by Mark Hewitt* (Boston, MA: Pucker Gallery, 2015). For Burlon Craig, see Charles G. Zug III, *Burlon Craig: An Open Window into the Past* (Raleigh: North Carolina State University Visual Arts Center, 1994), and Zug, "Burlon Craig," *Ceramics Monthly* 42:9 (1994): 38–44. For Kim Ellington, see Zug, "Entering Tradition: Kim Ellington, Catawba Valley Potter," in *The Individual and Tradition: Folkloristic Perspectives*, ed. Ray Cashman, Tom Mould, and Pravina Shukla (Bloomington: Indiana University Press, 2011), 27–45.

25. Katey Schultz, "Daniel Johnston Dreams Big," *Ceramic Arts Daily* (Sept. 15, 2009): 1, http://ceramicartsdaily.org/ceramic-art-and-artists/functional-pottery/daniel-johnston-dreams-big/ (accessed November 8, 2016).

26. Ibid.

27. Brown, *The Remarkable Potters of Seagrove*, 106–107.

28. Emmanuel Cooper, "Tradition in Studio Pottery," in Freestone and Gaimster, eds., *Pottery in the Making*, chap. 32.

4 | THE HUMAN IMAGE

Face Jugs and Other People Pots

And has not such a Story from of Old

Down Man's successive generations roll'd

Of such a clod of saturated Earth

Cast by the Maker into Human mold?

The Rubáiyát of Omar Khayyám[1]

ACE JUGS ARE PERHAPS THE MOST INTRIGUING OBJECTS MADE BY southern folk potters, capturing the imagination of collectors, museum curators, researchers, and potters alike. Where did they come from, and what have they meant to their makers and owners, both in the past and present? The story as I understand it should make it clear that the answers are anything but simple.

While these sculpted humanoid vessels are often referred to as face jugs, a better name for them is "people pots," since some are full-body figural jugs such as one made about 1890 by William Grindstaff of Tennessee (fig. 4.1), or are other vessel forms besides jugs (e.g., jars, pitchers, cups). Antebellum examples from the South survive, but information about them is so scant that later theories about origin and meaning are at best educated guesswork.

Some of the oldest southern people pots were made in 1862–1865 by enslaved African-American potters in Edgefield District, South Carolina (fig. 4.2). Created in a white-owned shop using the European technology of the potter's wheel and kiln and the European jug form, they're coated with woodash- or lime-based alkaline glazes that are probably Asian in inspiration (see Chapter 3). Yet the tendency has been to posit African roots for these South Carolina face vessels, as did ceramics historian Edwin AtLee Barber, the first to write about them in the early 1900s. Many can be attributed to slave potters working at the Palmetto Fire Brick Works, founded in 1862 at Bath in Aiken County, based on Barber's communication with the shop's former owner, Thomas Davies. As Barber put it,

Figure 4.1, below. Stoneware figural jug, salt glaze over dark slip, by William Grindstaff, Knox County, Tennessee, ca. 1890. The belly is stamped "W GRINSTAFF / S:KONT.TY"; the four curved stamps on the chest read "KNOXVILLE TENN." Private collection; photograph: author.

Figure 4.2, facing top. Stoneware face jugs by enslaved African-American potters at Thomas Davies' Palmetto Fire Brick Works, Bath, Edgefield District, South Carolina, 1862–1865. The alkaline glaze on some was darkened by adding pulverized iron-bearing "paint rock" (limonite). *Private collection; photograph: author.*

Figure 4.3, facing bottom. "An Aesthetic Darkey," stereoscope photograph by James A. Palmer, Aiken, Edgefield District, South Carolina, 1882. The face field jug probably had been slave-made locally. *Courtesy of J. Garrison and Diana Stradling.*

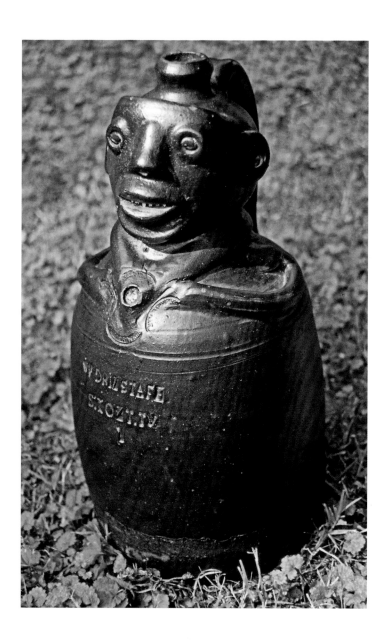

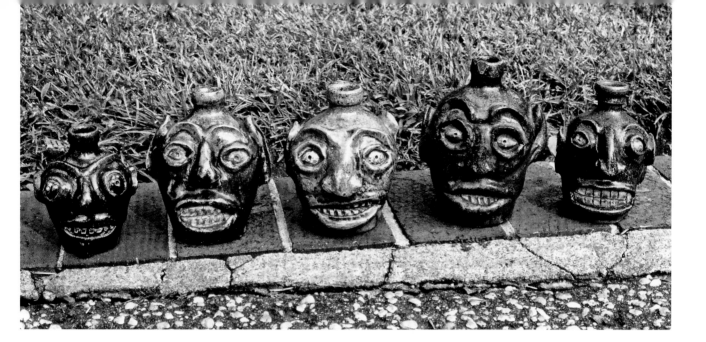

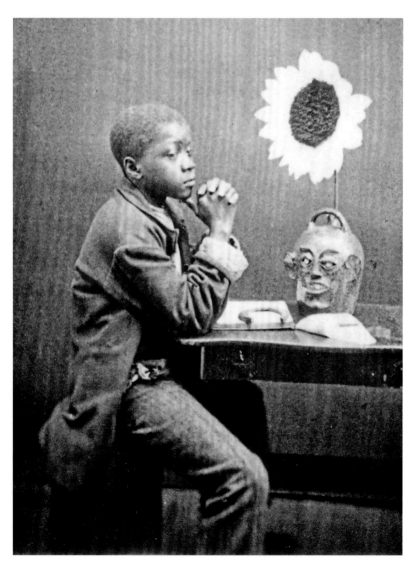

Figure 4.4, below. Face field jug, stoneware with paint rock-darkened alkaline glaze, Edgefield District, South Carolina, probably slave-made in early 1860s. *Collection of Augusta-Richmond County Museum, Augusta, Georgia, www.augustamuseum.org. Photograph: author.*

Figure 4.5, facing. Terracotta "portrait" jug, Mangbetu people, Democratic Republic of the Congo, Central Africa, early 1900s. Such jugs feature elite Mangbetu women with their distinctive hair styles. *Photograph © Michael C. Carlos Museum, Emory University, Atlanta, Georgia, carlos.emory,edu; photographer: Bruce M. White, 2006.*

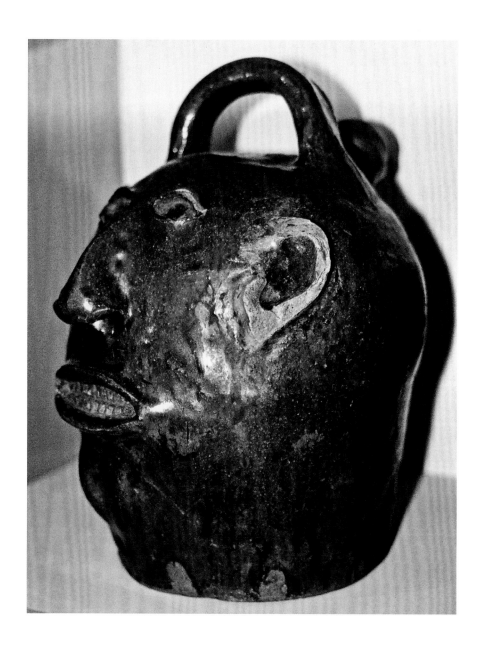

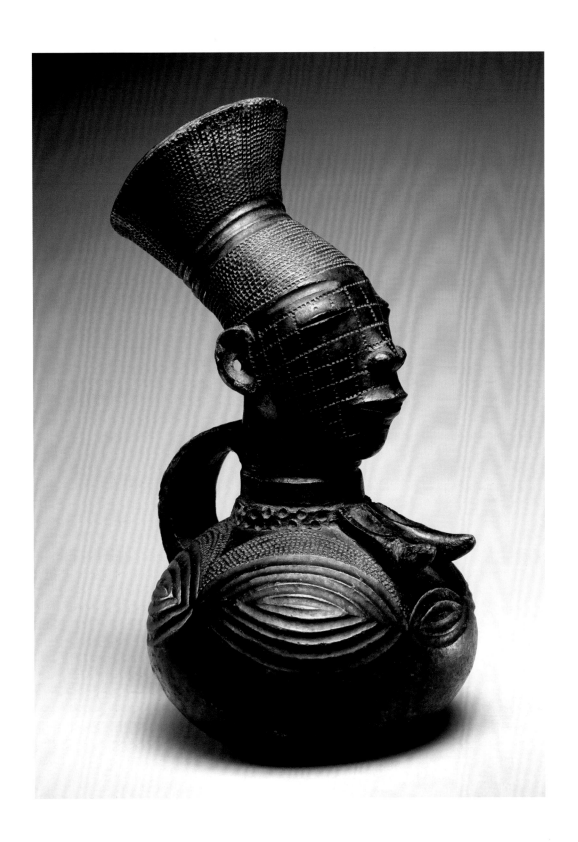

Figure 4.6. Stoneware face jug, slave-made at Thomas Davies' Palmetto Fire Brick Works, Bath, South Carolina, 1862–1865. On examples such as this, wax-resist kept the alkaline glaze from the inset kaolin eyes and teeth, creating greater contrast and accentuating the menacing expression. *Courtesy of Wooten & Wooten, Camden, South Carolina.*

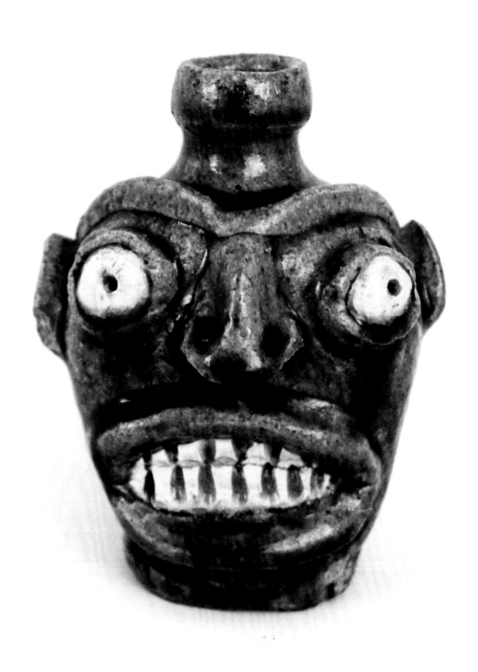

"These curious objects . . . possess considerable interest as representing an art of the Southern negroes . . . and we can readily believe that the modeling reveals a trace of aboriginal art as formerly practiced by the ancestors of the makers in the Dark Continent."[2]

Face jugs are further associated with the black population as early as early as 1882 on stereoscope cards titled "An Aesthetic Darkey" (fig. 4.3). Taken by photographer James A. Palmer of Aiken, South Carolina in his series on Aiken and vicinity (in Edgefield District), the pose was inspired by an engraving of W. H. Beard's painting "The Aesthetic Monkey" that appeared in *Harper's Weekly* of January 28, 1882.[3] Racist appeal aside, the vessel in the photo, with its stirrup handle and angled, off-center spouts—most likely slave-made locally—is known in the South as a "monkey jug," a type of field jug named from an Afro-Caribbean term for thirst.[4] Such vessels are common in Africa and Mediterranean Europe, so the form itself could indeed be an African contribution to southern folk pottery.[5] But is applying a face onto a pot (fig. 4.4) also an African idea?

There were, in fact, anthropomorphic ceramic traditions in West and Central Africa. For example, the Yungur people of Nigeria made portrait pots called *wiiso* to channel ancestral spirits at shrines; the Mambilla of Nigeria and Cameroon made similar figural pots; the Azande of South Sudan and the Democratic Republic of the Congo made tall-necked bottles topped with beautifully detailed heads; and the Mangbetu of northern Congo made female "portrait" jugs for drinking palm wine (fig. 4.5).[6] However, I've seen no evidence that those African traditions were early enough to have influenced South Carolina slaves.

An alternative possibility of African roots for the slave-made Edgefield face vessels is a switch to clay from the mixed-media (mainly wood) power figures called *nkisi*, used by Kongo people to receive magical help from ancestral spirits. A fresh infusion of African culture to Edgefield District occurred in 1858 with Kongo slaves from the illegal slave ship *Wanderer*, at least one of whom (Tahro/Romeo Thomas) worked at Thomas Davies' pottery. The angry bared teeth and bulging eyes of many Edgefield examples (fig. 4.6) may have served as a nonverbal expression of protest against enslavement, perhaps even applying the African-American belief in *conjure* or *hoodoo* by functioning as *mojos*, or magical charms, to cause harm to slave owners.[7]

A Global Phenomenon

Complicating the pursuit of origins for American people pots is the near-universality of humanoid vessels among clay-working societies, returning to the question of polygenesis versus diffusion raised in my Introduction to explain such

Figure 4.7. Terracotta head pot, Chickasawba Site, Mississippi County, Arkansas, Late Mississippian culture, 1350–1550 CE. Many of the approximately 200 examples excavated in the Central Mississippi Valley of Arkansas and Missouri seem to represent a person in death, perhaps a deceased high-status community member—or a severed trophy head. *Collection of Nelson-Atkins Museum of Art, Kansas City, Missouri, www.nelson-atkins.org. Photograph: Daderot, CC0 1.0, Wikimedia Commons.*

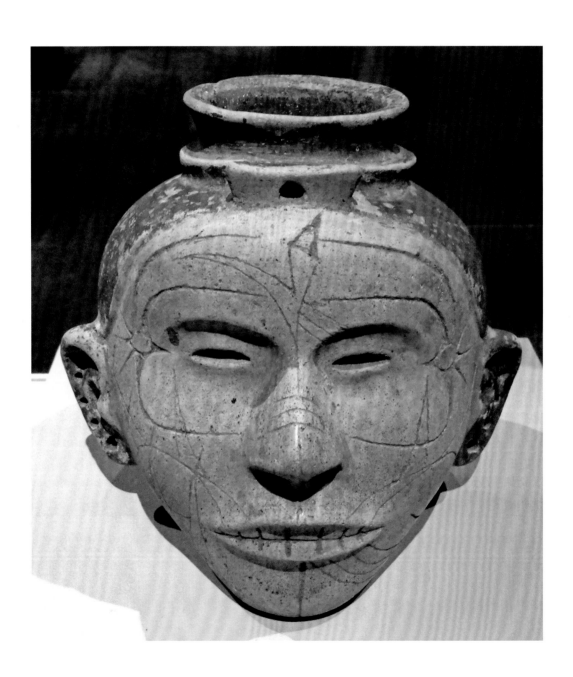

Figure 4.8. Four-face jar, 13th–15th century CE, Casas Grandes/Paquimé, Chihuahua, a pre-Columbian, Mogollon-culture urban center in northern Mexico whose painted pottery inspired a 20th-century revival at nearby Mata Ortiz. *Collection of the Metropolitan Museum of Art, New York, www.metmuseum.org.*

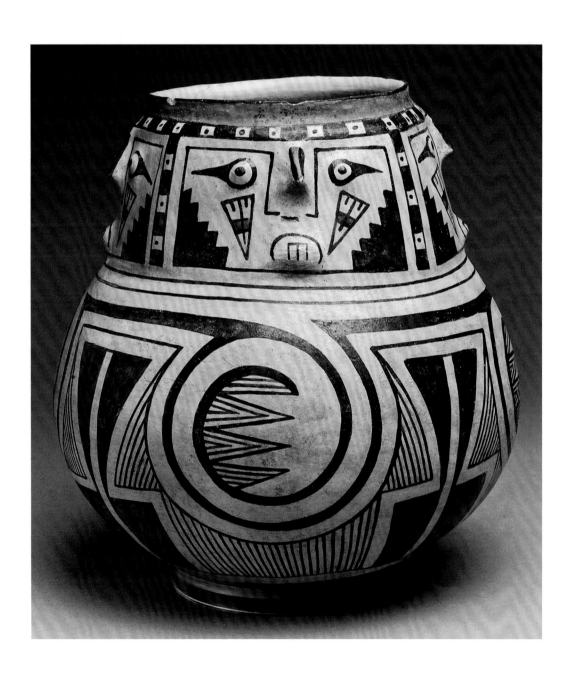

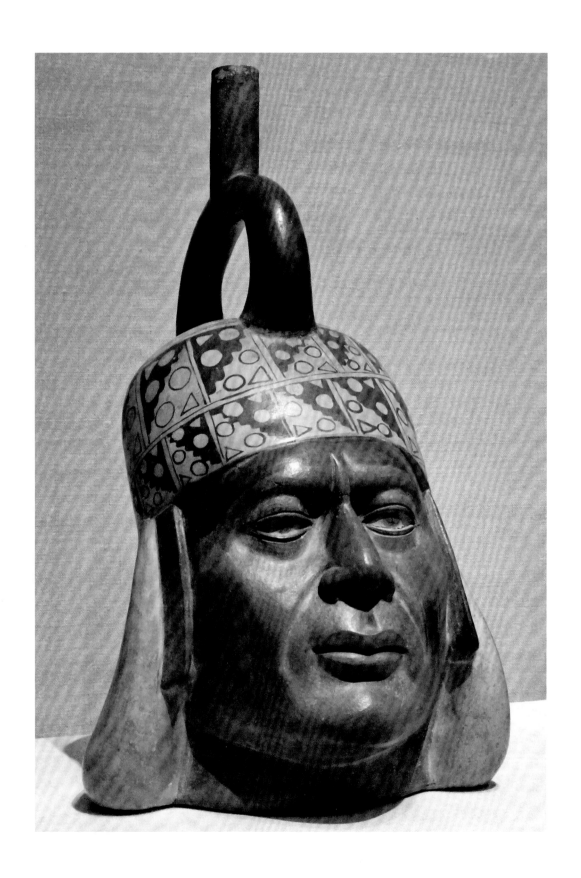

Figure 4.9, facing. Stirrup-spout "portrait" jug, Moche/Mochica culture, north coast of Peru, 100 BCE–500 CE. Over 900 examples of such vessels are known. Although mold-made, some were altered with added details to represent specific high-status males. *Collection of Art Institute of Chicago, www.artic.edu. Photograph: Daderot, via Wikimedia Commons.*

Figure 4.10, below. Face jar, Shipibo-Conibo people, San Francisco de Yarinacocha, Ucayali, Peru, pre-1980. The painted linear designs are related to those of Shipibo Indian textiles and facial paint. *Courtesy of UBC Museum of Anthropology, Vancouver, Canada, moa.ubc.ca, ID # Se160. Photograph: Jessica Bushey.*

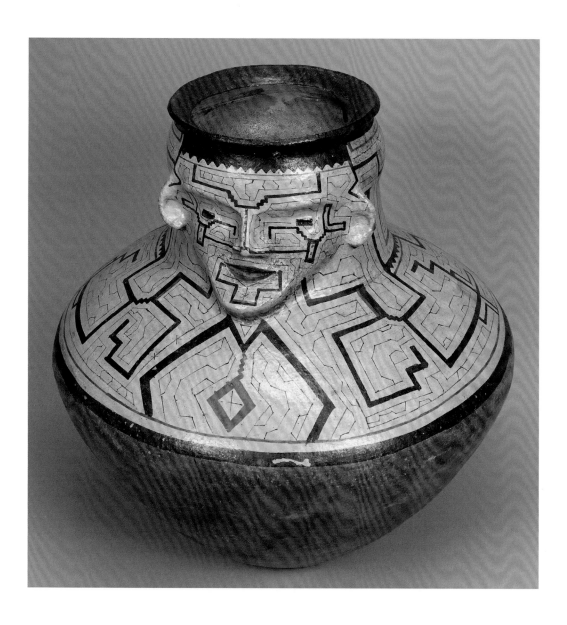

Figure 4.11, below. Terracotta cremation urn with stylized face, Gandhara grave culture, Swat Valley, Pakistan, ca. 1200 BCE. *Collection of Los Angeles County Museum of Art, www.lacma.org, public domain.*

Figure 4.12, facing. Earthenware figural jug (female) with burnished red slip, Memphis, Egypt, 1550–1295 BCE. *Collection of the Metropolitan Museum of Art, New York, www.metmuseum.org.*

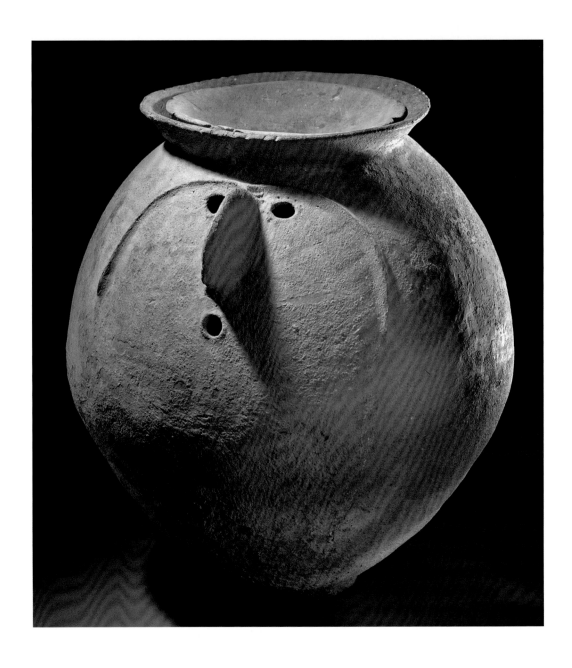

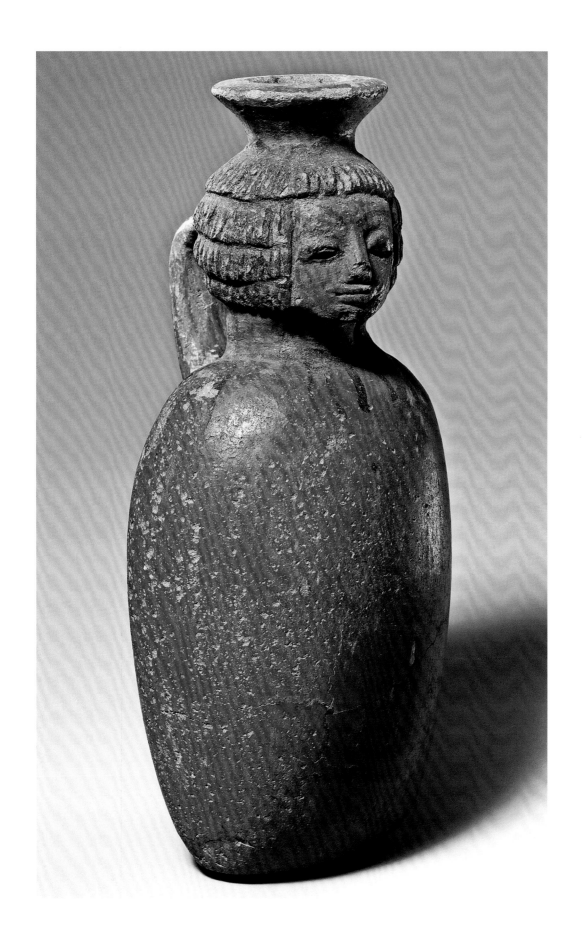

Figure 4.13. Etruscan *bucchero*-ware face jug with face lid, Chiusi, Tuscany, Italy, ca. 550 BCE. *Collection of the Metropolitan Museum of Art, New York, www .metmuseum.org.*

broad distribution. Potters' awareness of the corporeal character of their vessels is demonstrated by the terms used to describe the anatomical parts of a pot: mouth, lip, neck, shoulder, belly, foot. Is it any wonder, then, that potters the world over see clay as a sort of mirror, a reflection of their humanity, and exploit its plastic nature to sculpt it into a human likeness?

In the Mid-South, Native American potters of the Late Mississippian (Mound Building) period made face vessels for ceremonial use from about 1400 to 1600 CE (fig. 4.7), too early to have influenced the nineteenth-century southern face jug tradition.[8] Humanoid clay vessels are also found in Latin America, including the Casas Grandes culture of Chihuahua, Mexico, dating to between 1200 and 1500 CE (fig. 4.8), and Moche "portrait" jugs from Peru dating from 100 BCE to 700 CE (fig. 4.9). The native Shipibo-Conibo people along the Ucayali River in Peru's Amazon rainforest maintain a living tradition of face pots today (fig. 4.10) as part of their repertoire of jars for water and *chicha* (maize beer).

To extend the global distribution of anthropomorphic vessels beyond the Americas, we can start with the minimalist faces on cremation urns from the Swat Valley of Pakistan, dating to about 1200 BCE in the early Gandhara kingdom (fig. 4.11). In ancient Egypt, burnished red-slip jugs shaped as females (fig. 4.12), sometimes kneeling with a child or playing a lyre, were made during the New Kingdom in roughly the same time frame as the Pakistani urns.

Moving to Europe, the Etruscans—the pre-Roman inhabitants of Italy after whom Tuscany is named—specialized in *bucchero* ware, a burnished, reduction-fired black pottery that included jugs with molded human faces (fig. 4.13), while a specialty of ancient Greek potters in the Athens area was the *kantharos* (wine cup) and *aryballos* (jug/flask) with one or two (janiform) molded faces. The most intriguing of these juxtapose the faces of an African and European woman with the inscription *"kalos"* ("beautiful"; fig. 4.14). In France, there were a number of local traditions of humanoid vessels, both early and late; a mid-nineteenth-century potter who stands out in this regard is Marie Talbot of La Borne, Berry, whose ash-glazed stoneware figural bottles and dispensers, often depicting fashionable

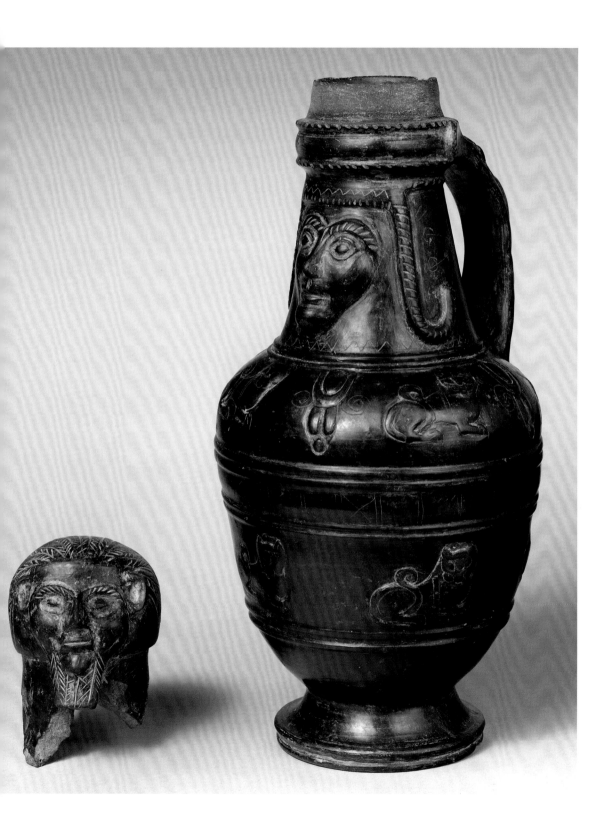

Figure 4.14, below. Janiform *aryballos* with African and Greek female faces and *kalos* ("beautiful") inscription, Attic Greece, 520–510 BCE. *Collection of Musée du Louvre, Paris, www.louvre.fr.; Photograph: Jastrow, via Wikimedia Commons.*

Figure 4.15, facing. Ash-glazed stoneware figural *fontaine* (dispenser), 27" high, signed "Fait par moi [Made by me] Marie Talbot," La Borne, Berry, France, ca. 1840s; the inscription identifies the subject as "Mademoiselle Degace." At least 50 of Marie Talbot's figural vessels are known; her father, Jacques-Sébastien Talbot, also made sculptural pieces, including a bottle portraying her. *Courtesy of Maurice Sauvin, www.sauvin.com—European Folk Arts.*

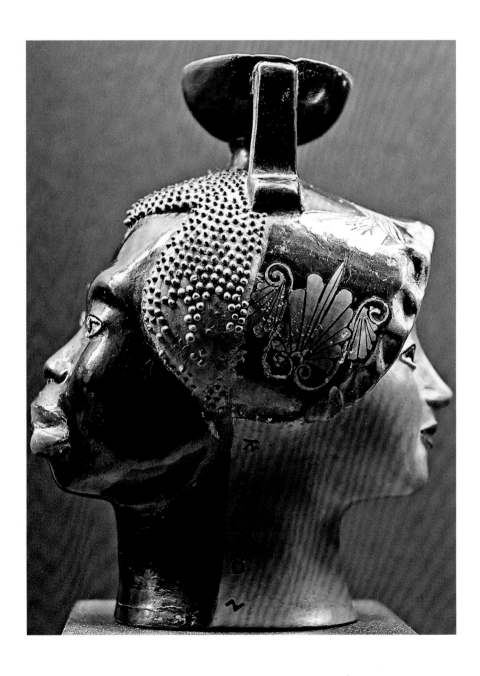

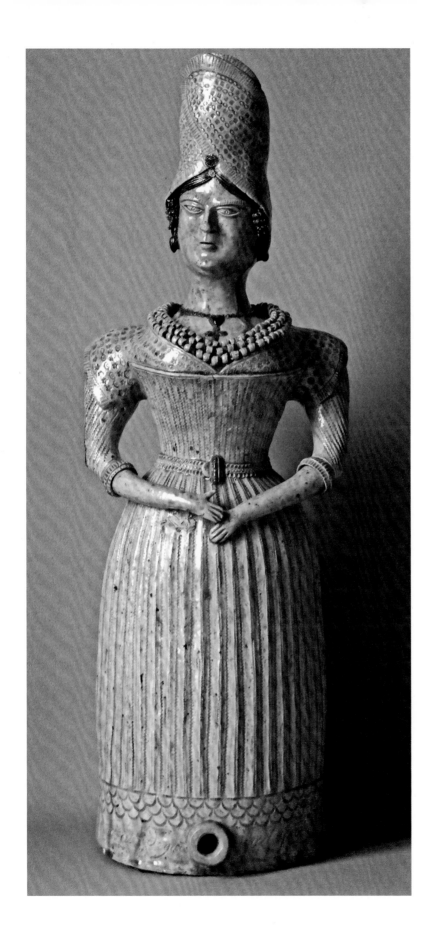

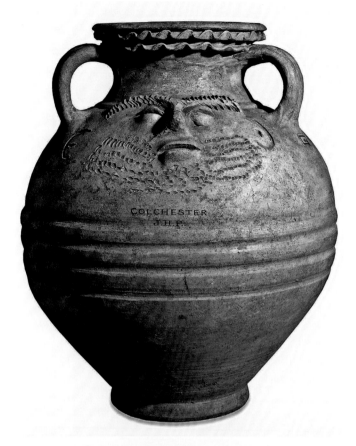

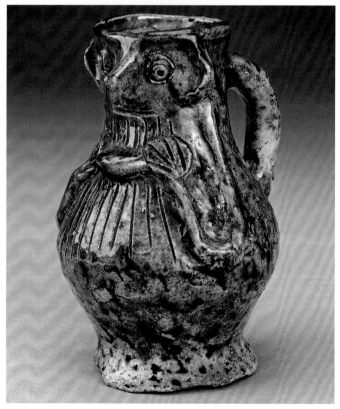

Figure 4.16, facing above. Terracotta face cinerary urn, Colchester, Essex, England, Romano-British, ca. 2nd century CE. Roman potters in Germany also made these. *Photograph © Trustees of the British Museum, London, www.britishmuseum.org.*

Figure 4.17, facing bottom. Medieval figural jug, earthenware with copper-green lead glaze, Kingston-upon-Thames, Surrey, England, ca. 1300. *Photograph © Trustees of the British Museum, www.britishmuseum.org.*

Figure 4.18, below. Face jug attributed to John Ifield, earthenware with manganese-colored lead glaze, the eyes and teeth overlain with white clay (missing for one eye), Wrotham, Kent, England, dated 1674. *Photograph © Victoria and Albert Museum, London, https://www.vam.ac.uk.*

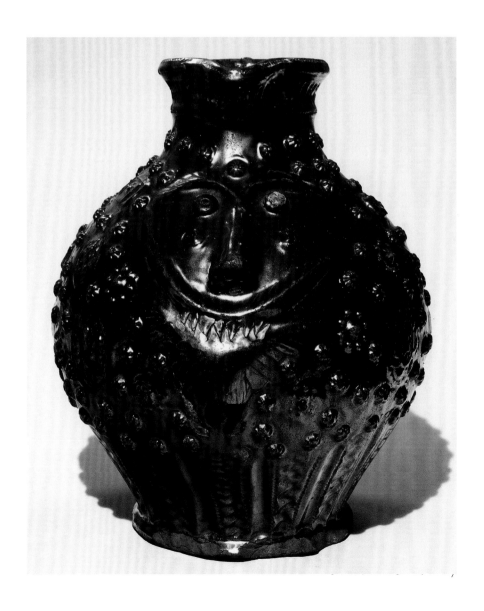

Figure 4.19, below. Toby jug attributed to Ralph Wood the Younger, molded, lead-glazed creamware (light-colored earthenware), Burslem, Staffordshire, England, late 1780s. Toby jugs are thought to have been inspired by Francis Fawkes's 1761 poem and related printed images, "The Brown Jug," featuring corpulent toper Toby Fillpot (based on real-life big drinker Henry Elwes). *Photograph © Victoria and Albert Museum, London, https://www.vam.ac.uk.*

Figure 4.20, facing. Salt-glazed stoneware face pitcher with iron-oxide coloring, wheel thrown, then hand modeled, London, England, early 1800s. Likely inspired by Toby jugs, it's one of 6 examples from the same workshop known to the author, the 2 illustrated in J. F. Blacker's *The ABC of English Salt-Glaze Stone-Ware* (1922) attributed to Charles Bloodworth of Lambeth. *Private collection; photograph: author.*

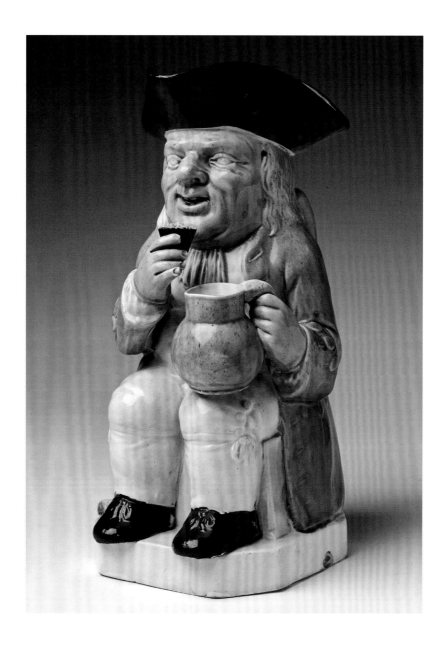

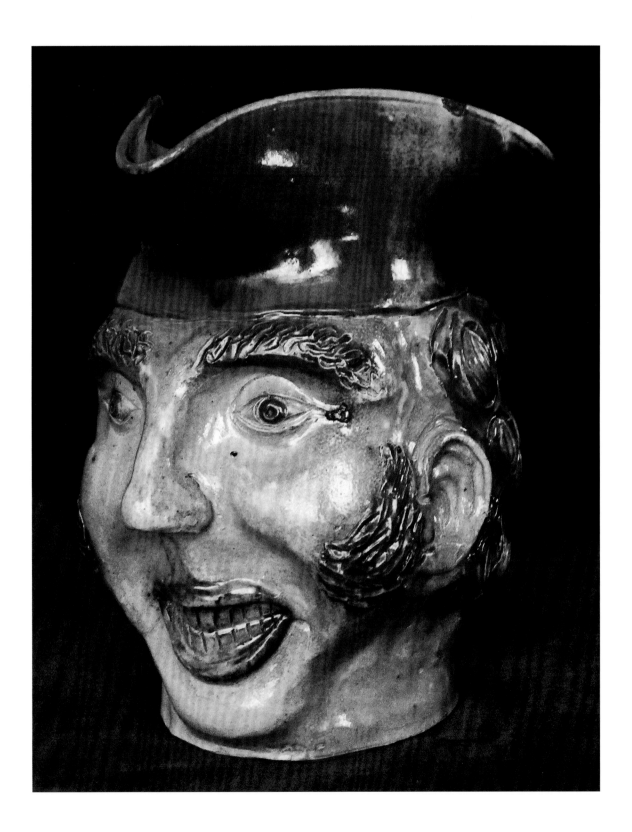

Figure 4.21, below. Salt-glazed stoneware *Bartmannskrug* (bearded-man jug) with cobalt-blue highlights, Cologne, North Rhine-Westphalia, Germany, ca. 1550. Sprig-molded acorns are a characteristic Cologne stoneware motif. *Photograph © Victoria and Albert Museum, London, https://www.vam.ac.uk.*

Figure 4.22, facing. Two-face field jug by Henry Harrison Remmey or his son Richard, salt-glazed stoneware with cobalt-blue highlights, Philadelphia, Pennsylvania, dated 1858. The Remmeys also applied faces to pitchers. *Courtesy of Tony and Marie Shank.*

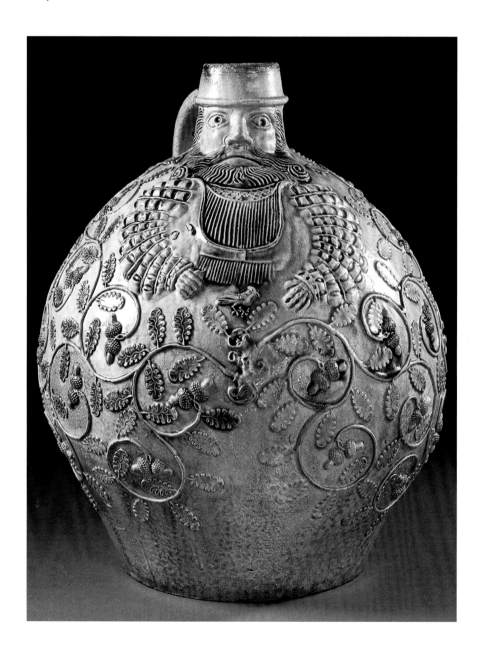

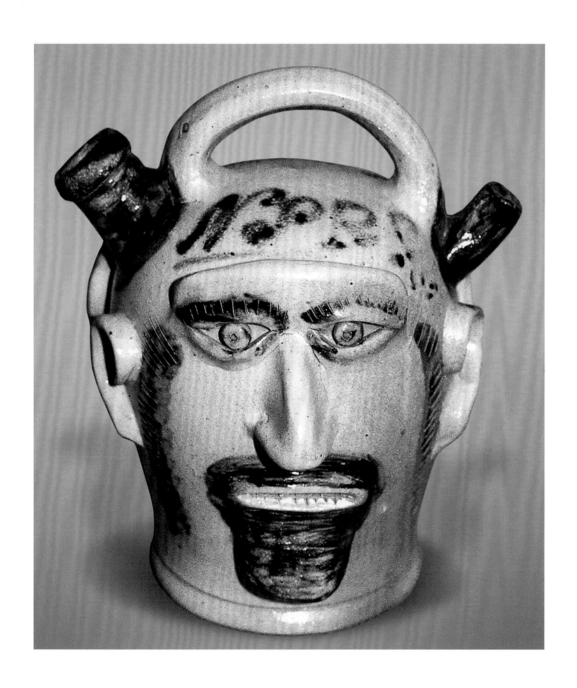

Figure 4.23. Face field jug by Thomas Mitchel Chandler Jr., alkaline-glazed stoneware, Kirksey's Crossroads, Edgefield District, South Carolina, ca. 1850. *Private collection; photograph attributed to Jill Beute Koverman, courtesy of McKissick Museum, University of South Carolina, Columbia, artsandsciences.sc.edu.*

women to whose status she may have aspired, are remarkable in their detail (fig. 4.15).

The impulse to humanize clay has been stronger in some cultures than in others. In England it emerged several times, first with cremation urns by Roman potters there (fig. 4.16), then in the Middle Ages when figural jugs were prevalent (fig. 4.17). A unique face jug dated 1674 is attributed to John Ifield of Wrotham, Kent; the teeth and eyes are overlain with white clay and the lead glaze is manganese-colored (fig. 4.18). With the rise of Staffordshire's pottery industry in the next century came the Toby jug, a character drinking vessel of molded earthenware (fig. 4.19). English manufacturers produced many variations, either as full figures or just heads, including salt-glazed stoneware examples (fig. 4.20).

A German tradition of humanoid jugs is a possible source for some American face vessels. Known as *Bartmannskruge* or bellarmines, these salt-glazed stoneware jugs, made from the sixteenth to eighteenth centuries, have a bearded face mask molded on the neck (fig. 4.21). One of America's first stoneware potters was Johannes/John Remmey, who emigrated from the Rhineland in 1735 to New York City. His descendants continued to make stoneware there as well as in Baltimore and Philadelphia, and were responsible for some of the earliest Euro-American face vessels, which I believe were extensions of the German Bartmann tradition.[9] In the 1850s a number of two-faced field jugs were made by John's great-grandson, Henry Harrison Remmey, or Henry's son Richard, in Philadelphia (fig. 4.22). How the Remmeys and other northern potters learned of the field-jug form is unknown, as it was not made in Germany or Britain.

Back to the South

A clear instance of the Remmeys influencing the southern face-jug tradition is in the person of German-born Charles Decker, who had worked at the Remmeys' Philadelphia operation before migrating with his family to the Nolichucky Valley of northeastern Tennessee. There in 1871 he established the Keystone Pottery, whose products included salt-glazed face jugs with cobalt-blue highlights for the facial hair (similar to those of the Remmeys and some German Bartmanns).[10]

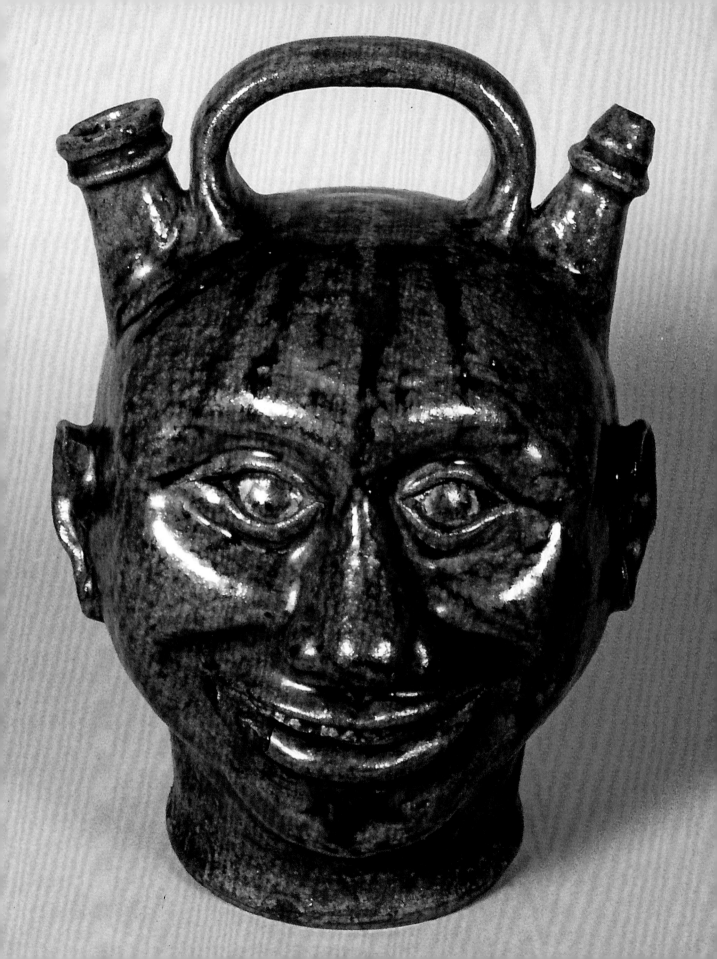

A further link can be made between Remmey face jugs and those by a white Edgefield District potter, Virginia-born Thomas Chandler. A lead-glazed earthenware face field jug with white-clay inserts for the eyes and teeth is attributed to him in the 1820s while working in Baltimore, likely with Henry Remmey and his son, Henry Harrison Remmey.[11] He moved to Edgefield about 1835 to become one of the South's finest stoneware potters. An ash-glazed, happy-face field jug stamped "CHANDLER / MAKER" (fig. 4.23) dates to about 1850, more than a decade before the slave-made pieces from Thomas Davies' Palmetto Fire Brick Works, and other Edgefield face jugs are tentatively attributed to Chandler. This is not to suggest, however, that he influenced the African-American tradition (by 1853 he had moved to North Carolina).

One researcher thinks the signed piece may have been Chandler's personal drinking jug, raising the question of use and meaning for the white potters who made such vessels.[12] Many Anglo-Southern face jugs are imbued with what I refer to as a "masculine aesthetic of the ugly," in contrast to the decoration (e.g., flowers, birds) on American stoneware made for women's use, pointing to a distinction based on intended gender use in potters' choice of form and decoration.

Another early southern face field jug, while something of a mystery, seems sufficiently important to include here, for reasons that will be apparent (fig. 4.24). Found in Atlanta, it has what appears to be a lime-based alkaline glaze on all but the unglazed face, brushed dark-brown beard, brow, and eyebrows, a skinny neck that terminates in a flat, heavily damaged base, and lobes pierced for earrings; most of the stirrup handle is missing. Especially intriguing is the inscription incised in cursive script: on the forehead, "Long," and behind the spout, "John Bull Esq."

Now, Maryland-born James Long was a pioneer middle Georgia folk potter who was in Washington County, the state's first stoneware center, by 1820, probably working with one of two potters who had come from Edgefield District; it's possible that Long also had worked in Edgefield. By 1826 he'd established himself further west in Crawford County as the progenitor of a "clay clan" there.[13] If "Long" is indeed his signature on the face jug, then it likely was made in Edgefield or Washington or Crawford County. A fragment of a large face jug was found

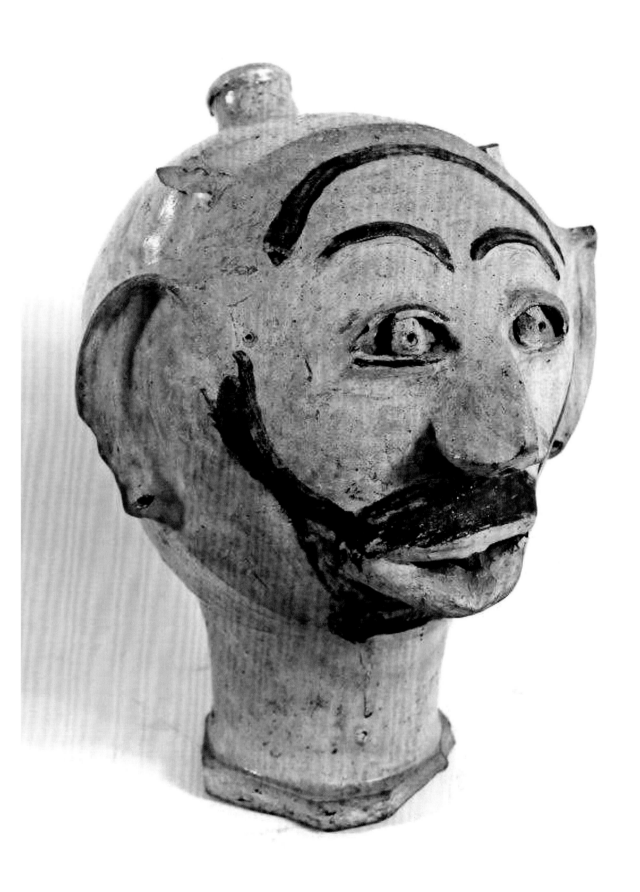

Figure 4.25, below. Face field jug by Jesse Calvin Ham, Albany slip-glazed stoneware inscribed "Drink my Blood," Perry County, Alabama, ca. 1900. *Courtesy of Allan Katz Americana, Woodbridge, Connecticut.*

Figure 4.26, facing. Figural jug by John David Lehman, alkaline-glazed stoneware, 20¼" high, Rock Mills, Randolph County, Alabama, ca. 1870. The lapel buttons read "J. LEHMAN." *Collection of the Birmingham Museum of Art, Birmingham, Alabama, arts manager.org. Museum purchase. Photograph: M. Sean Pathasema.*

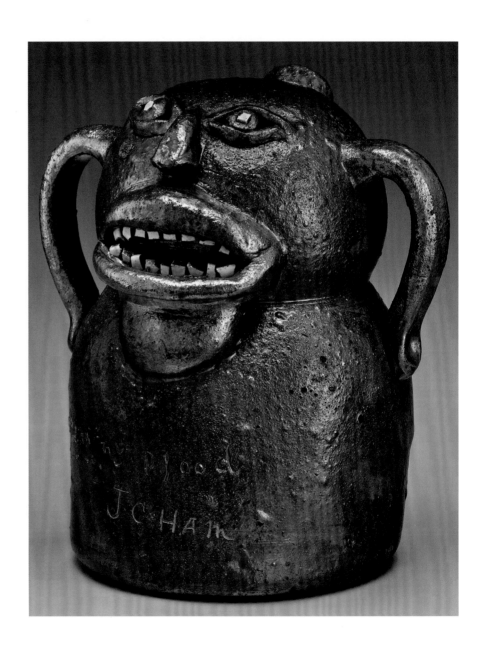

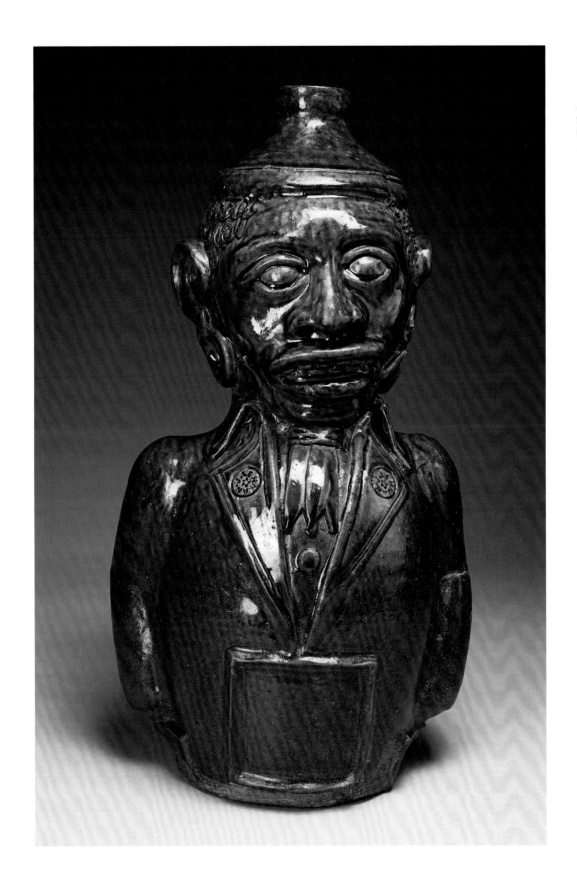

Figure 4.27, below. Face jug attributed to Atlanta's Brown pottery, Albany slip-glazed stoneware inscribed "Just Grace and me and the baby Makes III," Howell's Mills, Fulton County, Georgia, late 1920s. *Private collection; photograph: author.*

Figure 4.28, facing. Devil face jug attributed to Davis Pennington Brown, Brown's Pottery, Arden, Buncombe County, North Carolina, ca. 1930. The painted stoneware jug, 23¾" high, is inscribed "T. S. MORRISON HARDWARE STORE / LEXINGTON AVENUE / ASHEVILLE, NC." Oral history claims that women from a local church were offended by Satan's image and demanded its removal from the store front where it was displayed. *Collection of Philadelphia Museum of Art. Photograph: Jim, the Photographer, www.flickr.com, CC BY 2.0.*

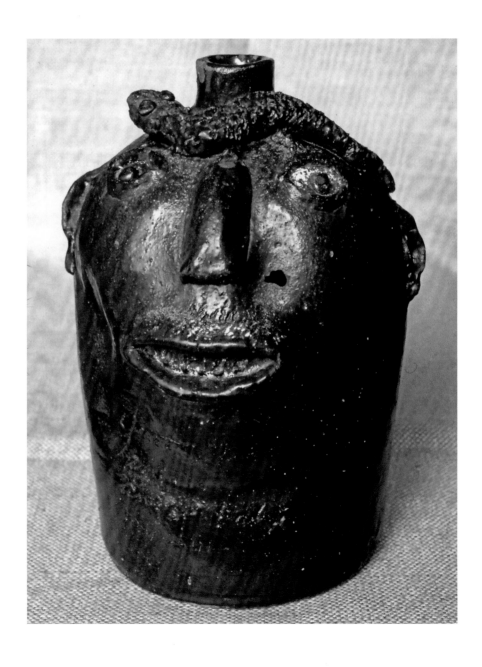

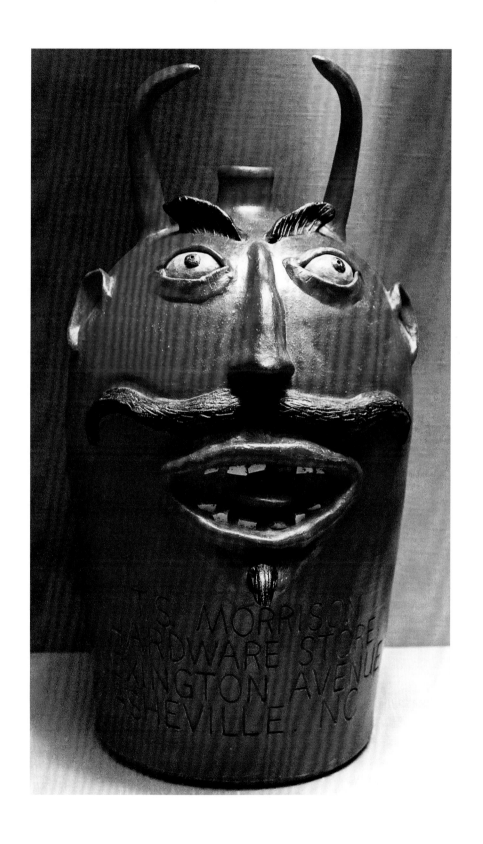

Figure 4.29. Alkaline-glazed stoneware face jug attributed to Edgar (Eddie) C. Averett (facial details perhaps added by his wife, Bertha), Lizella, Crawford County, Georgia, ca. 1920. *Private collection; photograph: author.*

in the Crawford County waster dump of James's son, Jesse Bradford Long, suggesting a family face-jug tradition. And what can we make of "John Bull Esq."? The fictional character John Bull, created by Scottish satirist John Arbuthnot in 1712, became the middle-class personification of England, not someone to whom the courtesy title "Esquire" likely would have applied. However, in coastal South Carolina lived an actual John Bull, Esq. (1693–1767), owner of Bulls Island and several plantations as well as justice of the peace, prominent enough to be remembered in that state and maybe even in Georgia. So while this piece raises questions, it has the potential of being one of the earliest known Euro-American face vessels.

As with the antebellum examples, the meaning of later face jugs can be obscure today. The inscription on one from about 1900 with a "monkey"-type canted spout, signed by white potter Jesse Ham of Perry County, Alabama, reads, "Drink My Blood" (fig. 4.25). Is this a reference to the Eucharist, and is the bearded face meant to represent Jesus Christ? If so, was this Ham's jibe at more formal Christian churches? Three similarly curious figural jugs, also from Alabama, were made by John Lehman at Rock Mills, Randolph County, in the 1870s (fig. 4.26). These skillfully modeled, alkaline-glazed stoneware pieces by the German-born potter depict a nattily attired man with a large belt buckle perhaps meant to frame a label. The figures are interpreted as representing an African American, possibly a black state or federal legislator elected during Reconstruction, the hoop earrings suggesting a pirate, in which case they would have had a political appeal to many white Southerners. Other decorative pieces by Lehman (e.g., the "Jefferson-Jackson" and "Jefferson-Washington" jars) certainly show his interest in American political history and support for the Democratic party.[14]

A face jug with a lizard modeled on the forehead, attributed to Ulysses Adolphus Brown or his son Horace ("Jug") at Howell's Mills in northwest Atlanta, is inscribed on the throat, "Just Grace and me and the baby Makes III" (fig. 4.27). The inscription, based on a stanza from the 1927 hit song "My Blue Heaven," dates the piece to shortly before the workshop closed in the early 1930s. In 1925 brothers Davis and Javan Brown, of the same extended Georgia clay clan, established Brown's Pottery at Arden, North Carolina. There they continued to make

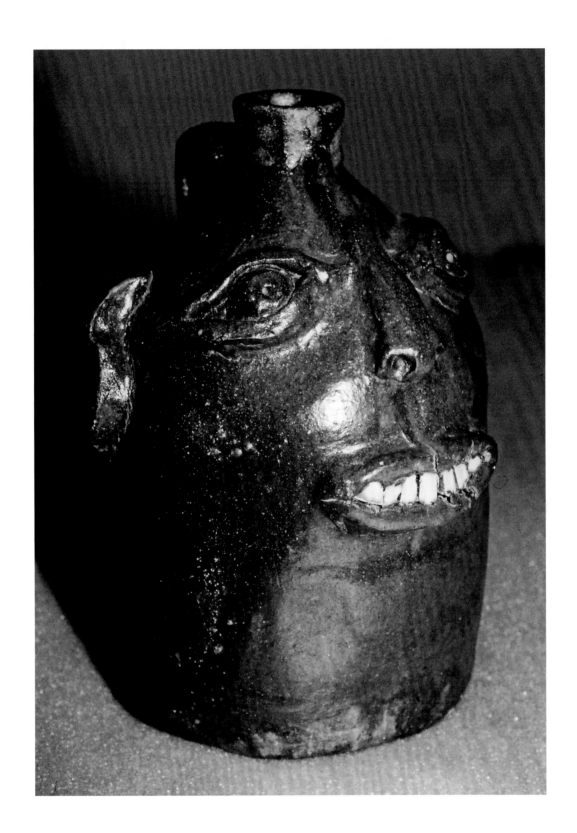

Figure 4.30. Face jug by Burlon Bart Craig, ash-glazed stoneware with melted-glass decoration, Vale, Lincoln County, North Carolina, 1980. Burl continued the face-jug tradition of two of his mentors, Harvey Reinhardt and Auby Hilton. *Private collection; photograph: author.*

face jugs, including large painted devil jugs to attract customers into Asheville hardware stores that carried their utilitarian pottery (fig. 4.28). Today, Davis's grandson, Charlie Brown, carries on the face-jug tradition at Arden; sadly, the extended family's other traditional face-jug maker, Jerry Brown of Hamilton, Alabama (son of Horace), passed away in 2016.[15]

A lime-glazed face jug (fig. 4.29) attributed to Eddie Averett, one of the last folk potters of middle Georgia's Crawford County, offers a rare insight into the social context of face jugs for the 1920s, illuminated by a letter I received from his daughter, Lucile Wills: "Papa made face jugs for sale. It tickled the men that bought them to think they had something funny-looking to put their whiskey in. Others bought them for inside-the-home decorations, and to sit on the porch where they could be seen. My mama, Bertha Pender Averett, made the faces on the jugs. The teeth were made out of broken-up pieces of white china. The face jugs looked scary to me as a child, so I particularly stayed away from them."[16] This is not the only instance of such marital collaboration; the details on face and figural vessels by W. T. B. Gordy, another middle Georgia folk potter, are said to have been added by his wife, Annie.[17]

The humor inherent in some Anglo-Southern face jugs is illustrated by a photograph of Catawba Valley, North Carolina potter Harvey Reinhardt taken in the late 1930s when they were being made in larger numbers as novelties. He is posed behind a horizontal board resting on a large upright barrel, with only his head poking up between two of his face jugs.[18] Reinhardt may have gotten the idea for face jugs from Casey Meaders, who left Georgia in 1921 to settle at Catawba, North Carolina. Burlon Craig worked for neighbor Reinhardt as a teen, later buying his operation after returning home from World War II. In the 1970s Craig was "discovered" as one of America's last old-fashioned folk potters, with one of his specialties, not surprisingly, being face jugs, sometimes decorated using the local melted-glass technique he revived (fig. 4.30).

The recent tradition reveals further shifts in the audience for southern face jugs. Lanier Meaders of Mossy Creek, Georgia, who made several thousand during his twenty-five-year career, revitalized the face-jug tradition in the late 1960s,

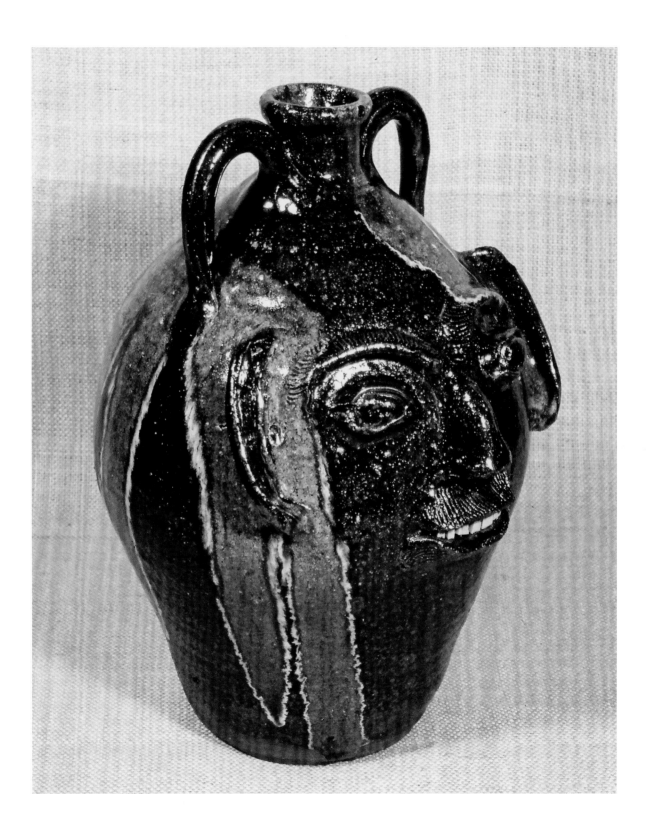

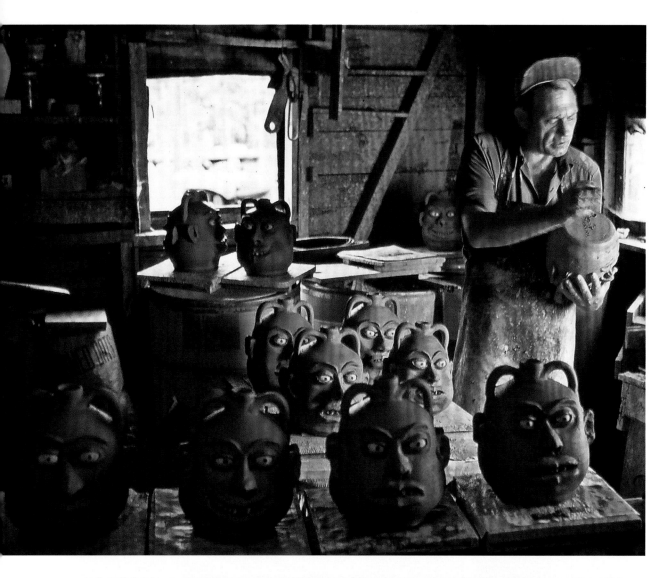

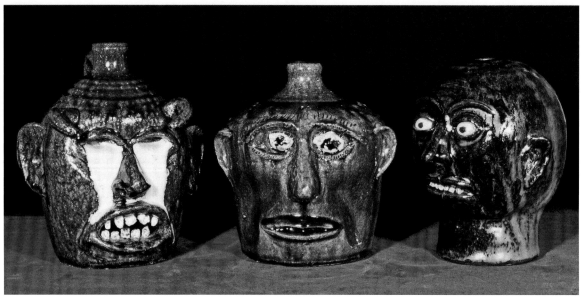

opening up a collectors' market for them as an icon of southern folk art. Beginning where his father, Cheever, left off with very basic facial details, Lanier's creativity and sculptural skill grew along with his national reputation. Among his innovations were two-faced jugs (which he began calling "politician" jugs after watching the 1973 Watergate hearings on television; fig. 4.31), to which he sometimes added hornlike candle sockets, devil jack-o'-lanterns, and wheel-thrown "wig stands" that depart from the jug form (fig. 4.32). Lanier died in 1998, but other family members, including his cousin, Clete Meaders, carry on the Meaders face jug tradition today.[19]

The Fergusons, another Georgia face-jug family, have a pottery history spanning seven generations. Stanley Ferguson maintains the family workshop today at Gillsville, Hall County, with his mother Mary and daughter Jamie Beth.[20] The colorful glazes they use were developed in the 1930s by Stanley's grandfather, Pat Ferguson, to appeal to Depression-era tourists. The first north Georgia potter known to make face jugs was Charles P. ("Charlie") Ferguson, Pat's father and a grandson of Edgefield-trained Charles H. Ferguson. Charlie made face jugs in two shapes: the standard jug form and the "monkey" field jug form.[21] His can't definitively be linked to those by slave potters or Thomas Chandler, since Charles H. migrated to Georgia from Edgefied before face jugs are known to have been made there.

The Hewells of Gillsville are a third north Georgia face-jug family. William J. ("Will" or "Bill") Hewell, the first of the family known to make them, probably borrowed the idea from his brother-in-law, Charlie Ferguson; he liked to work at Mossy Creek where his Albany slip-glazed examples of both jug forms likely were made in the early 1900s (fig. 4.33). Encouraged by the success of his friend Lanier Meaders, fifth-generation potter Chester Hewell revived his own family's face-jug tradition in the 1980s. The influence of these two families is circular, since Lanier's father, Cheever, had learned about face jugs from Will Hewell, Chester's great-uncle. One of Chester's innovations involved the size of his face jugs: he challenged himself to make some of the largest and smallest.[22] He also created

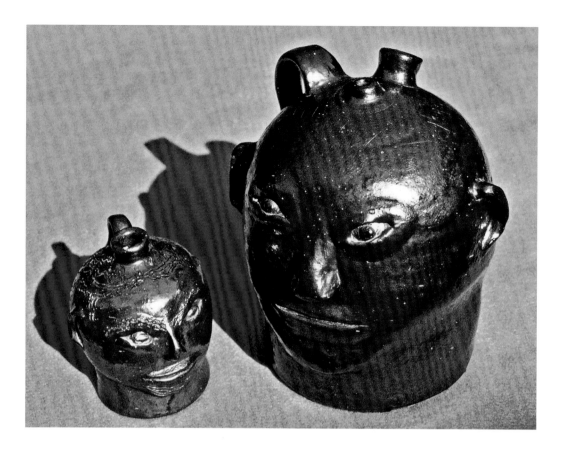

full-body figures of one of his heroes, the Confederate soldier.[23] Hewell's Pottery is now in the hands of Chester's sons, Matthew and Nathaniel.

While this discussion of American people pots focuses on the South where the tradition has been concentrated, a notable group of Midwestern face jugs was made by John M. Dollings at the workshop of his brother-in-law, Charles Stine, at White Cottage, Muskingum County, Ohio. By the late nineteenth century the Zanesville area had become an industrial pottery center, but there were still some "bluebird" or small-scale operations like Stine's.

The son of Virginia-born potter William Dollings, John is reputed to have made seven face field jugs, most of which are known, including one signed and dated 1881. Their racial character is defined by Negroid features, dark-brown Albany slip contrasting with unglazed eyeballs and teeth, and "coleslaw" (extruded) hair that includes eyebrows and moustache. Some have a wire-and-wood bail handle attached to pierced lugs, others the usual clay stirrup handle (fig. 4.34). Related examples in standard jug form are possibly by one of John's three potter brothers, and others were made in the 1930s by Fred Hicks at the Star Stoneware Company of Crooksville.[24] Any connection between these Ohio face jugs and the southern tradition is yet to be determined.

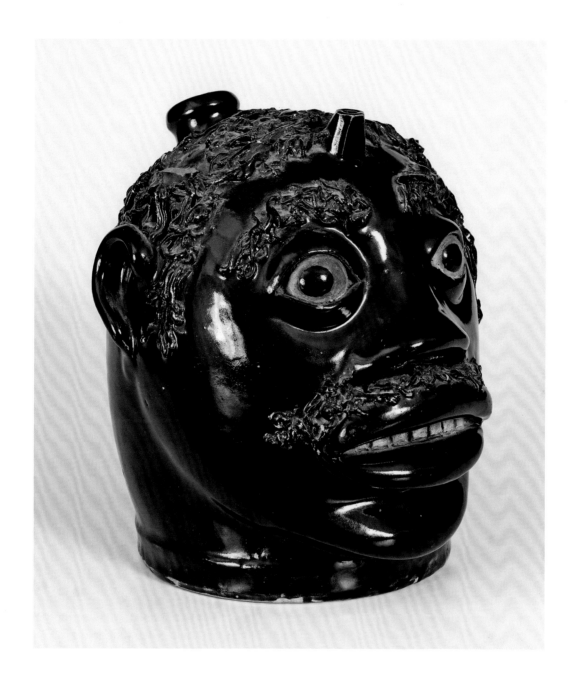

Figure 4.33, facing. Albany slip-glazed stoneware face jugs by William (Will/Bill) Jefferson Hewell, the small one in standard jug form, the other in the "monkey" (field) jug form, Gillsville or Mossy Creek, Georgia, early 1900s. *Private collection; photograph: author.*

Figure 4.34, above. Albany slip-glazed face field jug (most of stirrup handle missing) by John M. Dollings, White Cottage, Muskingum County, Ohio, ca. 1881. *Courtesy of Crocker Farm Auction of American Stoneware; photograph: Luke Zipp.*

Returning to the question of origins, the wide global distribution of anthropomorphic vessels seems to be largely a case of polygenesis: a basic human impulse to represent the species in the potter's medium, in some cases as "end of the day" pieces after turning out dozens of strictly utilitarian wares. But in the United States, the possibility exists for diffusion of the idea from the Old World. My research suggests that southern people pots are neither strictly African nor European in background, but most likely a synthesis of the two influences, reinterpreted with changes in meaning over time. If so, they're a good illustration of what social scientists refer to as creolization, the process whereby ideas from different cultures sharing the same geographic space blend to create something new.[25]

While much remains to be learned about the meaning of the nineteenth-century African-American face vessels, the makers' attitudes seem to have been quite serious, perhaps tapping into a magico-religious belief system or expressing a nonverbal form of protest. In contrast, at least some of the twentieth-century Anglo-Southern examples clearly were made in the spirit of play, adding fun to a functional form. As for their meaning to today's folk potters, face jugs are an important source of income from the collector market. What has remained constant over time is that people pots have served the makers as a vehicle for individual artistic expression within their handed-on tradition.

Notes

1. Edward FitzGerald, trans., *The Rubáiyat of Omar Khayyám*, 5th ed. (1889), verse 38; *Wikisource*, https://en.wikisource.org/wiki/The_Rubaiyat_of_Omar_Khayyam_(tr ._Fitzgerald,_5th_edition)

2. Edwin AtLee Barber, *Pottery and Porcelain of the United States* (New York: Putnam, 1909), 466. Earlier, in "Some Curious Old Water Coolers Made in America," *The Clay-Worker* 33:5 (1900): 353, Barber calls the slave-made face jugs "exceedingly hideous in appearance and crude in workmanship . . . while the glaze is composed of wood ashes mixed with sand. These vessels were called 'monkey jugs,' not on account of any supposed resemblance to the head of an ape, but because the porous vessels used for cooling water by evaporation through the clay, were so termed. . . . The evaporation can take place only through the eyes and mouth, which are not covered by the glaze." Barber's illustration is of an example in standard jug form, but his description of the typical "water monkey" is of a form also made by those slaves and in Africa and Mediterranean Europe, with one or two

canted spouts and a stirrup handle across the top. Barber belies his statement that the slave-made face jugs are "crude in workmanship" by mentioning the unglazed eyes and teeth, undoubtedly achieved by the sophisticated technique of wax-resist when the jugs were dipped in the glaze solution. The successful combination of stoneware clay for the jugs' main body and kaolin for the inset eyes and teeth also would have required technical skill beyond that of throwing and modeling. Barber's brief note in a periodical devoted largely to brickmaking may be the earliest reference in print to southern face jugs and alkaline-glazed stoneware.

3. Jill Beute Koverman, *Making Faces: Southern Face Vessels from 1840–1990* (Columbia: McKissick Museum, University of South Carolina, 2001), 15–16.

4. John Michael Vlach, *The Afro-American Tradition in Decorative Arts* (Athens: University of Georgia Press, 1990), 86–90.

5. African field jugs are poorly represented in print but can be found in museum collections; see John A. Burrison, "Fluid Vessel: Journey of the Jug," in *Ceramics in America 2006*, ed. Robert Hunter (Hanover, NH: University Press of New England, 2006), 109, fig. 36 (from the Ekoi people of Nigeria, in the British Museum). Another, brought back from Africa to England's Salisbury Museum, was reproduced in salt-glazed stoneware as the "Old Sarum Kettle" by Doulton of Lambeth for Salisbury distributor Watson & Co. in 1887. In Europe, Daunian examples of the vessel type from Canosa di Puglia, Italy, date to the fourth century BCE; in France, such a jug is called a *gargoulette* or *chevrette*; known as a *botijo* or *càntir* in Spain, it's virtually a national symbol there, with three museums devoted to its variety of form and decoration (Museo del Botijo in Toral de los Guzmanes, León, Museo del Botijo in Villena, Valencia, and Museu del Càntir d'Argentona, Cataluña).

6. Marla C. Berns, "Pots as People: Yungur Ancestral Portraits," *African Arts* 23:3 (1990): front cover, 50–60, 102.

7. Claudia A. Mooney, April L. Hynes, and Mark M. Newell, "African-American Face Vessels: History and Ritual in 19th-Century Edgefield," in *Ceramics in America 2013*, ed. Robert Hunter (Hanover, NH: University Press of New England, 2013), 18–32.

8. James F. Cherry, *The Headpots of Northeast Arkansas and Southern Pemiscot County, Missouri* (Fayetteville: University of Arkansas Press, 2009).

9. For a face pitcher dated 1838 attributed to John's great-grandson, Henry Harrison Remmey of Philadelphia, see Susan H. Myers, *Handcraft to Industry: Philadelphia Ceramics in the First Half of the Nineteenth Century* (Washington, DC: Smithsonian Institution Press, 1980), 22–25. The pitcher, of salt-glazed stoneware with cobalt-blue highlights, was made for local carpenter Lewis Eyre; impressed in small type on the brow is "KEEP ME FULL."

10. *The Pottery of Charles F. Decker: A Life Well Made* (Jonesborough, TN: Jonesborough-Washington County History Museum and Historic Jonesborough Visitors Center, 2004), 52–53, 58.

11. Philip Wingard, "From Baltimore to the South Carolina Backcountry: Thomas Chandler's Influence on 19th-Century Stoneware," in Hunter, ed., *Ceramics in America 2013*, 67–71.

12. Ibid., 68.

13. John A. Burrison, *Brothers in Clay: The Story of Georgia Folk Pottery*, rev. ed. (Athens: University of Georgia Press, 2008), 133–144.

14. Joey Brackner, *Alabama Folk Pottery* (Tuscaloosa: University of Alabama Press, 2006), 108–109 and plate 4, and Brackner, "The Search for John Lehman," *Alabama Heritage* no. 122 (Fall 2016): 32–39.

15. Charles G. Zug III, *Turners and Burners: The Folk Potters of North Carolina* (Chapel Hill: University of North Carolina Press, 1986), 384–385, and Stephen C. Compton, *A Handed Down Art: The Brown Family Potters* (Seagrove, NC: North Carolina Pottery Center, 2015), 11, 22, 37, 40, 58–59, 124–145.

16. Burrison, *Brothers in Clay*, xxi.

17. Ibid., 173–174.

18. Zug, *Turners and Burners*, 277 (fig. 9–4). For a survey of face jugs mainly from North Carolina, see L. A. Rhyne, ed., *Many Faces: North Carolina's Face Jug Tradition* (Seagrove, NC: North Carolina Pottery Center, 2014).

19. John A. Burrison, *From Mud to Jug: The Folk Potters and Pottery of Northeast Georgia* (Athens: University of Georgia Press, 2010), 126–132; see 68–74 for other north Georgia face-jug makers, both historical and contemporary.

20. Ibid., 137–144; see 71 for face jugs by Bobby Ferguson, Stanley's father.

21. Ibid., 69; see Burrison, *Brothers in Clay*, 227 for a monkey-form face jug by Charlie Ferguson, and John A. Burrison, "Clay Clans: Georgia's Pottery Dynasties," *Family Heritage* 2:3 (1979): 72, for monkey-form face jugs by Charlie's son, Pat.

22. Burrison, *From Mud to Jug*, 114; for face jugs by Will Hewell, see 70 (top), and Burrison, *Brothers in Clay*, 230.

23. Burrison, *From Mud to Jug*, 118; see 124 for the "Confederate Widow" figure by Chester's son, Matthew.

24. Jeff Carskadden and Richard Gartley, eds., *James L. Murphy's Checklist of 19th-Century Bluebird Potters and Potteries in Muskingum, County, Ohio* (Zanesville, OH: Muskingum Valley Archaeological Survey, 2014), 180–185.

25. Robert Baron and Ana C. Cara, eds., *Creolization as Cultural Creativity* (Jackson: University Press of Mississippi, 2013), and John A. Burrison, *Roots of a Region: Southern Folk Culture* (Jackson: University Press of Mississippi, 2007), 84, 102, 128–133.

5 | A CLAY MENAGERIE

The Animal World in Ceramics

. . . The animals went in two by two,

The elephant and the kangaroo,

And they all went into the ark

For to get out of the rain. . . .

. . . The animals went in five by five,

By hunting each other they kept alive,

And they all went into the ark

For to get out of the rain.

Variant of a children's counting folk song[1]

WE HUMANS HAVE HAD A COMPLEX RELATIONSHIP WITH OTHERS IN the animal world. One of the positive aspects of this relationship is the inspiration provided by our nonhuman cousins to visual artists, including the traditional potters whose creations are the focus of this book. The depiction of animals in clay art reflects the many roles humans have imposed on them: as a source of food; as helpmates/servants in our work; as objects/victims of sport and other entertainments; and as companions/pets.

Our anthropocentric perspective tends to project our human traits onto nonhuman animals, especially evident in cartoon treatments (e.g., Mickey Mouse, Donald Duck) but also in certain ceramic representations (fig. 5.1). Further, the fact that in both the ancient Mesopotamian and Hebrew Flood myths the animal world is saved through human agency (with divine blessing, of course) is early evidence of our sense of power over other species; to emphasize that point we're told that to give thanks for surviving the Flood both Utnapishtim and Noah sacrifice some of the animals they'd saved (fig. 5.2).

Figure 5.1. Salt-glazed stoneware love-bird jars—more anthropomorphic than zoomorphic—by Martin Brothers, Southall (Greater London), England, ca. 1900. The Martins were artist-potters who'd taken classes at Lambeth School of Art; Robert first worked as an architectural sculptor, while Walter and Edwin were introduced to stoneware at Doulton & Co., Lambeth. A fourth brother, Charles, managed the studio. *Courtesy of Skinner, Inc., www.skinnerinc.com.*

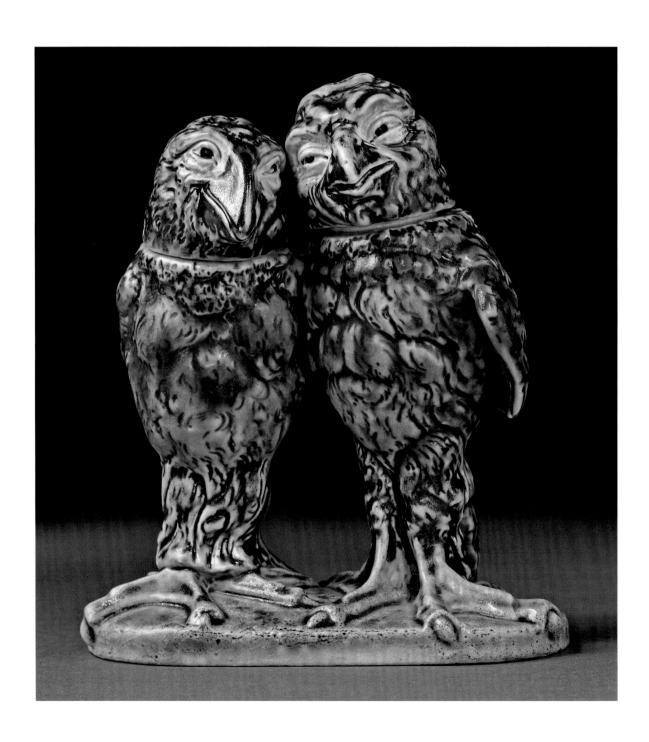

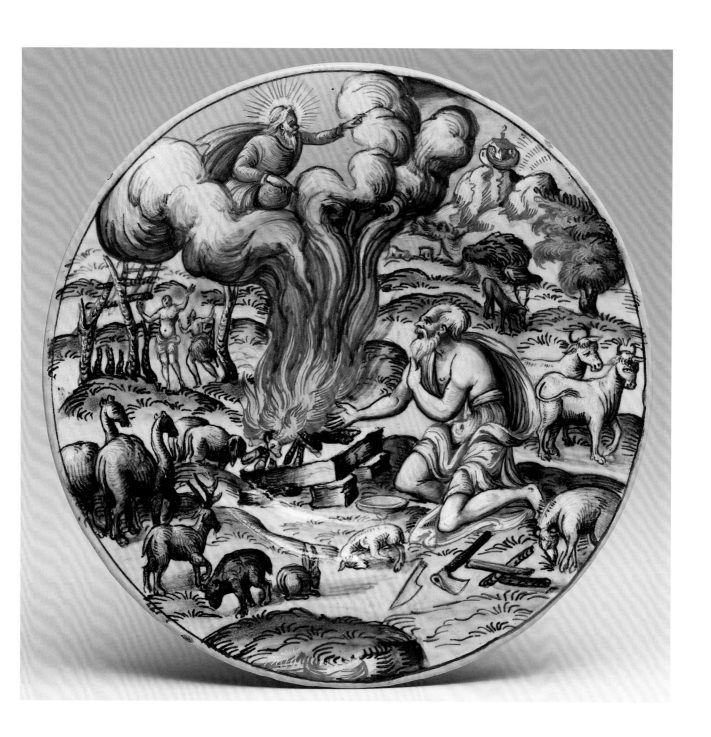

Figure 5.3. Terracotta *celengan* (piggy bank), Eastern Java, Indonesia, 1300–1500, perhaps broken by original owner to remove coins. Many were excavated around the site of Trowulan, early capital of the Majapahit Empire. Portuguese and later Dutch trade in Indonesia may have introduced the idea of a pig-shaped bank to Europe. *Collection of Rijksmuseum, Amsterdam, Netherlands, https://www.rijksmuseum.nl.*

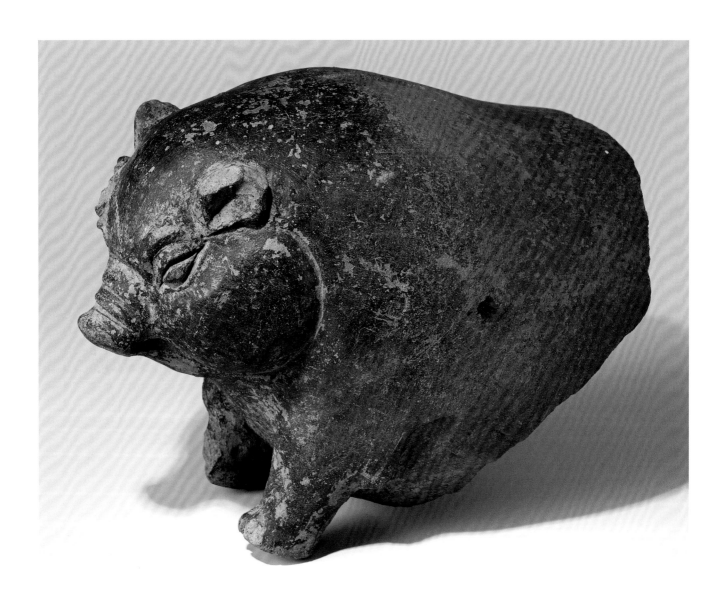

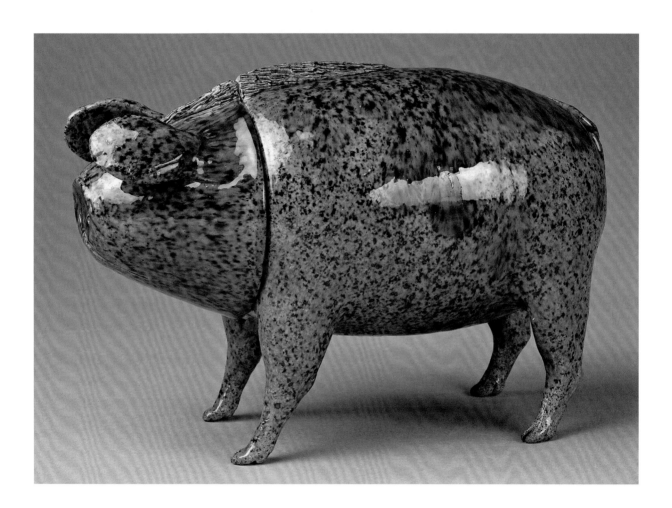

Figure 5.5. Salt-glazed stoneware pig flask by Cornwall and Wallace Kirkpatrick, Anna, Union County, Illinois, 1882. Anna Pottery produced these wheel thrown, then hand modeled, flasks for Midwestern businesses to distribute as premiums or for presentation, which also promoted the pottery. Most have an incised "Railroad and River Guide" map. *Courtesy of Rock Island Auction Company, Rock Island, Illinois.*

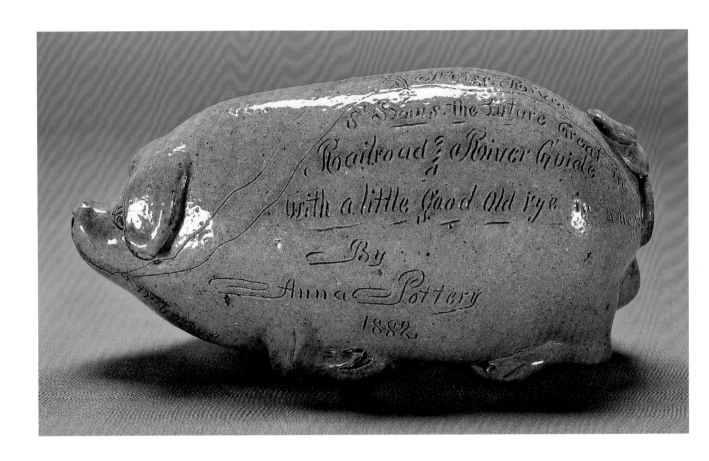

Figure 5.6. Yue-ware *huzi* (tiger) urinal, celadon-glazed stoneware, probably Zhejiang province, China, first Jin dynasty, ca. 300 CE, as displayed with recent porcelain kewpie doll at Hong Kong Heritage Museum, China. *Photo: Hermann Luyken, via Wikimedia Commons.*

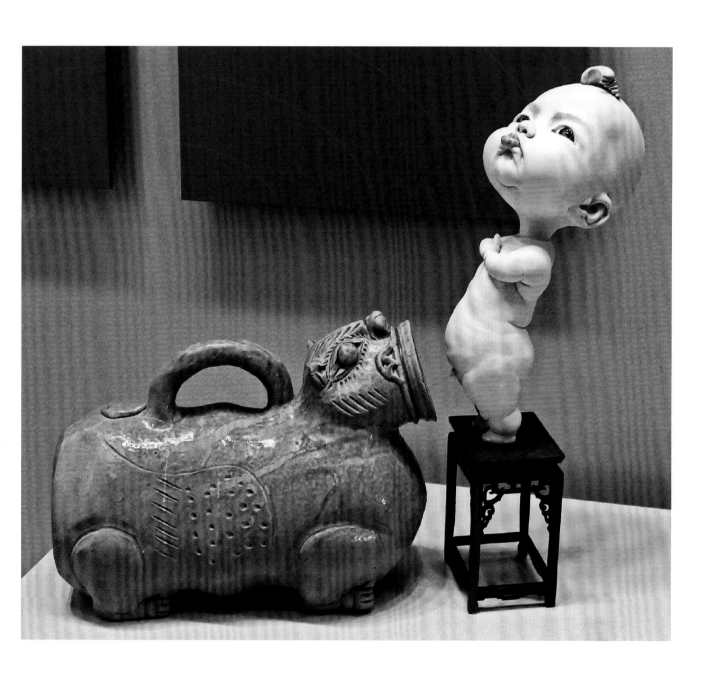

Figure 5.7. Cizhou-ware tiger pillow, painted stoneware, Hebei province, Great Jin dynasty, ca. 1200. Uncomfortable as such Chinese ceramic neck rests may appear, they are thought to have influenced dreams and maintained the elaborate hairstyles of elite women. *Collection of Chazen Museum of Art, University of Wisconsin–Madison. Photograph: Daderot, via Wikimedia Commons.*

In many pottery images the usefulness of nonhuman animals to us seems to be the main point, as if they exist solely for our purposes. Obvious examples would be containers shaped as animals. The earliest banks in pig shape are those of the Majapahit Empire of East Java, Indonesia, dating to the fifteenth century CE (fig. 5.3).[2] The represented animal is a *celeng*, or swaybacked, black-skinned Javanese wild boar, a symbol of prosperity. The slot in the bank's back was for receiving *kepeng*, round Chinese brass coins with square holes. When excavated, many *celengans* are found to be broken, the only way they could be emptied. How the idea of a piggy bank made its way to the West is a matter of speculation, but given our stereotype of pigs as gluttonous, they seem an appropriate animal to serve as money-saving receptacles.

Two less commendable traditions of porcine pots, both novelty drinking vessels from the second half of the nineteenth century, are the lead-glazed earthenware Sussex pigs that "wun't be druv" (wouldn't be driven, i.e., "pigheaded") that potters of Rye, England, fashioned to sit back on their haunches when full with removable head as a cup (fig. 5.4), and the pig-shaped flasks of gray salt-glazed, or brown Albany slip-glazed, stoneware by Wallace and Cornwall Kirkpatrick of Anna, Illinois, with the pig's anus serving as the filling and drinking hole (fig. 5.5).[3]

In early China, certain uses of ceramic animals were likewise questionable. What can we make, for example, of the fourth-century celadon vessels shaped as tigers that apparently were intended as urinals (fig. 5.6)? From our perspective today it would be difficult to imagine a more demeaning function, but the symbolism of the tiger in China as king of beasts should be taken into account. In the Great Jin dynasty (1115–1234 CE), the Cizhou/Tz'u-chou kilns of Hebei province made tiger-shaped pillows or neck rests thought to impart power to the sleeper, keep nightmares and malevolent spirits at bay, and ensure the birth of male children (fig. 5.7).

The Hunter's Quarry

The depiction of animals in clay began at least 15,000 years ago. An unfired sculpture of a bull and cow, dating to the Magdalenian phase of the Paleolithic period, was discovered in 1912 in a cave at Le Tuc d'Audoubert in the French Pyrenees (fig. 5.8).[4] Are these bison preparing to mate, as some would have it, and if so, did the sculpture serve the magico-religious function of creating more game to be hunted and consumed? Before domestication of animals in the New Stone (Neolithic) Age, human survival depended on hunting and fishing; we were no different from other carnivorous animals in our need for protein. So are those

once-critical activities, still practiced to put food on many of the world's tables as well as for sport, represented in traditional ceramics?

Surprisingly, I've found few folk-pottery scenes of actual hunting, and none of fishing. (More prevalent are hunting scenes on fashionable ceramics made for an elite clientele, as can be seen at the Museum of Hunting and Nature in Paris.) One example, however, is a graphic image of a hunt painted on an early sixteenth-century lusterware plate from Deruta, Italy (fig. 5.9). The dog is taking down a deer, perhaps venison-to-be for the castle on the hill. With the human hunter out of the scene, the image focuses on the way one nonhuman animal has been trained to efficiently turn on another. Another hunt is depicted on a dish of about 1200 from the Garrus district of Iran (fig. 5.10), executed in the *champlevé* technique (a variant of sgraffito, in which white slip is scraped away to expose the dark clay

Figure 5.8, facing. Unfired clay bison, each ca. 24" long, in a cave at Le Tuc d'Audoubert, Ariège, Midi-Pyrénées, France, Magdalenian phase of Upper Paleolithic period, 13,000–12,000 BCE. *Courtesy of Robert Bégouën, Association Louis Bégouën.*

Figure 5.9, below. Lusterware plate with deer-hunt scene, Deruta, Umbria, Italy, 1510–1520. *Collection of the Metropolitan Museum of Art, New York, www.metmuseum.org.*

beneath as background). In it, two men are spearing what appears to be an Asiatic or Persian lion, very much out of proportion to the humans who dominate the scene. The hunters seem pleased, but we don't know if they are killing the animal for sport or to eliminate a threat to their community.

A different sort of hunting scene, also from Iran and of the same vintage, appears on a bowl of the *mina'i* type (overglaze enamel-painted) that illustrates an episode from the Persian epic, the *Shahnameh* (Book of Kings), composed by the poet Ferdowsi about 1000 CE. Prince Bahram Gur is hunting on camelback with Azadeh, his favorite concubine and harp player. She challenges him to demonstrate his skill with a bow by turning a male gazelle into a female, a female into a male, and then to pin together the foot and ear of a third. He shoots two arrows into the female's head (giving her "antlers"), cuts off the male's antlers with a double-pointed arrow, and when the third raises her foot to scratch the ear he nicked with one arrow, he pins them together with a second (fig. 5.11). On this bowl the camel is shown trampling a second image of Azadeh after the young prince throws her off for pitying the gazelles and criticizing his inhumanity (the potters' way of conflating two different moments of time in the story). If, to the early Persians, Bahram Gur was displaying the heroic prowess and resolve that would lead to his kingship, it was certainly at the expense of the gazelles and his Roman slave, Azadeh.

Much closer to (my) home is a two-gallon, beehive-shaped whiskey jug made in 1871 by John Avera of Crawford County, Georgia. The rare alkaline-glazed jug is fully documented with an incised inscription and cartoonish illustration of a hunter grasping a rifle, two dogs in flight, and a fox fleeing into a row of cross-hatchings representing woods. Avera, a "jug turner" for Jesse Bradford Long (son of pioneer potter James Long), made the piece for John L. Marshall, a well-to-do landowner who had been overseer of James Long's plantation and who, according to a descendant, loved fox hunting. Crawford County is not in the mountains, but the omission of horses in Avera's illustration suggests that the kind of fox hunt enjoyed by Marshall was not the "riding to hounds" of the lowland gentry but the upland "auditor sport" version. One imagines Marshall and his hunter friends encamped around a fire, the "foxhunt jug" supplying "antifreeze" against the

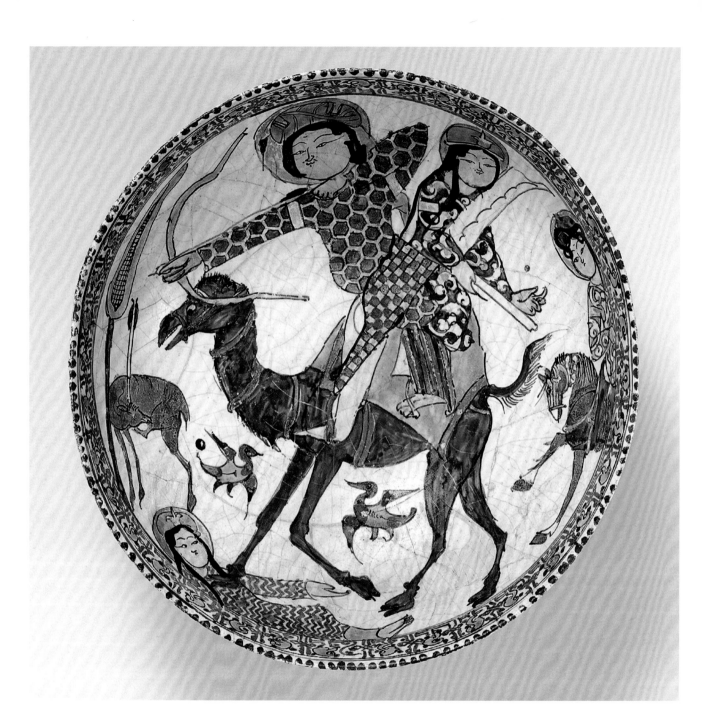

Figure 5.11. Fritware bowl in the *mina'i* (overglaze enamel) technique illustrating the hunt scene with Bahram Gur and Azadeh from the Persian *Shahnameh* epic, Kashan, Iran, 12th-13th century. *Collection of the Metropolitan Museum of Art, New York, www.metmuseum.org.*

evening chill, as they follow the hunt by listening to the sounds of their hounds in pursuit, the dogs' voices identifiable to the owners.[5]

Beasts of Burden

One of the traits that allow humans to survive as a species is our adaptability to different environments and tasks, but there are limits to our strength, speed, and endurance. That's where other species have come into play as helpmates, if not always willing ones. Before we harnessed steam and gasoline power, we harnessed oxen, horses, camels, and elephants to carry us and our burdens. Those roles of heavy lifter and long-distance traveler are represented in a variety of clay creations.

Oxen are slow, but strong; in the clay sculptures made for elite burials in Tang dynasty China (618–907 CE) they are often depicted pulling a cart (fig. 5.12). Model horses made for Tang tombs are typically shown saddled and sometimes richly caparisoned, as if waiting to be mounted by a cavalryman or nobleman (fig. 5.13). Bactrian (two-humped) camels, native to the Central Asian steppes, were the chief vehicles for transporting goods on the Silk Road between China and the Middle East, hence their frequent occurrence—sometimes seemingly unhappy about their job or ridden by a Central Asian merchant—in Tang tomb wares (fig. 5.14).[6]

Elephants modeled in blue-glazed fritware from thirteenth-century Iran have a howdah (a canopied platform for hunters or warriors) mounted on their backs (fig. 5.15). Early Persians used Indian-trained war elephants in such battles as Gaugamela against Alexander the Great in 331 BCE and Avarayr against Armenian Christian rebels in 451 CE (the Persians lost the first and won the second).

In Captivity

During the New Stone Age our ancestors realized that it would be easier to capture animals in the wild and then secure them at home to control the food supply, freeing them (our ancestors, that is) to devote more time to other pursuits and less time to the unpredictable and sometimes dangerous task of hunting. In captivity, animals could be bred to enhance whatever properties were desired; hence the

Figure 5.12. Tomb model of an ox and cart with human attendants (the bearded one apparently Central Asian), earthenware with partial lead glaze, China, Tang dynasty, ca. 7th century CE. *Photograph © 2017 Museum of Fine Arts, Boston, Massachusetts, www.mfa.org.*

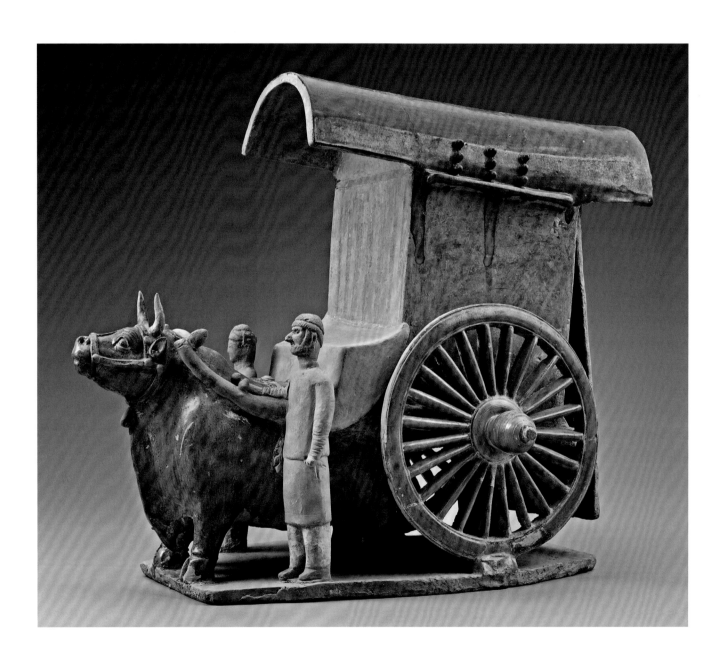

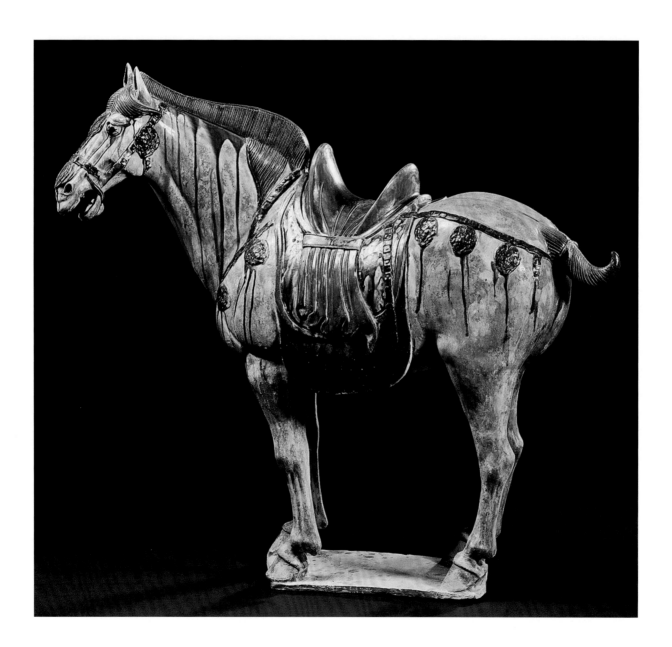

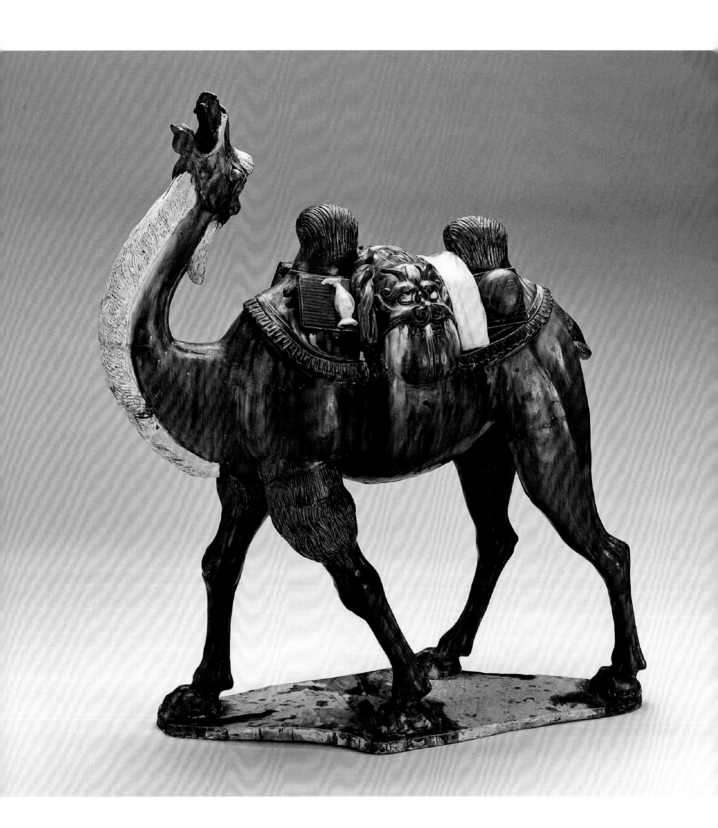

domesticated animals we exploit today for our meat, poultry, and dairy products. Pottery models of penned animals often were included in tombs of the noble class in Han dynasty China, where they were available to nourish the spirit of the deceased (fig. 5.16).

Once we satisfied our stomachs, we could turn to satisfying our hunger for the exotic with displays of wild and domestic animals. Remains of the oldest known menagerie, dating to 3500 BCE, were revealed in recent excavations of Hierakonpolis, Egypt.[7] As the Roman satirist Juvenal complained, political votes could be bought by giving citizens all they really desired: "bread and circuses"; indeed, captive animals, pitted against each other or humans, were a major source of "sport" in ancient Rome. The use of nonhuman animals for human entertainment is illustrated by an elaborate Staffordshire mantelpiece ornament of about 1830 representing the entrance to Polito's Menagerie (fig. 5.17). The banner includes what is thought to be its star attraction, the Indian elephant Chunee, who finally killed his keeper and was destroyed in 1826. The traveling menagerie, begun in 1773 at Exeter Exchange in London's Strand, toured through the 1820s and was owned by a series of showmen: Thomas Clark, Gilbert Pidcock (the self-styled "modern Noah"), Stephen Polito, his brother John, and Edward Cross.[8]

Among the crueler sports of Elizabethan and later England was bear baiting, in which dogs attacked and tormented a chained bear in an arena called a "bear garden." Henry VIII and Elizabeth I both enjoyed these "entertainments." Potters of eighteenth-century Staffordshire and Nottingham made novelty stoneware bear-baiting jugs for ale or cider, the bear's head removable as a drinking cup (fig. 5.18). The bear holds a smaller animal that may at first seem to be a cub, but on closer inspection is a dog being hugged to death. Bulls also were baited, with bulldogs bred with jaws that could get a death grip on the bull's nose to drive it to the ground. Bear and bull baiting ended in England when Parliament passed the Cruelty to Animals Act of 1835, but bear baiting continues to this day in South Carolina, and other animal-based blood sports (e.g., dog and cock fighting) are still practiced in parts of the United States and elsewhere.

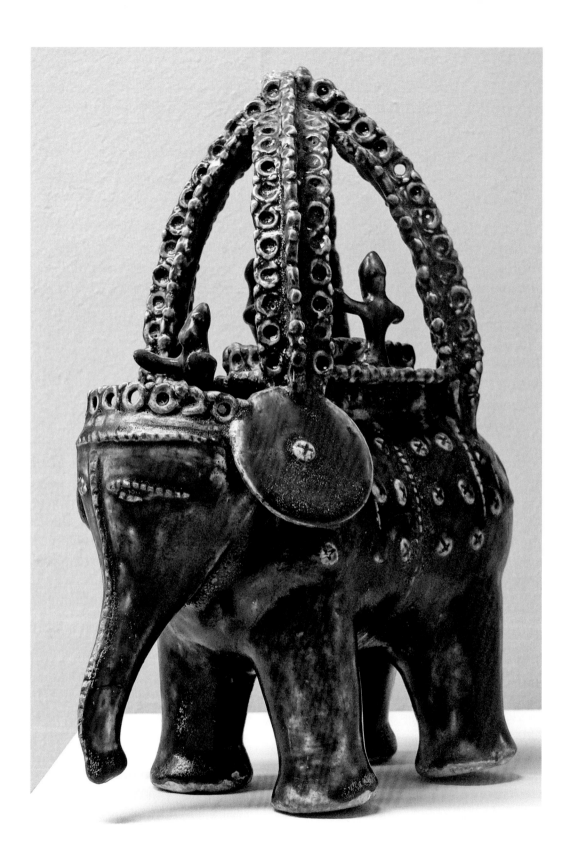

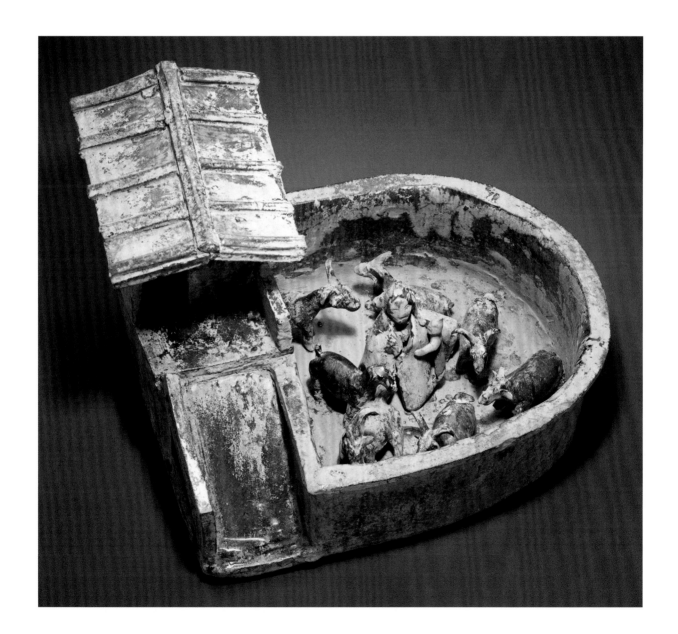

Figure 5.17, below. "Polito's Menagerie," lead-glazed earthenware mantel ornament assembled from molded pieces, Staffordshire, England, ca. 1830. *Photograph © Victoria and Albert Museum, London, https://www.vam.ac.uk.*

Figure 5.18, facing. Bear-baiting dispenser, brown salt-glazed stoneware, Nottingham, Nottinghamshire, England, ca. 1750. This example, with spigot and elevated on a thrown base, likely was made for a tavern. The "fur" is "grog" (crushed potsherds). *Photograph © Victoria and Albert Museum, London, https://www.vam.ac.uk.*

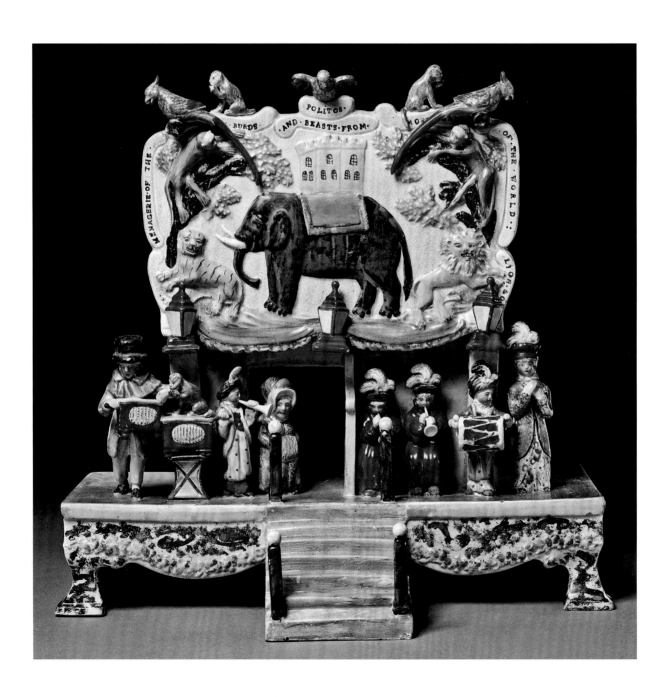

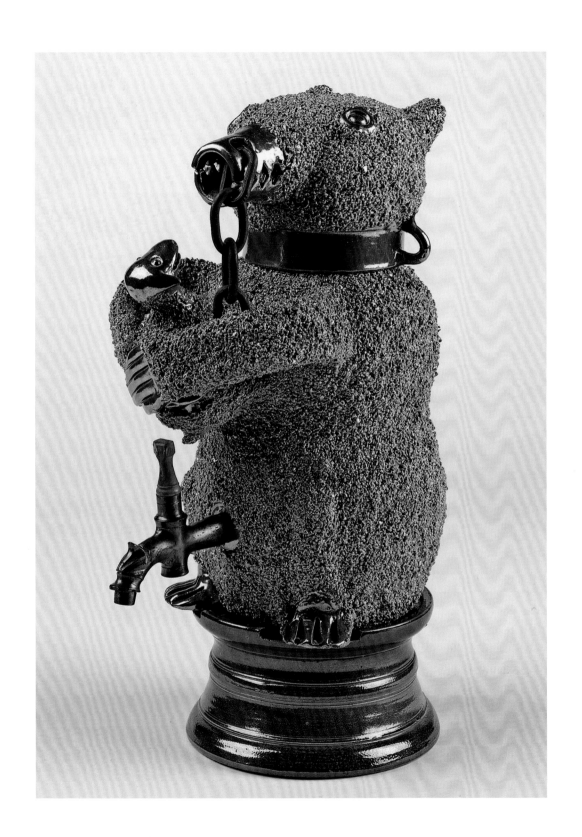

Figure 5.19. Blue-glazed "faience" hippopotamus figure from the tomb of steward Senbi II at Meir, Upper Egypt, ca. 1900 BCE (the Nile hippo is now extinct in Egypt). Three legs are restored; they had been purposely broken at burial to prevent the creature from harming the deceased. *Collection of the Metropolitan Museum of Art, New York, www.metmuseum.org.*

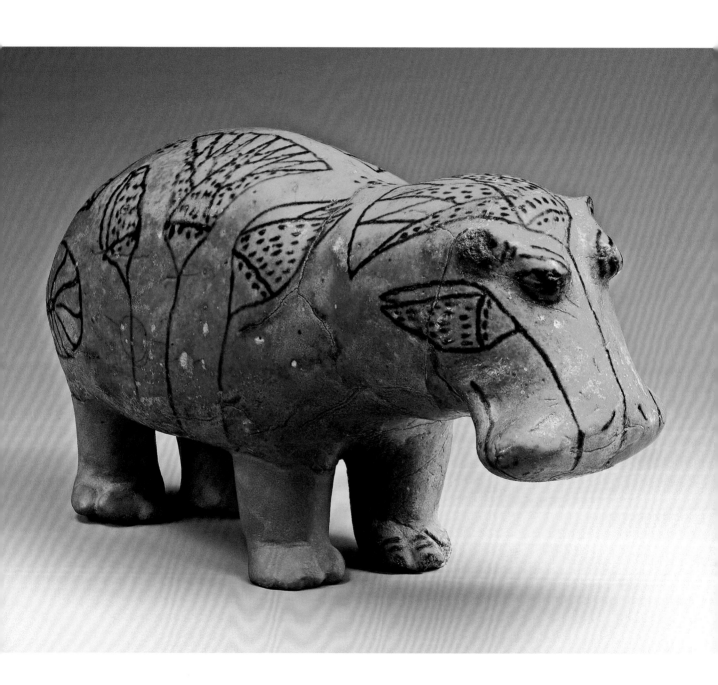

Aesthetic Appreciation: Creatures Great and Small

So far in this chapter the emphasis has been on the uses humans have made of our nonhuman cousins and how that is reflected in pottery images, an approach informed by the recent animal rights movement.[9] But there's more to the representation of these creatures in ceramic art than the practical basis of our mutual relationships. We have now, as our distant ancestors probably did, an aesthetic appreciation of animals that goes beyond their usefulness. We admire some for their beauty, gracefulness, or impressive size, and are attracted to others by the "cuteness" factor that endears them to us as pets. This admiration (if objectification in art) of certain animals for their own sake suggests a greater degree of respect than the ways they have been exploited. What follows is this more sympathetic approach to portraying animals in clay.

Among the larger animals represented in ceramics are hippopotami rendered in Egyptian "faience," associated with the fertility goddess Taweret (fig. 5.19), and bovines of several types (figs. 5.20–21). From America's Shenandoah Valley came the mid-nineteenth-century lion doorstops of John Bell of Waynesboro, Pennsylvania, and his brother Samuel of Winchester or Strasburg, Virginia. Of six known examples, five are lead-glazed earthenware with manganese-brown highlights (fig. 5.22), while one by John is stoneware with a cobalt-blue wash under the salt glaze.[10] Their "zipper" teeth make them less than ferocious, and their "coleslaw" (sieve-extruded) manes may relate them to the lion mantel ornaments of the same period produced by Lyman Fenton/United States Pottery Company of Bennington, Vermont (thought to have been modeled by Daniel Greatbatch, immigrant ceramic designer from Staffordshire, England).

Also represented in clay are animals of more moderate size, including cats, monkeys, frogs, and turtles (figs. 5.23–26). Dogs and cats can be more than pets, of course, with dogs serving the hunter or shepherd and cats controlling the rodent population. Early dogs in clay sometimes are so detailed as to represent an identifiable breed, such as China's Shar Pei with its loose, wrinkled skin, included in Han dynasty grave goods (fig. 5.27), or the hairless dogs (*itzcuintin*) buried in the shaft tombs of Colima, Mexico (see Chapter 7).

Birds comprise another group of smaller animals interpreted in clay, the most prevalent being owls and roosters (figs. 5.28–29). The Western association of owls with wisdom has its roots in classical mythology, where an owl was linked with the Greek goddess of wisdom, Athena, and her Roman counterpart, Minerva. Roosters, because they announce the sunrise with their crowing and thus "chase away" darkness, are a universal solar symbol across Eurasia. The tenth animal of the Chinese zodiac, the rooster is thought to embody punctuality and honesty. In

Figure 5.20. Terracotta zebu (hump-back bull) vessel, Iran, ca. 1000 BCE. The stylization may strike today's viewer as "modern." *Collection of Los Angeles County Museum of Art, www.lacma.org, public domain.*

Figure 5.21. Terracotta cow-head *rhyton*, painted in red-figure (unslipped and oxidized) technique, ca. 460 BCE. Potters of Attic Greece made cups representing a variety of animals, perhaps as novelties for use at symposia (drinking parties). *Collection of the Metropolitan Museum of Art, New York, www.metmuseum.org.*

Figure 5.22. Lion doorstop by John Bell Sr., lead-glazed earthenware with manganese-colored "coleslaw" (sieve-extruded) hair, Waynesboro, Franklin County, Pennsylvania (north end of Shenandoah Valley), 1840–1865. *Courtesy of Winterthur Museum, Winterthur, Delaware, bequest of Henry Francis du Pont, 1967.1630.*

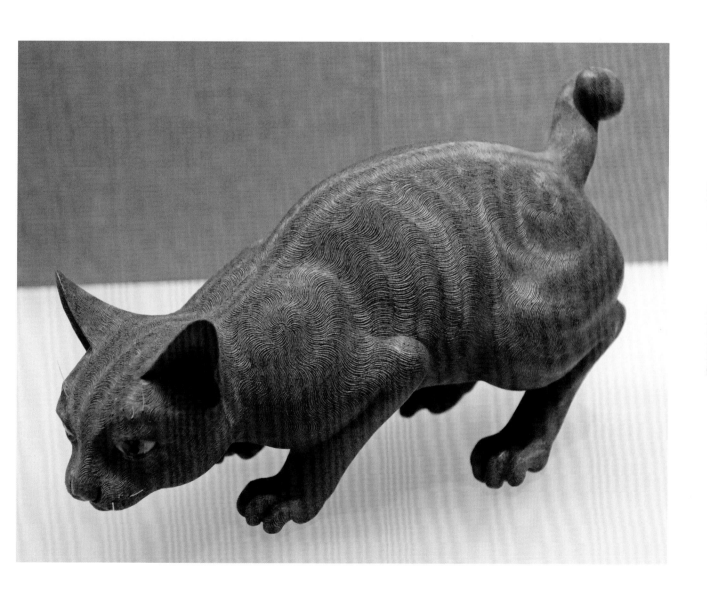

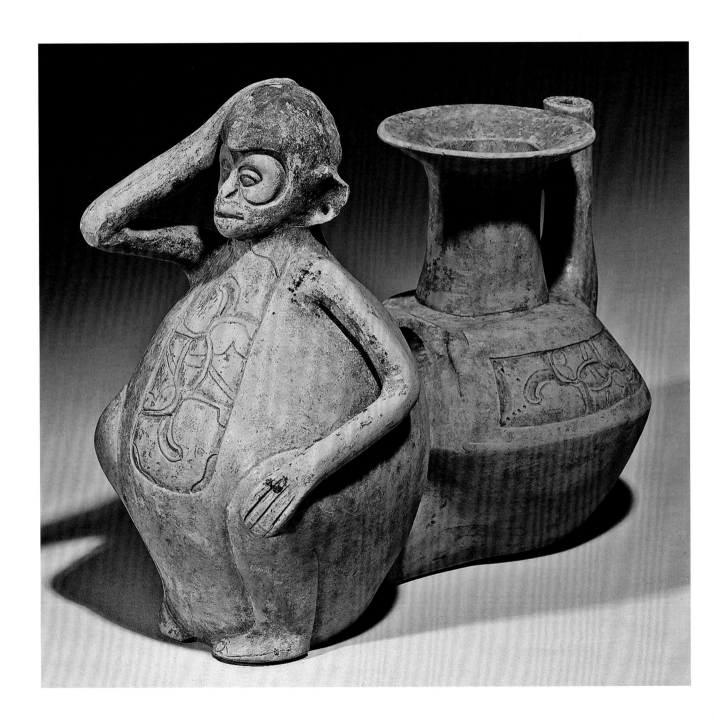

Figure 5.24, facing. Terracotta vessel, one chamber modeled as a monkey, Veracruz, Mexico, 600–900 CE. *Collection of the Walters Art Museum, Baltimore, Maryland, https://thewalters.org. CC BY-SA 3.0, via Wikimedia Commons.*

Figure 5.25, below. "Faience" frog amulet likely representing fertility goddess Heqet, Egypt, 3rd-first century BCE. *Collection of the Metropolitan Museum of Art, New York, www.metmuseum.org.*

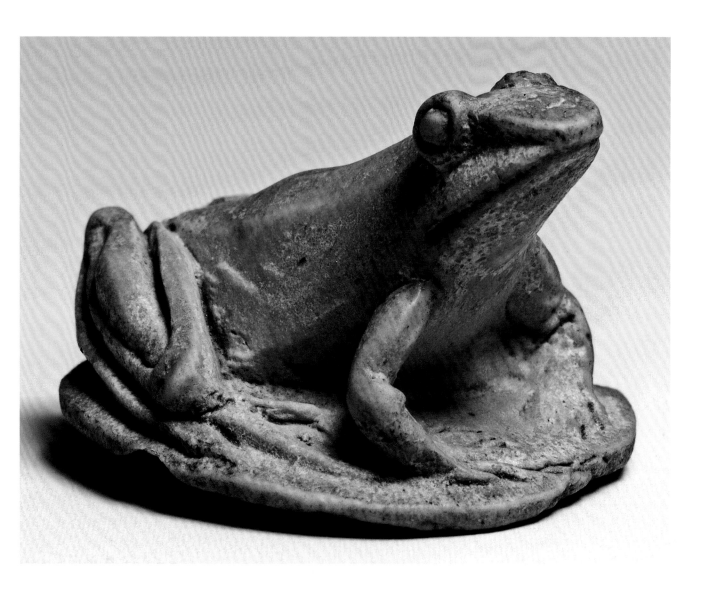

Figure 5.26, below. Turtle-shaped vessel, earthenware with burnished red slip and sgraffito shell pattern, Colima, Mexico, 200 BCE–300 CE. *Collection of the Metropolitan Museum of Art, New York, www.metmuseum.org.*

Figure 5.27, facing. Terracotta tomb figure of a Shar Pei dog, China, Han dynasty, 206 BCE–220 CE. *Collection of Asian Art Museum, San Francisco, www.asianart .org. Photograph: Hispalois, CC BY-SA 3.0, via Wikimedia Commons.*

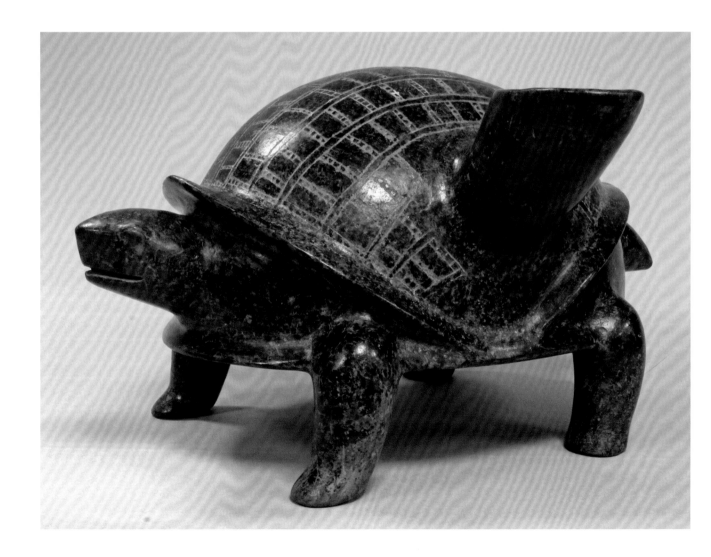

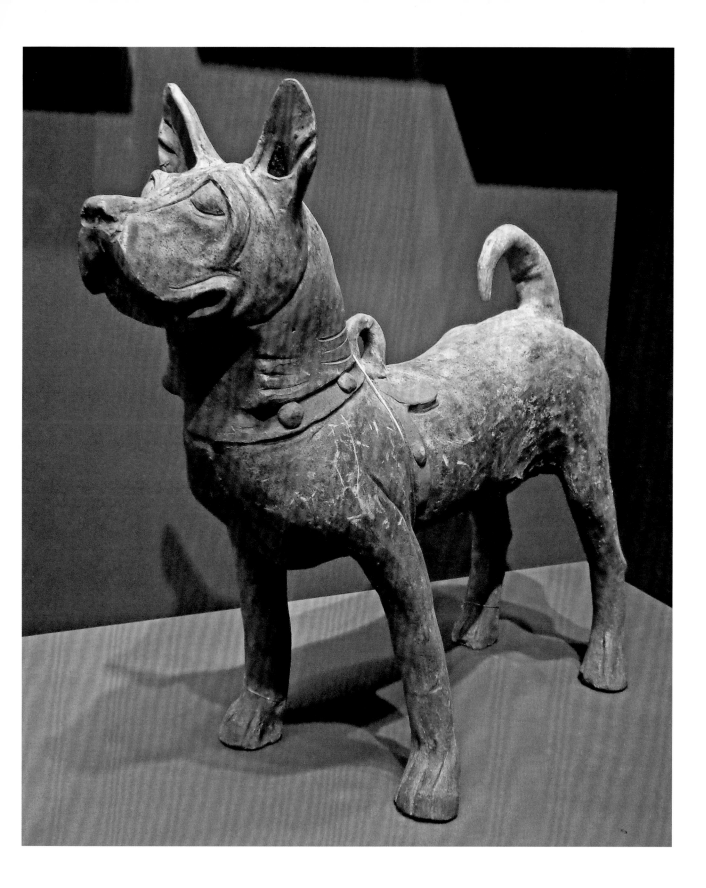

Figure 5.28, below. Owl jug, lead-glazed earthenware with "feathered" slips and drinking-cup head, Staffordshire, England, late 1600s. At least 10 related examples, attributed by some to Thomas Toft, are known in collections. *Courtesy of Chipstone Foundation, Milwaukee, Wisconsin.*

Figure 5.29, facing. Crowing rooster figure of porcelain with enamel colors, China, ca. 1700. *Collection of Rijksmuseum, Amsterdam, Netherlands, https://www .rijksmuseum.nl.*

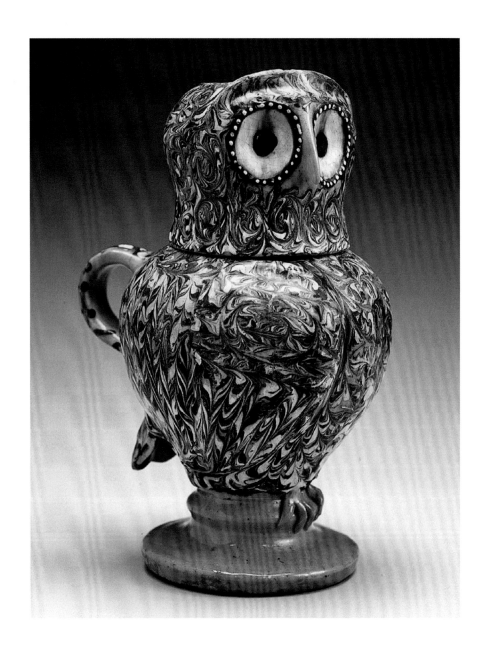

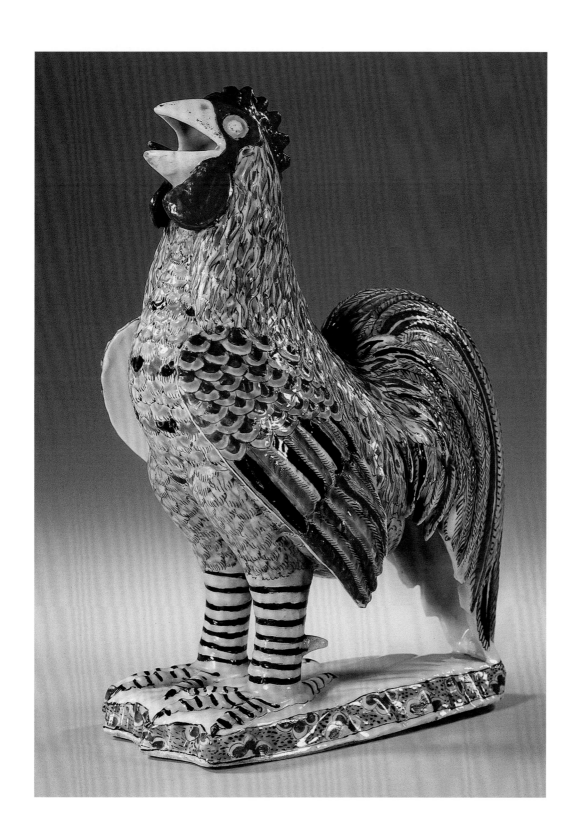

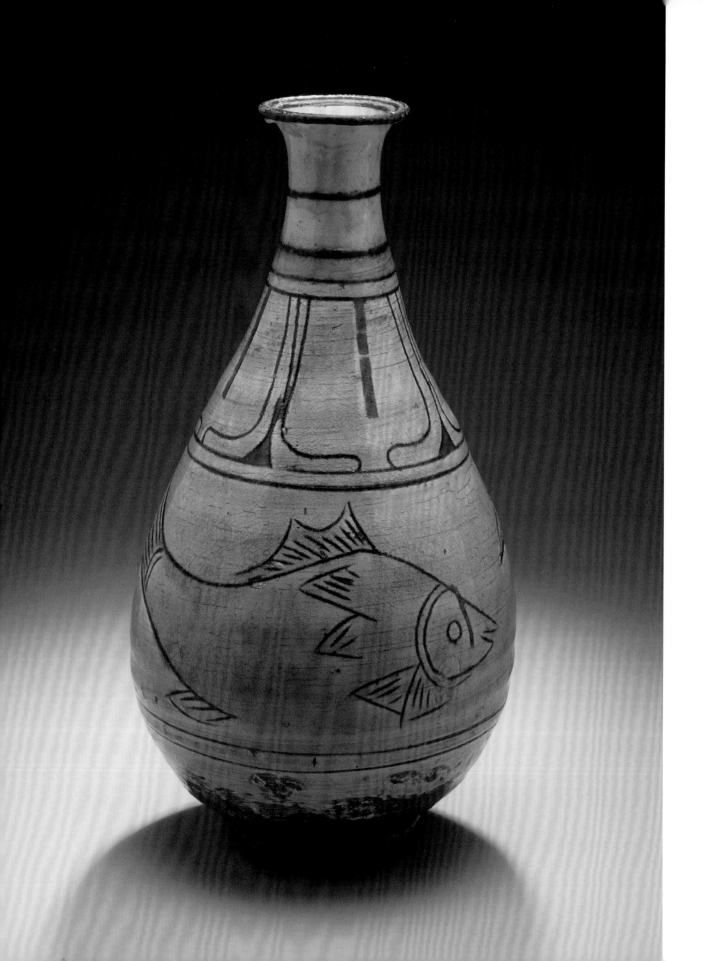

Figure 5.30, facing. Stoneware bottle with fish motif in sgraffito technique, Korea, Joseon dynasty, ca. 1500. *Collection of Los Angeles County Museum of Art, www .lacma.org, public domain.*

Figure 5.31, below. Terracotta "stirrup jar" with painted octopus, Mycenaean Greece, 1200–1100 BCE. *Collection of the Metropolitan Museum of Art, New York, www. metmuseum.org.*

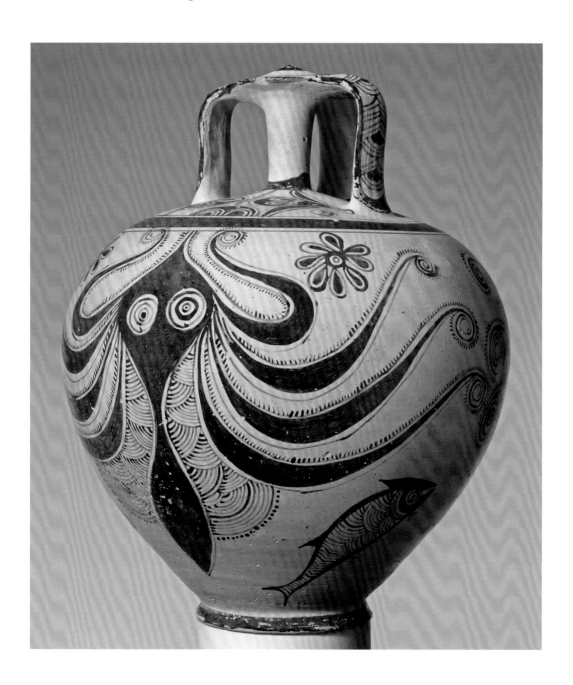

Figure 5.32. Terracotta octopus traps in the fishing port of Sayada, Tunisia, 2013. The elegantly shaped pots attract octopuses, which nest in them. *Photograph: Habib M'henni, CC BY-SA 3.0, via Wikimedia Commons.*

Japan, white roosters are venerated and allowed to run freely in Shinto temples where their dawn call is thought to awaken the sun goddess, Amaterasu. Roosters have become an iconic subject for north Georgia folk potters since Arie Meaders of Mossy Creek (mother of Lanier) created her first wheel-thrown birds in the late 1950s; her youngest son, Edwin, came to be known as "Rooster Man" for his specialty (ironically, he'd worked in a poultry processing plant before returning to his family's pottery tradition).[11]

Having sampled ceramic animals of the land and air, what remain are those of the water. We would expect societies located near the ocean to depict marine life in their pottery. The Korean Peninsula is surrounded by the Sea of Japan to the east and the Yellow Sea to the west. Seafood has always been an important part of the Korean diet, as suggested by a stoneware bottle dating to about 1500 that features an incised fish (fig. 5.30). The ancient Mycenaean art of mainland Greece (1600–1100 BCE) borrowed its marine imagery from Minoan Crete, largest of the Greek islands, with octopuses featured prominently in the ceramics of both cultures (fig. 5.31). Simple terracotta pots were used for centuries in the Mediterranean as octopus traps, and are still used in Tunisia (fig. 5.32), Portugal, and Japan (now sometimes replaced by plastic).

Coastal Peru is visited by the Humboldt Current, which carries cold, low-salinity water from the Antarctic to the west coast of South America. Rich in plankton, the current supports one of the world's most fertile fishing grounds. Potters of the Nazca/Nasca culture (ca. 100 BCE–750 CE) on Peru's south coast created polychrome wares that often depicted aquatic animals, such as the lobster shown here (fig. 5.33) and an anthropomorphic, mythic killer whale.

Bigger Than Life: Symbolic Meanings

At the positive end of the scale in ceramic depictions of animals are wares that express belief in the divinity of nature, that represent human authority, or that envision animals in a mythic world connected to ours. The animals so depicted are not to be understood literally, but metaphorically as standing for something else, often something bigger than ordinary life.

No animals have had a richer symbolic life than snakes. In some cultures they are fertility symbols; the Hopi Indians of Arizona, for example, perform a biennial Snake Dance in which live snakes are handled as a prayer for rain and good crops; similarly, to Aboriginal Australians the Rainbow Serpent is a water and creator spirit. Quetzalcoatl ("The Feathered Serpent"), a major Mesoamerican deity, was, at various times and among various Mexican cultures, a water and vegetation god, the god of the morning and evening star, the god of wind, the patron of priests,

Figure 5.34. Rattlesnake figure, alkaline-glazed stoneware (the scales picked out with plastic drinking straws), by Michael and Melvin Crocker, Lula, Banks County, Georgia, 1991. *Donated by the makers for the Goizueta Folklife Gallery of the Atlanta History Museum. Photograph: author.*

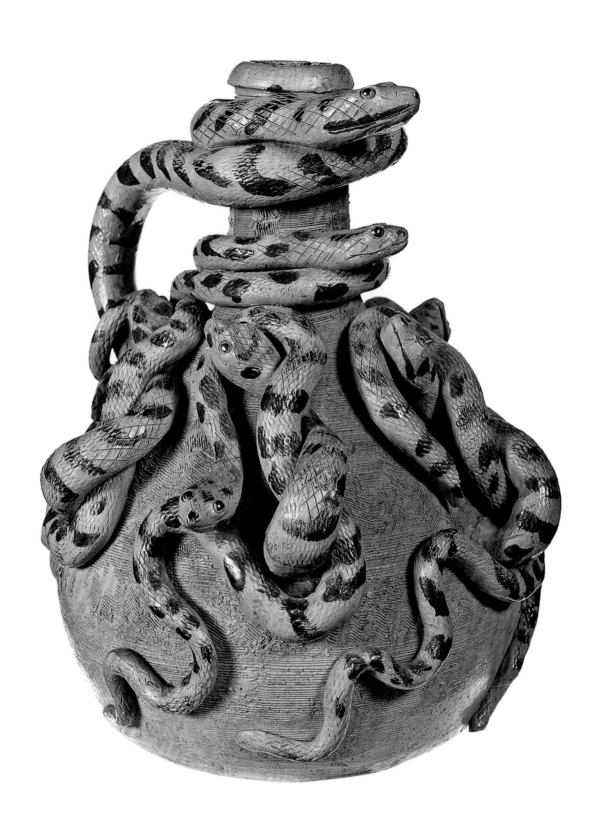

Figure 5.35. Snake jug by Wallace Kirkpatrick, salt-glazed stoneware with Albany slip highlights, Anna Pottery, Union County, Illinois, 1877. The writhing snakes here may symbolize the convolutions of American politics; "8 to 7" incised on the lip refers to the Compromise balloting that resolved the disputed 1876 presidential election in favor of Republican Rutherford B. Hayes. Two other "presidential" snake jugs retain their coiled-snake stoppers. *Courtesy of Rock Island Auction Company.*

and the god of learning and writing; his image appears on painted pre-Columbian pottery.

In Western society snakes tend to be viewed negatively, associated with the tempter Satan in the Garden of Eden. In the folk arts of the American South, snakes, as this embodiment of evil and danger, appear in such media as clay, wood, and iron, likely a reflection of the Bible Belt's fundamentalist brand of Protestantism.[12] Folk potters such as North Carolina's Burlon Craig and Georgia's Lanier Meaders made vessels featuring applied snakes, while the Crocker brothers (Michael, Melvin, and Dwayne) of Lula and Gillsville, Georgia, have created startlingly realistic stoneware rattlesnakes, either wrapped around jugs or freestanding (fig. 5.34).[13] For Lanier, the meaning of his "snake and grape" vases was more literal than symbolic: the cold-blooded reptiles, often encountered in the vicinity of his kiln, were an unavoidable part of his rural environment.

Snakes also can be seen on folk pottery of the American Midwest. Brothers Wallace and Cornwall Kirkpatrick belonged to a pottery family that had left Ohio for Illinois. In 1859 they moved to the village of Anna in Union County following reports of good stoneware clay in the area. The bread-and-butter products of their operation were utilitarian stonewares largely made by hired potters, freeing the brothers to exercise their artistic talents in decorative work, some of the most remarkable in American ceramics history. The snake jugs of Anna Pottery represented the evils of drink or, to quote the title on one, "The Drunkard's Doom." Huck Finn describes his alcoholic father in the grip of delirium tremens in Mark Twain's novel: "There was pap, looking wild and skipping around every which way and yelling about snakes. He said they was crawling up his legs; and then he would give a jump and scream, and say one had bit him on the cheek—but I couldn't see no snakes."[14]

The snake jugs were a specialty of Wallace, whose fascination with serpents included collecting and exhibiting them live. With their pottery's growing success the brothers entered local politics; Cornwall was mayor for three terms. The temperance movement was a hot-button issue in Anna, and as politicians the brothers were publically on its side. But the fact that they made some snake jugs and

pig flasks specifically for saloons and distillers suggests the potters' ambivalence toward alcohol. A number of the decorated pieces also reflect their interest in politics, such as the snake jugs that make reference to the 1876 presidential election (fig. 5.35).[15] Beyond Anna, snake jugs were made by German-American potters John M. Jegglin and August Blanck of Boonville, Missouri and Jacob Bachley of Texarkana, Arkansas, as well as by John L. Stone at Oletha and Kosse, Texas, who evidently had worked with the Kirkpatricks at Anna.

Gods and Power

Some early societies visualized their deities as fully or partly zoomorphic, as in dynastic Egypt with the baboon god of wisdom, Thoth (fig. 5.36), the falcon sky god, Horus, and the ram-headed water and creator god, Khnum. The Hindu elephant-headed god Ganesha dates as far back as the fifth century CE and is still worshiped as remover of obstacles, lord of success, patron of arts and learning, and god of beginnings. Clay images of Ganesha are still commonly made throughout the Hindu world. Vijaya Perumalla, a native of Andhra Pradesh, India who now lives in Knoxville, Tennessee, describes her transplanted practice of this Old World tradition:

> I am a practicing Hindu and Ganesha holds a very important place in our religious life. When I make the Ganesha figures, I make them with utmost sanctity from the moment I touch the clay and carry that sentiment all through the worship, up to the moment I finally return the clay to the earth (when it is dissolved into water to go back to the earth).
>
> For the past few years, I have been making Ganesha with store-bought air-dry clay. I usually make them for my own use at home. In 2015, I made one for the local temple. I sold a few idols some years back when I had crafted a few Ganeshas with clay using a mold. These were sold at a local event, and one was bought by the mayor of Knoxville! I crafted the one you are interested in [fig. 5.37] at home for use in my home puja [prayer ritual] in 2016. We did not get a chance to immerse it in a river, instead I let it sit out in the garden where it was melted by the rains to return back to the earth.[16]

Figure 5.37, facing. Hand-modeled air-dry clay figures of elephant-headed god Ganesha and his mouse mount, Mooshika, by Vijaya Perumalla, Knoxville, Knox County, Tennessee, 2016. *Courtesy of the maker, www.vpartist.com.*

Figure 5.38, below. Slipware plate by Thomas Toft, Staffordshire, England, ca. 1680. The rampant lion and unicorn of the Royal Arms flank Charles II hiding from Parliamentarian soldiers in Boscobel Wood's "Royal Oak" after Royalist defeat in the 1651 Battle of Worcester that ended the English Civil War. The plate would have appealed to supporters of the monarchy, restored in 1660 with Charles as king. *Collection of the Metropolitan Museum of Art, New York, www.metmuseum.org.*

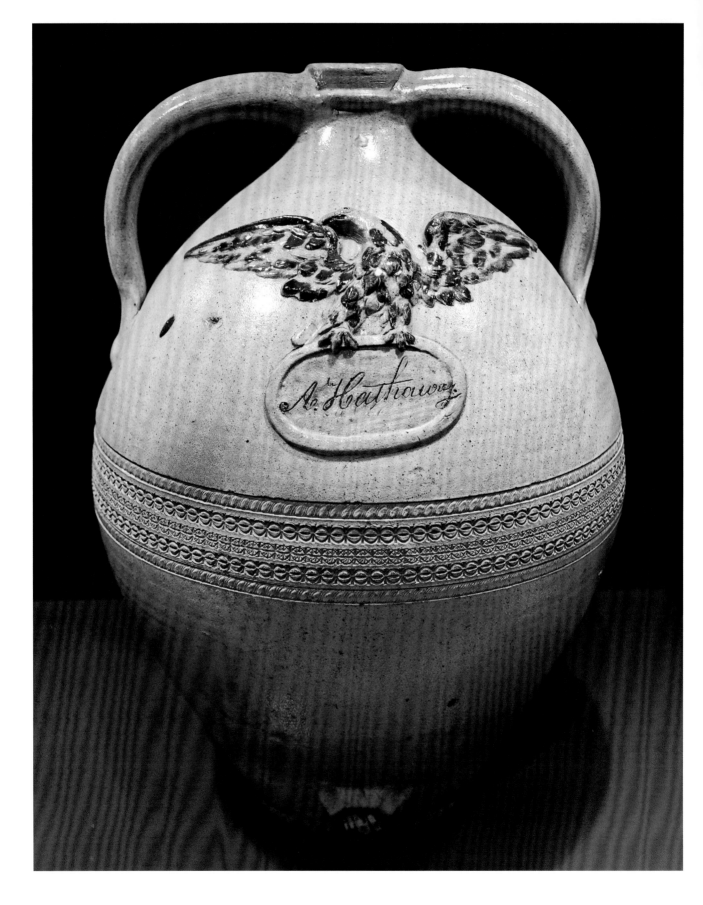

Animals also have served as symbols of human authority and power. The lion, "king of beasts" in England, became a royal emblem under the Normans, with three lions passant adopted as the official King's Arms at the end of the twelfth century. Great Britain's Royal Arms pairs the English lion with a chained unicorn representing Scotland (fig. 5.38), a combination dating to 1603 when James VI of Scotland also became King of England as James I.

Among the birds depicted in clay is the eagle, a symbol of strength and power since early times; the *aquila* was used by Roman legions as their standard. As our national symbol, the eagle appears on American stoneware made throughout the nineteenth century (fig. 5.39). History tells us that soon after the Declaration of Independence was signed on July 4, 1776, the Continental Congress appointed Benjamin Franklin, Thomas Jefferson, and John Adams to design an official seal for the new nation. Their proposal, and those of two subsequent committees, was rejected, so in 1782 the task was given to Charles Thomson, secretary of the Congress. Later that year his design, which featured a bald (white-headed) eagle, was adopted.

There is a grain of truth in the legend that Franklin had unsuccessfully lobbied for the turkey as our national symbol; in a letter of January 26, 1784 to his daughter, Sarah Bache, he wrote, "For my own part, I wish the Bald Eagle had not been chosen as the Representative of our Country; he is a Bird of bad moral Character. . . . [T]he Turk'y is in comparison a much more respectable Bird, and withal a true original Native of America."[17] Both species are, in fact, indigenous to North America. Despite the bald eagle's symbolic importance, it faced extinction in the twentieth century, but thanks to the efforts of conservationists and federal laws it has sufficiently recovered to be removed from the "endangered" and "threatened" lists. Its depiction on American folk pottery now serves as a reminder that there is hope for those species that have not yet joined the ranks of the passenger pigeon and Carolina parakeet.

Figure 5.40, below. Five-claw dragon chasing "flaming pearl" (now broken), glazed tiles on Nine Dragon screen wall facing Gate of Imperial Supremacy, Forbidden City, Beijing, China, erected in the early 1770s during reign of the Qianlong Emperor. *Photograph: Richard Fisher, CC BY 2.0, via Wikimedia Commons.*

Figure 5.41, facing. Phoenix-shaped stoneware ewer, Chu Dau, Red River Delta, Vietnam, ca. 1500. A pottery-making revival at Chu Dau village, east of Hanoi in Hai Duong province, began in the 1980s. *Collection of the Metropolitan Museum of Art, New York, www.metmuseum.org.*

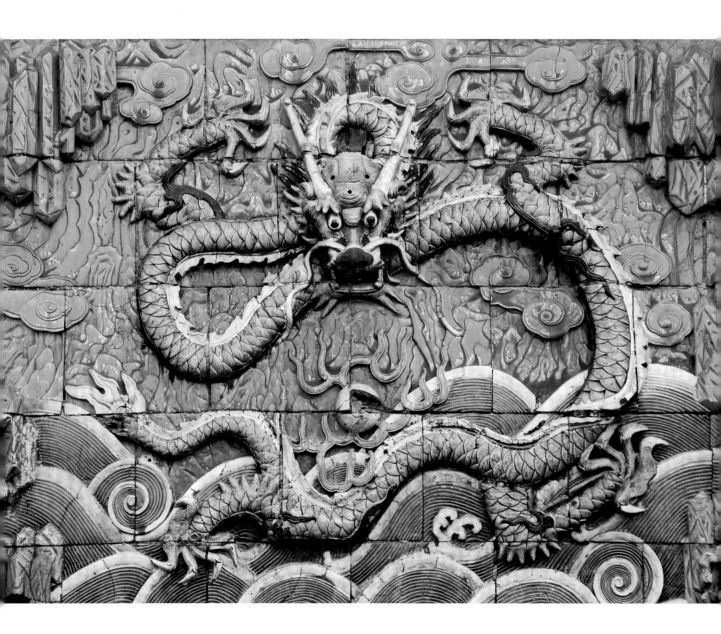

Figure 5.42, below. "Faience" sphinx figure of Amenhotep III, Thebes or Karnak, Egypt, 1390–1352 BCE. *Collection of the Metropolitan Museum of Art, New York, www.metmuseum.org.*

Figure 5.43, facing. Slipware dish depicting a mermaid holding a comb and mirror by Thomas Toft, Staffordshire, England, 1670–1689. The fine slip "jeweling" is a Toft trademark. *Photograph © Victoria and Albert Museum, London, https://www.vam .ac.uk.*

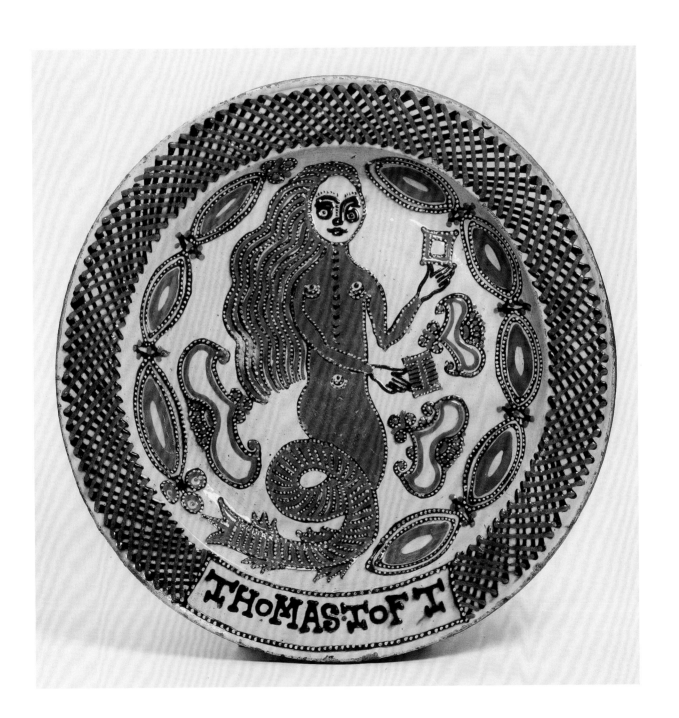

Fantastic Animals

Early societies invented a host of fabulous creatures that became part of their mythology or that have served a symbolic function (as in heraldry). Illustrated bestiaries that included both real animals and imagined ones such as the unicorn were especially popular in medieval Europe.

The Far Eastern dragon is not the winged, fire-breathing menace of the West to be slain by a hero like Saint George of medieval legend. Instead, the eastern dragon is a positive source of power that controls water. In China the five-clawed dragon was an emblem of the emperor, depicted in ceramics and other media as chasing a "flaming pearl" (fig. 5.40).[18] The emblem of the empress, on the other hand, was the phoenix, a composite of several birds. Unlike the phoenix of Greek mythology, she was not reborn from her ashes after bursting into flame, but embodied grace, nobility, and virtue. The Vietnamese version, or *phuong* (fig. 5.41), has similar attributes; its song is said to include all five notes of the pentatonic musical scale.

Some of the fantastic creatures depicted in ceramics are hybrids: combinations of two or more nonhuman animals such as the griffin and above-mentioned phoenix, or partly human like the sphinx, with its human head and lion's body that served as an emblem for Egyptian pharaohs (fig. 5.42) and had its Theban riddle correctly answered by Oedipus in the Greek tale. The mermaid, another such hybrid whose appearance "with a comb and glass [mirror] in her hand" is a portent of disaster for sailors in old British ballads, is pictured precisely that way on slip-decorated plates by Thomas and Ralph Toft of late-1600s Staffordshire (fig. 5.43).[19]

Masters of Clay Animals

Among the many representations of nonhuman animals in world ceramic art, three exemplary cases deserve singling out for their ingenuity and quality. The first was an extension of a local earthenware tradition, the second belonged to a porcelain tradition spanning three centuries, and the third had no tradition behind it and is unique in the annals of world ceramics history.

My first case is the "rustic wares" of sixteenth-century potter Bernard Palissy, introduced in Chapter 2 for the monuments honoring his achievements. Palissy spent much of his early life in Saintonge, then a French province noted for its medieval lead-glazed earthenware. He began his career as a glass painter, but after being shown a white cup (perhaps maiolica) he was inspired to take up pottery, using the kilns at La Chapelle-des-Pots near his home in Saintes. He made a name for himself with his "rustic wares," mainly oval display platters decorated with reliefs

Figure 5.44. "Rustic-ware" platter attributed to Bernard Palissy, Saintes or Paris, France, 1556–1588. *Collection of Los Angeles County Museum of Art, www.lacma .org, public domain.*

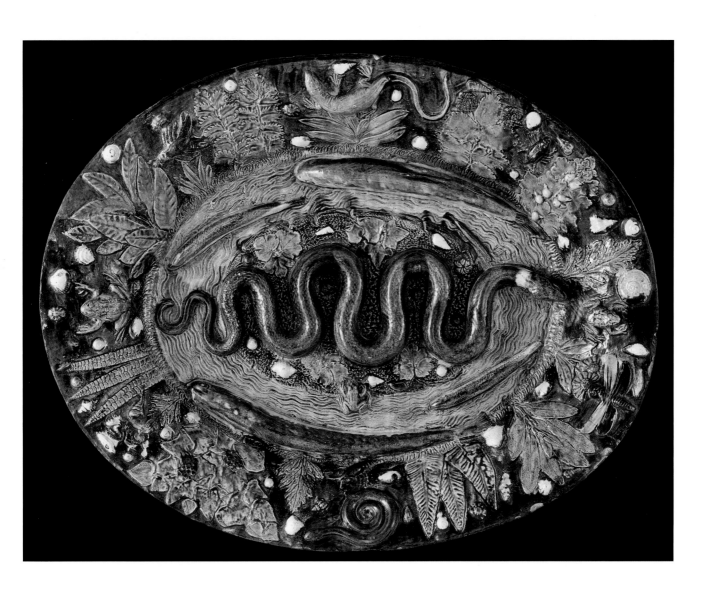

Figure 5.46. Billy goat modeled by J. J. Kändler for Augustus the Strong's porcelain menagerie, Meissen Porcelain Manufactory, Meissen, Germany, 1732, as displayed in London's Victoria and Albert Museum. *Photo: Andreas Praefcke, public domain, via Wikimedia Commons.*

of amphibians, reptiles, fish, and insects from Saintonge's salt flats rather than the more imposing creatures seen elsewhere in this chapter—his personal expression of the Renaissance interest in nature. He did so by pressing the creatures' actual bodies in clay to create molds and then placing the resulting clay reliefs (so-called "life casts," perhaps better named "death casts") in simulated natural settings—not unlike the wildlife paintings of American artist John James Audubon three centuries later—before painting and glazing (fig. 5.44).

In 1565 Palissy was invited to Paris by the Duc de Montmorency and the French queen, Catherine de' Medici, where he operated workshops in the grounds of the Tuileries Palace (now the site of the Louvre Museum) under royal patronage until, in 1588, he was imprisoned in the Bastille, where he died two years later, for his outspoken Protestantism. Many surviving brightly colored "rustic wares" are attributed to his workshops, but since they are unsigned it is now the practice to attribute them to "Palissy atelier/school/follower," and they were actively imitated in nineteenth-century France and Portugal.[20]

My second case is that of Hirodo porcelain animals. In the 1590s, Japanese invaders of Korea under the warlord Toyotomi Hideyoshi (a patron of the arts and a tea ceremony devotee) transplanted whole villages of potters to Kyushu, Japan's southernmost major island, so as to advance native ceramic production. In the mid-1600s, the *daimyō* (feudal lord) of the Hirado Domain on Kyushu, Matsura Chinshin, had a residence in the village of Mikawachi, and it was there that he established a kiln to produce porcelain for the upper class, following the example set by Hideyoshi of noble appreciation of, and support for, ceramics.

With the decline of Japan's feudal system in the early 1800s production shifted to export wares, finally ending a century later. *Okimono* (display pieces) were a Hirado specialty, and among those of the eighteenth and nineteenth centuries are delightful animal figurines (fig. 5.45). Such pieces could be featured in a *tokonoma* (guest-room alcove), the focal point of a Japanese home, but they were also made for export.[21]

My final case is that of Meissen's porcelain menagerie. Augustus the Strong of Saxony converted what came to be known as his Japanese Palace on the banks of the Elbe River in Dresden to house his collection of some twenty-thousand pieces of Asian ceramics, as well as porcelain from the factory he founded in 1710 at nearby Meissen, the latter displayed on the palace's upper floor. The most spectacular exhibit was a menagerie of exotic and domestic animals ordered in 1728. The commission was for nearly 600 life-size and near-life-size figures, to be modeled by sculptors Johann Gottlieb Kirchner and Johann Joachim Kändler.[22] Production continued until 1736, three years after Augustus's death, but was never

completed; individual pieces now reside in museums (fig. 5.46). Some fine traditional pottery was supported by noble patronage, but in the case of these unique porcelain animals there was no tradition behind their creation.

<center>⟶•◦•⟵</center>

As this chapter makes clear, nonhuman animals are among the most frequent subjects in world ceramic art. Their representation in clay mirrors the complex attitudes we humans have held toward them since prehistory. The range of these attitudes, from reverence to arrogance, is best expressed by mythologist Joseph Campbell: "The animal envoys of the Unseen Power no longer serve, as in primeval times, to teach and to guide mankind. Bears, lions, elephants, ibexes, and gazelles [now] are in cages in our zoos."[23]

Notes

1. "The Animals Went in Two By Two," *BBC School Radio*, http://www.bbc.co.uk/learning/schoolradio/subjects/mathematics/countingsongs/A-F/animals_two_by_two (accessed August 18, 2016). The fifth verse of another variant has the more standard "The animals went in five by five, they warmed each other to keep alive."

2. For the larger tradition to which these early Javanese piggy banks belonged, see Soedarmadji Jean Henry Damais, *Majapahit Terracotta: The Soedarmadji Jean Henry Damais Collection* (Jakarta: BAB Publishing Indonesia, 2012).

3. For Sussex pig flasks, see John Manwaring Baines, *Sussex Pottery* (Brighton, UK: Fisher, 1980), 16–19, 48–49. For Anna Pottery pig flasks, see Ellen Paul Denker, *The Kirkpatricks' Pottery at Anna, Illinois* (Urbana-Champaign: Krannert Art Museum, University of Illinois; Springfield: Illinois State Museum, 1986), 16–17, 27; Richard D. Mohr, *Pottery, Politics, Art: George Ohr and the Brothers Kirkpatrick* (Urbana: University of Illinois Press, 2003), 23, 32–35, 92–100, plates 8–9; and Suzanne Findlen Hood, "An Early Anna Pottery Pig Flask," in *Ceramics in America 2008*, ed. Robert Hunter (Hanover, NH: University Press of New England), 312–315.

4. R. Bégouën, Jean Clottes, Valérie Fergulio, and Andreas Pastours, *La Caverne des Trois-Frères: Anthologie d'un exceptionnel sanctuaire préhistorique* (Paris: Somogy Éditions d'Art, 2014).

5. John A. Burrison, *Brothers in Clay: The Story of Georgia Folk Pottery*, rev. ed. (Athens: University of Georgia Press, 2008), 158–161, plate 5; Anne M. Hastings, "Fox Hunting: History and Change in a Mountain Sport," *Appalachian Journal* 25 (Fall 1997): 30–46; and Parley B. Flanery Jr., "Fox Hunting in Eastern Kentucky," *Appalachian Heritage* 9:1 (Winter 1981): 47–50.

6. Elfriede Regina Knauer, *The Camel's Load in Life and Death: Iconography and Ideology of Chinese Pottery Figurines from Han to Tang and Their Relevance to Trade along the Silk Routes* (Kilchberg, Switzerland: Akanthus, 1998).

7. Mark Rose, "World's First Zoo—Hierakonpolis, Egypt," *Archaeology* 63:1 (2010): 25–32.

8. Reino Liefkes and Hilary Young, *Masterpieces of World Ceramics in the Victoria and Albert Museum* (London: V&A Publishing, 2008), 112–113.

9. For the animal rights movement's view of imagery see Randy Malamud, *An Introduction to Animals and Visual Culture* (Houndmills, UK: Palgrave Macmillan, 2012), and Steve Baker, *Picturing the Beast: Animals, Identity, and Representation*, rev. ed. (Urbana: University of Illinois Press, 2001). For folkloristic approaches to animals, see Venetia Newall, *Discovering the Folklore of Birds and Beasts* (Oxford: Shire, 2008), and Simon J. Bronner, *Killing Tradition: Inside Hunting and Animal Rights Controversies* (Lexington: University Press of Kentucky, 2008).

10. H. E. Comstock, *The Pottery of the Shenandoah Valley Region* (Chapel Hill: University of North Carolina Press, 1994), 150–151, 230–232, and Diana Stradling and J. Garrison Stradling, "Dealers' Choice," in *Ceramics in America 2014*, ed. Robert Hunter (Hanover, NH: University Press of New England), 208, 211–212.

11. John A. Burrison, *From Mud to Jug: The Folk Potters and Pottery of Northeast Georgia* (Athens: University of Georgia Press, 2010), 75, 79–82, 131, 145.

12. John A. Burrison, *Shaping Traditions: Folk Arts in a Changing South* (Athens: University of Georgia Press, 2000), 49 and plate 1.

13. For snake vessels by Burlon Craig and his son Don, see Charles G. Zug III, *Burlon Craig: An Open Window into the Past* (Raleigh: Visual Art Center, North Carolina State University, 1994), 19, and Jason Harpe and Brian Dedmond, *Valley Ablaze: Pottery Tradition in the Catawba Valley* (Conover, NC: Goosepen Studio & Press, 2012), 97, 148–149. For snake vessels by Lanier Meaders and the Crocker brothers, see Burrison, *Brothers in Clay*, 273 and plate 12, and Burrison, *From Mud to Jug*, 73, 75, 84–85.

14. Mark Twain, *Adventures of Huckleberry Finn* (New York: Charles L. Webster, 1885), 51.

15. Denker, *The Kirkpatricks' Pottery*, frontispiece, 10–11, 17–19, 28–30; Mohr, *Pottery, Politics, Art*, 4–5, 20, 25–65, 124–125, 165–174, and plates 1–5; and "Anna Pottery Auction Highlights," http://www.crockerfarm.com/highlights/anna-pottery/ (accessed September 2, 2016).

16. Vijaya Perumalla, email correspondence with the author, January 27, 2017.

17. Albert Henry Smyth, ed., *The Writings of Benjamin Franklin*, vol. 9 (New York: Macmillan, 1906), 166–167.

18. T. Volker, *The Animal in Far Eastern Art. . .* (Leiden, Netherlands: E. J. Brill, 1975), 55–67, and Helmut Nickel, "The Dragon and the Pearl," *Metropolitan Museum Journal* 26 (1991): 139–146.

19. Francis James Child, ed., *The English and Scottish Popular Ballads*, vol. 2 (1885; repr. New York: Dover, 1965), no. 58, "Sir Patrick Spens," 17–32 (variants J, L, P, and Q), and vol. 5 (1894; repr. New York: Dover, 1965), no. 289, "The Mermaid," 148–152. See also

Gwen Benwell and Arthur Waugh, *Sea Enchantress: The Tale of the Mermaid and Her Kin* (London: Hutchinson, 1961).

20. Leonard N. Amico, *Bernard Palissy: In Search of Earthly Paradise* (Paris and New York: Flammarion, 1996), chap. 3; Hanna Rose Shell, "Casting Life, Recasting Experience: Bernard Palissy's Occupation between Maker and Nature," *Configurations* 12:1 (2004): 1–40; Marshall P. Katz, *Portuguese Palissy Ware: A Survey of Ceramics from Caldas da Rainha, 1853–1920* (New York: Hudson Hills, 1999); and Katz and Robert Lehr, *Palissy Ware: Nineteenth-century French Ceramists from Avisseau to Renoleau* (London: Athlone, 1996).

21. Louis Lawrence, *Hirado: Prince of Porcelains* (Chicago: Art Media Resources, 1997), and C. Philip Cardeiro, *Hirado Ware: Japanese Hirado Porcelain 1640–1909* (Seattle: Far Eastern Press, 1989).

22. Samuel Wittwer, *A Royal Menagerie: Meissen Porcelain Animals* (Los Angeles: J. Paul Getty Museum, 2001), and Wittwer, *The Gallery of Meissen Animals: Augustus the Strong's Menagerie for the Japanese Palace in Dresden* (Munich: Hirmer, 2006).

23. Joseph Campbell, *The Way of the Animal Powers*, vol. 1 of *Historic Atlas of World Mythology* (New York: Alfred van der Marck; San Francisco: Harper & Row, 1983), 73.

6 | IDOLS WITH FEET OF CLAY

Ceramics and World Religions

O Lord . . . we are the clay, and thou our potter, and we all are the work of thy hand.

Isaiah 64:8 [Authorized Version]

A GIFT OF MOTHER EARTH, CLAY IS THE HUMBLEST OF ARTISTIC MEDIA, but in the hands of a skilled artisan it can be transformed into an object fit to honor the gods.[1] In contrast to painting, and to sculpture in stone, metal, and wood, religious expression in ceramics has received little attention.

The link between clay and religion should come as no surprise; in the sacred narratives of many world cultures, a deity creates humankind from clay. (The Judeo-Christian story in the Torah and Old Testament is ambiguous: "The Lord God formed man of the dust of the ground.") A Native American account from California is typical: "Earth-Maker took soft clay and formed the figure of a man and of a woman, then many men and women, which he dried in the sun and into which he breathed life: they were the First People."[2] The ancient Egyptian version of the theme has an interesting twist: the ram-headed god Khnum, the "Divine Potter," creates human figures from Nile clay on his potter's wheel, then places the figures in women's wombs to grow after Heqet, frog-headed goddess of childbirth, gives them life (fig. 6.1).[3]

Deities

We begin with idols, material representations of divinities used to connect with them where they dwell. Some of the earliest fired-clay objects are not pots, but stylized figurines of women, often with exaggerated breasts and in some cases evidently pregnant. The general consensus is that these are images of fertility or Mother Goddesses, or if not deities, representations of fecundity that may have been intended to ensure human pregnancy (on the homeopathic-magic principle of "like produces like").[4] The so-called Venus of Dolní Věstonice, from the

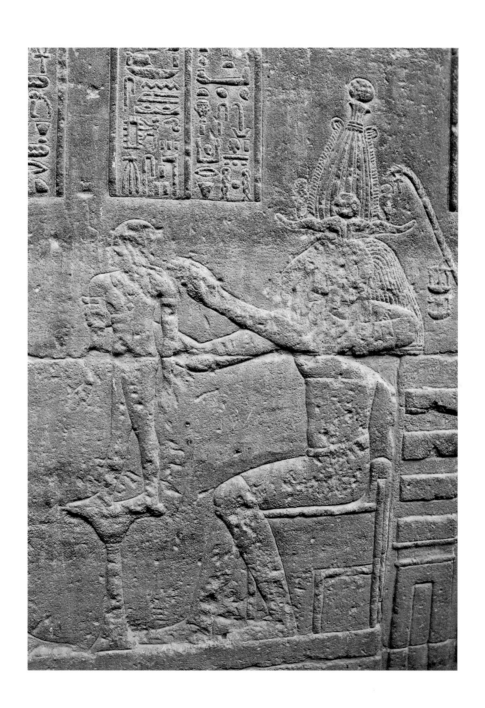

Figure 6.2. Terracotta "Venus of Dolní Věstonici" from the Paleolithic Gravettian culture of the present-day Czech Republic, 29,000–25,000 BCE. Archaeological excavations revealed remains of a hut with a clay-built oven in which this figure and others may have been fired. *Collection of Moravské Zemské Muzeum, Brno, Czech Republic, www.mzm.cz/en. Photograph: Petr Novák, CC BY-SA 2.5, via Wikimedia Commons.*

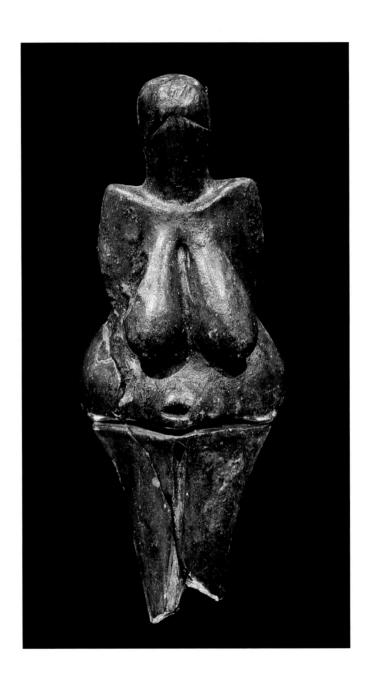

Figure 6.3. Terracotta female figure (head and one feline armrest restored), Çatalhöyük, Turkey, ca. 6000 BCE. Excavated in 1961 from the remains of a granary at the Neolithic site, the figure has prompted these questions: Is she really a goddess? If so, is she related to the later Anatolian Mother Goddess, Cybele?; Is she giving birth on her throne? Collection of Museum of Anatolian Civilizations, Ankara, Turkey, http://www.anadolumedeniyetlerimuzesi.gov.tr/. Photograph: Nevit Dilmen, CC BY-SA 3.0, via Wikimedia Commons.

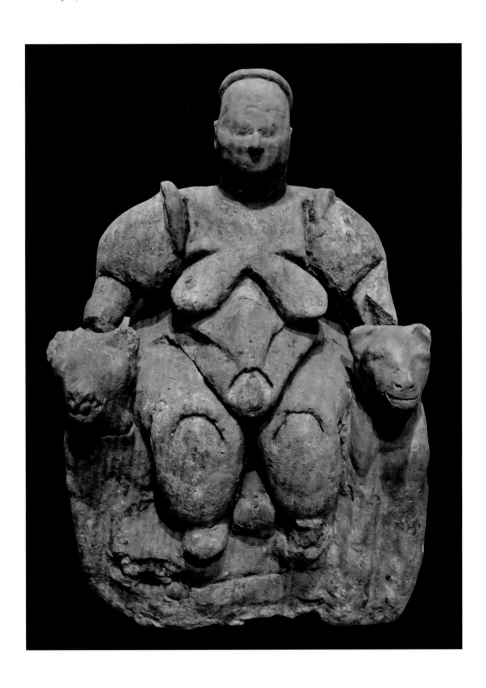

Figure 6.4. Terracotta "Burney Relief"/"Queen of the Night" plaque thought to depict the goddess Ishtar/Inanna, Babylon, Iraq, ca. 1800 BCE. *Collection of British Museum, London, www.britishmuseum.org. Photograph: Aiwok, CC BY-SA 3.0, via Wikimedia Commons.*

Figure 6.5. Minoan "faience" serpent-handling figure from Knossos temple complex, Heraklion, Crete, Greece, ca. 1600 BCE. Is that a cat perched on her headdress? *Collection of Heraklion Archaeological Museum, www.heraklion.gr. Photograph: George Groutas, CC BY 2.0, via Wikimedia Commons.*

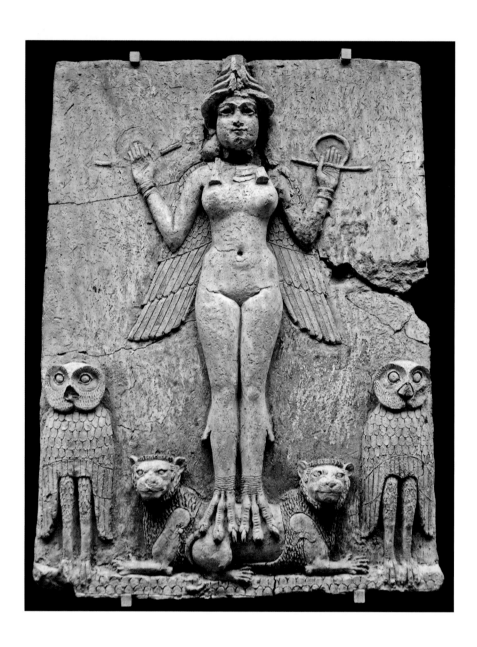

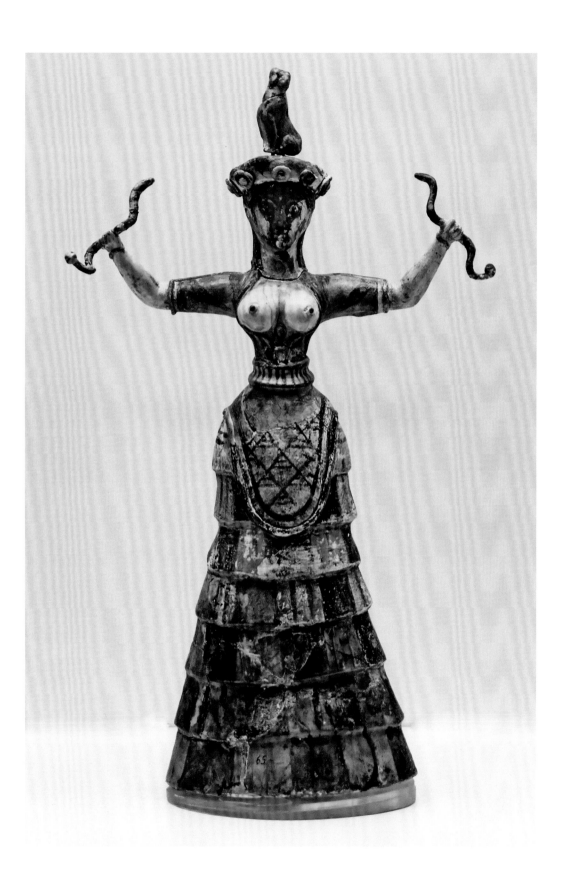

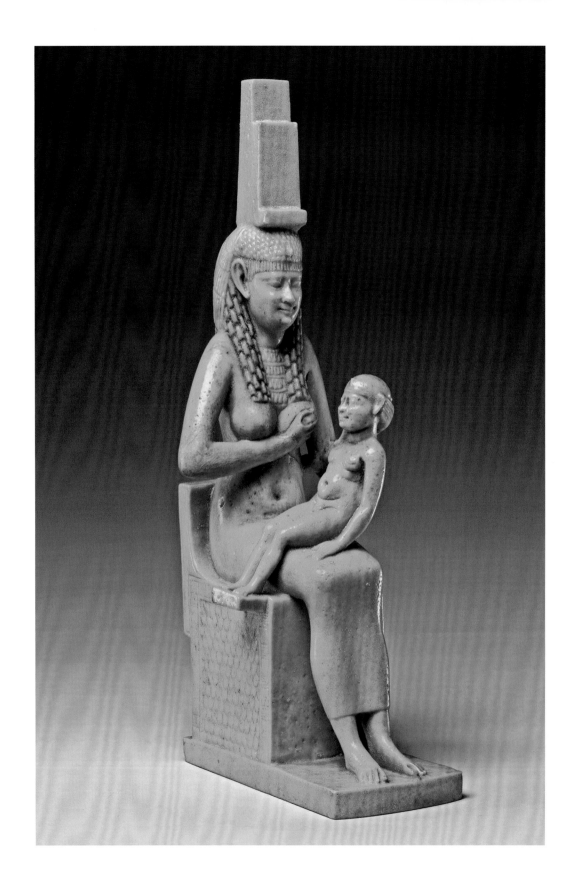

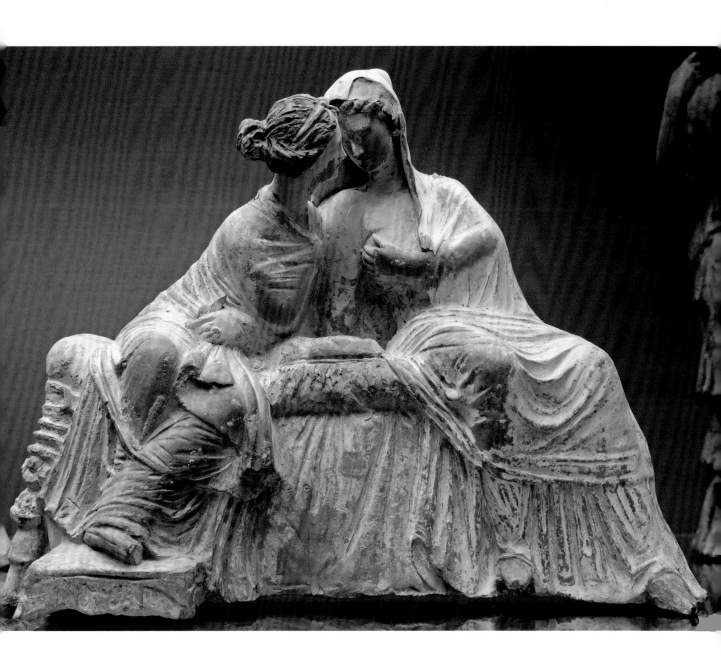

Figure 6.8, below. Recent terracotta group depicting the Hindu goddess Durga and her retinue, as set up for the October *Durga Puja* (devotional festival) at Barisha Netaji Sangha social club in Kolkata (Calcutta), West Bengal, India, 2010. *Photograph: Jonoikobangali, CC BY-SA 3.0, via Wikimedia Commons.*

Figure 6.9, facing. Terracotta cup in black-figure (reduction-fired slip) technique featuring Zeus, chief god of ancient Greece, with his eagle companion the *Aetos Dios*, attributed to the "Naucratis Painter" at the Greek trading post of Naucratis, Egypt, ca. 560 BCE. *Collection of Musée du Louvre, Paris, www.louvre.fr. Photograph: Bibi Saint-Pol, public domain, via Wikimedia Commons.*

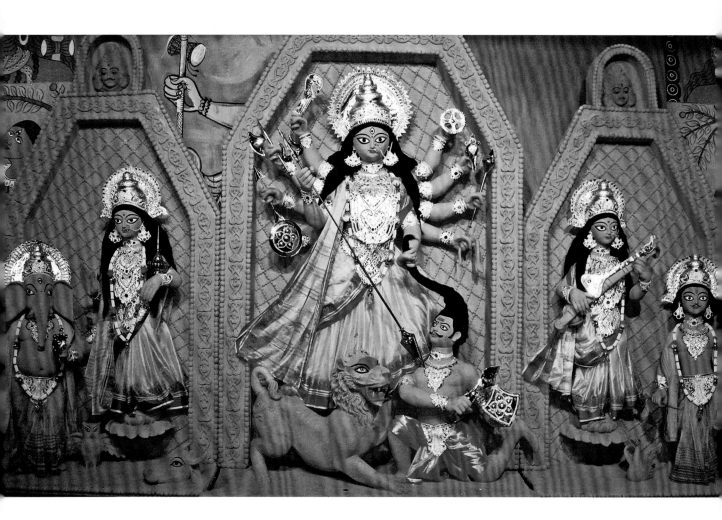

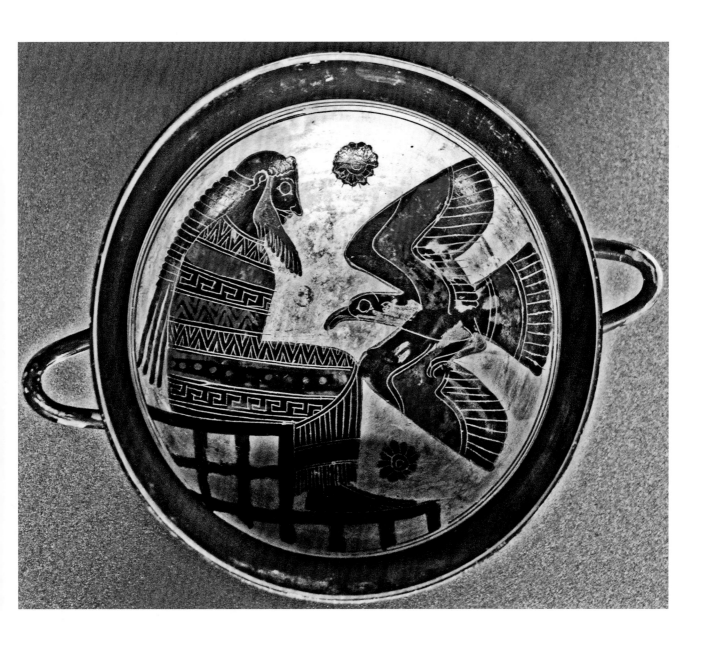

Gravettian culture in what is now the Czech Republic, is one of the oldest such figures known, dating to about 26,000 BCE in the Upper Paleolithic (Old Stone Age) period (fig. 6.2).

These ancient images are found throughout much of the world: a Neolithic seated woman from Çatalhöyük, Turkey, dating to about 6000 BCE (fig. 6.3); Japan's Nishinomae and Tanabatake "Jōmon Venus" *Dogū* (clay figures) dating to 3000–2000 BCE; the "Burney Relief" plaque from Babylon, Iraq, thought to depict Ishtar, the Mesopotamian goddess of fertility, love, and war, dating to about 1800 BCE (fig. 6.4); a bare-breasted, serpent-grasping female of about 1600 BCE from Minoan Crete, thought to depict either a goddess or priestess (fig. 6.5); and an amulet molded in Egyptian "faience" representing the Mother Goddess, Isis, suckling her son, Horus, that dates to about 600 BCE (fig. 6.6).

Note that over time, these representations become more refined, as with the appearance and nature of the gods as described in later narratives of some world religions. A naturalistically depicted, painted terracotta couple thought to be fertility goddesses Demeter and her daughter Persephone (the subjects of one of Greece's Descent-to-the-Underworld myths) was found in Myrina, Asia Minor, and dates to about 100 BCE (fig. 6.7). In some cultures such images are still being made, as with an example from Calcutta, India (fig. 6.8), created for the 2010 Durga Puja, a festival celebrating Durga, regarded by many Hindus as the Supreme Goddess and an aspect of Divine Mother Parvati. Her retinue here includes, at far left, the elephant-headed god Ganesha, son of Parvati.

Not all of the deities represented in clay are female, of course. For the sake of gender balance I include a few male examples, beginning with Zeus, the Father of the Gods in ancient Greece's pantheon. On a cup of about 560 BCE he's painted with the *Aetos Dios*, the eagle that served as his messenger and animal companion (fig. 6.9). The Egyptian god Bes, despite (or perhaps because of) his gruesome appearance, was an enemy of evil and protector of households, and thus a favorite subject for "faience" amulets (fig. 6.10).

To illustrate divergent approaches to the same basic concept for different peoples of the same region, I contrast two native vessels from western Mexico

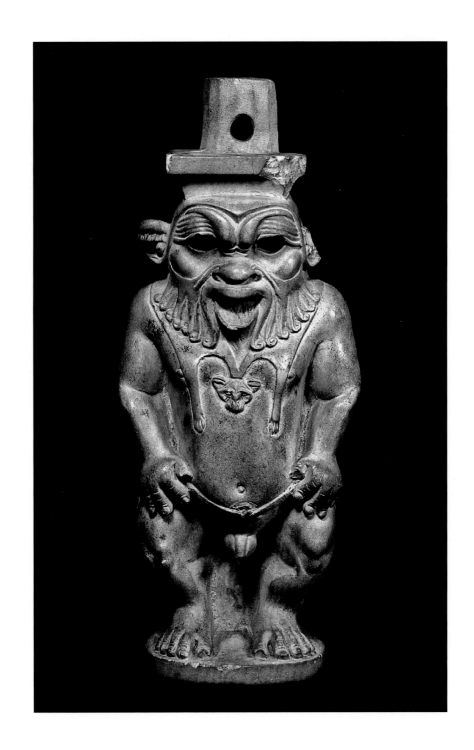

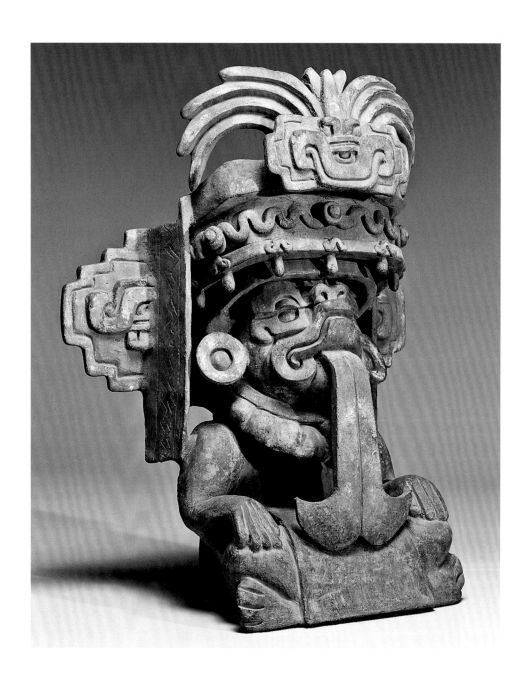

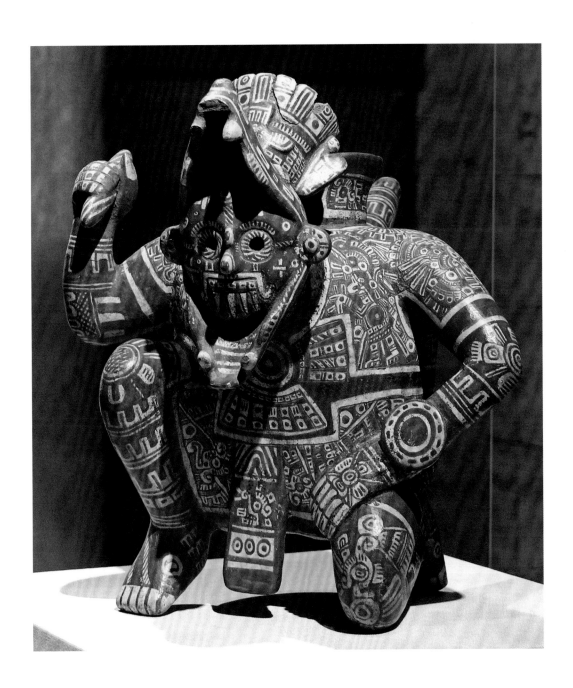

Figure 6.13. Terracotta cuneiform tablet containing the Neo-Assyrian Flood myth, 11th tablet of Gilgamesh Epic from library of King Ashurbanipal, Nineveh, Iraq, 7th century BCE. *Collection of British Museum, www.britishmuseum.org. Photograph: Fæ, CC BY-SA 3.0, via Wikimedia Commons.*

representing the Rain God specific to each group, obviously an important deity in any early agricultural society. The first, Cocijo ("Lightning"), was the powerful Zapotec creator divinity. He was worshiped for his life-bringing rain into colonial times; in the 1540s, three caciques (chiefs) of Yanhuitlán town were tried by the Spanish inquisitor Francisco Tello de Sandoval for making human sacrifices to him. A burial urn from Oaxaca depicting Cocijo dates to about 400 CE (fig. 6.11). The other vessel, made in Colima further north nearly a millennium later, is thought to represent a shaman ceremonially impersonating the Mixtec Rain God Dzahui, to whom child sacrifices were made in times of drought, sickness, and harvest (fig. 6.12). Other Mexican rain gods were Tlaloc (Aztec) and Chaac (Mayan).

Sacred Narratives

A terracotta tablet dating to the seventh century BCE and now in the British Museum (fig. 6.13) recounts in cuneiform how Utnapishtim survived the Great Flood with his family, craftsmen, and animals in a ship built at the instruction of Ea, the Akkadian god of water. This eleventh tablet of the Epic of Gilgamesh, one of the oldest surviving works of literature, is from the library of Assyrian King Ashurbanipal at Nineveh, Iraq. Scholars think this Babylonian story was a major influence on the Hebrew account of Noah in the Torah and Old Testament.[5]

A similarly dramatic story from the Hindu scripture *Bhagavata Purana* tells of Krishna, warrior-king avatar of the Supreme God, Vishnu, killing the horse-demon Keshi, who had been sent by Kamsa, evil king of Mathura, to kill Krishna. A terracotta relief plaque illustrating the fight, now in the Metropolitan Museum of Art (fig. 6.14), dates to the fifth century CE and is from Uttar Pradesh, India, where it probably decorated a temple. A second figure of Keshi at lower left, now dead, reassured worshipers of the struggle's positive outcome.

Images of Buddha Shakyamuni (Siddhārtha Gautama) molded into terracotta votive tablets were a ceramic specialty of twelfth-century Burma (present-day Myanmar). A typical example shows the thirty-five-year-old Buddha, having renounced his princely life, seated in the lotus position under a pipal (fig) tree in

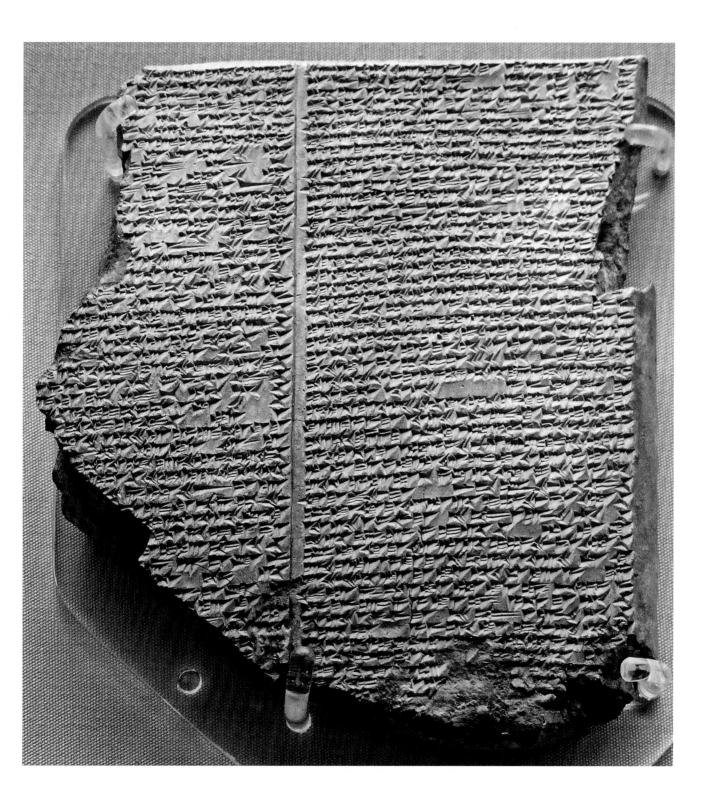

Figure 6.14, below. Terracotta plaque illustrating the fight between Hindu god Krishna and horse demon Keshi, Uttar Pradesh, India, Gupta period, 5th century CE. Shown above the lower figure of Keshi are balls of dung discharged at moment of his death. *Collection of the Metropolitan Museum of Art, New York, www.metmuseum .org.*

Figure 6.15, facing. Terracotta votive tablet molded with an image of Buddha Shakyamuni at the moment of his Enlightenment, Myanmar (Burma), 1050–1100 CE. *Collection of Los Angeles County Museum of Art, www.lacma.org, public domain.*

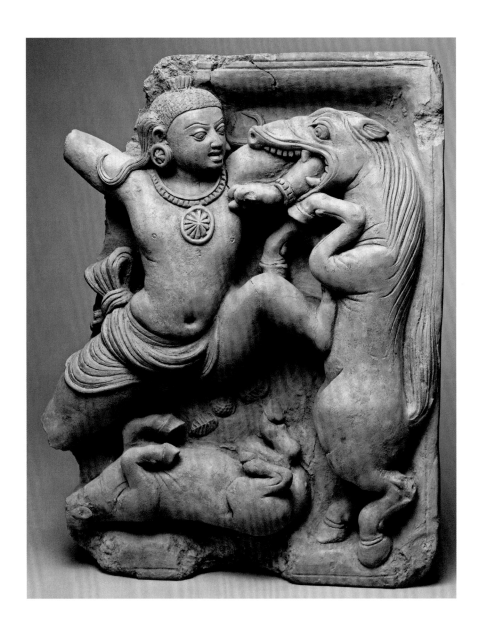

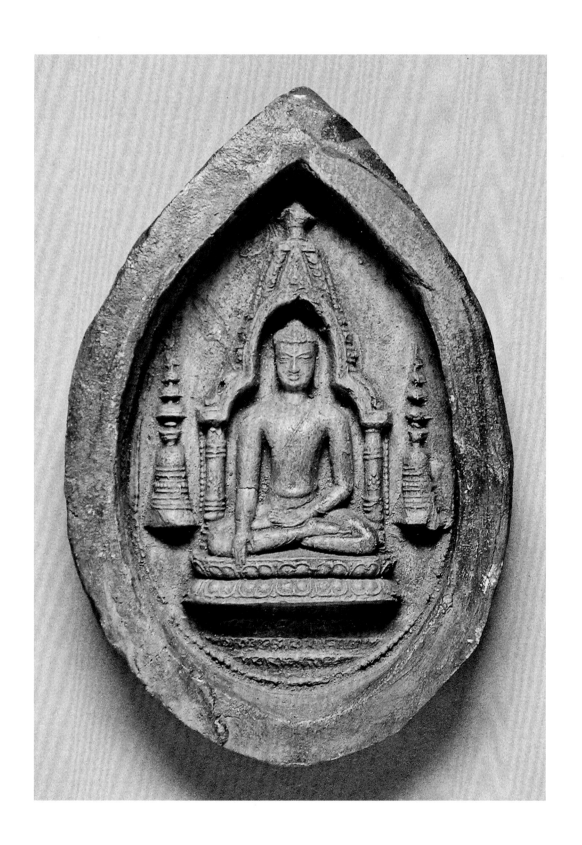

Figure 6.16, below. Maiolica Adam and Eve altarpiece by Giovanni della Robbia workshop, Florence, Tuscany, Italy, made to celebrate the triumphal entrance to that city of native son Pope Leo X in 1515. Giovanni was a great-nephew of Luca della Robbia, who passed on to family members the glazing techniques he developed in the early 1440s. *Collection of the Walters Art Museum, https://thewalters.org. CC BY-SA 3.0, Wikimedia Commons.*

Figure 6.17, facing. Maiolica "Buonafede Nativity" altarpiece by Benedetto and Santi Buglioni of Florence, Italy, ca. 1520, commissioned by abbot Leonardo Buonafede for the Church of San Michele Arcangelo in Badia Tedalda. *Collection of Los Angeles County Museum of Art, www.lacma.org, public domain.*

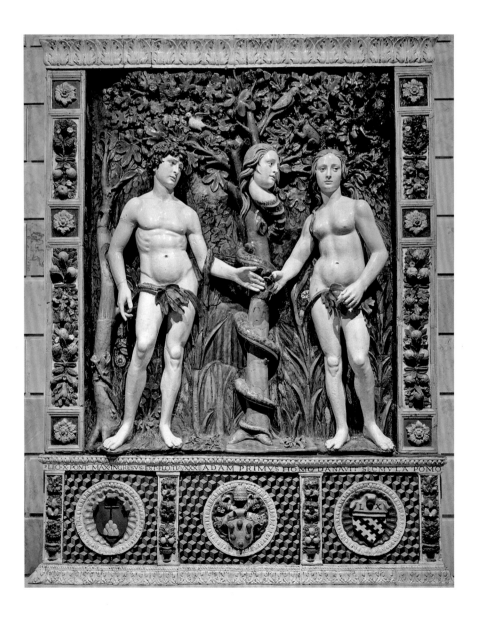

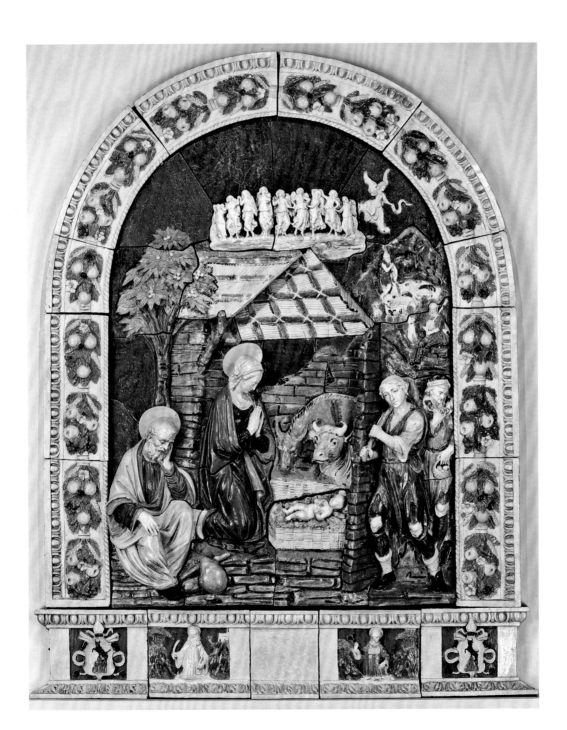

Bodh Gaya, India, at the moment of Enlightenment after forty-nine days of meditation, his right hand lowered to touch the earth (fig. 6.15).

Now we come to the Judeo-Christian Holy Book we know as the Bible. Biblical stories in clay and other media were used for both teaching and devotion, one of the most popular being the Old Testament narrative of Adam and Eve. A superb maiolica altarpiece of 1515 from the Florence workshop of Giovanni della Robbia depicts, in high relief, Eve handing Adam the forbidden fruit (a fig) from the tree of knowledge of good and evil in the Garden of Eden; interestingly, the serpent's head is a mirror image of Eve's (fig. 6.16). The central coat of arms on the predella (base), that of Pope Leo X, a member of Florence's Medici family, is flanked by the arms of two other local families that supported the Pope. Della Robbia belonged to a dynasty of master Renaissance sculptors that included his father, Andrea, and great-uncle, Luca (founder of the ceramic branch). "Folksier" depictions of Adam and Eve appear on seventeenth-century English plates in delftware (tin-glazed earthenware) from London and Bristol, and in slipware from Staffordshire by Thomas Toft, one of which, dated 1674 in Leeds City Museum, has an angel hovering over Adam and a winged demonic creature above Eve.

Ceramic illustrations from the New Testament are so numerous, especially from Catholic Europe, that an episodic life history of Jesus can be assembled with them; a few examples will suffice. The "Buonafede Nativity" (fig. 6.17) of about 1520 by Florence's Benedetto Buglioni and his nephew, Santi Buglioni, shows the newborn Christ Child in the manger and prayerful Mary and Joseph being visited by ragged shepherds, the knees of the two in foreground right sticking through their worn britches. The Buglionis (rumored to have surreptitiously acquired Luca della Robbia's secret glaze techniques) were commissioned to produce this altarpiece by Leonardo Buonafede, abbot of Badia Tedalda, whose arms appear at each end of the predella.

Pontius Pilate's words prior to the Crucifixion, *"Ecce homo"* ("Behold the man"), are used to describe devotional images of Christ such as a maiolica bust of about 1500 thought to be from Montelupo in Tuscany (fig. 6.18). Here, Jesus is shown after the scourging, crowned with a wreath pierced to receive real thorns.

Figure 6.19, below. *Pietà* plate by Derck Hamman, lead-glazed earthenware with sgraffito and polychrome decoration, Niederrhein region, North Rhine-Westphalia, Germany, 1750. *Collection of Hetjens-Museum (Deutsches Keramikmuseum), Düsseldorf, Germany. Photograph: author.*

Figure 6.20, facing. Lusterware "Incredulity of Saint Thomas" plate, Deruta, Umbria, Italy, 1510–1520. *Collection of Rijksmuseum, Amsterdam, Netherlands, https://www.rijksmuseum.nl.*

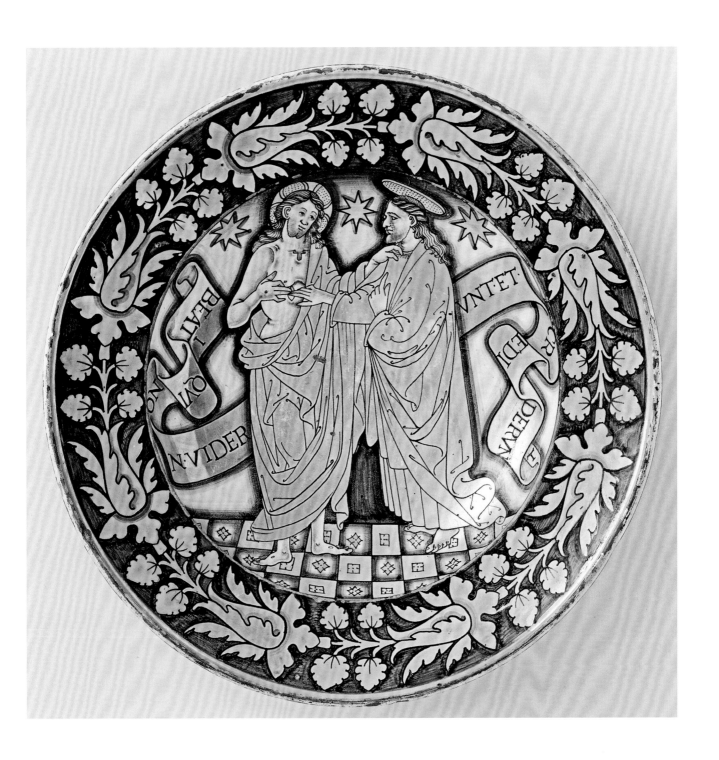

Figure 6.21, below. Fayence (tin-glazed earthenware) plate pairing Martin Luther with Johann Georg I by G. F. Grebner, Nuremberg, Bavaria, 1730. *Collection of Kunstgewerbemuseum, Berlin, Germany, http://www.smb.museum/en/museums -institutions/kunstgewerbemuseum/home.html. Photograph: FA2010, public domain, via Wikimedia Commons.*

Figure 6.22, facing. Lead-glazed earthenware bowl with Orange Order (Protestant) motifs in sgraffito technique, made ca. 1870 at Castle Espie Pottery, County Down, Northern Ireland, for lodge master Samuel Stewart of nearby Comber. *Collection of Ulster Folk & Transport Museum, Holywood, Northern Ireland. Photograph: author.*

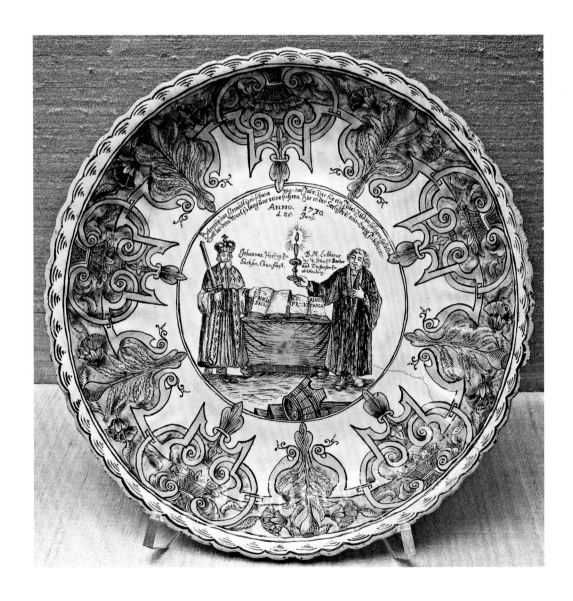

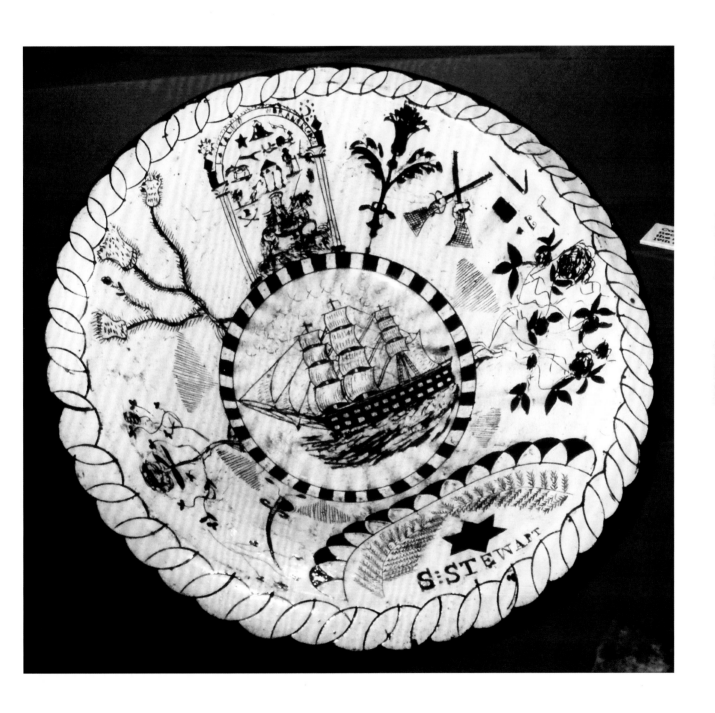

Figure 6.23. Recent factory-made porcelain *Ka'arah* (plate for Passover Seder), with symbolic food referencing the story of Exodus in which the Israelites, led by Moses, escaped slavery in Egypt. *Courtesy of Julie Rana, www.goldenthalfamilyblog.com.*

A polychrome slipware plate from the largely Catholic Niederrhein (Lower Rhine) region of Germany, made in 1750 by Derck Hamman, features a *Pietà* with Mary cradling her dead son (fig. 6.19). The final example in this New Testament series is an early-1500s lusterware plate from Deruta, Italy, with Jesus showing Doubting Thomas, one of the twelve apostles, the Crucifixion wounds as evidence of His resurrection, a scene titled by painters such as Caravaggio as "The Incredulity of Saint Thomas" (fig. 6.20).

The Protestant Reformation found its way into European ceramics much less frequently, given its de-emphasis of religious iconography. A fayence (the spelling for German tin-glazed earthenware) plate dated 1730 by Georg Friedrich Grebner of Nuremberg (fig. 6.21) imagines the spirit of Martin Luther illuminating Johann Georg I, who reigned as Elector of Saxony from 1611 to 1656. Johann was a Lutheran, but for political reasons often was on the fence about supporting the Protestant cause. The plate was thus a reminder of a complex period in German history, the Thirty Years' War.

A sgraffito-decorated earthenware bowl of about 1870 (fig. 6.22), made at Castle Espie Pottery in County Down, Northern Ireland, alludes to the sectarian conflict that at times has torn apart the six majority-Protestant counties of Ulster. It's replete with siege-mentality emblems of the Protestant Orange Order, from a British man-of-war at its center to a folk-art gateway of an urban Protestant enclave above featuring an image of William of Orange, Protestant hero of the 1690 Battle of the Boyne. Also depicted are roses and thistles, floral emblems of England and Scotland, but no shamrock, with the tiny clay pipe at far right being the only reference to Ireland. The bowl was presented to Samuel Stewart, an Orange lodge master in the town of Comber.

In Judaism today, a particular ceramic item that has special religious significance is the Passover Seder plate (Hebrew: *Ka'arah*). In this case, it is not the object that is traditional but its customary use. The Seder is a communal ritual meal retelling the story from the book of Exodus in the Torah and Old Testament of the liberation of the Israelites from slavery in Egypt. Usually factory made if sometimes hand painted, such plates are sectioned to hold the food items referencing

the narrative (fig. 6.23): *maror/chazeret*, bitter herbs symbolizing the bitterness of enslavement; *karpas*, a vegetable such as parsley dipped in salt water to represent tears shed by the enslaved Hebrews; *charoset/haroset*, a sweet brown mixture (e.g., chopped nuts and apples mixed with red wine) representing mortar or clay for the bricks used by those slaves to build the storehouses or pyramids of Egypt; *z'roa*, meat such as a roasted lamb shank bone or chicken wing, representing the sacrifice offered in the Temple in Jerusalem; and *beitzah*, a hard-boiled egg associated with mourning over the destruction of the Temple as well as a symbol of new life that occurs in the spring at the time of Passover. As with all folk traditions there are variants, such as the orange now added by some to affirm, according to one

explanation, that we are all equal under God's eye. A separate plate with three cloth-covered *matzohs* reminds participants of the unleavened bread baked in the hurry to escape Egypt.

Religious Practitioners

A life-sized, polychrome-glazed earthenware statue from twelfth-century China represents an *arhat/luohan* (India/China), a devotee of Buddhism who has achieved full Enlightenment or is well along that path (fig. 6.24). Shown seated in the cross-

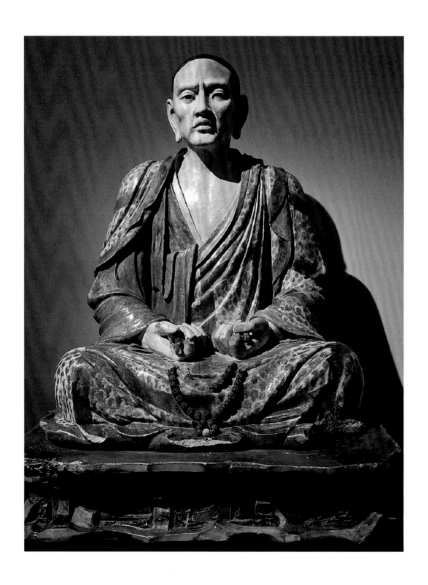

Figure 6.24, facing. Statue of an *arhat/luohan* (India/China) thought to represent Buddha's sixth disciple, Tamrabhadra, polychrome-glazed earthenware (missing some prayer beads), one of 8 life-size disciple statues found in caves in Yixian county, Hebei province, China, probably made in that area ca. 1150 (Great Jin dynasty). *Collection of Musée Guimet, Paris, www.guiment.fr. Photograph: Jean-Pierre Dalbéra, CC BY 2.0, via www.flickr.com and Wikimedia Commons.*

Figure 6.25, below. Terracotta tile molded with figures of emaciated ascetics, Harwan, Kashmir, India, 4th–6th century CE. *Collection of the Metropolitan Museum of Art, New York, www.metmuseum.org.*

Figure 6.26. Lead-glazed earthenware *monniksbeker* (monk beaker), probably made at Limburg, Netherlands, ca. 1600. *Collection of Museum Boijmans Van Beuningen, Rotterdam, Netherlands, http://www.boijmans.nl/en/.*

legged posture and grasping his *Japa mala* (prayer beads used as a meditation tool to count the number of times a mantra is recited), the subject is identified as Buddha's sixth disciple, Tamrabhadra ("The Arhat Who Crossed Rivers"), sent by the Buddha to spread the word in Ceylon.

Molded terracotta tiles from fifth-century Kashmir, India, contrast emaciated ascetics with couples conversing behind a balcony above (fig. 6.25). The tiles decorated a low sidewall of a sanctuary courtyard near the village of Harwan, a site thought to be Buddhist; but another possibility is that the tiles were made for followers of the Ajivika movement, a rival of early Buddhism and Jainism, one tenet of which was strict predestination.

Scholars are undecided about what to make of a group of *monniksbekers* (monk beakers, although at least one example represents a nun), also known as *geuzenbekers* (beggar beakers), lead-glazed, molded figures from the Netherlands dating to the early seventeenth century. Evidently drinking vessels, they have an opening at the back representing a billowing hood or yawning sack. One theory is that they were made for the Geuzen, a Calvinist group opposed to the Netherlands policies of Philip II of Spain, who used them at their gatherings to deride their Catholic adversaries. But unlike the beakers' German counterparts (one of which depicts a cleric about to become violently ill after too much drink, another showing a monk slipping a nude woman into his robes), these images seem benign, the pictured example reading his bible or prayer book (fig. 6.26). They are believed to come from Limburg, a largely Catholic province of the Netherlands, so it's possible they were meant to be more respectful than anticlerical, perhaps a mildly humorous way of depicting local "idols" with "feet of clay."[6]

Securing Divine Help and Protection

Literal feet of clay (fig. 6.27) and other clay body parts were used by the ancient Romans as votive offerings to a divinity such as Asclepios, the Greco-Roman god of medicine, to gain supernatural help with an ailment or, as ex-votos, to give thanks for having been healed. The practice survives today in Latin America as

Figure 6.27, below. Terracotta foot, Roman votive offering, 200 BCE–200 CE. *Collection of Wellcome Trust, London. CC BY-SA 4.0, via Wikimedia Commons.*

Figure 6.28, facing. Unglazed stoneware *komainu* (guardian lion-dog) at Shinto Kumano shrine, Kurashiki, Okayama Prefecture, Japan, made at Bizen in the same prefecture, perhaps 19th century. *Photograph: Reggaeman, CC BY-SA 3.0, via Wikimedia Commons.*

Figure 6.29, below. Dragon-head *taoshou* (corner-beam end cap), lead-glazed earthenware, from Old Summer Palace, Beijing, China, 1736–1796. *Collection of Royal Ontario Museum, Toronto, Canada, www.rom.on.ca/en. Photograph: Daderot, CC0 1.0, via Wikimedia Commons.*

Figure 6.30, facing. Large terracotta horses for spirit soldiers of Hindu protector-god Ayyanar, Tamil Nadu, India, 20th century. *Collection of Sanskriti Museums, New Delhi, India, www.sanskritifoundation.org/museums.htm. Photograph courtesy of Jenny Lewis.*

Figure 6.31, facing top. "Faience" *wedjat* (Eye of Horus protective amulet) made as a pectoral (pendant) and inset with glass paste and ivory, Egypt, ca. 1000 BCE. *Photograph © Trustees of the British Museum, www.britishmuseum.org.*

Figure 6.32, facing bottom. Lusterware *mihrab* tile set, Kashan, Iran, early 14th century. The molded inscription is a passage from chapter 15 of the *Qur'an* referring to Paradise. *Collection of Los Angeles County Museum of Art. Photograph: Beesnest McClain, CC BY-SA 2.5, via www.flickr.com and Wikimedia Commons.*

part of folk Catholicism; in Canindé, Brazil, for instance, clay is the second most frequent medium for body-part offerings (*milagres*) after wood.[7]

In Japan a pair of *komainu*, or lion-dogs, guards the entrance of many Shinto shrines to ward off evil spirits. These frightening creatures, which originate in China where they are known as *shishi* ("foo dogs" to Westerners), are usually carved in stone, but at several Japanese shrines they are made of stoneware from the pottery center of Bizen (fig. 6.28). Glazed figural tiles on the roofs of Chinese homes and palaces served a similar purpose, with the dragon—symbol of power, prosperity, and protection against ill fortune—as a prominent figure. Dragon tiles were placed on the most protective feature of a dwelling, where they could be seen from a distance. The dragon also was an emblem of the emperor; as a palace roof tile it often was yellow, the emperor's color (fig. 6.29).

In Tamil Nadu, southern India, large terracotta horses are still made to be placed at temples and shrines for the *Veeran*, or spirit soldiers of the guardian-god Ayyanar, to ride at night as they protect villages from evil. These votive horses, hand built and dedicated by *Velars* (potter-priests) in sacred ceremonies, can exceed fifteen feet in height (fig. 6.30).[8] Protection against evil also was provided in ancient Egypt by a "faience" amulet called a *wedjat*, or Eye of Horus (fig. 6.31). The falcon-headed Horus was both a god of protection and the sky god whose right eye was associated with the sun.

Worship and Pilgrimage

Tiles for religious buildings were a specialty of pottery centers like Kashan and Isfahan in Iran and Iznik in Turkey. A lusterware tile set from fourteenth-century Kashan (fig. 6.32) belonged to a *mihrab*, the niche in a mosque wall that points to the *Kaaba* (Cube, believed by Muslims to be the house of God) in Mecca and hence, the direction Muslims face when praying. Islamic potters did not always limit their commissions to fellow Muslims; another tile wall set from

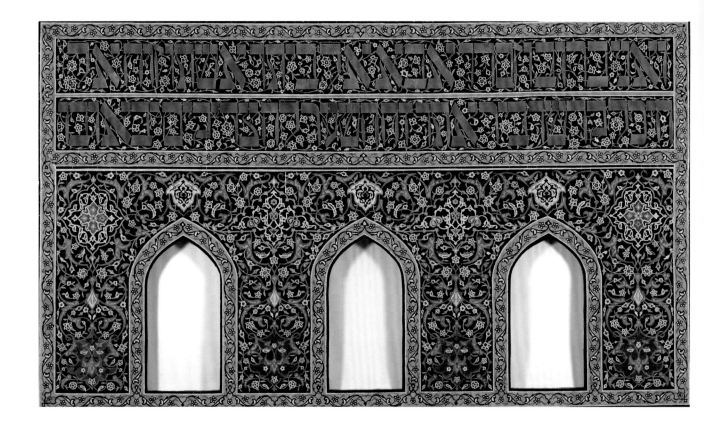

sixteenth-century Isfahan was made for a synagogue there (fig. 6.33). Individual fritware plaques from seventeenth-century Iznik present a stylized plan of the Sacred Mosque in Mecca, the holiest place in Islam, with the *Kaaba* in the court-yard's center (fig. 6.34). Apparently they were made as mementos for those who completed the pilgrimage to Mecca, or *Hajj*.

Among the religious souvenirs for Christians were "pilgrim flasks" such as the terracotta Byzantine examples made for devotees of Saint Menas/Mena. An Egyptian soldier in the Roman army who was martyred in 309 for refusing to recant his Christian faith, Menas is revered for his miraculous healing powers. According to the story referenced by the camels depicted on each side of his image on the molded flasks (fig. 6.35), when the camel carrying his corpse came to a well by Lake Mariout near Alexandria it wouldn't budge, and this was taken as a sign to bury him there. A later attempt to move his body proved unsuccessful; passing the same spot at the lake, the second camel refused to move, so the Roman governor had Menas permanently buried there. Pilgrims visiting the saint's shrine at Abu

Figure 6.33, facing. Tile wall set from a synagogue in Isfahan, Iran, made by potters of that town, 16th century. The Hebrew letters above the Torah scroll niches spell out 2 passages from the Book of Psalms. *Collection of the Jewish Museum, New York, thejewishmuseum.org.*

Figure 6.34, below. Fritware pilgrimage tile featuring the Great Mosque and *Kaaba* in Mecca, Saudi Arabia, made at Iznik, Turkey, 17th century. The three lines of Arabic are from chapter 3 of the *Qur'an*. *Collection of the Walters Art Museum, Baltimore, Maryland, https://thewalters.org. CC BY-SA 3.0, via Wikimedia Commons.*

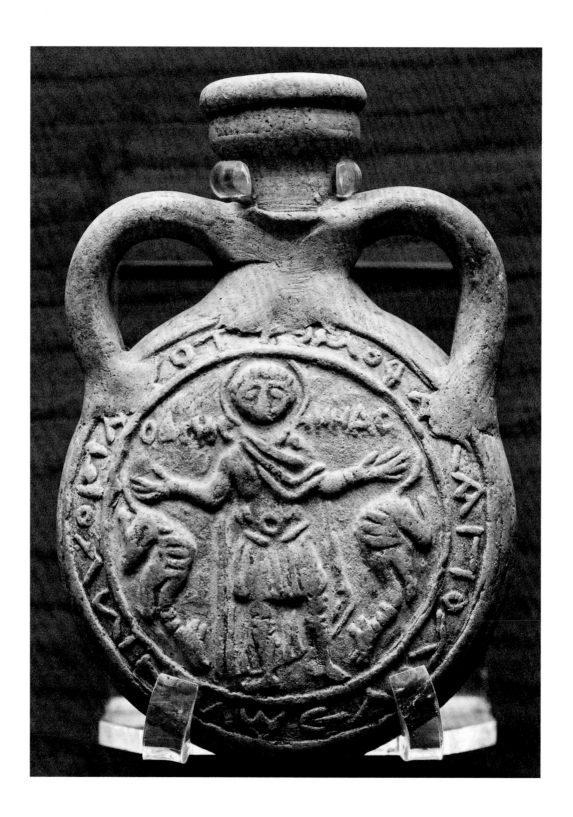

Figure 6.35, facing. Byzantine terracotta pilgrim flask with a molded image of Saint Menas flanked by two camels, probably made at Abu Mina near Alexandria, Egypt, 6th–7th century. *Collection of Musée du Louvre, www.louvre.fr. Photograph: Marie-Lan Nguyen, CC BY 3.0, via Wikimedia Commons.*

Figure 6.36, below. Stoneware *kendi* (pouring vessel for Buddhist ceremonies), Sawankhalok ware, Si Satchanalai, Sukhothai province, Thailand, 16th century. The panel at far left on this example shows an underglaze-painted *bodhisattva*. *Collection of Los Angeles County Museum of Art, www.lacma.org, public domain.*

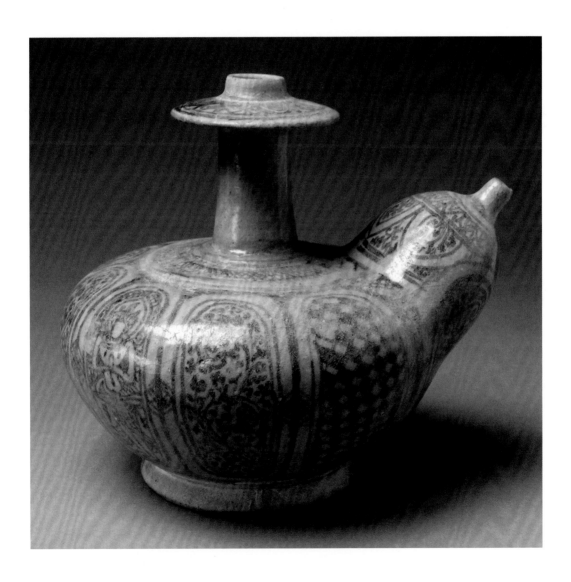

Figure 6.37, facing. Fritware mosque lamp signed by the decorator, Musli, and inscribed in Arabic with a saying by the Prophet Muhammad, made at Iznik, Turkey in 1549 (Western equivalent) for the Dome of the Rock shrine in Jerusalem. *Collection of British Museum, London, www.britishmuseum.org. Photograph: Aa77zz, CC0 1.0, via Wikimedia Commons.*

Figure 6.38, below. Salt-glazed stoneware holy-water stoup with Crucifixion relief, 6.4" high, Westerwald, Germany, 2nd half of 18th century. *Collection of Rijksmuseum, Amsterdam, Netherlands, https://www.rijksmuseum.nl.*

Figure 6.39, below. Hindus lighting terracotta *diyas* (Diwali lamps), Bangladesh, 2014. In that country (where Hindus are very much in the minority) the goddesses Kali and Lakshmi and the god Rama are honored in the "Festival of Lights." *Photograph: Khokarahman, CC BY-SA 4.0, via Wikimedia Commons.*

Figure 6.40, facing. Painted earthenware *olla* (jar) by Rose Chino Garcia (1928–2000), Acoma Pueblo, Cibola County, New Mexico, ca. 1995. She was one of 5 potter sisters, all of whom learned the art from their famous mother, Marie Zieu Chino, who, with her friend Lucy M. Lewis, helped to revive ancient Ancestral Pueblo pottery designs. *Courtesy of Andrea Fisher Fine Pottery, Santa Fe, New Mexico, www.andreafisherpottery.com.*

Mina for its healing powers brought home holy water or oil in the flasks, which archaeologists have found throughout the Mediterranean world.

Ceramics made specifically for worship have been important furnishings at religious sites as well as in homes around the globe. In Asia, a type of pouring vessel called a *kendi* provided libations in Buddhist and Hindu ceremonies (fig. 6.36). In Ottoman Turkey, decorated fritware lamps were made to hang in mosques (fig. 6.37). In Europe, stone holy-water fonts in Catholic, Anglican, and some Lutheran churches are placed at entrances for worshipers to dip their fingers in before crossing themselves, but folk potters in the seventeenth through nineteenth centuries made smaller stoups of earthenware and stoneware (called *bénitiers* in France) for domestic use by the more orthodox Christian faithful (fig. 6.38).

An important autumn festival for Hindu, Sikh, and Jain worshipers is Diwali/Deepavali (Tihar for Nepalese), which celebrates the victory of light over darkness. For some Hindus the event honors Lakshmi, goddess of prosperity and wife of Vishnu, the Supreme God. A main feature of the festival is the lighting of *diyas*, or saucer-shaped lamps, still often made simply of clay on the potter's wheel and fueled with ghee (clarified butter; fig. 6.39). To some, they represent the lights set out to guide Lord Rama (an avatar of Vishnu) and his wife, the goddess Sita (avatar of Lakshmi), back from their fourteen-year exile, as narrated in the ancient epic, *Ramayana*.

———◦———

In some societies, the actual making of pottery is considered an act of reverence: a way of giving thanks for the skill and natural materials that make the creative process possible. Traditional Pueblo potters of the American Southwest may sprinkle cornmeal on the ground where they dig their clay as an offering to Mother Earth and a request for the "blessing" that allows them to successfully transform the clay into a work of art (fig. 6.40).[9]

All great art, in whatever medium, can be understood as a union of divine spirit and human spirit—what we call inspiration. This partnership creates beauty that lifts us, at least temporarily, above our worldly concerns.

Notes

1. The expression "idols with feet of clay," normally applied to prominent people who are flawed, is derived from the Torah and Old Testament; Nebuchadnezzar, King of Babylon, dreams of a large idol made mainly of metal, but its feet are a combination of iron and clay,

materials that don't mix well. The prophet Daniel interprets this as predicting a future kingdom that "shall be partly strong, and partly broken" (Daniel 2: 41–43 [Auhorized Version]).

2. "Story of Creation," in Theodora Kroeber and Robert F. Heizer, *Almost Ancestors: The First Californians* (San Francisco: Sierra Club, 1968), 62.

3. Garry J. Shaw, *The Egyptian Myths: A Guide to the Ancient Gods and Legends* (New York: Thames & Hudson, 2014), 155, 157, and Veronica Ions, *Egyptian Mythology* (New York: Peter Bedrick, 1982), 33, 104.

4. Suzanne Staubach, *Clay: The History and Evolution of Humankind's Relationship with Earth's Most Primal Element* (New York: Berkley Books, 2005), 120, 204–207.

5. N. K. Sandars, *The Epic of Gilgamesh*, rev. ed. (Baltimore: Penguin, 1964), chap. 5, and Alexander Heidel, *The Gilgamesh Epic and Old Testament Parallels*, 2nd ed. (Chicago: University of Chicago Press, 1963). Baked clay as a medium for the written word reappeared when Chinese inventor Bi Sheng adopted it for the world's first movable printing type in the 1040s CE, four centuries before Johannes Gutenberg used mold-cast metal for the same purpose.

6. Carl Christian Dauterman, "Netherlands Beggar Beakers," *Metropolitan Museum of Art Bulletin*, n.s. 20:7 (March 1962): 232–235.

7. Lindsey King, *Spiritual Currency in Northeast Brazil* (Albuquerque: University of New Mexico Press, 2014), 89–90. For an overview of the practice in Greece and Rome, see Steven M. Oberhelman, "Anatomical Votive Reliefs as Evidence for Specialization at Healing Sanctuaries in the Ancient Mediterranean World," *Athens Journal of Health* 1 (March 2014): 47–62.

8. Jane Perryman, *Traditional Pottery of India* (London: A & C Black, 2000), chap. 6.

9. For Pueblo Indian cornmeal prayer offerings for pottery clay, see Rick Dillingham, *Acoma & Laguna Pottery* (Santa Fe, NM: School of American Research Press, 1992), 44; Susan Peterson, *The Living Tradition of Maria Martinez* (Tokyo: Kodansha International, 1989), 165; Stephen Trimble, *Talking with the Clay: The Art of Pueblo Pottery*, 2nd ed. (Santa Fe, NM: School of American Research Press, 1993), 10; and Betty LeFree, *Santa Clara Pottery Today* (Albuquerque: University of New Mexico Press, 1975), 9.

7 | RETURNING TO CLAY
Death and the Afterlife

Beneath this stone lies CATHERINE GRAY,

Changed to a lifeless lump of clay;

By earth and clay she got her pelf,

And now she's turned to earth herself.

Ye weeping friends, let me advise,

Abate your tears and dry your eyes;

For what avails a flood of tears?

Who knows but in a course of years,

In some tall pitcher or brown pan,

She in her shop may be again.

Epitaph on the grave of an earthenware seller at Chester, England[1]

WHAT HAPPENS TO US WHEN WE DIE REMAINS ONE OF THE GREAT mysteries of human existence. Goods (including pottery, of course) buried with the deceased in prehistoric times are mute evidence of early belief in some sort of afterlife; our species finds it difficult to accept that nothing follows the cessation of earthly life. Belief in an afterlife is one of the cornerstones of most religions, whose dogma tells us that our stay in this world is fleeting and that there's more to come (for better or worse). Some societies have a preoccupation with death, especially those in which the mortality rate is high, with constant reminders of the strong possibility that one could be next. That possibility existed among people who practiced human sacrifice to appease the gods, such as the Aztecs and Mayans of pre-Columbian Mesoamerica. A lidded jar from eighth-century Guatemala illustrates both the Mayan principle of dualism and the transience of human existence by contrasting a full-fleshed face on one half and the inevitable skeletal face on the other (fig. 7.1).

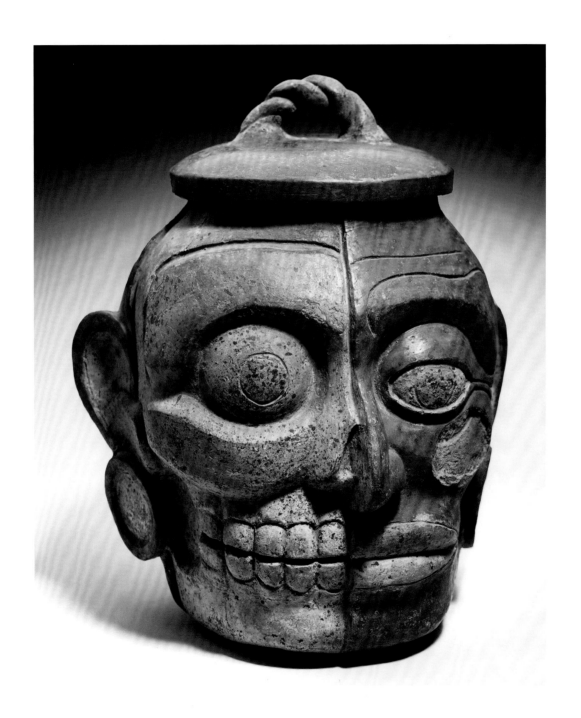

Figure 7.1. Mayan "living and dead" head pot, terra-cotta with white and burnished red slip, Guatemala, ca. 700 CE. *Photograph © 2017 Museum of Fine Arts, Boston, Massachusetts, www.mfa.org.*

Figure 7.2. *Barro negro* (black clay) skull made for *Día de Muertos* (Day of the Dead) with open base and holes for a candle inside to shine through, San Bartolo Coyotepec, Oaxaca, Mexico, 1995. *Private collection; photograph: author.*

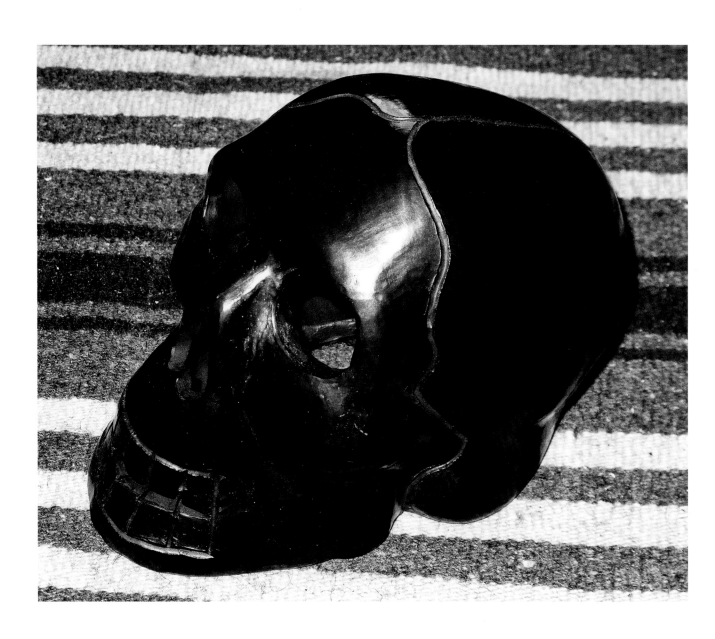

The Mexican festival known as *Día de Muertos* (Day of the Dead) honors spirits of the departed by acknowledging them as still among the living. The holiday, which has pre-Christian roots, was originally observed at the beginning of summer, but was later rescheduled in autumn to coincide with the Roman Catholic Allhallowtide (All Saints' Eve/Halloween, All Saints' Day, and All Souls' Day). Some see the celebration as morbid, with its communion in cemeteries with the spirits of departed relatives and friends and its images of skeletons and skulls in sweets and clay that are sold and displayed everywhere (fig. 7.2). Others see it as a healthy respect for death and a belief that the soul lives on to interact with the survivors.

Art from the Tomb

One way the ancient Greeks memorialized departed loved ones was to deposit a *pinax*, or votive plaque, with a painted mourning scene, often of terracotta (fig. 7.3), in the burial chamber. The illustrated example of about 520 BCE from the Athens area is typical, showing the deceased on his bier and survivors in mourning posture painted in red slip that turned black in a reduction firing (the "black figure" technique). The chariot race below may have been a reference to the funeral games held in honor of legendary heroes, a reminder that every race has its end, or the artist's way of saying, "Life goes on for the survivors, so enjoy it while you can."

In ancient Egypt, royal personages often were entombed with a group of "faience" *shabtis/ushabtis/shawabtis*, funerary figurines that would serve as surrogates to assume tasks the deceased was called upon to perform in the afterlife. Known as "answerers," their inscriptions assert their readiness to answer the gods' summons to work. The illustrated examples from the tomb of King Senkamanisken of Nubia, dating to about 630 BCE, have the usual mummy shape but with facial features individualized rather than all created from the same mold (fig. 7.4).

On a much grander scale is the now-famous Terracotta Army (fig. 7.5), part of the burial complex of China's first emperor and unifier, Qin Shi Huang, at Lintong (a suburb of Xi'an), Shaanxi province, discovered in 1974 by farmers digging a well. The three pits containing the army are estimated to house at least 7,000 soldiers and 600 draft and saddled horses, all of clay and slightly larger than life-size, 100 wooden war chariots, and innumerable bronze weapons, meant to defend the emperor's tomb. The army consists of heavy infantry wearing plate armor, light infantry, cavalrymen, archers, crossbowmen, charioteers, and officers of several ranks. The figures were assembled from hand-built parts, the soldiers' faces molded and then hand worked to individualize them. Inconspicuous marks (probably for quality control) so far include the names of eighty-five *gong shi*

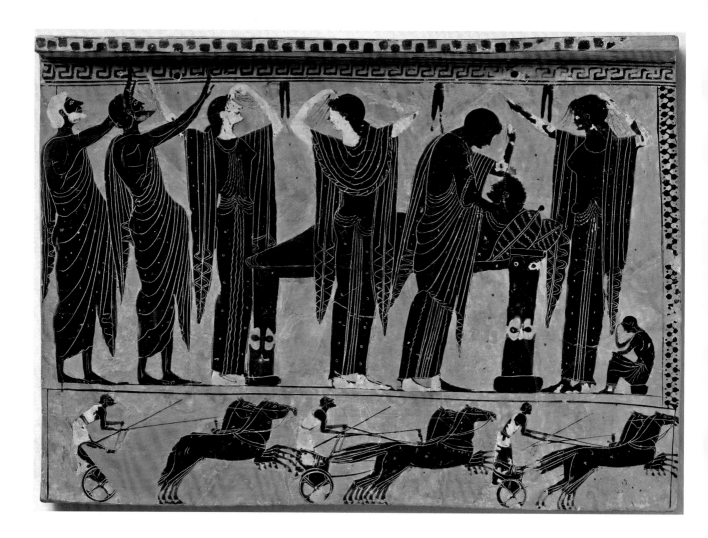

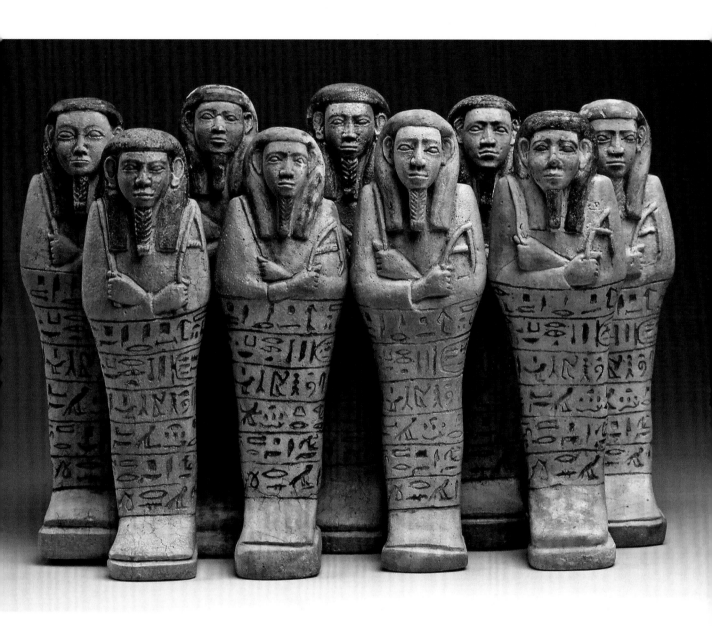

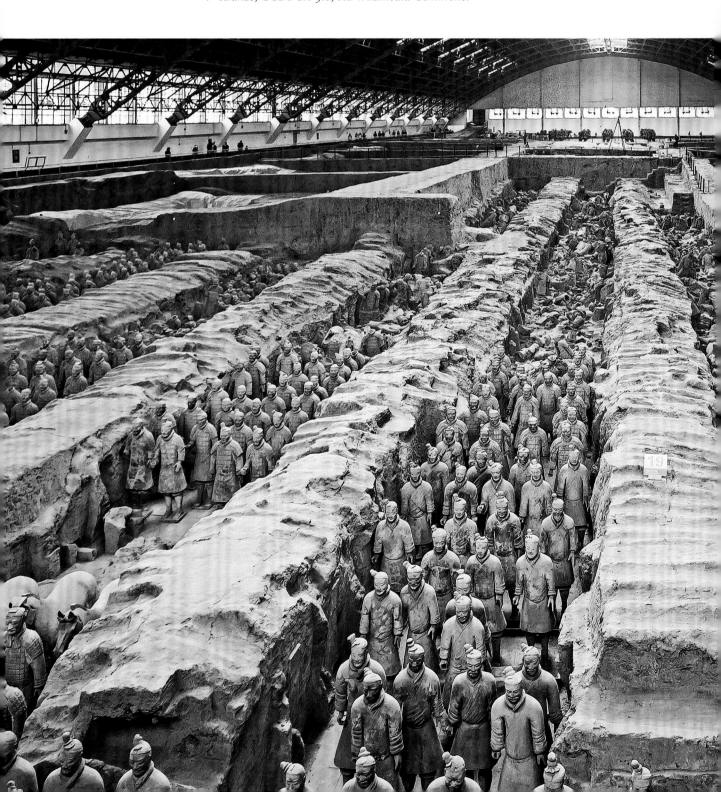

Figure 7.5. Pit No. 1 at Emperor Qinshihuang's Mausoleum Site Museum, estimated to contain over 6,000 slightly-larger-than-life-size terracotta statues of warriors and horses (1,000 of which have been excavated as the museum's main attraction), Lintong, Xi'an, Shaanxi province, China, 221–208 BCE. *Photograph: CEphoto, Uwe Aranas, CCBY-SA-3.0, via Wikimedia Commons.*

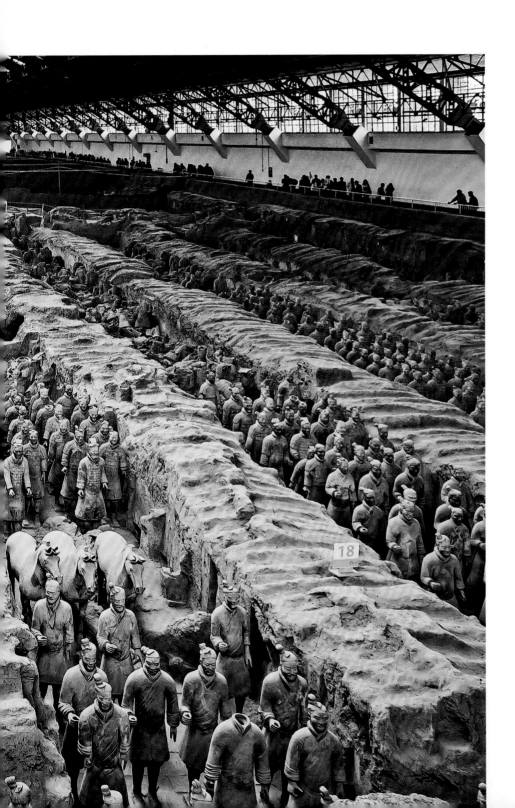

Figure 7.6, below. Burnished red-slip figure of an *itzcuintli* (hairless dog) from a shaft tomb, Colima, Mexico, 100 BCE–300 CE. Some Colima dog effigies have human mask-faces, perhaps representing the creature's inner spirit. *Collection of the Walters Art Museum, Baltimore, Maryland, https://thewalters.org., CC BY-SA 3.0, via Wikimedia Commons.*

Figure 7.7, facing. "Earth-spirit" figure, earthenware with *sancai* ("3-color") glaze, meant to be paired with another guardian figure at the entrance to a noble tomb, China, Tang dynasty, 7th–8th century CE. *Collection of Shanghai Museum, http://www.shanghaimuseum.net/en/. Photograph: Dennis Jarvis, CC BY-SA 2.0, via Wikimedia Commons.*

Figure 7.8. Terracotta *haniwa* horse, 47¾" tall, Japan, Kofun period, 6th century CE. *Collection of Los Angeles County Museum of Art, www.lacma.org, public domain.*

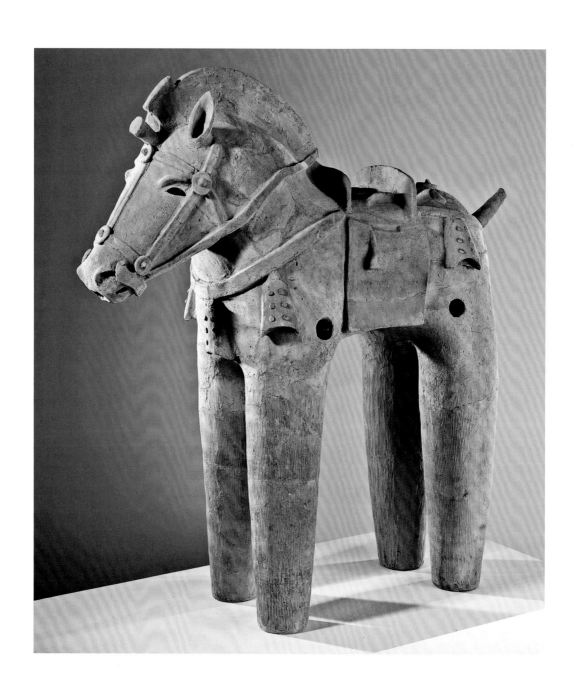

(master craftsmen), each of whom had eighteen assistants: a minimum of 1,615 artisans to create the army (the entire "mortuary garden" is said to have involved 700,000 laborers, many of them conscripts). Work stopped in 208 BCE, two years after the emperor's death. The pits lie to the east of the burial mound, which has yet to be excavated.[2]

From the Colima culture of western Mexico (200 BCE–200 CE), red-slipped figures of *itzcuintin* or hairless dogs (fig. 7.6) are often found in shaft tombs (vertical tunnels leading to burial chambers). Less fearsome than Cerberus, the three-headed dog of Greek mythology, they were associated with the Aztec underworld deity, Xolotl (himself often depicted as a monstrous dog), and served as guardians of the underworld and guides there for the newly departed.

In Tang dynasty China (618–907 CE), ferocious "earth-spirit" and *lokapala* (Buddhist warrior-protector) figures guarded noble tombs (fig. 7.7), perhaps serving the dual purpose of keeping intruders out and preventing the deceased's spirit from emerging to disturb the living. The early Chinese believed that an individual had two spirits: one left the body upon death, the other (the *po*) remaining inside the tomb until the body fully decomposed, supported by grave goods known as *mingqi* (spirit objects). From the Han (206 BCE–220 CE) through Ming (1368–1644 CE) dynasties, noble tombs were furnished with clay models of anything the deceased's spirit might need: houses and furnishings, watch towers, animals (see Chapter 5), and court attendants including musicians and dancers.

Potters of Japan's Kofun period (third to sixth century CE) made terracotta *haniwa*, or funerary sculptures, for the ruling elite, with warrior and horse figures being especially prevalent (fig. 7.8). According to the *Nihongi* (*Japanese Chronicle*), the Emperor Suinin, in 3 CE, decreed that the compulsory "following in death" of a deceased noble person's retainers and animals was to be replaced by these clay figures.[3] Unlike the preceding examples, they were not buried in the tomb, but placed on the funeral mound; then in later times they were set toward the outside of the grave area, perhaps as boundary markers, the animal-shaped examples arranged in a line.

Containers for the Dead

The impressive tomb of Bibi Jawindi, great-granddaughter of Sufi saint Jahaniyan Jahangasht, at Uch Sharif in Punjab province, Pakistan, is covered with tiles made at Multan, still a major Pakistani pottery center known for its blue-decorated, tin-glazed earthenware. The shrine is said to have been built by an Iranian prince, Dilshad, in 1493, and in later centuries suffered heavy erosion damage; it's on the list of tentative UNESCO world heritage sites (fig. 7.9).

Figure 7.9. Tomb of Bibi Jawindi at Uch Sharif, Punjab, Pakistan, decorated with blue tin-glazed tiles from Multan. Built in 1493 and part of a complex of other tombs, graves, and a mosque, the structure has suffered severe erosion damage. *Photograph: Shaun Metcalfe, CC BY 2.0, via Wikimedia Commons.*

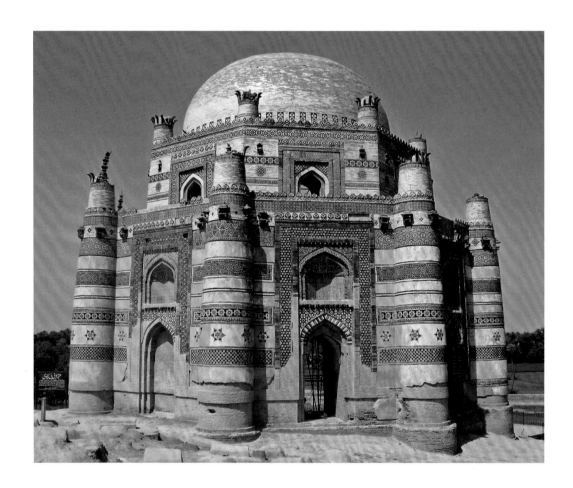

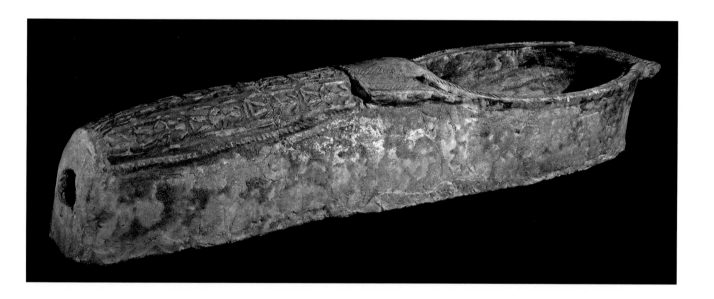

In the ancient Middle East, slab-built earthenware coffins were not uncommon, some with stylized images of the deceased sculpted on the lid. One type is referred to as a "slipper coffin" because from the side it resembled a giant slipper; the corpse was slipped into it through the opening at the head end. So-called Parthian examples from Iraq are coated with a low-fired alkaline glaze (fig. 7.10).[4] In Minoan Crete, lidded terracotta chests with painted decoration, known as *larnakes*, were used to inter cremated ashes or the body bent on itself (fig. 7.11). Similarly, pre-Columbian Brazilian Indians on Marajó Island and the lower Amazon made elaborately sculpted and painted burial urns, some in human shape (fig. 7.12).[5]

Etruscan potters of pre-Roman Italy also made terracotta burial vessels. Two of the most remarkable were found during nineteenth-century excavations of the necropolis at Caere (today's Cerveteri) and date to about 520 BCE. Known as the "Sarcophagi of the Spouses," each depicts a finely sculpted couple reclining as at a

Figure 7.11, below. Painted terracotta *larnax* (chest-shaped sarcophagus), Minoan Crete, Greece, 13th century BCE. *Collection of Archaeological Museum Heraklion, Crete, www.heraklion.gr. Photograph: Jebulon, CC0 1.0, via Wikimedia Commons.*

Figure 7.12, facing. Terracotta anthropomorphic (female) burial urn, Marajó Island, Pará, Brazil, 1000–1250 CE. *Collection of American Museum of Natural History, New York, www.amnh.org. Photograph: Daderot, CC0 1.0, via Wikimedia Commons.*

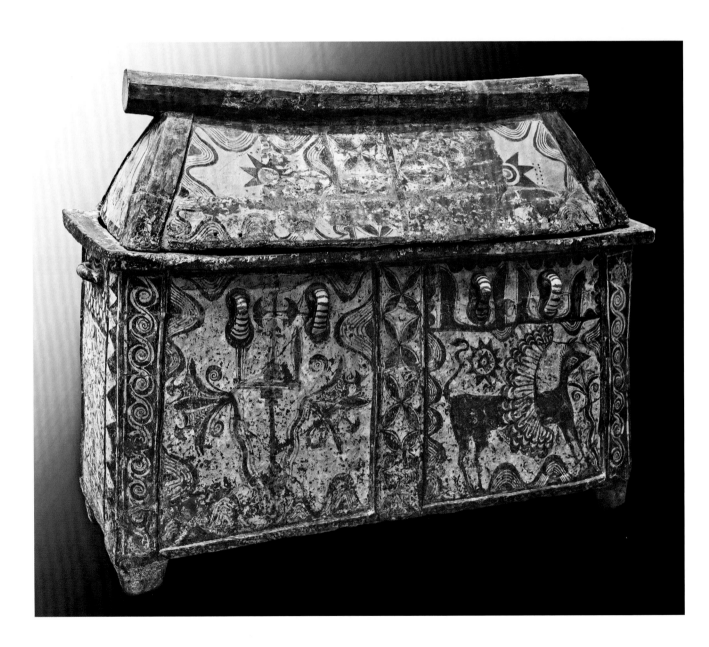

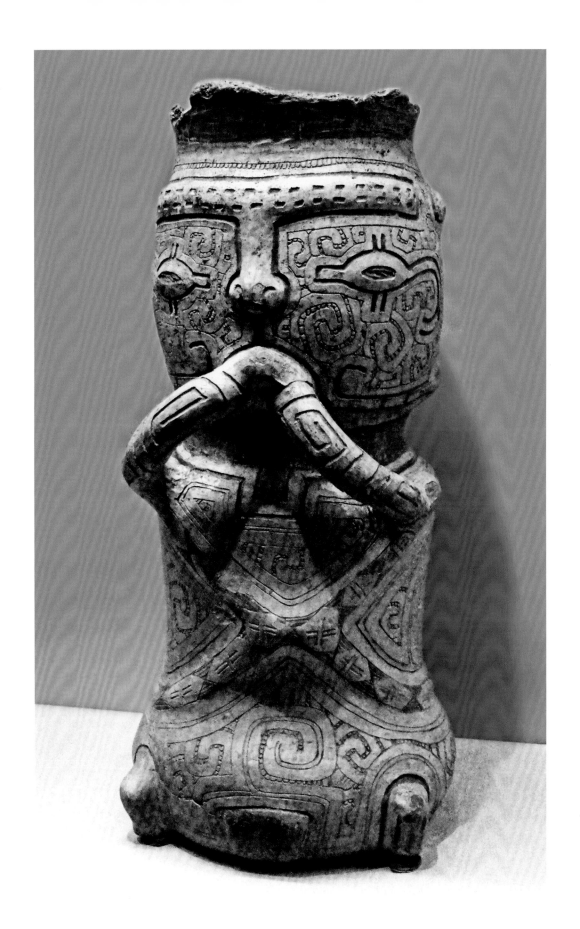

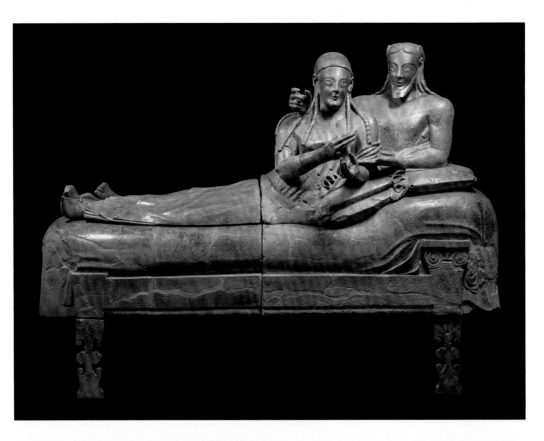

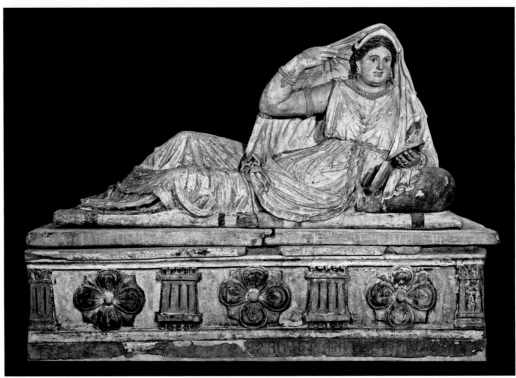

banquet. One is now displayed in the National Etruscan Museum of Villa Giulia in Rome (fig. 7.13), the other at the Louvre in Paris. A later Etruscan sarcophagus found at Poggio Cantarello, and now in the British Museum, displays on its lid a modeled portrait of a well-to-do woman identified in the inscription as Seianti Hanunia Tlesnasa. Retaining some original paint, it contained the bones of a female aged about fifty (fig. 7.14).

Grave Markers

After discovering ceramic cemetery markers in my Georgia research, I learned they were made throughout the South, from Virginia's Shenandoah Valley all the way to Texas. Based on the death dates on those with inscriptions, most were created during the hard times after the Civil War as alternatives to more expensive stone, where there were potters to provide them for their own families or neighbors and even to market commercially. Although fired clay is a reasonably durable material, it is still subject to weathering and breakage, so not many examples survive today. Ceramic grave markers are not uniquely American, however; they are found in many parts of the world, their widespread distribution likely due to polygenesis (local necessity and custom) rather than diffusion of the concept.

Not bound by a container function like much pottery, these objects display great diversity in form and decoration, limited only by the potter's ingenuity and skill. Based on construction, they can be divided into four types: the slab form similar in appearance to a tombstone, its flat face inscribed with information about the deceased; the hollow wheel-thrown type, not always inscribed; the cruciform type, fashioned by wheel, hand, or mold and sometimes rusticated to resemble tree bark; and the molded and rusticated stump type (symbolizing a person cut down like a tree, as with stone markers for members of Woodmen of the World, a fraternal society). Related pottery planters and flower holders, either wheel thrown or molded, were also made specifically for use in cemeteries.

Figure 7.15, below. Fritware memorial tablets, Iran, 17th century, as displayed in the Victoria and Albert Museum, London, https://www.vam.ac.uk. *Photograph: author.*

Figure 7.16, facing. Patent for two-part stoneware grave marker combining slab and wheel-thrown types, granted to folk potters W. P. and W. D. Loyd of Itawamba County, Mississippi, 1879. *United States Patent and Trademark Office, Alexandria, Virginia, https://uspto.gov.*

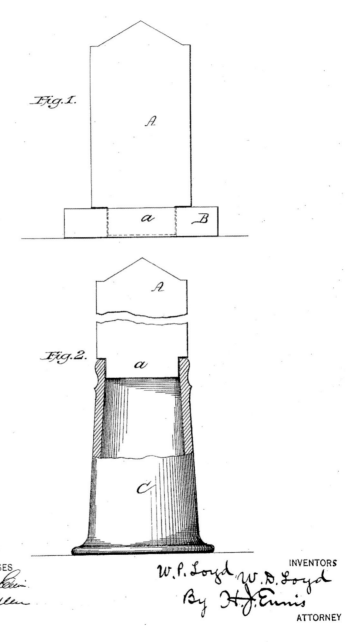

Memorial tablets of the slab type were made of fritware in seventeenth-century Iran, with inscriptions and elaborate borders painted on the white face. The Persian inscription on the example at upper left in my photo (taken at the Victoria and Albert Museum; fig. 7.15), probably from Tabriz and dated 1627 (Western equivalent), translates in part, "At the throne of thy mightiness, oh pardon granter, into the corner of the grave I have fallen lamenting and miserable; from thee [comes] all mercy and from me, fault. I am nothing, thou art all, grasp my hand."

In the collections of The Potteries Museum and Art Gallery of Stoke-on-Trent there is a brown salt-glazed stoneware slab marker from Burslem, Staffordshire, hand-inscribed in block letters for a seventeen-year-old girl who died in 1790. And fragments of three alkaline-glazed stoneware slab markers signed "F. E. JUSTICE / MAKER," with death dates of 1868 and 1873, were found in an Edgefield District, South Carolina, cemetery. Justice was an African-American potter who uniquely inscribed each marker by carving block letters and a cross or heart into the leather-hard face and inlaying with white clay before glazing and firing.[6]

In 1879 William Payne Loyd and his son, William Dickinson Loyd, Alabama potters who had moved to Tremont, Itawamba County, Mississippi, were granted a US patent for a slot-and-tab joint that combined the slab and wheel-thrown types of grave marker (fig. 7.16). The open top of the thrown base was to be pushed partly in when still pliable, creating a slot to receive the tenon at the bottom of the molded slab. Produced by the Loyds and other folk potters for sale or for their own families, these two-piece markers usually were of salt-glazed stoneware, the slab's face inscribed by filling printer's-type impressions with cobalt blue; incised or stamped designs (e.g., a weeping willow) sometimes were added. Hilliard Falkner of Alabama's Jugtown in Shelby County, however, made them with a lime-based alkaline glaze. These distinctive markers have been found in both Mississippi and Alabama cemeteries.[7]

In the nineteenth and early twentieth centuries, male Bakongo potters in what is now the Democratic Republic of the Congo used a tournette (turntable) to fashion cylindrical *mabondo* (singular: *diboondo/dibondo*) to be placed on high-status graves, their embossed designs said to represent the path the deceased takes in

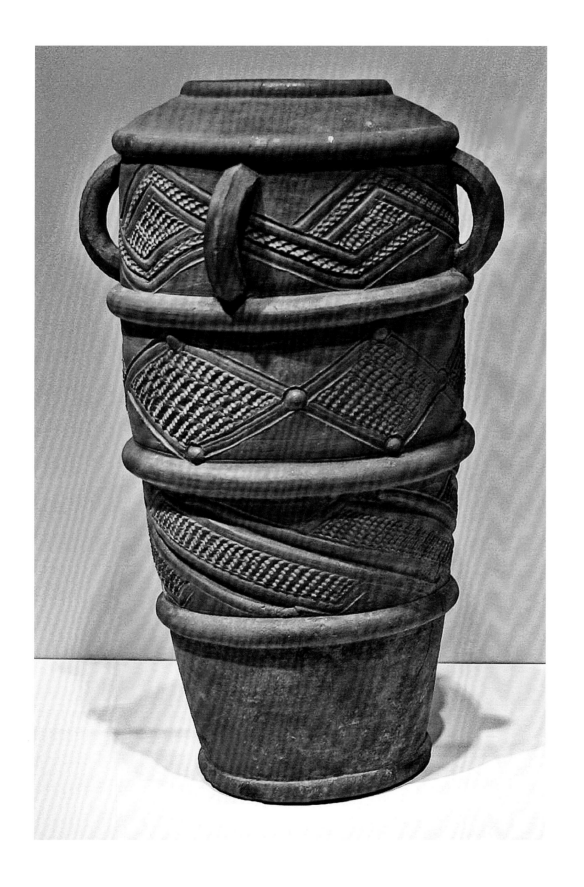

Figure 7.18, below. Salt-glazed stoneware grave markers, wheel-thrown in what could be described as the "Tastee-Freez" shape, attributed to Daniel Cagle, Whynot, Randolph County, North Carolina, late 1800s. *Private collection; photograph: author.*

Figure 7.19, facing. Cruciform grave marker combining wheel-thrown segments, salt-glazed stoneware with cobalt-blue highlights and inscription, Westerwald, Germany, ca. 1883. *Collection of Museum Wiesbaden, Germany, https://museum-wiesbaden.de /en. Photograph: author.*

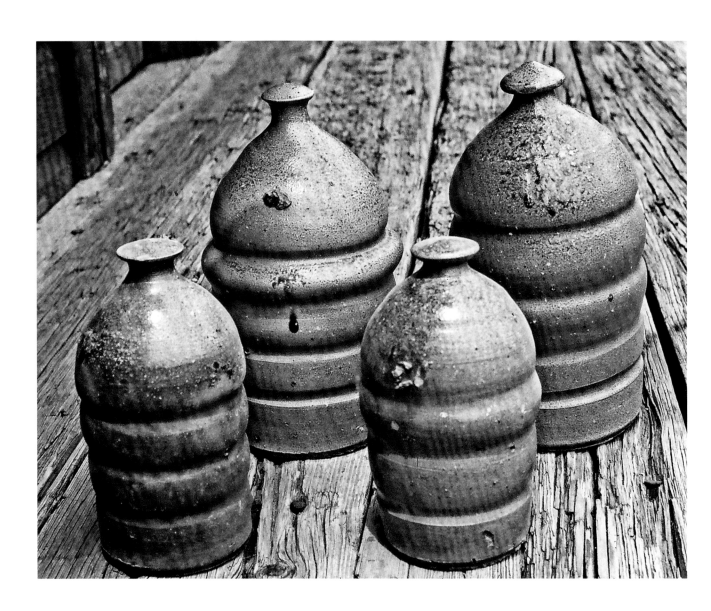

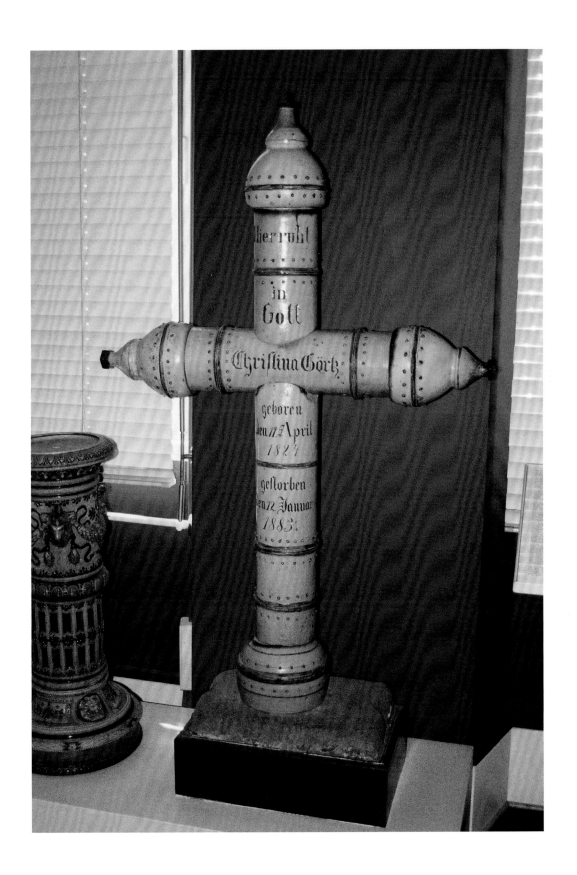

Figure 7.20. Cruciform grave marker of rusticated, brown salt-glazed stoneware made at Errington and Reay pottery, Bardon Mill, Northumberland, England, 1880s. *Photograph: author.*

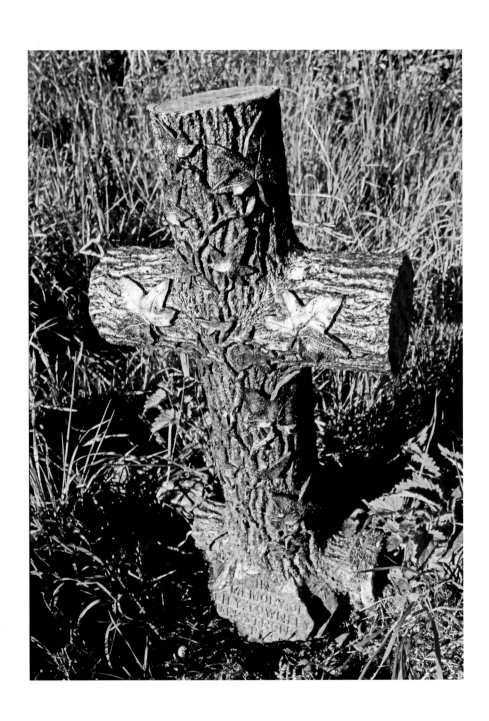

Figure 7.21. Tree-stump grave marker of rusticated, brown salt-glazed stoneware in Alloway Auld Kirk cemetery, Ayrshire, Scotland, perhaps made in Glasgow, ca. 1868. *Photograph: author.*

Figure 7.22. Stoneware grave markers by Gerald Stewart, the wheel-thrown examples with brown Albany slip and white Bristol glazes, the post unglazed but for Albany-slip marking, Louisville, Winston County, Mississippi, 3rd quarter of 20th century. *Photograph: author.*

journeying to the otherworld (fig. 7.17). Some examples are pierced with holes of diamond, triangle, or square shape or have applied or incised human or animal figures. One scholar describes the diboondo as "an exquisite shell of honor around . . . the presence of an unseen spirit."[8]

In the American South, wheel-thrown markers, most of stoneware—glazed and unglazed, inscribed and uninscribed—were made in several states, including Georgia and North Carolina (fig. 7.18).[9] Also using the potter's wheel, late nineteenth-century potters in Germany's Westerwald region created cruciform markers composed of salt-glazed stoneware segments bolted together by an internal iron armature, the inscription filled with cobalt blue (fig. 7.19).

For rusticated examples of the cruciform and tree-stump types I offer two markers from Great Britain, both of brown salt-glazed stoneware. The first (fig. 7.20), with a hand-modeled, applied leafy vine, was made in the 1880s as a one-off for the grave of a drowned girl by Errington and Reay, makers of extruded stoneware drainpipes at Bardon Mill, Northumberland. The second, in Alloway Auld Kirk cemetery, Ayrshire (where poet Robert Burns's father, William, is buried), stands over the grave of a gamekeeper who died in 1868, according to the inset metal plaque (fig. 7.21). It likely was made at a semi-industrial stoneware factory, perhaps in Glasgow.

The tradition of ceramic grave markers in the American South continued into the twentieth century. When I visited folk potter Gerald Stewart of Louisville, Winston County, Mississippi, in 1973 he was making simple wheel-thrown cylindrical markers partially glazed with Albany slip; the name of the deceased was incised through the glaze. He would make four to be placed as boundary markers at the corners of an individual grave or family plot (plus an extra in case one was damaged in the firing), charging three dollars apiece. Stewart said his brother James originated these; he took me to a local cemetery to see examples in situ, some with white Bristol glaze, as well as oblong posts used for the same purpose (fig. 7.22).[10] Southern potters who have recently revived the making of wheel-thrown grave markers include Clint Alderman of Georgia and Vernon Owens, Sid Luck, Mark Hewitt, and Daniel Johnston of North Carolina.[11]

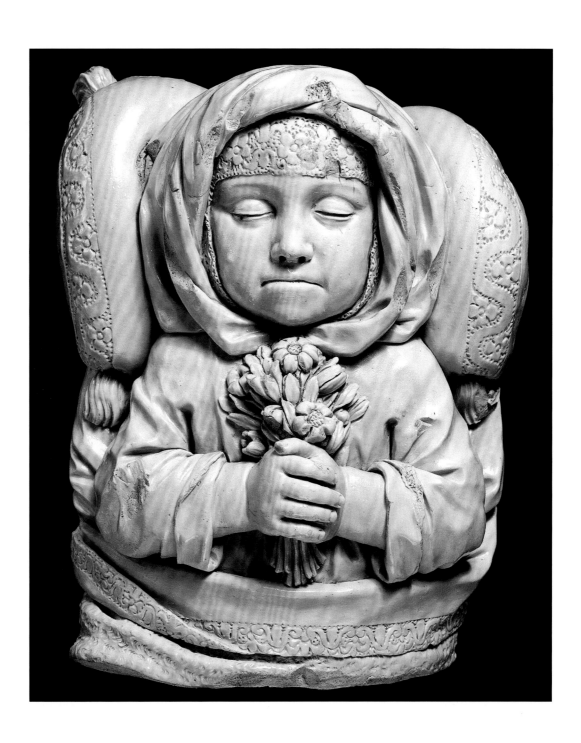

Two Anomalies

Lying in a Georgia cemetery is a group of six molded, Albany-slip glazed grave covers (fig. 7.23), the number of segments making them up depending on the size of the deceased (one for a newborn, two for an older child, three for adults). Applied to the edges of these odd "sewer-tile" stoneware objects are extruded cylindrical flowerpots, one each at the head and foot with shorter pockets along the sides, all with scalloped tops. The covers are decoratively embossed and hand-lettered, with death dates ranging from 1880 to 1895.

These seem to be ceramic equivalents of the cast-iron covers patented in 1873 by civil engineer Joseph R. Abrams of Greenville, Alabama, meant to protect graves from erosion. The December 2, 1874 issue of the *Union & Recorder*, published at Milledgeville, Georgia, printed a letter to the editor about the nearby Stevens Pottery, founded by Englishman Henry Stevens in 1858. According to the letter, "Mr. [Charles] Capels (an Englishman) bosses the Pottery, and is a superior workman in his line of business, introducing many things needful, such as . . . coffins, grave tops or slabs—all made of clay, burnt and painted any color desired." It's likely, then, that the items in question were made at Stevens Pottery or a similar semi-industrial operation.

The second anomaly moved me to tears when I saw it firsthand years ago in London's Victoria and Albert Museum (fig. 7.24). A small (just ten inches high) death effigy in salt-glazed stoneware, it was made at John Dwight's pottery in Fulham, near London, and depicts in repose John's six-year-old daughter, Lydia, who died, according to the inscription, on March 3, 1673. Dwight was trained as a chemist; his early efforts in clay attempted to discover the secrets of porcelain manufacture. His success, however, came with the development of Britain's first commercially viable stoneware that could compete with German imports, drawing his workers from London-area delftware (tin-glazed earthenware) operations. One innovation was the creation of figures modeled in stoneware clay. The finest of these, such as the portrait busts of Charles II and Prince Rupert of the Rhine, are attributed to sculptor Edward Peirce, but others simpler in style, such as the Lydia Dwight portrait, are perhaps by another artist.[12]

What was the purpose of this powerful little effigy? I would liken it to the late-Victorian photographs of corpses laid out for their funerals, taken as mementos for the surviving families. *Memorialization* best describes such ways of keeping alive the memory of departed loved ones, maintaining in a rationalistic way an ancient belief in the connection between the living and the dead.

Notes

1. William Andrews, *Curious Epitaphs Collected from the Graveyards of Great Britain and Ireland* (Hull, UK: Charles Henry Barnwell, 1883), 45. The fact that variations in this "epitaph" were printed elsewhere, and that John Abraham Fisher included it as "a glee for three voices" in his *A Comparative View of the English, French and Italian Schools, Consisting of Airs and Glees . . .* (Edinburgh: Corri & Sutherland, n.d., ca. 1790), suggest that it may be apocryphal.

2. Jane Portal, *The First Emperor: China's Terracotta Army* (Cambridge, MA: Harvard University Press, 2007), and Roberto Ciarla, ed., *The Eternal Army: The Terracotta Soldiers of the First Emperor*, rev. ed. (Novara, Italy: White Star, 2012).

3. Herbert H. Sanders, *The World of Japanese Ceramics* (Tokyo: Kodansha International, 1967), 41.

4. Andrew Middleton, St. John Simpson, and Antony P. Simpson, "The Manufacture and Decoration of Parthian Glazed 'Slipper Coffins' from Warka," *British Museum Technical Research Bulletin* 2 (2008): 29–37, and Julia Lawson, "The Resurrection of Seven Clay Coffins from Nippur," *Expedition* (University of Pennsylvania Museum of Archaeology and Anthropology), 48:3 (2006): 44–48.

5. Margaret Young-Sánchez, *Marajó: Ancient Ceramics from the Mouth of the Amazon* (Norman: University of Oklahoma Press, 2011).

6. Carl Steen, *An Archaeological Survey of Pottery Production Sites in the Old Edgefield District of South Carolina* (Columbia, SC: Diachronic Research Foundation, 1994), 106–110.

7. Joey Brackner, *Alabama Folk Pottery* (Tuscaloosa: University of Alabama Press, 2006), 30–31, 36–39, 137–138, 183–185; Patti Carr Black, ed., *Made By Hand: Mississippi Folk Art* (Jackson: Mississippi Department of Archives and History, 1980), 66; William T. Thornton, "Loyd-style Stoneware or Pottery Grave Markers," *Terry Thornton's Hill Country of Monroe County Mississippi* (March 20, 2010), http://hillcountryhogsblog.blogspot.co.uk/2010/03/loyd-style-stoneware-or-pottery-grave.html; and Mona Robinson Mills, "William Payne Loyd, Itawamba Potter," *Itawamba Connections* (February 16, 2009), http://itawambaconnections.blogspot.co.uk/2009/02/william-payne-loyd-itawamba-potter.html (both accessed August 18, 2016).

8. Robert Farris Thompson and Joseph Cornet, *The Four Moments of the Sun: Kongo Art in Two Worlds* (Washington, DC: National Gallery of Art, 1981), 77.

9. Charles G. Zug III, *"Remember Me as You Pass By": North Carolina's Ceramic Grave Markers* (Seagrove: North Carolina Pottery Center, 2011); M. Ruth Little, *Sticks & Stones: Three Centuries of North Carolina Gravemarkers* (Chapel Hill: University of North Carolina Press, 1998), 84–85; and John A. Burrison, *Brothers in Clay: The Story of Georgia Folk Pottery*, rev. ed. (Athens: University of Georgia Press, 2008), 68, 125–126, 154–155, 209, and plate 7.

10. John A. Burrison, "The Living Tradition: A Comparison of Three Southern Folk Potters," *Northeast Historical Archaeology* 7–9 (1978–1980): 37.

11. Zug, *"Remember Me as You Pass By,"* nos. 26–34.

12. Chris Green, *John Dwight's Fulham Pottery: Excavations 1971–79* (London: English Heritage, 1999), 81–83.

8 | LIVING TRADITIONS TODAY
Continuity, Change, Revival

This place here will go when I go. This place will go with me, 'cause there'll be nobody else to carry it on. And, without it, what they can get here, they can't get anywhere else.

Folk potter Lanier Meaders of Mossy Creek, Georgia, 1968[1]

IN ONE RESPECT, LANIER WAS CORRECT: SINCE HIS DEATH IN 1998, THE original Meaders Pottery site where he worked is now overgrown with weeds. But in a more important way he was wrong, and a good thing, too. In 1968 Lanier was Georgia's last old-fashioned folk potter, still digging his own clay, refining his alkaline stoneware glazes in a hand-turned stone mill, "turning" his pots on a foot-powered treadle wheel, and "burning" with wood the "tunnel" kiln he built himself, much as his father, Cheever, had done. A half-century later, some thirty traditional potters ply their craft at Mossy Creek and Gillsville, in the same northeast corner of the state that was home to Lanier. He could not have predicted how things would develop, of course, but his obituary for the tradition was, as it's turned out, premature. And therein lies a cautionary tale.

It is not unusual for the fortunes of pottery traditions to experience cycles of decline and revival throughout their histories. In some cases, the spark that kept a tradition alive appears to have been extinguished, only to be fanned back into flame by one or two individuals determined to pick up the torch. In the case of northeast Georgia, it was the stubborn persistence, creative vision, and relative financial success of a few potters of the Meaders and Hewell families, as well as the outside attention their work attracted, that encouraged relatives and other locals to immerse their hands in clay. Returning to the craft they'd left earlier for more lucrative jobs, or learning from kin and neighbors, they carry on the tradition today. Although their work may have connections to that of Cheever Meaders and his nineteenth-century predecessors, it is not the same; Lanier and his mother, Arie, pushed the utilitarian tradition that served the needs of farming folk toward

more decorative wares geared mainly to collectors, and that is how most of today's Georgia folk potters now make their living.[2]

Along with northeast Georgia, North Carolina is the last stronghold of Euro-American folk pottery today. As mentioned in Chapter 3, North Carolina's revival began in 1921 with the founding of Jugtown Pottery. Collectors now flock to Seagrove, where there are about a hundred workshops (but only a dozen or so rooted in the local tradition). North Carolina's other active center, the Catawba Valley (Lincoln and Catawba counties), saw its revival begin in the 1980s when young Charles Lisk, Kim Ellington, Steve Abee, and others got excited about the ash-glazed stoneware of the great Burlon Craig (inheritor of a tradition begun there in the 1840s by Daniel Seagle) and embraced him as a mentor.[3] The annual Catawba Valley Pottery and Antiques Festival in Hickory is the go-to venue for that tradition.

I'll return to the United States and address Native American pottery traditions later, but first I'd like to explore the recent state of affairs in other countries, beginning with my own fieldwork in the British Isles, where I've had the privilege of knowing what may be the last practicing folk potters of England and Ireland—a story quite atypical of what is happening in much of the world. For me, the question of folk pottery's survival in the industrialized West has been of particular interest.

With England as the birthplace of the Industrial Revolution, one would expect it to have been tough going for the small-scale, hand-based "country potteries" in the shadow of factories like those of Staffordshire, and indeed it was. My Yorkshire friend and pottery scholar Peter Brears estimated that in 1900 about a hundred of the old shops were active; when I came on the scene in the mid-1970s, only four had survived.[4] What has since become of them? Wetheriggs Pottery in Cumbria closed in 2008, after being run by a succession of young potters (Jonathan Snell [see fig. 1.5], Peter Strong, and Mary Chappelhow) who replicated the slipware of the original Schofield-Thorburn family there; Farnham Pottery in Surrey was sold to Farnham Buildings Preservation Trust in 1998 after brothers David and Philip Harris, fifth-generation descendants of the founder, retired; and Errington Reay & Co. Ltd. (Bardon Mill Pottery) in Northumberland, while still in business producing salt-glazed stoneware garden wares, lost much of its connection to the founding family when David Reay died in 2012. What remains to consider is the most traditional of the four shops I visited: Littlethorpe Pottery, below Ripon in North Yorkshire.

Established in 1831, Littlethorpe is now operated by Roland ("Roly") Curtis (fig. 8.1). Roly took over in 1972 from his father, George, who began there as a

Figure 8.1. Roland ("Roly") Curtis throwing a planter at Littlethorpe Pottery, Ripon, North Yorkshire, England, 1991. *Photograph: author.*

clay boy and apprentice to "big-ware" thrower Albert Kitson. In the late 1800s the old potter's wheel, hand-cranked by an assistant, was replaced by one powered by steam, later converted to electricity. Aside from a few other technological changes, a workforce reduction from about ten in 1915 to just Roly, and a shift in product emphasis from lead-glazed farm wares to unglazed horticultural pots, on my visits the operation remained much as it was in the nineteenth century.

The good news here is that Roly no longer works alone but has been joined by his son, Mark, holding out hope that Littlethorpe will continue with the next generation. In my recent contact with Roly he had this to say:

> Littlethorpe Pottery is continuing much as before, with the production process being unchanged. When we last met [July 1996] most of our sales were to trade outlets for selling on, but our business is now almost 100% retail thanks to the internet. Son Mark has introduced "The Littlethorpe Pottery Experience" which is a one-day, very hands-on course with people actually doing the whole process themselves right from digging the clay to making their own pots. . . . Mark now works at the pottery three days each week and is rapidly becoming an excellent thrower.[5]

Ireland's postmedieval and recent pottery history has received much less attention from researchers than that of England, but there is more there than meets the eye, as suggested in my introduction. No one knew that story better than the late Megan McManus, who said this about Paddy Murphy of Enniscorthy, County Wexford: "[H]e was the last traditional potter."[6] Paddy's career began at Carley's Bridge, Ireland's oldest continuous pottery operation, established in the 1650s by two brothers from Cornwall. About 1830 a potter surnamed Brickley arrived to work there. His son, Samuel, followed in his footsteps, with Samuel's great-grandson, Paddy Murphy, picking up the mantle at age fourteen to eventually become the master potter. In 1980 Paddy left Carley's Bridge to open his own Hillview Pottery nearby, where I visited him in 1986 (fig. 8.2).

Before the 1940s Carley's Bridge potters made lead-glazed milk crocks, pans, and jugs, but demand for such farm wares declined and the emphasis shifted to terracotta garden pots, as with England's Littlethorpe and Farnham potteries (country potters had always made a limited amount of horticultural wares). Paddy

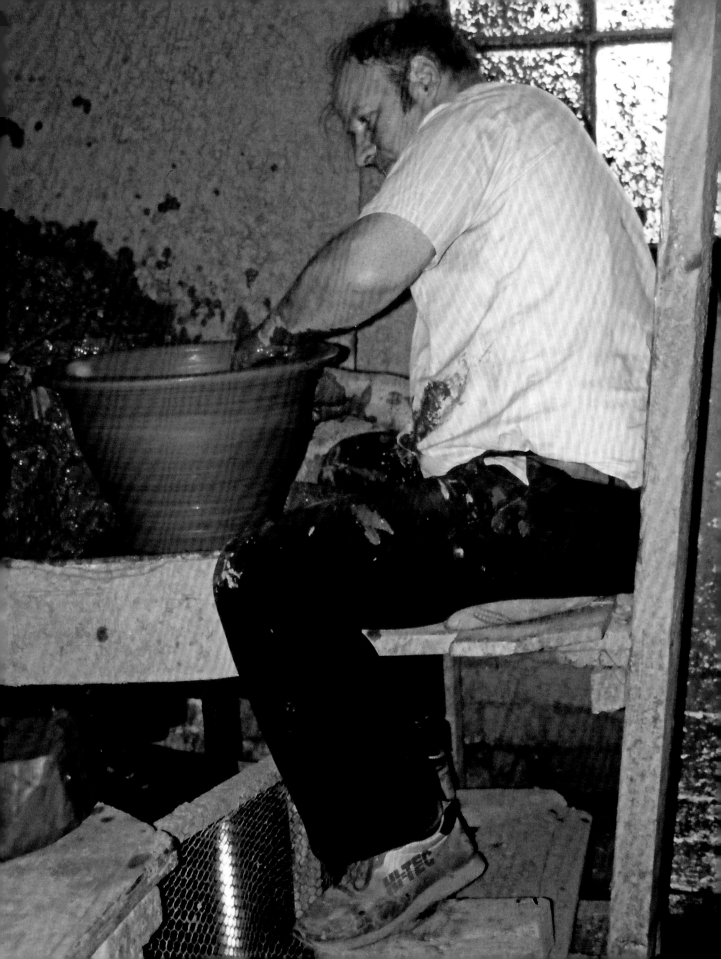

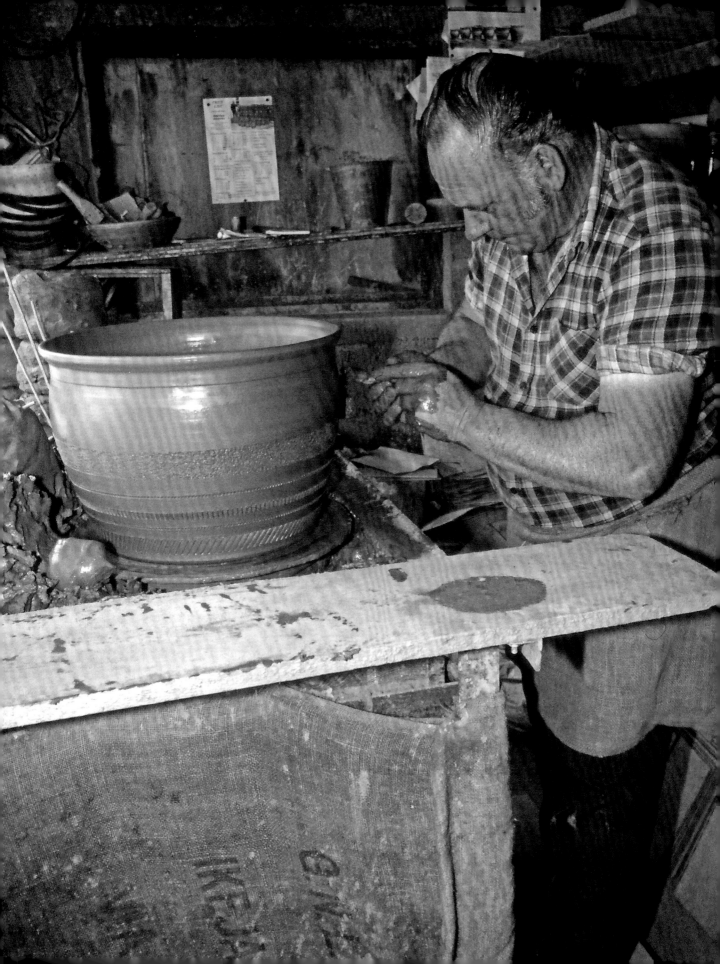

told me that he was considering reviving the glazed earthenware of his forebears but was understandably concerned about the toxicity of lead glaze, so I left him contact information for potters using similar-looking but safer alternatives. He was also having trouble with bits of lime in his locally dug marl (earthenware clay) and had recently installed a filter press to combat the problem.

With the larger-scale Carley's Bridge Pottery up the road producing a handsome line of hand-thrown plant pots and competition from imports on the Irish market, it became a struggle for Paddy to keep his one-man workshop going. In 1997 he was quoted as saying, "Now I only go out to the wheel for half a day now and again. . . . I used to glory in making pots. And it was lovely, when the day would be over, to stand and look at what pots you've turned out and say, well, they're made to my satisfaction now."[7] Not long thereafter, Paddy was gone, with Hillview in the hands of his young nephew, Derek O'Rourke. Clearly, O'Rourke learned something from his uncle, but the wares shown on his Hillview Pottery Facebook page,[8] with the exception of terracotta planters and the chimney cowls Paddy also made to keep birds from nesting in chimneys, are glazed in bright colors and look like the crafts-fair work of a school-trained potter, perhaps his strategy for appealing to a contemporary clientele.

Produced in 1980, episode 19 of David and Sally Shaw-Smith's excellent documentary film series for RTÉ (*Raidió Teilifís Éireann*), *Hands*, has Paddy Murphy saying, "There's nobody to follow me; I am the last."[9] Note how similar this pronouncement is to that of Lanier Meaders quoted at the head of this chapter. But just as Lanier had no way of knowing how the north Georgia revival he helped to fertilize would blossom, Paddy could not have predicted in 1980 that the seed planted in his nephew would bear fruit. Is Derek O'Rourke Ireland's next-generation folk potter? Time will tell.

A Plethora of Potters: Selective Survey

Without doubt, there are places in the world where traditional pottery making is alive and well. My folklorist friend, Henry Glassie, has devoted a good part of his career to documenting some of those places. His study of the 500-year-old potters'

Figure 8.3. *Çini* plate by Nurten and Ahmet Hürriyet Şahin (daughter-in-law and son of the master Ahmet Şahin), Kütahya, Turkey, 2004. The improved fritware body combines white clay, quartz, and chalk; the artistry in such jigger-molded wares lies in the creation and execution of the painted designs, often inspired by early Ottoman examples. *Private collection; photograph: author.*

craft in Kütahya, Turkey, offers a good illustration of that pattern of decline and revival I mentioned earlier. Henry estimated that in 1991 fifty ateliers there were producing *çini* (painted, composite white-bodied ware) and a hundred shops were selling it. Back in the 1500s the town was giving Iznik a run for its money, with some fritware identified as being from Iznik more likely made in Kütahya. The Iznik story was over by 1700, but Kütahya remained an active center through the eighteenth and nineteenth centuries, with wares from that later period, including those by Armenian potters, having evolved into a distinctive local style. The tradition declined in the first half of the twentieth century, but Henry credits its revival to masters like Ahmet Şahin, whose designs were inspired by centuries-old Iznik pieces in museum collections. Ahmet's sons, daughter-in-law (fig. 8.3), and grandson now carry on his work, along with other high-quality *çini* artists who have come along.[10]

Kütahya is the pottery focus of Henry's book, but he also discusses the utilitarian wares of Sille (Konya) and Bursa and the more decorative work of Kinik.[11] There are other active ceramic centers in Turkey as well. The remarkable landscape of Central Anatolia's Cappadocia region, with its otherworldly "fairy chimney" rock formations, is home to the pottery town of Avanos in Nevşehir province. There were close to 200 workshops in 1970, but the number then declined until an increase in tourism sparked something of a pottery renaissance. For centuries earthenware clay has been dug from the banks of the Red River that runs through Avanos, but in recent years local potters have adopted the decorative Iznik style like that in Kütahya, using the improved çini body developed there.[12] One of these is Galip Körükçü, whose operation, Chez Galip, is a model of a successful art-based business geared to tourists. In the cave complex that houses his pottery he gives demonstrations, conducts workshops, sells carpets, organizes tours, and displays some 16,000 cuttings from women around the world in his Hair Museum! While indeed a "character," Galip is also a serious potter, with a family tradition that spans at least five generations; his own hands have been in clay now for about fifty years.[13]

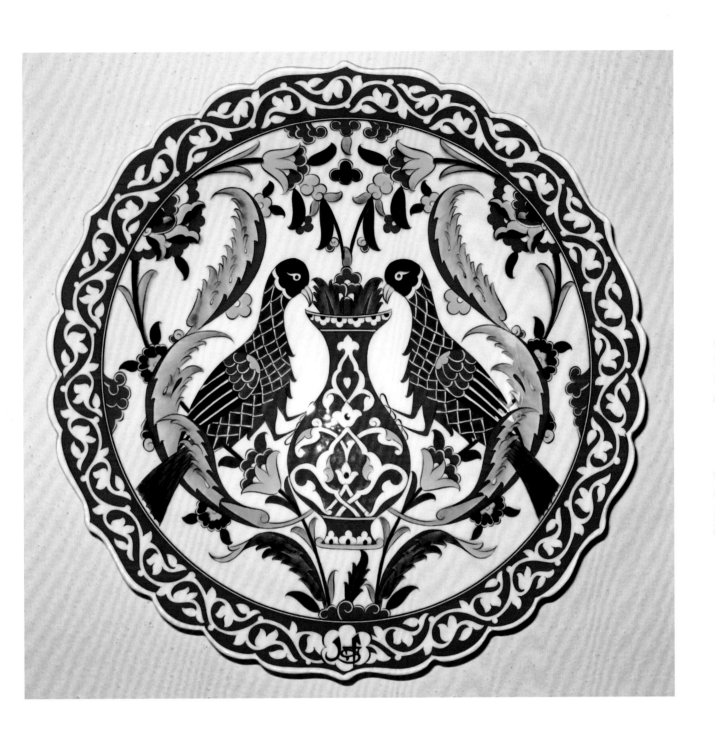

Another successful Avanos pottery business is that of Firça Ceramic, with roots in clay dating to the mid-1700s.[14] I visited their satellite shops in Istanbul and Selçuk, the latter close enough to the excavated ancient town of Ephesus to capitalize on tourism there. Firça's is as slick as any traditional pottery operation I've ever seen, and that's not necessarily a bad thing; while the tourist and collector markets certainly affect a tradition, they also can keep it alive when older markets dry up. My Selçuk visit included a throwing demonstration on the Cappadocia-style kick wheel in a reception room with the customary tea service, and two floors of extensive showrooms, including an enclosure to highlight a recently developed line of wares aglow in the dark with fluorescent paints. One of their Cappadocian specialties is the "sun" jug, an elaborately painted, wheel-thrown ring jug for wine inspired by ancient Hittite specimens.

My task at this juncture is to sketch *some* of the other places where folk pottery thrives, many documented by the fieldwork of others, the references to which are provided in my notes. I do this simply to establish that folk pottery is still being made in much of the world. Many of my sources for this information are not as up to date as I'd wish; hence, my decision to include current websites in my notes, especially when information in printed sources is dated, scant, or nonexistent for the following centers and individual potters. Even so, the only way to obtain the latest state of these traditions is to be on the ground in each location; as living organisms, folk traditions can be in constant flux.

New Guinea, Africa, and the Middle East

New Guinea is no longer as isolated as it was a century ago, but what is essentially a prehistoric pottery technology is still practiced there, in contrast to its South Pacific neighbor, Australia—less than a hundred miles away by sea—where no aboriginal pottery tradition exists. Archaeological evidence of ceramics in New Guinea goes back three millennia, with much of today's activity concentrated along tributaries of the Sepik River. To mention a few of these terracotta centers, the Iatmul-speaking people of Aibom village make jars for storing sago (a

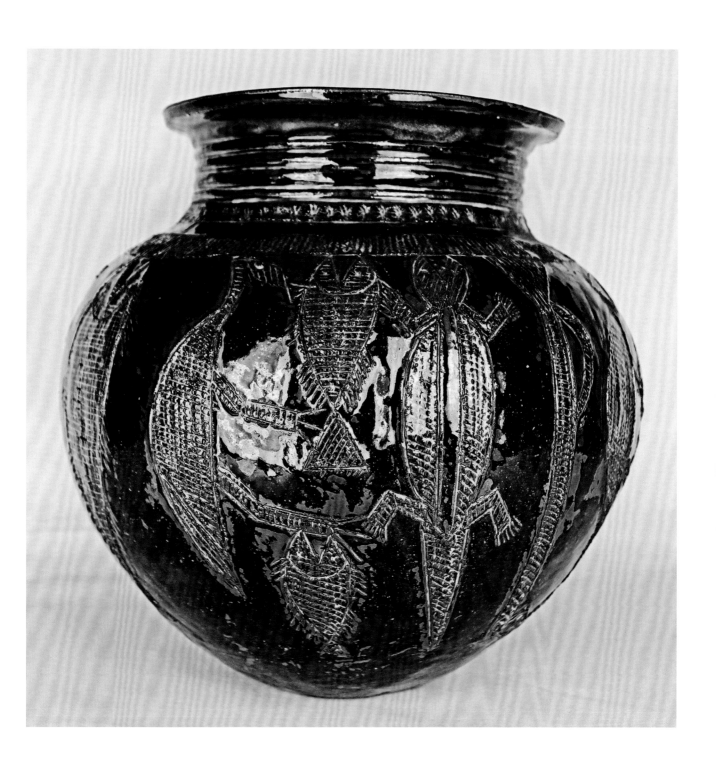

palm-based starch central to the diet), often modeled with mythological bird, pig, and human faces, as well as totemic roof finials; in the Peilungua Mountains the Kwoma make face pots representing sacred spirits for cult use; and the Sawos of Koiwat and Kamanggaui villages make conical sago-eating bowls with carved and ochre-painted curvilinear designs, hand-built by the women and decorated by the men.[15]

Among the countries of sub-Saharan Africa, Nigeria's terracotta traditions are especially rich, with extraordinary vessel forms hand-built by potters of the Nupe and Igbo peoples. English studio potter Michael Cardew's efforts to promote Nigerian ceramics also deserve mention. In 1951, with colonial government support, he established the Abuja Pottery Training Centre, controversially introducing the potter's wheel, kiln, and stoneware glazes to an already developed native terracotta tradition with the goal of producing saleable tableware. The experiment yielded only limited success, but Cardew's "star" pupil, Ladi Kwali (1925–1984), a Gwari woman from Kwali village (already a skilled potter when she arrived at Abuja in 1954, having learned from her aunt), achieved international recognition (fig. 8.4).[16]

In Morocco, Tunisia, Egypt, Pakistan, and Afghanistan, colorfully painted tin-glazed earthenware in the Islamic tradition is the rule, often alongside utilitarian terracotta, with some workshops specializing in tiles. Fez/Fes and Safi are key production centers of Morocco, with decorative plates, elaborately metal-mounted vessels, and conical-lidded tagines for cooking and serving stews emphasized.[17] Multan, in the Punjab region of Pakistan, remains a center for blue-painted (*kashi*) pottery, as it has been for centuries.[18] The potters of Istalif, in Afghanistan's war-torn Kabul province, have shown remarkable resilience in the face of adversity. The village was destroyed by the Taliban in 1999 (before that, by the Soviets in 1983 and by the British in 1843), but fifty pottery families have since returned and are at work, some still using low-fired alkaline glaze, with ashes from a desert bush (*ishkor*) mixed with crushed quartz, to display the distinctive turquoise color for which the local wares are famed. Support to rebuild the village and help the potters has been provided by Turquoise Mountain, a British- and Kabul-based NGO.[19]

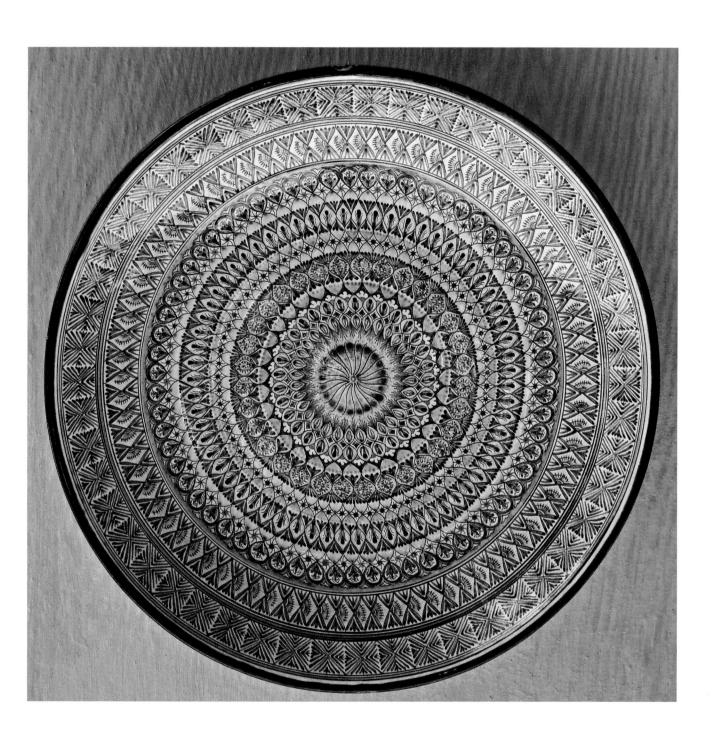

Asia

One of the oldest centers of ceramic art in Central Asia is the town of Rishtan in the Fergana Valley of Uzbekistan. One source states that there are more than a thousand potters in the area, many working at Rishtan's Art Ceramics Factory.[20] In 1920 the Soviet government created the factory by collectivizing thirty small workshops, introducing mass production and lead glaze; by the late 1960s the local tradition was nearly gone. But in 1974 the All-Union Conference of Art Critics met in Fergana and launched an effort to encourage local authorities and potters to return to the old ways, including the *ishkor* glaze. Uzbekistan's political independence in 1991 freed potters such as Rustam Usmanov to pursue individual careers. After graduating from art school and while employed by the factory, Usmanov studied old local earthenwares to arrive at his adaptation of the traditional style. He works with his son, Damir, and nephew, Ruslan, to create superbly intricate designs (fig. 8.5). Since 2005 the Usmanovs have been featured at the International Folk Arts Market in Santa Fe, New Mexico.[21]

The number of traditional potters active in India is uncountable, with entire villages and a professional caste (*Kumhar/Prajapati*) devoted to the craft, a goodly portion of their terracotta production supporting the complex ritual life there.[22] One exception to unglazed earthenware in that country is the "Jaipur blue" wares of Rajasthan's Jaipur: tin-glazed, cobalt-painted, clayless fritware, likely of Persian inspiration, introduced from Delhi in the nineteenth century. The revival of this tradition, nearly vanished by the 1950s, is credited to painter Kripal Singh Shekhawat. It's estimated that there are between twenty-five and thirty workshops now in the Jaipur area.[23]

Bangladesh is another major South Asian terracotta–producing country. In his book about traditional arts there, Henry Glassie describes the making of clay *murtis* (sacred images) of Saraswati, Hindu goddess of the arts and learning, and their use in the annual puja, or festival, devoted to her. After the festival is over and the goddess has departed the unfired, elaborately decorated statues, they are thrown in the river to return to their original amorphous state.[24]

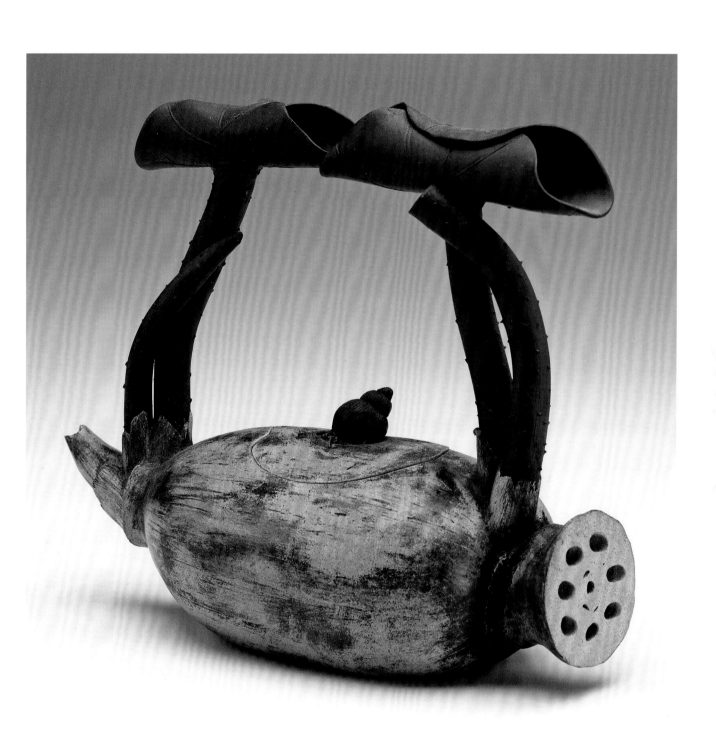

Figure 8.7, facing top. Family meal with factory-made utensils, Dongsi hutong, Beijing, China, 2011. *Photograph: author.*

Figure 8.8, facing bottom. Recently made stoneware food-storage jars in use, Dongsi hutong, Beijing, 2011. *Photograph: author.*

The historical—often celadon-glazed—stoneware of Southeast Asia seems to have been largely replaced by terracotta in the last few centuries.[25] However, a half-dozen celadon revival factories operate in Chiangmai, Thailand, the oldest established in the 1950s; while a few places in Vietnam (e.g., Chu Dau and Bat Trang, both in the north) also produce stoneware inspired by historic wares, with a porcelain industry having jumped in to fill the gap left by China during its Cultural Revolution.[26]

China is deservedly famous for its porcelain, which now is largely mass-produced in places like Jingdezhen; but traditional stoneware is also made in several locations, including Yixing county, Jiangsu province, where the production of *zisha* ("purple-sand" clay) tea wares has continued since the Ming dynasty. Today, in the town of Dingshu within Yixing, 70% of the 30,000 inhabitants are involved in the *zisha* teapot trade.[27] Built into this tradition is an emphasis on creativity and novelty. An early master, Chen Mingyuan (1654–1722), is known for his trompe l'oeil teapots and "scholar's table" pieces that cleverly imitate objects from nature (e.g., fruits, nuts, bamboo, lotus).[28] That same innovative spirit continues today, both at hand-based ateliers and studios of individual masters such as Lu Wenxia (born 1966), who studied with several famous *zisha* artists and sometimes collaborates with her husband, sculptor Lu Jianxing. Her work exhibits a high degree of naturalism, with the "wood grain" on some teapots, for example, so realistic that it's hard to believe they're made of clay (fig. 8.6).[29]

Given China's recent explosive manufacturing growth, one might easily assume that traditionally handcrafted utilitarian wares have been totally displaced by factory-made products. Is the use of folk pottery, especially in urban China, now a dead issue? A small case from my 2011 visit to Beijing may help answer that question. For centuries, such cities have attracted migrants from the countryside who bring their rural ways to their new homes. Especially since preparation for the 2008 Summer Olympics, parts of Beijing present a futuristic facade, but a number of *hutong* (narrow-alley neighborhoods) have survived "redevelopment." One of these, Dongsi, within walking distance of the Forbidden City, dates to the Ming dynasty; its very public street life would not be out of place in a village. I looked

for evidence of folk pottery in use; at first glance, the containers all seemed to be made of plastic, metal, or mass-produced porcelain (fig. 8.7). But exploring further, there were hand-thrown flowerpots and glazed stoneware jars everywhere, some of the latter still being used to preserve food (fig. 8.8). I never learned where those pots were made, but they're clearly recent.

Korea has a long history of gray-green celadon and white porcelain, but the emphasis today seems to be on the production of *onggi*, dark-glazed earthenware once found in every household for fermenting and storing foods central to the Korean diet: *kimchi* (pickled vegetables) and condiments such as bean and red pepper pastes and soy sauce (fig. 8.9). One researcher estimated that there were about 500 *onggi* workshops in South Korea in 1971 but just half that number a decade later, with declining demand for their products attributed to the increased use of mass-produced alternatives.[30] Ulsan in the Yeongnam region, with its Oegosan Onggi Village (a pottery theme park/"living museum" that combines eight workshops), is said to produce half of Korea's total *onggi* wares today. The traditional potters combine hand-building with throwing for larger jars and employ wood-fired, multichamber climbing kilns. Elsewhere in Korea, some stoneware tea bowls and reproductions of Goryeo-dynasty celadons are made.

Stoneware production was introduced to Japan from Korea about 450 CE, and by 1500 utilitarian stonewares, enlivened by splashes of "natural" (fly-ash) glaze, were being made throughout the country. These rustic wares were admired by tea masters such as Sen no Rikyū because they seemed to embody the Zen Buddhist *wabi-sabi* aesthetic that embraces natural simplicity and imperfection, and folk potters were encouraged to expand their repertoires to include *chanoyu* (tea ceremony) wares. Much that same philosophy was part of Yanagi Sōetsu's *Mingei* (Folk Craft) movement of the 1920s–1930s, which romantically glorified the handwork of "unknown" peasant artisans.[31] *Mingei* helped stimulate a revival by drawing public attention to the wares of living Japanese folk potters, which now enter the shelves and display cases of urban department stores as well as the collections of museums and connoisseurs. A few of these artisans, no longer "unknown," are officially designated as "Preservers of Important Intangible

Cultural Properties" (informally, "Living National Treasures"). One such designee was Toyō Kaneshige (1896–1967) of Imbe, Okayama Prefecture, who represented the seventy-eighth generation of Bizen stoneware potters. A member of the 1930s Momoyama Revival movement, he's credited with rediscovering the techniques of late-1500s wabi tea wares.

In no other country is traditional stoneware so widely made today as in Japan. Some folk potters follow closely in the footsteps of their forebears, while others build innovatively upon their tradition, not infrequently influenced by trends in

studio pottery. Distribution maps and location lists of recent practitioners virtually blanket the country, with a concentration in the southern half.[32] Here I'll just briefly mention one center: Shigaraki, Shiga Prefecture. As one of the Six Ancient Kilns, the town is home to established pottery families as well as factories and ceramists from elsewhere, including studio potters. A recent source states that of the one hundred potters using traditional methods there, forty-four are considered "masters," and of these nine are regarded as the best producers of Shigaraki wares for the tea ceremony.[33]

At the traditional end of the scale is the Takahashi Rakusai family, potting at Shigaraki for more than 180 years, with three generations now active. The family pioneered the revival of local unglazed stoneware tea wares in the early 1900s and that is their specialty today, using the sandy clay from nearby Lake Biwa and wood-fired kilns.[34] At the other end of the spectrum, some Shigaraki factories and ateliers produce cartoonish figures of the *tanuki* (Japanese raccoon dog, a member of the canid family). The modern ceramic version, with its sake flask, straw hat, and big belly and scrotum, is said to have been designed by potter Tetsuzō Fujiwara in the 1930s. These molded and painted ornaments are what the Japanese public identifies with Shigaraki today. In folklore, the *tanuki* is a mischievous shape-shifter thought to bring good fortune, hence its portrayal in clay in a range of sizes for outdoor display, something like the West's garden gnome. As a symbol of nature at Shinto shrines like the small Yanagimori Shrine in Tokyo's Akihabara district, *tanuki* figures also serve a more spiritual function. While not exactly folk pottery, they do a marvelous job of expressing the whimsical side of Japanese culture (fig. 8.10).[35]

Continental Europe

No country of Eastern Europe has a more vital pottery tradition than Romania, with Horezu, Vâlcea County, one of the more prominent centers. In the small, family-based workshops the men shape the clay on the potter's wheel and the women decorate, using a cowhorn slip cup and fine goose-feather brush to create

elaborate polychrome plates for display on the walls of homes, some featuring the iconic Horezu rooster.[36] Since 1971 the town has celebrated and promoted its pottery heritage with the *Cocoşul de Hurez* (Horezu Rooster) ceramics fair.

Pockets of traditional pottery making are still to be found throughout Western Europe. The town of Deruta in Italy's Umbria region saw a decline, then a revival of its Renaissance-based maiolica tradition, with much of today's work continuing the historicism of the early 1900s when Alpinolo Magnini and Ubaldo Grazia rediscovered the lost art of lusterware. The workshops now cater to an export and tourist market as well as a high-end Italian clientele.[37]

Figure 8.11. Potter and musician Giovanni Andreani with one of his maiolica-body electric guitars, Deruta, Umbria, Italy, 2016. *Courtesy of Giovanni Andreani.*

I know of no better exemplar of innovation in traditional ceramics than De-ruta's Giovanni Andreani. Born in 1972, his early love was music; then at twenty-six he embraced the maiolica revival, learning from his uncle Franco. Giovanni's big idea was to combine those two passions, and in 2005, after much experimentation, he hand-crafted his first electric guitar with a solid body of earthenware clay painted in the colorful sixteenth-century Deruta style, a most unusual fusion of folk and popular culture. He has since produced at least nine models of these beautiful guitars (so far, not for sale; fig. 8.11), presenting one to his idol, famed Latino-rock guitarist Carlos Santana.[38]

Many of Spain's pottery centers went into decline during the later twentieth century; for example, in 1992 potters in the town of Colmenar de Oreja, Madrid, produced their last *tinaja* (a huge terracotta barrel for fermenting and storing wine, now replaced by cement vats).[39] But there are bright spots, some in the province of Granada: at Monachil, the Casares family and others make colorful tin-glazed earthenware, sometimes employing the medieval Hispano-Moresque *cuerda seca* (dry cord) technique in which designs are first outlined in black grease that prevents the in-filled colors from bleeding into each other (the ceramic equivalent of cloisonné enamel metalwork); and in Guadix, Miguel Cabrerizo López is credited with reviving the *jarra accitana*, a terracotta vase with elaborate clay filigree customarily given as a wedding gift, and inspiring the next generation, such as potter Juan Manuel Gabarrón Gómez, to carry on this tradition.[40]

In the town of Úbeda, Andalusia, Paco Tito (Francisco Martínez Villacañas) applied his art-school training to the utilitarian tradition inherited from his folk-potter father, Pablo Martínez Padilla, creating a line of decorative glazed earthenwares with reticulated and sgraffito patterns alluding to Hispano-Moresque wares. Others of the family—his son Pablo, brother Juan, cousin Melchor Tito, and Melchor's son, Juan Pablo—further contribute to this rejuvenation of a local pottery tradition.[41]

One of Portugal's active pottery centers is Barcelos in Minho province. Lead-glazed earthenware *càntirs* (field jugs) and baking dishes distinctively decorated with patterned dots of slip have been made there for some time, but the town is

Figure 8.12. Robert Hausser Pottery, Soufflenheim, Alsace, France, 2009. *Photograph: Ji-Elle, CC BY-SA 3.0, via Wikimedia Commons.*

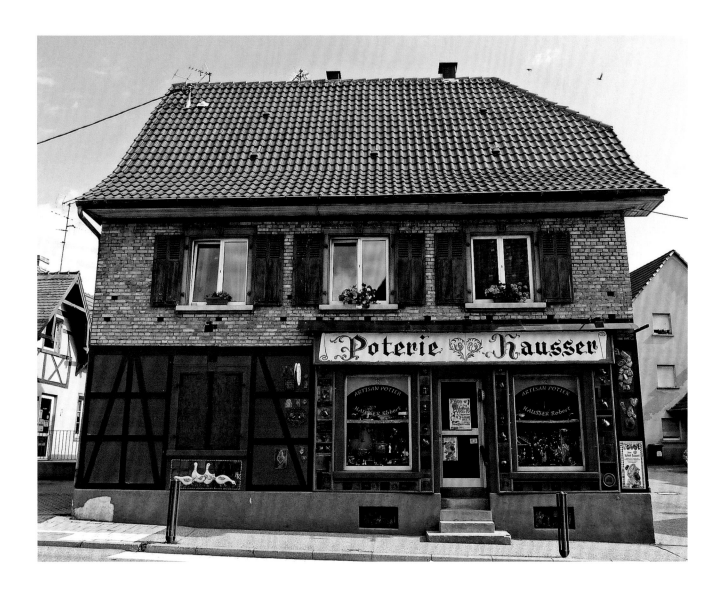

also known for its *figurado* (figurine) tradition of glazed sculptural pieces. The exemplar was Rosa Ramalho (Rosa Barbosa Lopes, 1888–1977), who returned to clay as a widow at age sixty-eight to create a host of imaginative animal, religious, and devil figures. Her work is now carried on by her granddaughter, Júlia Ramalho, and other family members.[42] The town's most iconic ceramic item is the molded and colorfully painted Barcelos rooster, a Portuguese "good luck" souvenir, complete with legend: A Galician pilgrim passing through town is accused of theft and sentenced to death. Pointing to the roast chicken the magistrate is eating, he declares, "If I am innocent, that cock will crow as I am hanged." Of course, the bird miraculously revives and crows in the nick of time, and the innocent pilgrim is set free.[43]

In the Alsace region of eastern France, across the Rhine River from Germany, there are two pottery centers that reflect the mixed culture of this border land. In the first, Soufflenheim ("*Cité des Potiers*"), a glazed-earthenware tradition with medieval roots is practiced. In 1837 there were fifty-five workshops in town; now there are about fifteen, with tourism supporting those that survive (fig. 8.12). The culinary wares emphasized here, often slip-trailed in simple floral motifs on a monochrome ground, include *Kouglof* (bundt) and *Osterlammele* (Easter lamb) cake molds and casseroles for *Baeckoffe*, a meat and vegetable stew.[44]

In the early 1700s, potters from Germany's Westerwald introduced their salt-glazed stoneware tradition to Betschdorf, just six miles above Soufflenheim. Servatius Remy arrived in 1822, returning his branch of the pottery family to France after Huguenot ancestors fled to Germany in the late 1500s (this is the same family that stoneware potter Johannes Remmey left Germany for Manhattan in 1735).[45] The Betschdorf tradition reached its height in 1864 with fifty workshops; as demand for their utilitarian wares declined, surviving potters shifted to more decorative products. The potteries now number about a half-dozen, including those of Matthieu and Vincent Remmy, twelfth-generation potters, whose blue-gray stoneware echoes that of their German forebears. Betschdorf wares often are mistaken for those of the Westerwald, but distinctive Alsatian forms include the footed, barrel-shaped *tonnelet* for dispensing vinegar.[46]

In Germany's Kannenbäckerland there are about a dozen workshops, like that run by Walter Manns, still making the blue-gray, salt-glazed stoneware typical of the Westerwald since the 1600s.[47] Walter's family operation in the town of Ransbach-Baumbach, Töpferei Gerharz & Manns, was established in 1876. My second visit in 2009 found Walter dealing with the same Great Recession that was hurting my Georgia folk-potter contacts; a reduced part-time staff and an export arrangement with American distributor Lehman's of Ohio were among his survival

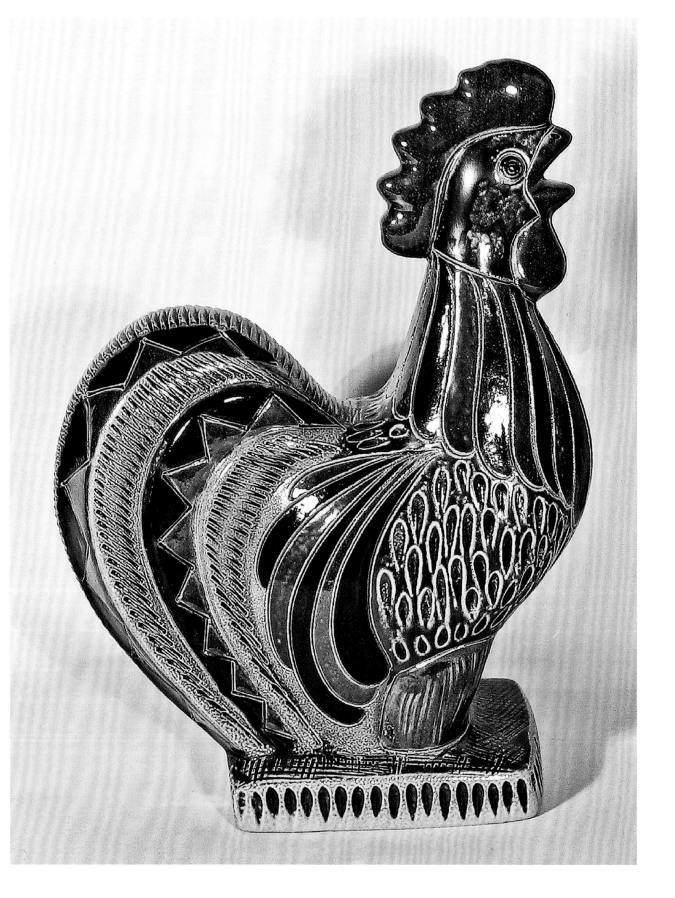

Figure 8.13. Stoneware rooster, press-molded and painted with cobalt, manganese, and iron oxides under salt glaze, Töpferei Gerharz & Manns, Ransbach-Baumbach, Westerwald, Germany, 1996. *Private collection; photograph: author.*

strategies. He and other local traditional potters make both molded and hand-thrown wares, the latter marked *"Handarbeit"* so customers will appreciate the skill involved. When I first met Walter in 1996, pieces with irregular shapes not producible on the potter's wheel were press-molded (i.e., a sheet of damp clay was pushed by hand into each side of a plaster mold; fig. 8.13), but he has since adopted slip-casting, with liquid clay poured into the mold and the excess later drained after a clay skin has formed inside, which is less labor-intensive and results in a lighter-weight product. Wares are decorated by the old *red* (hand-incising) technique, in which gamboling deer, prancing horses, and roosters are filled in with brushed cobalt, manganese, and iron oxides. Salt remains Walter's chief glaze, but he also uses some glaze solutions, including one containing volcanic ash.

The Americas

In the countries of South and Central America the mix of native, European, and African cultures is reflected in the variety of current terracotta and glazed earthenware traditions.[48] Henry Glassie and his folklorist wife, Pravina Shukla, have been doing fieldwork in Brazil, where in the village of Maragojipinho, Bahia, there are, according to Henry, 150 workshops "knocking out lead-glazed utilitarian earthenware at an astonishing rate."[49] Alto do Moura, Pernambuco, is Brazil's center for miniature figurative sculpture, with scenes of everyday life, religious subjects, and the country's "Bonnie and Clyde" of the 1930s, outlaw folk heroes Lampião and Maria Bonita, rendered in terracotta that is often painted. This tradition was made famous by Mestre Vitalino (Vitalino Pereira dos Santos, 1909–1963) and is carried on now by his son Severino, grandson Elias, and others in the community.[50]

Mexico, where I first encountered folk pottery, boasts a surprising range of terracotta and glazed earthenware traditions, some indigenous, some brought from Spain, and others drawing on both cultures. At San Bartolo Coyotepec, Oaxaca, with its history of Zapotec Indian pottery-making, Doña Rosa Real Mateo de Nieto discovered that by burnishing her hand-built pots with quartz and reduction-firing at a lower-than-usual temperature, the normally matte gray

surface would turn shiny black, and *barro negro* (black clay) pottery was born. Doña Rosa died in 1980, but what became a successful family business is now carried on by later generations, with neighbor potters adopting and contributing to this tradition (see fig. 7.2).[51]

Similarly, when Juan Quezada Celado of Mata Ortiz, Chihuahua, became intrigued by fragments of painted pottery from the pre-Columbian ruins of nearby Paquimé (Casas Grandes), he taught himself to replicate those wares, then innovated upon them with a modernist sensibility that was adopted by family members and neighbors (fig. 8.14). A 1976 visit by anthropologist Spencer McCallum helped to shine an international spotlight on the Mata Ortiz revival, making some local potters sought-after artists whose work is now highly valued in the collector and museum markets.[52] Thus, what began in these two Mexican villages as an individual creative reworking of an older local tradition has blossomed into some of the world's most vibrant folk pottery.

As for the United States, another successful revival, in addition to the active centers of Georgia and North Carolina previously mentioned, is that of the Pueblo Indians of New Mexico and Arizona. Painted terracotta there extends back a good thousand years, but the tradition was running out of steam until the arrival of the railroads in the 1880s and the resulting rise of a tourist and collector market. Tapped into the earlier tradition but no longer strictly bound to it by the conservative mindset of the older generation, the creative work being done now at Acoma, Laguna, Zuni, Cochiti, San Ildefonso, Santa Clara, Kewa (Santo Domingo), Hopi, Taos, Nambe, Zia, and other pueblos equals the best pottery made anywhere in the world, folk or not. Much of this revival's success can be attributed to pioneers who innovated upon the older tradition, sometimes using pieces from museum collections and archaeological excavations for design inspiration. Among them were Lucy Lewis of Acoma (fig. 8.15), Maria and Julian Martinez of San Ildefonso, Margaret Tafoya of Santa Clara, and Helen Cordero of Cochiti.[53] It is here, in the Southwest, that America's most vital living pottery tradition can be found.

While not as extensive as the Pueblo tradition, pottery making among Catawba and Cherokee Indians of the Southeast deserves mention. The Catawba Nation is concentrated in the vicinity of Rock Hill, York County, South Carolina, with a centuries-old ceramic heritage later geared to white settlers and tourists as a source of income. As with Pueblo pottery, Catawba potters, about fifty today (of whom a small number are deemed "masters"), employ a native technology, hand-building, burnishing, and often baking their pots in bonfires. These unpainted wares are distinguished by dark fire flashings, with modeled animals such as blacksnakes (once a Catawba war symbol) added to pots or freestanding, and Indian-head smoking

Figure 8.14. Casas Grandes–revival *olla* (jar), hand-built earthenware with painted rattlesnake by Juan Quezada Celado, Mata Ortiz, Chihuahua, Mexico, 2000. *Courtesy of Andrea Fisher Fine Pottery, Santa Fe, New Mexico, www .andreafisherpottery.com.*

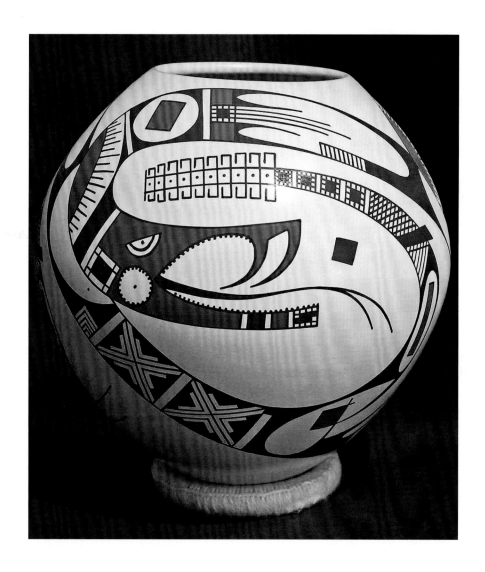

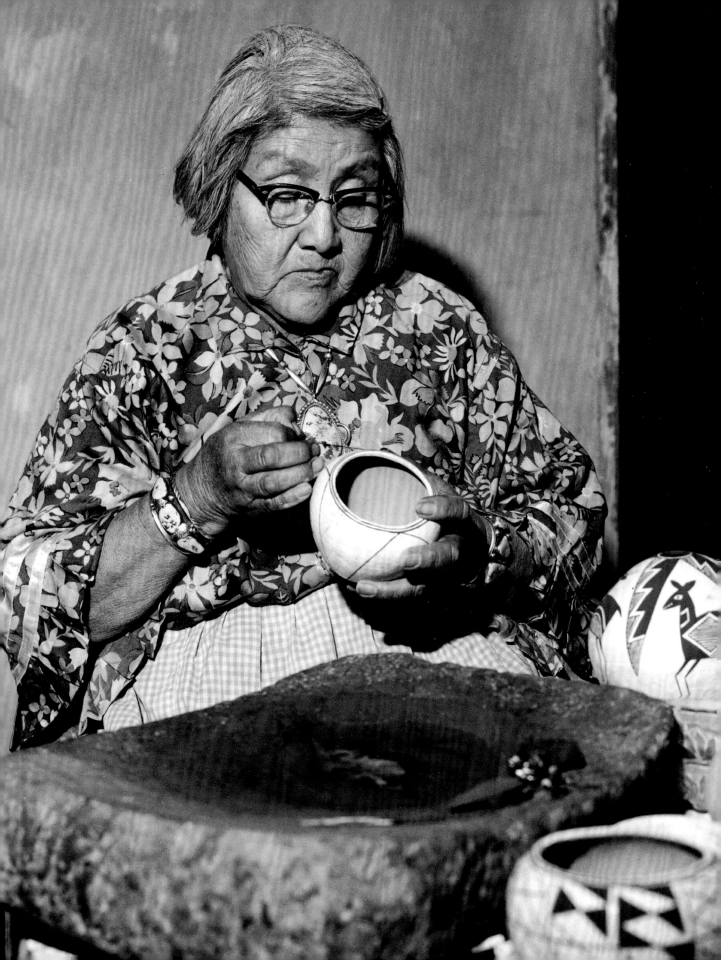

Figure 8.15, facing. Pueblo Indian potter Lucy Martin Lewis (ca. 1898–1992), Acoma, Cibola County, New Mexico, painting with a yucca brush, 1961. Best known for her black-on-white "fine-line" jars, she began working in clay with her great aunt at age 8. Many of her designs were inspired by ancient Ancestral Pueblo pottery. *Photograph: Lee Marmon. Courtesy of Center for Southwest Research, University Libraries, University of New Mexico, Albuquerque.*

Figure 8.16, below. Terracotta jar hand-built by Joel Queen, Whittier, Jackson/ Swain counties, North Carolina, ca. 2010. Queen, a 9th-generation potter of the Bigmeat family, is one of the Cherokee potters who revived the early technique of paddle-stamped decoration; the dark flashing resulted from bonfire firing. *Courtesy of Andrea Fisher Fine Pottery, www.andreafisherpottery.com.*

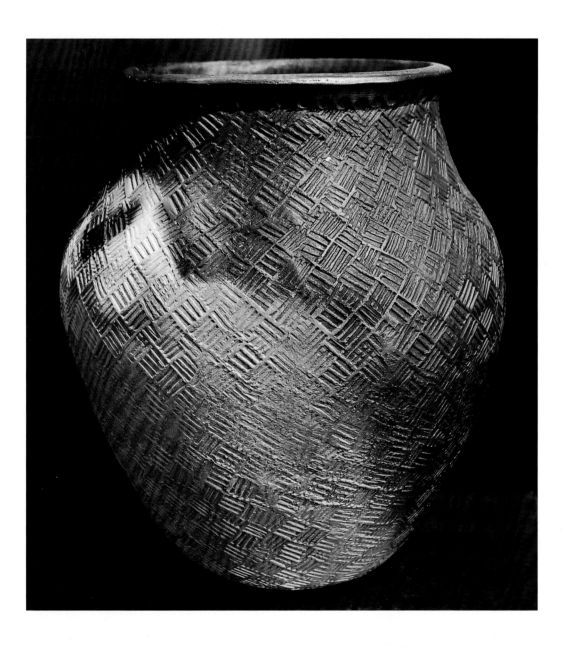

pipes—the same molded heads applied to jars—as a specialty. The "wedding jug" (basically a field-jug form with a gracefully arching handle attached to the two spouts) was borrowed by Catawba and Cherokee potters from the Pueblo tradition in the 1930s. Notable Catawba potters of the recent past include Sara Ayers (1919–2002) and Georgia Harris (1905–1997), the latter posthumously awarded a National Heritage Fellowship by the National Endowment of the Arts.[54]

The Eastern Band of Cherokee Indians is located on the Qualla Boundary in Swain and Jackson counties, North Carolina, while the western Cherokee are concentrated in the vicinity of Tahlequah, Cherokee County, Oklahoma. This division resulted from forced relocation as part of the late 1830s Trail of Tears. The pottery making that occurs today in both places is mainly a revival tradition. By the mid-1800s, Catawbas were living among the Cherokee in Western North Carolina, with many Cherokee potters adopting the Catawba style, as exemplified in the work of Maude Welch (1894–1953).[55] The early approach to Cherokee ornamentation, impressing with a pattern-carved wooden paddle, has been revived by Rebecca "Amanda" Wolf Youngbird, Cora Wahnetah, and Joel Queen in North Carolina (fig. 8.16) and by Anna Belle Sixkiller Mitchell in Oklahoma.

What does the future hold for pottery traditions throughout the world? Based on my observations and those of others, the prognosis is mixed. Some traditions clearly are endangered by the forces of modernity, if not teetering on the brink like those of England and Ireland. Others are robust, enjoying healthy revivals led by visionaries, or are flexibly adapting to change while maintaining respect for the core tradition. Yet others carry on relatively unaffected by change, either because there is still a viable market for their products or simply due to isolation.

For so-called developed and developing nations, the transformation of an agriculturally based peasant society into one with an economy based on manufacturing and/or service helps to explain the decline and revival experienced by many of the pottery traditions just surveyed.[56] As a survival strategy for folk potters, the shift from utilitarian wares needed for living—now often replaced by mass-produced equivalents—to more decorative ceramics that appeal to consumers with a disposable income is certainly a theme that emerges in this chapter. The rise of a tourist and collector market, as well as the educational and promotional efforts of researchers, journalists, and museums, have contributed to the success of many folk potters in today's world.

Throughout history, ceramic traditions seldom have been stagnant; they evolve, sometimes slowly, sometimes rapidly. But of this I feel certain: somewhere in the world, there will always be those who end their work day by washing the clay from their hands.

Notes

1. John A. Burrison, *Brothers in Clay: The Story of Georgia Folk Pottery*, rev. ed. (Athens: University of Georgia Press, 2008), 273, from a 1968 interview with Lanier Meaders conducted by Robert Sayers for the Smithsonian Institution's Office of Folklife Programs.

2. John A. Burrison, *From Mud to Jug: The Folk Potters and Pottery of Northeast Georgia* (Athens: University of Georgia Press, 2010), chaps. 7–10.

3. Jason Harpe and Brian Dedmond, *Valley Ablaze: Pottery Tradition in the Catawba Valley* (Conover, NC: Goosepen Studio & Press, 2012), chaps. 3 and 4.

4. Peter C. D. Brears, *The English Country Pottery: Its History and Techniques* (Rutland, VT: Tuttle, 1971), 80–81; John A. Burrison, "Survivors: The Country Potters of Post-Industrial England," *The Studio Potter* 26:1 (1997): 68–77; Burrison, "The Living Tradition of English Country Pottery," *Folk Life* 36 (1997–1998): 25–39; Richard Carlton, "The Origins and Survival of Littlethorpe Potteries in the Context of British Country Pottery-Making," *Interpreting Ceramics* 4 (2003), http://www.interpretingceramics.com/issue004/origins4.htm (accessed August 9, 2016); Andrew McGarva, *Country Pottery: The Traditional Earthenware of Britain* (London: A & C Black, 2000); and Barbara Blenkinship, *Wetheriggs Pottery: A History and Collectors Guide* (n.p. [U.K.]: Spencer Publications, 1998).

5. Roland Curtis, email correspondence to the author, August 19, 2015.

6. Megan McManus, "Coarse Ware," in *Traditional Crafts of Ireland*, ed. David Shaw-Smith (New York: Thames & Hudson, 2003), 203.

7. Jane Powers, "Potty about Containers," *Irish Times* (October 11, 1997), http://www.irishtimes.com/news/potty-about-containers-1.114925 (accessed August 9, 2016). For Paddy Murphy's nephew Derek O'Rourke at Hillview Pottery, see Mary Jean Jecklin and Kelley V. Rea, *Buy the Best of Ireland: A Shopping and Learning Guide to Irish Goods and Crafts* (Lanham, MD: Roberts Rinehart/Taylor Trade, 2004), 65–66.

8. https://www.facebook.com/Hillview-Pottery-1940556633969956/.

9. "disk 19 hands carleys bridge pottery est 1659 full video," YouTube video, 26:45, episode 19 of David and Sally Shaw-Smith, *Hands*, televised by RTÉ, posted by "john clarke," January 10, 2012, http://www.dailymotion.com/video/xn16hx_disk-19-hands-carleys-bridge-pottery-est-1659-full-video_travel (accessed August 8, 2016).

10. Henry Glassie, *Turkish Traditional Art Today* (Bloomington: Indiana University Press, 1993), part 3.

11. Ibid., 340–348, 400–424.

12. Martha Stewart, "Turkish Pottery in Avanos," video, 6:40, http://www.martha stewart.com/1012378/turkish-pottery-avanos (accessed August 10, 2016).

13. Chez Galip, "Pottery in Cappadocia," https://www.chezgalip.com/galip-korukcu -biography/ (accessed August 10, 2016).

14. "Firça Handmade Quartz and Ceramics," www.fircaceramic.com/ (accessed August 10, 2016).

15. Patricia May and Margaret Tuckson, *The Traditional Pottery of Papua, New Guinea*, rev. ed. (Honolulu: University of Hawaii Press, 2000), chap. 9.

16. Michael Cardew, *Pioneer Pottery*, rev. ed. (Englewood Cliffs, NJ: Prentice Hall, 1971); *Wikipedia*, "Ladi Kwali," https://en.wikipedia.org/wiki/Ladi_Kwali; and "Ladi Kwali, Nigeria's Most Famous Potter," *The Unknown Nigeria Blog*, https://theunknown nigeriablog.blogspot.com/2014/08/ladi-kwali-nigerias-most-famous-potter.html (both accessed August 10, 2016). For broader African pottery traditions, see Kathleen Bickford Berzock, *For Hearth and Altar: African Ceramics from the Keith Achepohl Collection* (New Haven, CT: Yale University Press, 2005), and Christopher D. Roy, ed., *Clay and Fire: Pottery in Africa* (Iowa City: University of Iowa, School of Art and Art History, 2000).

17. John Hedgecoe and Salma Samar Damluji, *Zillij: The Art of Moroccan Ceramics* (Reading, UK: Garnet, 1992).

18. Hasan Mubarak, "Multan's Got the Blues," *Express Tribune* (Pakistan), June 26, 2011, https://tribune.com.pk/story/196218/multans-got-the-blues/, and "History of Blue Pottery," http://multanbluepottery.blogspot.co.uk/p/about-us.html (both accessed August 9, 2016).

19. Thomas Wide, "Istalif Pottery," *Steppe* 5 (Winter 2008): 96–101, www.steppemagazine.com/articles/feature-istalif-pottery/, and Noah Coburn and Ester Svensson, "Rebuilding Afghanistan Pot by Pot: The Turquoise Mountain Foundation and the Potters of Istalif," *Ceramics Today*, http://www.ceramicstoday.com/articles/istalif_potters.htm (both accessed August 10, 2016).

20. M. K. Rakhimov, *Artistic Ceramics of Uzbekistan* (Tashkent, Uzbekistan: UNESCO, 2006); Ljalja Kuznetsova, *Ceramics of Rishtan* (n.p.: Photoalbum, 2005); Corianne Brosnahan, "Shades of Blue: The Ceramics of Rishtan, Uzbekistan" (October 17, 2013) http://www.projectbly.com/blog/shades-of-blue; and Clare Brett Smith, "Bowled Over," *Hand/Eye* (August 25, 2011), http://www.handeyemagazine.com/content/bowled-over (both accessed August 10, 2016).

21. Abhisek, "Rustam Usmanov (Master Ceramist from Rishtan)," *Arastan*, https:// arastan.com/journey/rustam-usmanov, and "Artist Profiles: Rustam Usmanov, Damir Usmanov," *International Folk Art Alliance*, https://www.folkartalliance.org/artist/rustam -usmanov-damir-usmanov/ (both accessed August 10, 2016).

22. Jane Perryman, *Traditional Pottery of India* (London: A & C Black, 2000). It's estimated that in 1980 there were 1.7 million potters in India, with 700 in the village of Bindapur, on the outskirts of Delhi, alone (Ron du Bois, "Bindapur Potters As Documented in 1980," *Ceramics Today*, http://www.ceramicstoday.com/articles/bindapur%20potters.htm [accessed October 28, 2016]).

23. *Wikipedia*, s.v. "Blue Pottery of Jaipur," https://en.wikipedia.org/wiki/Blue_Pottery _of_Jaipur (accessed August 10, 2016).

24. Henry Glassie, *Art and Life in Bangladesh* (Bloomington: Indiana University Press, 1997), 149–167.

25. Mick Shippen, *The Traditional Ceramics of Southeast Asia* (Honolulu: University of Hawaii Press, 2005). For earlier traditions, see Dawn F. Rooney, *Ceramics of Seduction: Glazed Wares from Southeast Asia* (Bangkok, Thailand: River Books, 2013).

26. Elaine Dann Goldstein, "Shopper's World: Provincial Pottery from Thai Kilns," *New York Times*, September 16, 1990, http://www.nytimes.com/1990/09/16/travel/shopper-s -world-provincial-pottery-from-thai-kilns.html?pagewanted=all (accessed August 17, 2016), and Isabelle C. Druc, *Traditional Potters: From the Andes to Vietnam* (Blue Mounds, WI: Deep University Press, 2016), chap. 7. China's porcelain production during the Cultural Revolution was limited mainly to politically themed pieces, many featuring likenesses of Chairman Mao Zedong. While Mao scorned the decorative porcelain formerly made for export and the elite, that didn't prevent his aides from ordering a thousand pieces for him, made in 1975 (Associated Press, "For Sale: Porcelain Made Secretly for Mao," *New York Times*, December 12, 1996, http://www.nytimes.com/1996/12/12/garden/for-sale-porcelain-made -secretly-for-mao.html [accessed August 17, 2016]).

27. Druc, *Traditional Potters*, 111.

28. Lai Suk Yee and Terese Tse Bartholomew, eds., *Themes and Variations: The Zisha Pottery of Chen Mingyuan* (Shanghai: Shanghai Museum and Art Museum; Hong Kong: Chinese University of Hong Kong, 1997). For recent zisha wares, see K. S. Lo, *The Stonewares of Yixing: From the Ming Period to the Present Day* (London: Sotheby's Publications; Hong Kong: Hong Kong University Press, 1986), chaps. 6 and 7.

29. "Lu Wen Xia Main Page," *Leona Craig Yixing Zisha Gallery*, http://www.leonacraig .com/catalogue_art_gallery/teapots/Lu_wen_xia_page_z.htm (accessed August 9, 2016).

30. Robert Sayers with Ralph Rinzler, *The Korean Onggi Potter*, Smithsonian Folklife Studies 5 (Washington, DC: Smithsonian Institution Press, 1987), 249. For Korea's historical stoneware and porcelain, see Kang Kyung-sook, *Korean Ceramics* (Seoul: Korea Foundation, 2008).

31. Yanagi Sōetsu, *The Unknown Craftsman: A Japanese Insight into Beauty*, rev. ed. (Tokyo: Kodansha International, 1989). For historical overviews of Japanese pottery, see Lorna Price, ed., *Yakimono: 4000 Years of Japanese Ceramics* (Honolulu: Honolulu Academy of Arts, 2005); Robert Moes, *Quiet Beauty: Fifty Centuries of Japanese Folk Ceramics from the Montgomery Collection* (Alexandria, VA: Art Services International, 2003); and Henry Trubner, ed., *Ceramic Art of Japan: One Hundred Masterpieces from Japanese Collections* (Seattle, WA: Seattle Art Museum, 1972).

32. Anneliese Crueger, Wulf Crueger, and Saeko Itô, *Modern Japanese Ceramics: Pathways of Innovation & Tradition* (New York: Lark, 2007); Penny Simpson, Lucy Kitto, and Kanji Sodeoka, *The Japanese Pottery Handbook*, rev. ed. (New York: Kodansha USA, 2014), 115–123; and Herbert H. Sanders, *The World of Japanese Ceramics* (Tokyo: Kodansha International, 1967). Recent practices at particular centers are discussed in Louise

Allison Cort, *Shigaraki: Potters' Valley* (Bangkok, Thailand: Orchid Press, 2006), chap. 11; Daniel Rhodes, *Tamba Pottery: The Timeless Art of a Japanese Village* (Tokyo: Kodansha International, 1970), chap. 3; Brian Moeran, *Lost Innocence: Folk Craft Potters of Onta, Japan* (Berkeley: University of California Press, 1984); and Andrew L. Maske, *Onda Yaki: Japanese Folk Ceramics* (Boston: Pucker Gallery, 2007).

33. Gloria Garcia, "Internationalization of Culture through Traditional Arts: A Case of Japanese SMEs," *Copenhagen Journal of Asian Studies* 30:1 (2012): 85.

34. Ai Kanazawa, "The Flavor of the Earth: The Rustic Ceramics of Shigaraki," February 15, 2015, https://www.studiokotokoto.com/2015/02/25/the-flavor-of-the-earth-the-rustic-ceramics-of-shigaraki/ (accessed August 11, 2016).

35. Cort, *Shigaraki*, 266–267; *Wikipedia*, s.v. "Japanese Raccoon Dog," https://en.wikipedia.org/wiki/Japanese_raccoon_dog; and "Tanuki in Japanese Artwork," *A to Z Photo Directory, Japanese Buddhist Statuary*, http://www.onmarkproductions.com/html/tanuki.shtml (both accessed August 11, 2016).

36. *Wikipedia*, s.v. "Horezu Ceramics," https://wikipedia.org/wiki/Horezu_ceramics, and "Le Savoir-faire de la céramique traditionnelle de Horezu," *UNESCO TV*, YouTube video, 9:23, https://www.youtube.com/watch?v=T10FF88i2QQ (accessed August 11, 2016).

37. Elizabeth Helman Minchilli, *Deruta: A Tradition of Italian Ceramics* (San Francisco: Chronicle Books, 1998). For recent pottery workshops throughout Italy, see *Le Città della ceramica* (Milan: Touring Club Italiano, 2001).

38. "Giovanni Andreani Ceramics Guitars," http://www.ceramicsguitars.com/; "Liutaio e ceramista è un insolito mix artistico per far nascere chitarre, ma Giovanni, con la sua passione, crea strumenti unici al mondo: parola di Santana!," http://www.derutanelmondo.it/ceramista-majolica-artisan/ceramics-guitars/andreani-ceramics-guitars/ (both accassed August 9, 2016); and Claudio Sampaolo, "L'uomo che costruice le chitarre di ceramica," September 7, 2014, http://www.umbriatouring.it/luomo-che-costruisce-le-chitarre-di-ceramica/ (accassed August 11, 2016).

39. José Llorens Artigas and José Corredor-Matheos, *Spanish Folk Ceramics of Today*, 2nd ed. (New York: Watson-Guptill, 1974), 114–117, and Daniel Fernández Garcia and Sergio Gómez Pérez, *Colmenar de Oreja a través de su patrimonio histórico* (Hamburg: Eustory, n.d.), 20–21.

40. "Ceramica granadina de cuerda seca," *Ciencias Sociales, Naturales y Plástica*, December 23, 2013, http://laclase55.blogspot.com/2013/12/ceramica-granadina-de-cuerda-seca.html, and "La jarra accitana," *Ciencias Sociales, Naturales y Plástica*, November 23, 2011, http://laclase55.blogspot.com/2011/11/la-jarra-accitana.html (both accessed August 17, 2016).

41. Artigas and Corredor-Matheos, *Spanish Folk Ceramics*, 147; *Wikipedia*, s.v. "Paco Tito," https://es.wikipedia.org/wiki/Paco_Tito; *Museo de Alfarería Paco Tito memorio de la cotidiano*, http://conelaguayelbarro.blogspot.com/ (both accessed August 11, 2016); and Juan Martínez Villacañas, "Tito," http://www.alfareriatito.com/ (accessed August 15, 2016).

42. *Wikipedia*, s.v. "Rosa Ramalho," https://en.wikipedia.org/wiki/Rosa_Ramalho; Sérgio C. Andrade, "Rosa Ramalho, a artesã de Barcelos," http://www.snpcultura.org/vol_rosa_ramalho.html; and "Entrevista de Júlia Ramalho" (2010), https://www.youtube.com/watch

?v=BbL8vu_-AOo (all accessed August 11, 2016). Portuguese author Mário Cláudio's 2008 novel, *Rosa*, is based loosely on Rosa Ramalho's life.

43. *Wikipedia*, s.v. "Rooster of Barcelos," https://en.wikipedia.org/wiki/Rooster_of _Barcelos (accessed August 11, 2016).

44. Marc Grodwohl, "La Poterie de Soufflenheim à Ecomusée d'Alsace," http://www .marc-grodwohl.com/m%C3%A8moires-de-l%E2%80%99ecomus%C3%A9e-d%E2%80 %99alsace/la-poterie-de-soufflenheim-%C3%A0-lecomus%C3%A9e-dalsace; Amy Eber, "How Traditional Alsace Pottery Is Made in Soufflenheim," *Crawfish and Caramel*, October 27, 2012, http://crawfishandcaramel.com/soufflenheim-alsace-pottery/; Claude Truong-Ngoc, "Une Tradition Alsacienne: L' Osterlammede [molded Easter lamb cake]," http:// osterlammcle.canalblog.com/ (all accessed August 11, 2016); and Jean-Pierre Dezavelle, Claudia Albisser-Hund, Jean-Luc Syren, Valerie Walter, and Susan Brown, *Cooking with Soufflenheim Pottery* (Ingersheim, France: Editions SAEP, 2012).

45. Ilse Müller, Günther Schweizer, and Peter Werth, *Die Familie Remy: Kannenbäcker und Unternehmer: Eine Genealogische Bestandsafnahme* (Tübingen, Germany: GmbH, 2009), 144, and "400 Years of Ceramics," *Ceramic Industry*, April 5, 2000, http://www .ceramicindustry.com/articles/82753%3CN%3E400-years-of-ceramics (accessed August 11, 2016).

46. Joseph Ehrhard, ed., *Betschdorf: Le Village des Potiers* (Strasbourg, France: Coprur, 1999).

47. David R. M. Gaimster, *German Stoneware, 1200–1900: Archaeology and Cultural History* (London: British Museum Press, 1997), 251–271; Beatrix Adler, *Early Stoneware Steins from the Les Paul Collection: A Survey of All German Stoneware Centers from 1500 to 1850* (Dillingen & Merzig, Germany: Krüger Druck + Verlag, 2005), 342–393; and Franz Baaden, "Das Kannenbäckerland und seine Ausstrehlungen," www.chronik.gemeinde -hilgert.de/dzk/lit/baad/ausst.htm, from *Die Schaulade* (May 1981) (accessed October 10, 2016). Westerwald's revival began in the late 1860s as historicism inspired by the region's baroque wares, and continued as *Jugendstil*, a German modernist version of art nouveau, beginning about 1900 (Gaimster, 325–334). For Westerwald's recently active potteries, see *Keramik auf der Spur* (On the Ceramic Trail), http://www.kannenbaeckerland.de/fileadmin /regionen/kannenbaeckerland/Dokumente/Broschueren/VRH-12007_final_Blaetterkatalog .pdf (accessed August 11, 2016).

48. Gertrude Litto, *South American Folk Pottery* (New York: Watson-Guptill, 1976); Druc, *Traditional Potters*, chaps. 2 and 3; Ronald J. Duncan, *The Ceramics of Ráquira, Colombia: Gender, Work, and Economic Change* (Gainesville: University Press of Florida, 1998); and Duncan, *Crafts, Capitalism, and Women: The Potters of La Chamba, Colombia* (Gainesville: University Press of Florida, 2000).

49. Henry Glassie, correspondence to the author, July 2015.

50. "Arte Popular do Brasil: Mestre Vitalino," http://artepopularbrasil.blogspot.com/2010 %20/11/este-blog-sera-inaugurado-com-un.html; Elfi Kürten Fenske, "Mestre Vitalino—a Arte Feita de Barro," *Templo Cultural Delfos*, http://www.elfikurten.com.br/2013/01/mestre -vitalino-arte-feita-de-barro.html; and *Wikipedia*, s.v. "Mestre Vitalino," https://pt .wikipedia.org/wiki/Mestre_Vitalino (all accessed August 11, 2016).

51. Paul Van De Velde and Henriette Romeike Van De Velde, *The Black Pottery of Coyotepec, Mexico*, Southwest Museum Papers 13 (Whitefish, MT: Literary Licensing LLC, 2013); Arden Aibel Rothstein and Anya Leah Rothstein, *Mexican Folk Art from Oaxacan Artist Families*, 2nd ed. (Atglen, PA: Schiffer, 2007), chap. 1; Chris Goertzen, *Made in Mexico: Tradition, Tourism, and Political Ferment in Oaxaca* (Jackson: University Press of Mississippi, 2010), 39–44; and Orville Goldner, *Doña Rosa: Potter of Coyotepec* (Orville and Dorothy Goldner, 1959), https://archive.org/details/dona_rosa_potter_of_coyotepec (accessed August 15, 2016).

52. Susan Lowell, Jorge Quintana, Walter Parks, W. Ross Humphreys, Robin Stancliff, and James Hills, *The Many Faces of Mata Ortiz* (Tucson, AZ: Rio Nuevo, 1999), and Walter P. Parks, *The Miracle of Mata Ortiz: Juan Quezada and the Potters of Northern Chihuahua*, 2nd ed. (Tucson, AZ: Rio Nuevo, 2012). For recent traditions throughout Mexico, see Amanda Thompson, *Cerámica: Mexican Pottery of the 20th Century* (Atglen, PA: Schiffer, 2007).

53. Susan Peterson, *Lucy M. Lewis: American Indian Potter*, 2nd ed. (New York: Kodansha USA, 2004); Peterson, *The Living Tradition of Maria Martinez* (Tokyo: Kodansha International, 1989); Alice Marriott, *Maria: The Potter of San Ildefonso* (Norman: University of Oklahoma Press, 1987); Richard L. Spivey, *The Legacy of Maria Poveka Martinez* (Santa Fe: Museum of New Mexico Press, 2003); Charles S. King, *Born of Fire: The Pottery of Margaret Tafoya* (Santa Fe: Museum of New Mexico Press, 2008); Mary Ellen Blair and Lawrence Blair, *Margaret Tafoya: A Tewa Potter's Heritage and Legacy*, 3rd ed. (Atglen, PA: Schiffer, 1986); and Barbara A. Babcock, *The Pueblo Storyteller: Development of a Figurative Ceramic Tradition* (Tucson: University of Arizona Press, 1986). See also Karen M. Duffy, "Bringing Them Back: Wanda Aragon and the Revival of Historic Pottery Designs at Acoma," in *The Individual and Tradition: Folkloristic Perspectives*, ed. Ray Cashman, Tom Mould, and Pravina Shukla (Bloomington: Indiana University Press, 2011), 194–218.

54. Thomas John Blumer, *Catawba Indian Pottery: The Survival of a Folk Tradition* (Tuscaloosa: University of Alabama Press, 2004).

55. M. Anna Fariello, *Cherokee Pottery: From the Hands of Our Elders* (Charleston, SC: History Press, 2011).

56. See, for example, Julian H. Steward, ed., *Contemporary Change in Traditional Societies*, 3 vols. (Urbana: University of Illinois Press, 1967); Rudi Volti, *Society and Technological Change*, 7th ed. (London: Worth/Macmillan, 2013); and Henry Glassie, *The Potter's Art* (Bloomington: Indiana University Press; Philadelphia: Material Culture, 1999).

SUGGESTED READING

Adler, Beatrix. *Early Stoneware Steins from the Les Paul Collection: A Survey of All German Stoneware Centers from 1500 to 1850*. Dillingen & Merzig, Germany: Krüger Druck + Verlag, 2005.

Arnold, Dean E. *Ceramic Theory and Cultural Process*. Cambridge: Cambridge University Press, 1988.

Atasoy, Nurhan, and Julian Raby. *Iznik: The Pottery of Ottoman Turkey*. London: Laurence King, 2008.

Baldwin, Cinda K. *Great & Noble Jar: Traditional Stoneware of South Carolina*. Athens: University of Georgia Press, 1993.

Barber, Edwin AtLee. *Tulip Ware of the Pennsylvania-German Potters*. 2nd ed. 1926. Reprint, New York: Dover, 1970.

Barker, David, and Steve Crompton. *Slipware in the Collection of The Potteries Museum and Art Gallery*. London: A & C Black, 2007.

Barley, Nigel. *Smashing Pots: Works of Clay from Africa*. Washington, DC: Smithsonian Institution Press, 1994.

Berzock, Kathleen Bickford. *For Hearth and Altar: African Ceramics from the Keith Achepohl Collection*. New Haven, CT: Yale University Press, 2005.

Bey, George Jay, III, and Christopher A. Pool, eds. *Ceramic Production and Distribution: An Integrated Approach*. Boulder, CO: Westview, 1992.

Blumer, Thomas John. *Catawba Indian Pottery: The Survival of a Folk Tradition*. Tuscaloosa: University of Alabama Press, 2004.

Brackner, Joey. *Alabama Folk Pottery*. Tuscaloosa: University of Alabama Press, 2006.

Branin, M. Lelyn. *The Early Makers of Handcrafted Earthenware and Stoneware in Central and Southern New Jersey*. Rutherford, NJ: Fairleigh Dickinson University Press, 1988.

———. *The Early Potters and Potteries of Maine*. Middletown, CT: Wesleyan University Press, 1978.

Brears, Peter C. D. *The Collector's Book of English Country Pottery*. Newton Abbot, UK: David & Charles, 1974.

———. *The English Country Pottery: Its History and Techniques*. Rutland, VT: Tuttle, 1971.

Bunzel, Ruth L. *The Pueblo Potter: A Study of Creative Imagination in Primitive Art.* 1929. Reprint, New York: Dover, 1972.

Burrison, John A. *Brothers in Clay: The Story of Georgia Folk Pottery.* Rev. ed. Athens: University of Georgia Press, 2008.

———. *From Mud to Jug: The Folk Potters and Pottery of Northeast Georgia.* Athens: University of Georgia Press, 2010.

Caiger-Smith, Alan. *Tin-Glaze Pottery in Europe and the Islamic World: The Tradition of 1000 Years in Maiolica, Faience and Delftware.* London: Faber & Faber, 1973.

Camusso, Lorenzo, and Sandro Bortone, eds. *Ceramics of the World: From 4000 B.C. to the Present.* New York: Harry N. Abrams, 1992.

Carskadden, Jeff, and Richard Gartley. *James L. Murphy's Checklist of 19th-Century Bluebird Potters and Potteries in Muskingum County, Ohio.* Zanesville, OH: Muskingum Valley Archaeological Survey, 2014.

Carswell, John. *Iznik Pottery.* Northampton, MA: Interlink, 2007.

Charleston, R. J., ed. *World Ceramics: An Illustrated History.* London: Hamlyn, 1968.

Comstock, H. E. *The Pottery of the Shenandoah Valley Region.* Chapel Hill: University of North Carolina Press, 1994.

Cooper, Emmanuel. *Ten Thousand Years of Pottery.* 4th ed. Philadelphia: University of Pennsylvania Press, 2000.

Cort, Louise Allison. *Shigaraki: Potters' Valley.* Bangkok, Thailand: Orchid Press, 2006.

Crueger, Anneliese, Wulf Crueger, and Saeko Itô. *Modern Japanese Ceramics: Pathways of Innovation and Tradition.* New York: Lark, 2007.

Denny, Walter B. *Iznik: The Artistry of Ottoman Ceramics.* London: Thames & Hudson, 2004.

Dillingham, Rick. *Acoma & Laguna Pottery.* Santa Fe, NM: School of American Research Press, 1992.

Druc, Isabelle C. *Traditional Potters: From the Andes to Vietnam.* Blue Mounds, WI: Deep University Press, 2016.

Duncan, Ronald J. *The Ceramics of Ráquira, Colombia: Gender, Work, and Economic Change.* Gainesville: University Press of Florida, 1998.

Fariello, M. Anna. *Cherokee Pottery: From the Hands of Our Elders.* Charleston, SC: History Press, 2011.

Fehérvári, Géza. *Pottery of the Islamic World in the Tareq Rajab Museum.* Hawelli, Kuwait: Tareq Rajab Museum, 1998.

Frank, Larry, and Francis H. Harlow. *Historic Pottery of the Pueblo Indians, 1600–1880.* West Chester, PA: Schiffer, 1990.

Gaimster, David R. M. *German Stoneware, 1200–1900: Archaeology and Cultural History.* London: British Museum Press, 1997.

Gavin, Robin Farwell, Donna Pierce, and Alfonso Pleguezuelo, eds. *Cerámica y Cultura: The Story of Spanish and Mexican Mayolica.* Albuquerque: University of New Mexico Press, 2003.

Glassie, Henry. *The Potter's Art.* Bloomington: Indiana University Press; Philadelphia: Material Culture, 1999.

Greer, Georgeanna H. *American Stonewares, The Art and Craft of Utilitarian Potters.* 4th ed. Exton, PA: Schiffer, 2005.

Grigsby, Leslie B. *English Slip-Decorated Earthenware at Williamsburg.* Williamsburg, VA: Colonial Williamsburg Foundation, 1993.

Guilland, Harold F. *Early American Folk Pottery.* Philadelphia: Chilton, 1971.

Hedgecoe, John, and Salma Samar Damluji. *Zillij: The Art of Moroccan Ceramics.* Reading, UK: Garnet, 1992.

Heimann, Robert B., and Marino Maggetti. *Ancient and Historical Ceramics: Materials, Technology, Art, and Culinary Traditions.* Stuttgart, Germany: Schweizerbart Science, 2014.

Hess, Catherine. *Italian Ceramics: Catalogue of the J. Paul Getty Museum Collection.* Los Angeles: Getty, 2002.

Hewitt, Mark, and Nancy Sweezy. *The Potter's Eye: Art and Tradition in North Carolina Pottery.* Chapel Hill: University of North Carolina Press, 2005.

Hume, Ivor Noël. *If These Pots Could Talk: Collecting 2,000 Years of British Household Pottery.* Milwaukee, WI: Chipstone Foundation, 2001.

Ionas, Ioannis. *Traditional Pottery and Potters in Cyprus: The Disappearance of an Ancient Craft Industry in the 19th and 20th Centuries.* Aldershot, UK: Ashgate, 2000.

Ketchum, William C., Jr. *Potters and Potteries of New York State, 1650–1900.* 2nd ed. Syracuse, NY: Syracuse University Press, 1987.

Kyung-sook, Kang. *Korean Ceramics.* Seoul: Korea Foundation, 2008.

Lewis, J. M. *The Ewenny Potteries.* Cardiff, UK: National Museum of Wales, 1982.

Litto, Gertrude. *South American Folk Pottery.* New York: Watson-Guptill, 1976.

Llorens Artigas, José, and José Corredor Matheos. *Spanish Folk Ceramics of Today.* 2nd ed. New York: Watson-Guptill, 1974.

Lowell, Susan, Jorge Quintana, Walter Parks, W. Ross Humphreys, Robin Stancliff, and James Hills. *The Many Faces of Mata Ortiz.* Tucson, AZ: Rio Nuevo, 1999.

Mack, Charles R. *Talking with the Turners: Conversations with Southern Folk Potters.* Columbia: University of South Carolina Press, 2006.

May, Patricia, and Margaret Tuckson. *The Traditional Pottery of Papua, New Guinea.* Rev. ed. Honolulu: University of Hawaii Press, 2000.

McGarva, Andrew. *Country Pottery: The Traditional Earthenware of Britain.* London: A & C Black, 2000.

McQuade, Margaret C., and Jaime C. Castro. *Talavera Poblana: Four Centuries of a Mexican Ceramic Tradition.* Albuquerque: University of New Mexico Press, 2000.

Medley, Margaret. *The Chinese Potter: A Practical History of Chinese Ceramics.* 3rd ed. London: Phaidon, 1989.

Minchilli, Elizabeth Helman. *Deruta: A Tradition of Italian Ceramics.* San Francisco: Chronicle Books, 1998.

Moes, Robert. *Quiet Beauty: Fifty Centuries of Japanese Folk Ceramics from the Montgomery Collection.* Alexandria, VA: Art Services International, 2003.

Oakley, John H. *The Greek Vase: Art of the Storyteller.* Los Angeles: Getty, 2013.

Oswald, Adrian, R. J. C. Hildyard, and R. G. Hughes. *English Brown Stoneware 1670–1900*. London: Faber & Faber, 1983.

Pancaroğlu, Oya. *Perpetual Glory: Medieval Islamic Ceramics from the Harvey B. Plotnick Collection*. New Haven: Yale University Press, 2007.

Perryman, Jane. *Traditional Pottery of India*. London: A & C Black, 2000.

Peterson, Susan. *The Living Tradition of Maria Martinez*. Tokyo: Kodansha International, 1977.

Poulet, Marcel. *Poteries et Potiers de Puisaye et du Val de Loire, XVIème-XXème Siècle*. Merry-la-Vallée, France: n.p., 2000.

Price, Lorna, ed. *Yakimono: 4000 Years of Japanese Ceramics*. Honolulu: Honolulu Academy of Arts, 2005.

Rawson, Philip. *Ceramics*. London: Oxford University Press, 1971.

Ray, Anthony. *Spanish Pottery 1248–1898 with a Catalogue of the Collection in the Victoria and Albert Museum*. London: V&A Publications, 2000.

Ribeiro, Maria. *Iznik Pottery and Tiles*. London and New York: Scala, 2010.

Rooney, Dawn F. *Ceramics of Seduction: Glazed Wares from Southeast Asia*. Bangkok, Thailand: River Books, 2013.

Roy, Christopher D., ed. *Clay and Fire: Pottery in Africa*. Iowa City: University of Iowa, School of Art and Art History, 2000.

Sayers, Robert, with Ralph Rinzler. *The Korean* Onggi *Potter*. Smithsonian Folklife Studies 5. Washington, DC: Smithsonian Institution Press, 1987.

Sentance, Bryan. *Ceramics: A World Guide to Traditional Techniques*. London: Thames & Hudson, 2004.

Shippen, Mick. *The Traditional Ceramics of Southeast Asia*. Honolulu: University of Hawaii Press, 2005.

Skerry, Janine E., and Suzanne Findlen Hood. *Salt-Glazed Stoneware in Early America*. Hanover, NH: University Press of New England, 2009.

Smith, Samuel D., and Stephen T. Rogers. *Tennessee Potteries, Pots, and Potters—1790s to 1950*. 2 vols. Nashville: Tennessee Department of Environment and Conservation, Division of Archaeology, 2011.

Staubach, Suzanne. *Clay: The History and Evolution of Humankind's Relationship with Earth's Most Primal Element*. New York: Berkley Books, 2005.

Stevenson, John, and John Guy, eds. *Vietnamese Ceramics: A Separate Tradition*. Chicago: Art Media Resources, 1997.

Sweezy, Nancy. *Raised in Clay: The Southern Pottery Tradition*. Rev. ed. Chapel Hill: University of North Carolina Press, 1994.

Thompson, Amanda. *Cerámica: Mexican Pottery of the 20th Century*. Atglen, PA: Schiffer, 2007.

Todd, Leonard. *Carolina Clay: The Life and Legend of the Slave Potter Dave*. New York: Norton, 2008.

Truong, Philippe. *The Elephant and the Lotus: Vietnamese Ceramics in the Museum of Fine Arts, Boston*. Boston: MFA Publications, 2007.

Vincentelli, Moira. *Women and Ceramics: Gendered Vessels*. Manchester, UK: Manchester University Press, 2000.

———. *Women Potters: Transforming Traditions*. New Brunswick, NJ: Rutgers University Press, 2004.

Wasserspring, Lois. *Oaxacan Ceramics: Traditional Folk Art by Oaxacan Women*. San Francisco: Chronicle Books, 2000.

Watkins, Lura Woodside. *Early New England Potters and Their Wares*. Cambridge, MA: Harvard University Press, 1950.

Watson, Oliver. *Ceramics from Islamic Lands*. New ed. London: Thames & Hudson, 2006.

Zhiyan, Li, Virginia L. Bower, and He Li, eds. *Chinese Ceramics: From the Paleolithic Period through the Qing Dynasty*. New Haven, CT: Yale University Press; Beijing: Foreign Languages Press, 2010.

Zug, Charles G., III. *Turners and Burners: The Folk Potters of North Carolina*. Chapel Hill: University of North Carolina Press, 1986.

INDEX

Page numbers in italics refer to figures and tables.

287, 294; salt, 5, 7, 20, 25–27, 29, 45, 54, 94, *100*, 119–121, 122, *142*, 146, 149, *163*, 165, *182*, 188, 245, 270, 272–275, 277, 279, 280, 283, 305, 306; *sancai*, 80, 81, *157–158*, 259. *See also* celadon; delftware; faience; Hispano-Moresque ware; maiolica

goat, *161*, *197*

Gómez, Juan Manuel Gabarrón, 303

gong shi, 253, 261

Gordy: Annie and William Thomas Belah, 132; Dorris Xerxes (D. X.), 38

grave markers (ceramic), 267–277, *268–269*, *271–276*

Gray, Catherine, 250

Grazia, Ubaldo, 302

Greatbatch, Daniel, 165

Great Britain, 11, 20, 189, 194, 228, 277, 280. *See also* England; Scotland; Wales

Great Recession, 305, 307

Grebner, Georg Friedrich, 226, 228

Greece, 30, *177*, 180, *211*, *212*; Attica (Athens area), 112, *114*, *167*, 253-254; Crete (including Heraklion), 180, 207, 212, 263, 264; Thebes, *192*

Greer, Georgeanna H., 80, 88

griffin, 194

Grindstaff, William, 99, *100*

"grog," 11, *163*

Guatemala, 250, *251*

Gutenberg, Johannes, 249n5

Guthrie, George Duncan, 8n2

Ha Jeong Lee, 91

Hajj, 240

Ham, Jesse Calvin, 126, 130

Hamman, Derck, 224, 228

hand-building, 28, 30, *33*, 253, 292, 298, 307–308, *309–311*

haniwa, 260, 261

"hare's fur." *See* glaze: Jian (Chien)

Harris: David and Philip, 283; Georgia, *33*, 312

Hathaway, Anthony, *188*

Hausser, Robert, *304*

Hawaii, 8n2

Hayes, Rutherford B., *182*

Henry VIII, 159

Heqet, *171*, 202

Hetjens-Museum (Deutsches Keramikmuseum), 59

Hewell: Chester, 135–136; Grace Nell Wilson, 30, 32; Matthew and Nathaniel, 136; William Jefferson "(Will"/"Bill"), 135, *136*

Hewell's Pottery, 59, 136, 282

Hewitt, Mark, 94

Hicks, Fred, 136

Hillview Pottery, 284, 286, 287

Hilton, Ernest Auburn ("Auby"), 132

hippopotamus, *164*, 165

Hispano-Moresque ware, 19, 72, *73*, 91, 303

Höhnen, Olaf, 45, 55, 57

Holland: Delft, 16, 69, 72, 80, 86. *See also* Netherlands

Holz, Manfred, 45, 56

hoodoo. See conjure

horse, 153, 155, *157*, 216, *218*, 237, 238, 253, *256–257*, 260, 261, 307

Horus, 185, *208*, 212, 238, *239*

Huang Bing, *169*

Hubener, George, *18*

Hughes, John, 5, 7

Huguenin, Jean Pierre Victor, 55

Huizong, Emperor (Zhao Ji), 24

Humboldt Current, 180

Ifield, John, *117*, 122

Illinois: Anna, *146*, 149, *182*, *183*, *185*

Imari ware, 69, 71

"Incredulity of Saint Thomas," 225, 228

India: Andhra Pradesh, 185; Bodh Gaya, 216, *219*, 222; Delhi, 294; Harwan, *231*, 232; Jaipur, 294; Kolkata (Calcutta), *210*, 212; Mathura, 216; Tamil Nadu, 237, *238*; Uttar Pradesh, 216, *218*

Indonesia: Belitung, 65; East Java, *144*, 149; Trowulan, *144*

Industrial Revolution, 10, 283

The author with a recent Chinese face jug at Panjiayuan Flea Market, Beijing, 2011.
Photo: Pan Shan.

JOHN A. BURRISON is Regents Professor of English and Director of the Folklore Curriculum at Georgia State University in Atlanta, where he has taught folklore since 1966. He also has served as curator of the Folk Pottery Museum of Northeast Georgia at Sautee Nacoochee and of the Goizueta Folklife Gallery at the Atlanta History Museum. His previous books include *Brothers in Clay: The Story of Georgia Folk Pottery* and *From Mud to Jug: The Folk Potters and Pottery of Northeast Georgia*, as well as *Storytellers: Folktales and Legends from the South, Roots of a Region: Southern Folk Culture*, and *Shaping Traditions: Folk Arts in a Changing South*.